# THE P.R.B. JOURNAL

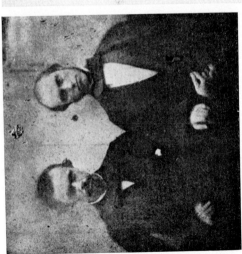

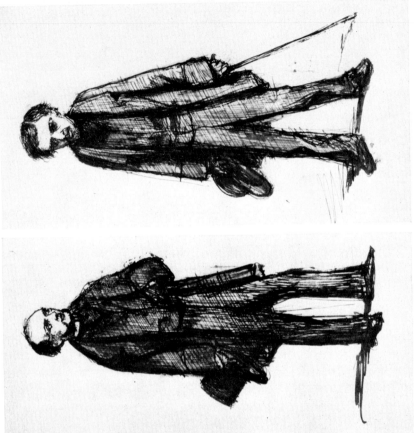

The Rossetti Brothers in 1853:
*a.* Contemporary photograph
*b.* Caricature by D. G. Rossetti

# The P.R.B. Journal

WILLIAM MICHAEL ROSSETTI'S
DIARY OF THE
PRE-RAPHAELITE BROTHERHOOD
1849–1853

TOGETHER WITH

OTHER PRE-RAPHAELITE DOCUMENTS

*Edited from the Original Manuscript*
*with an Introduction and Notes*
*by*
WILLIAM E. FREDEMAN

OXFORD
AT THE CLARENDON PRESS
1975

37777

*Oxford University Press, Ely House, London W. 1*

GLASGOW  NEW YORK  TORONTO  MELBOURNE  WELLINGTON
CAPE TOWN  IBADAN  NAIROBI  DAR ES SALAAM  LUSAKA  ADDIS ABABA
DELHI  BOMBAY  CALCUTTA  MADRAS  KARACHI  LAHORE  DACCA
KUALA LUMPUR  SINGAPORE  HONG KONG  TOKYO

ISBN 0 19 812505 4

*Printed in Great Britain
at the University Press, Oxford
by Vivian Ridler
Printer to the University*

IN MEMORIAM
HELEN ROSSETTI ANGELI
(1879–1969)

# PREFACE

WILLIAM MICHAEL ROSSETTI incorporated a large portion of the *P.R.B. Journal* in his collection of early family materials, *Præraphaelite Diaries and Letters* (1900), but what survives of the manuscript has never before been published in its entirety. The *Journal* is the black orchid among Pre-Raphaelite documents, for, apart from correspondence, it is the sole contemporary authority for the history of the Pre-Raphaelite Brotherhood and *The Germ*. Rossetti relied on it in his several accounts of Pre-Raphaelite activities, and his edition has become the foundation stone upon which later commentaries on the Brotherhood have been built.

Like most excerpts, Rossetti's partial edition does not tell the whole story; the omissions reflect the editor's taste and discretion, his discernment of what is interesting and valuable, and, especially, his own overwhelming modesty. For, though he kept the *Journal* as part of his duties as Secretary of the P.R.B.—a post he described as 'more nominal than burdensome'—in editing his own work he tended to excise himself and to concentrate his focus on his more illustrious companions.

This edition preserves the whole of the surviving manuscript. In editing it, I have tried to combine modern practices with common sense, retaining as much as possible of the style of the original. I have also been concerned to produce a legible and uncluttered text, relegating the editorial business to an apparatus section at the end, where will also be found explanatory notes and a series of appendices. Since both the Explanatory Notes and the Critical Apparatus have their own introductions, only the seven appendices require comment here. Six of these make accessible complementary documents that assist in placing the *Journal* more accurately within the context of the P.R.B. Two of the appendices are unpublished; the others have been gathered from scattered sources and should prove convenient to users of the *Journal*. Appendix 5 provides a chronological survey of the known facts

relating to *The Germ*, extracted from *Journal* entries and other sources. Details of the composition, transmission, and subsequent publication of the *P.R.B. Journal* are given in the Introduction.

There remains only the pleasant task of thanking the many students and colleagues, private collectors, institutions and foundations that have contributed to this edition. Several years ago, five students in my graduate seminar in bibliography produced, as their major course project, a preliminary edition of the *P.R.B. Journal*; their initial work and the insights they brought to the problems of editing the manuscript have benefited me enormously. Subsequently, two of my graduate research assistants did much of the spade work on the material incorporated into the notes. For their assistance, I should like to thank both Dr. Warwick Slinn, now of Massey University, New Zealand, and Dr. Allan Life, whose wide knowledge of Pre-Raphaelitism and unflagging devotion to the minutiae of scholarship have proved invaluable. Both have invested their time and talent in the preparation of this edition.

For their availability as consultants and advisers, I am grateful to Simon Nowell-Smith, whose editorial experience and impeccable taste I have always found reliable, and to Dr. J. A. Lavin, my colleague, who is ever ready to lend sound counsel on scholarly matters. Productive colleagues working in related areas deserve far more credit than is afforded by footnote and bibliographical references, and I am pleased to single out for special acknowledgement Mary Bennett, Ian Fletcher, Roger Peattie, Virginia Surtees, and Christopher Wood, without whose researches my notes would have been infinitely less rich.

The late Signora Helen Rossetti Angeli first lent me the manuscript of the *P.R.B. Journal* in 1963; later, it was acquired with other manuscripts in the Angeli Papers by the University of British Columbia Library. For allowing me to publish the manuscript and letters of her grandfather, W. M. Rossetti, I am most grateful to Mrs. Imogen Dennis. Other manuscripts and letters are published with the kind permission of the following copyright owners: Diana Holman Hunt, Sir Ralph Millais, and Major-General C. G. Woolner. In spite of every effort, I have been unsuccessful in tracing copyright holders on manuscript material by

the following writers: E. Bellamy, James Collinson, W. J. Cox, W. H. Deverell, A. Heraud, R. H. Horne, John Orchard, Coventry Patmore, R. S. Rintoul, Bernhard Smith, F. G. Stephens, and the two Tupper brothers, John Lucas and George. I should be happy to make the necessary arrangements at the first opportunity. Libraries have also been responsive in allowing me to include unpublished materials in their collections, especially the Beinecke Rare Book and Manuscript Library of Yale University, the Bodleian, Durham University Library, the Henry E. Huntington Library, and the University of British Columbia. Among those who have assisted me with permissions, I should like to acknowledge John Carter, Professor Ronald E. Freeman of U.C.L.A., Mary Lutyens, Lady Mander, Jean Preston of the Huntington Library, Marjorie G. Wynne of the Beinecke Library, and Professor R. H. Tener of the University of Calgary. For the continuing interest which he has shown in my various projects over the years and for his practical encouragement, I should particularly like to thank the University of British Columbia Librarian, Basil Stuart-Stubbs.

Finally, I must acknowledge the generous support of the John Simon Guggenheim Memorial Foundation, the Canada Council, and the University of British Columbia. Without their practical assistance in the form of research grants and leave time, this edition would not have been possible.

# CONTENTS

# LIST OF PLATES

# ABBREVIATIONS

THE following abbreviations of standard works and recurring proper names are employed throughout the editorial matter in this edition. Abbreviations for standard reference works (*DNB*, *Wellesley*, etc.) follow conventional usage. Short titles only are given below; full publication details will be found in the Bibliography.

## A. PERSONS

| | | | |
|------|-------------------------|------|-------------------------|
| CGR  | Christina Georgina Rossetti | JLT  | John Lucas Tupper |
| CP   | Coventry Patmore | TW   | Thomas Woolner |
| DGR  | Dante Gabriel Rossetti | WBS  | William Bell Scott |
| FGS  | Frederic George Stephens | WCT  | William Cave Thomas |
| FMB  | Ford Madox Brown | WHD  | Walter Howell Deverell |
| JC   | James Collinson | WHH  | William Holman Hunt |
| JEM  | John Everett Millais | WMR  | William Michael Rossetti |

## B. MANUSCRIPTS AND PUBLISHED SOURCES

| | |
|------|---|
| AP | Angeli Papers, University of British Columbia Library. |
| BSP | Stephens Papers, Bodleian Library. |
| HDP | Deverell Papers in the Henry E. Huntington Library. |
| *PRBJ* | MS. of the *P.R.B. Journal*, U.B.C. Library; also refers to the present edition. |

| | |
|------|---|
| *AN* | *Autobiographical Notes of WBS*, 2 vols. (1892). |
| *Brown* | Exhibition of FMB, catalogue by Mary Bennett (1964). |
| Champneys | *Memoirs and Correspondence of CP*, 2 vols. (1900). |
| *DGRDW* | *DGR as Designer and Writer*, by WMR (1889). |
| DW | *Letters of DGR*, ed. Doughty and Wahl, 4 vols. (1965–7). |
| *FLCGR* | *Family Letters of CGR*, ed. WMR (1908). |
| FLM | *Family-Letters of DGR with a Memoir*, ed. WMR, 2 vols. (1895). |
| Gere | *Pre-Raphaelite Painters* by Robin Ironside with Descriptive Catalogue by John Gere (1948). |
| *Hunt* | Exhibition of WHH, catalogue by Mary Bennett (1969). |
| *LLJEM* | *Life and Letters of JEM*, 2 vols. (1900). |
| *Millais* | Exhibition of JEM, catalogue by Mary Bennett (1967). |

Peattie        Bibliography in 'WMR as Critic and Editor' (unpublished Ph.D. dissertation, 1966).

*PDL*        *Præraphaelite Diaries and Letters*, ed. WMR (1900); refers specifically to the published portion of *PRBJ* included in that volume.

*PFG*        WMR's Preface to the Stock facsimile of *The Germ* (1901).

*Pre-Raphaelitism*        *Pre-Raphaelitism: A Bibliocritical Study*, by W. E. Fredeman (1965).

*PR&PRB*        *Pre-Raphaelitism and the Pre-Raphaelite Brotherhood*, by WHH, 2 vols., 2nd rev. ed. (1913).

*SR*        *Some Reminiscences*, by WMR, 2 vols. (1906).

Surtees        *DGR: A Catalogue Raisonné*, 2 vols. (1971).

*TWLL*        *TW: His Life in Letters*, ed. Amy Woolner (1917).

Wood        *Dictionary of Victorian Painters* (1971).

*Works*        *Works of DGR*, ed. WMR (1911).

# INTRODUCTION

## I

INTRODUCING the *P.R.B. Journal* to his audience at the turn of
the century, William Michael Rossetti felt the necessity of re-
hearsing the 'frequently summarized' history of the Brotherhood.
So successful has been the revival of the Pre-Raphaelites since the
centenary year that to-day such a recapitulation would be an act
of supererogation. The movement that Dante Rossetti later
labelled the 'visionary vanities of half-a-dozen boys' has by this
time become commonplace. In the past two decades, no less than
two dozen popular and serious books (including two novels) have
been written on the Pre-Raphaelites; the three principal P.R.B.s
have had important retrospective exhibitions—Dante Gabriel
Rossetti most recently in the halls of that arch institutional enemy
of the Brotherhood, the Royal Academy; and Pre-Raphaelite
pictures command ever-escalating prices in the sale-rooms of
England and America. The Pre-Raphaelites have also attained
scholarly respectability, in both the literary and artistic disciplines,
where they are studied and researched with a belated fury. These
artistic revolutionaries of 1848 have now become almost orthodox,
a part of the aesthetic establishment, a recognized and generally
admired link in the chain of British and European art.

Such acclaim could hardly have been predicted for the P.R.B.s
by their contemporaries, certainly not by the Brothers them-
selves. Within the loose framework of the Brotherhood, they
sought to make a collective impact that no single artist working
independently might hope to accomplish; but the Brotherhood
was to prove too loose-fitting a mantle to disguise for long the
basic diversity—of talent, training, and temperament—that
characterized the original seven. They found in union a temporary
security, but public exposure, critical onslaught, personal ambi-
tion, and, especially, their inability to forge a common purpose—
to articulate, even in their magazine, a consistent set of principles
—all militated against the continuance of the group.

One of the principal difficulties in appraising the P.R.B. is to

preserve a balanced perspective. It is easy to overemphasize the relevance of their coalition by isolating in their productions common elements which are too vague to be critically useful, such as their reliance on the maxim to follow nature in all things; but it is equally erroneous to dismiss casually the real benefits which each gained from participating in a shared enterprise.

As soon as the Præraphaelite Brotherhood was formed [wrote William Rossetti], it became a focus of boundless companionship, pleasant and touching to recall. We were really like brothers, continually together, and confiding to one another all experiences bearing upon questions of art and literature, and many affecting us as individuals. We dropped using the term 'Esquire' on letters, and substituted 'P.R.B.' I do not exaggerate in saying that every member of the fraternity was just as much intent upon furthering the advance and promoting the interests of his 'Brothers' as his own. There were monthly meetings, at the houses or studios of the various members in succession; occasionally a moonlight walk or a night on the Thames. Beyond this, but very few days can have passed in a year when two or more P.R.B.'s did not foregather for one purpose or another. The only one of us who could be regarded as moderately well off, living *en famille* on a scale of average comfort, was Millais; others were struggling or really poor. All that was of no account. We had our thoughts, our unrestrained converse, our studies, aspirations, efforts, and actual doings; and for every P.R.B. to drink a cup or two of tea or coffee, or a glass or two of beer, in the company of other P.R.B.'s with or without the accompaniment of tobacco . . . was a heart-relished luxury, the equal of which the flow of long years has not often presented, I take it, to any one of us. Those were the days of youth; and each man in the company, even if he did not project great things of his own, revelled in poetry or sunned himself in art. (*FLM*, i. 133)

Rossetti's[1] account is admittedly nostalgic and sentimental—the reflections of an old man looking back upon his salad days—and it contrasts dramatically with Holman Hunt's re-creation in his autobiography. But it is precisely those aspects of fraternity— companionship, sociability, mutual concern, reciprocal enthusiasm, and community of interests—that are conveyed in the *P.R.B. Journal*, along with the factual account of the comings and goings,

[1] In this edition, the surname Rossetti, when it appears alone, always refers to William Michael Rossetti; when more than one member of the family is mentioned in the same passage, Christian names are employed.

the work and play, the hopes and disappointments, the successes and failures that attended the Brotherhood throughout its brief existence.

## II

Of the origin and history of the *P.R.B. Journal*, Rossetti wrote:

[It] was entirely my own affair, and was compiled without pre-consulting any of my fellow-members, and without afterwards submitting it to them. At the same time, the object of it was understood to be a record, from day to day, of the proceedings of *all* the Members, so far as these were of a professional or semi-professional character, and came within my knowledge; it was not in any sense a diary personal to myself (save in so far as I was one P.R.B. among seven), nor deriving from my own thoughts or feelings. The Journal was producible to any Member who might choose to ask for it—I don't think any one ever did. I used to make it a rule to myself to mention only the Members of the Brotherhood, along with some few other persons who came into close relation with them, their purposes, and their work. (*PDL*, pp. 206–7)

Unfortunately, the *Journal* is not a complete record, for it does not even cover the formative months of the Brotherhood. Rossetti began keeping it about the time of the Academy exhibition in 1849, and continued, with occasional lapses, until 29 January 1853, by which time, as Christina Rossetti wrote, the P.R.B. was in its decadence. More damaging, however, are the missing pages and mutilations, for which Rossetti gives the following explanation:

After the Journal had been finally (though not of any set purpose) discontinued, it lay by me unnoticed for a number of years. When at last I had occasion to re-inspect it, I found that several pages had been torn out by my Brother, and several others mutilated. I never knew accurately—never at all enquired—why he did this. I suppose that at some time or other he took up the MS. in a more or less haphazard way, and noticed in it some things which he did not care to have on record regarding himself, and also in all likelihood regarding Miss Elizabeth Siddal, to whom he was then engaged. Not that I recorded anything whatever in a spirit of detraction or ill-nature concerning either of them—far from that. (*PDL*, p. 208)

The mutilations and missing leaves, which Rossetti estimates at about 'a fair fifth of the whole', are discussed at length in the

Critical Apparatus. His estimate of the extent of the destruction is conservative. In addition to the 49 extant leaves, it can be demonstrated that the original manuscript consisted of at least 20 more, so the missing leaves alone constitute almost 30 per cent of the original, and the mutilations probably amount to another three to four leaves.

The pattern of the mutilations and missing pages also casts doubt on William's speculations concerning his brother's reasons for ravaging the manuscript. Helen Rossetti Angeli follows her father in accounting for her uncle's 'arbitrary and drastic treatment' of the *Journal*, but the story remains unconvincing. In the first place, there are in the *Journal* almost no references of an intimate or personal nature, and William's innate reserve, even so early as 1849–53, is probable warrant that the document never contained revelations of an indiscreet, let alone scandalous, sort. If the precise date when Walter Deverell discovered Elizabeth Siddal in the milliner's shop could be established, the question could be resolved with certainty, but in all that has been written on the Pre-Rapaelites there is nothing to establish either this date or the date of D. G. Rossetti's actual meeting with his future wife. G. H. Fleming, citing no authority, says that the meeting between Deverell and Miss Siddal took place in March 1850. However, William Rossetti always hedges, placing the event between late 1849 and early 1850. Even in Frances Deverell's manuscript memoir, where the date, based on the death of Deverell's mother in October 1850, is given as 'some little time prior to that date', William adds, 'and perhaps in 1849'. The earliest reference to her in Dante Gabriel's letters is 3 September 1850, when he comments to William about the 'disgraceful hoax' that Hunt has perpetrated on Jack Tupper in 'passing Miss Siddal upon him as Hunt's wife'. Helen Angeli described Dante Gabriel as having been 'very angry' about this hoax, but the letter rather reveals him as indifferent concerning Miss Siddal's feelings in the affair: 'As soon as I heard of it', he writes to William, 'I made the Mad [Hunt] write a note of apology to Jack' (DW 57). Whatever the exact date, Deverell must have met Elizabeth Siddal before May 1850 since she posed for his *Twelfth Night* which was exhibited at the National Institution in that month. The tone of Dante Gabriel's letter of 3 September 1850 suggests that there was no close association between them until sometime later.

In the manuscript there are twenty mutilated leaves and ten breaks owing to missing leaves. Fourteen of the mutilations and six breaks (involving fourteen leaves) occur before 1 January 1850, that is, before, in all likelihood, Elizabeth Siddal was introduced into the Pre-Raphaelite circle. Another single-leaf break and three further mutilated pages occur before 4 April 1850. In a letter from F. Bassett to Hunt in the Stephens Papers in the Bodleian (dated 2 December 1850), there is a reference to Hunt's hoax and to its effect on Tupper. If William did record the incident in the *P.R.B. Journal*, that reference would almost certainly be found in entries subsequent to 3 September. In the later part of the *Journal*, that is, after 4 April 1850, there are only three mutilated leaves (two of these in 1851) and three breaks (amounting to five leaves), the first in the long entry for 24 October, the second between 15 and 29 November, and the third in early May. It may well be that in one of these two passages there was a report of Hunt's hoax, which, in retrospect, Dante Gabriel might have found offensive; but this assumption does not account for the preponderance of mutilations and missing leaves in the earlier portion of the manuscript.

Clearly, the matter is not capable of absolute resolution. One must accept William's statement that the destruction was the work of his brother. The evidence does not, however, point to any systematic paring of the manuscript; the tears are too uneven, and the context, which frequently can be re-created, evinces an indiscriminate attack, without conscious motive. Since William does not specify either the timing of the incident or the reason behind it, one can only speculate that it may have taken place during the summer of 1872, when Dante Gabriel underwent his most serious physical and mental crisis. The nature and extent of the damage and the irrationality of the action would be perfectly consistent with the derangement that he suffered during that period, when even the devoted William seriously considered having him incarcerated in an insane asylum.[1] Whatever the motive, whenever performed, the loss is irreparable; the fragmentation of the *Journal* removed for ever entries which would have made possible a more accurate documentation of the day-to-day activities of the P.R.B.

[1] On this point see W. E. Fredeman, *Prelude to the Last Decade: Dante Gabriel Rossetti in the Summer of 1872* (Manchester, 1971).

### III

By his own approximation, Rossetti published 'something like half of the extant manuscript' in his edition of the *P.R.B. Journal* 'In what remains', he asserted, 'a good deal is mere plodding journey-work, of no interest to myself, still less to others' (*PDL*, p. 208). Though such a blanket stricture by the author of the *Journal* might seem to require a later editor to justify a decision to reproduce the whole of the manuscript, an analysis of Rossetti's exclusions will make immediately apparent the superiority of a complete over a selected edition. To assist the reader in making his own appraisal, without recourse to the earlier edition, a guide to the unpublished portions of the *Journal* has been provided in the Critical Apparatus.

It is not easy to see at first glance a rationale behind some of Rossetti's editorial deletions. Initially he seems to have been apprehensive, owing to the flat factuality of the *Journal*'s style, that the publication of the whole would produce a surfeit of dullness:

> I am aware that even these extracts are not written in an entertaining style: the Journal was intended to be simply, and rather servilely, a compendium of *facts*. It is however a highly authentic account of the early stages in a movement which proved of great importance, and to which much and increasing public interest has attached—a movement in which men of staunch achievement and eminent name bore the leading parts. As such, I suppose the P.R.B. Journal may be regarded in some quarters as a document not undeserving of attention. (*PDL*, pp. 208–9)

Logically, one might suppose, the attitude advanced in the later part of this quotation would argue for completeness, yet Rossetti chose excerption, even though the material omitted is at least as interesting as that which was retained.

Considerations of length may have influenced him, or his publishers. The extant manuscript runs to approximately 40,000 words, distributed over 255 entries. Rossetti omitted 80 complete entries of varying length and excerpted others, retaining a total of about 21,500 words and reproducing, in 101 printed pages, slightly more than half the *Journal*.

On the manuscript Rossetti marked—not always accurately— the passages to be printed, providing where required the necessary

connectives, and following, apparently, predetermined editorial decisions about the material to be included. One major exclusion —the removal of himself from the *Journal*—has already been touched upon in my Preface. Although he says categorically that the *Journal* was in no sense a personal diary, it was virtually impossible for him in keeping it to avoid imposing on the entries his own point of view, simply because his were the eyes through which all the recorded events were seen. Letters to him, as Secretary of the P.R.B. and Editor of *The Germ*, are quoted or paraphrased; his visits within and outside the fraternity are noted; and his individual activities are reported, especially when, as is so often the case, 'Pre-Raphaelite news [is] at a discount' (17 October 1849). A high proportion of the entries contain references to the composition of his poems, to his attendance at various drawing classes, to his editorial and secretarial duties, and, occasionally, to non-Pre-Raphaelite business.

Almost without exception, these personal notices are either totally omitted or edited to remove whatever part of the entry applies exclusively to himself. A single instance will illustrate this tendency. On 11 September 1849, he journeyed with James Collinson to the Isle of Wight. Collinson returned to London on the 15th and William travelled in the island until the end of the month, during which time he composed the major portion of his poem, 'Mrs. Holmes Grey', the progress of which he reported in the *Journal* along with information relating to *The Germ* and other matters. Between 11 and 28 September there is an entry for each day (except that for the 16th and those for the end of the month, which are missing owing to mutilations), but in his published edition, he retained only one complete entry and six excerpts, carefully deleting anything of a personal nature. Rossetti's motive in excising himself was doubtless commendable, but the effect distorts the *Journal* as written, and at the same time practically erases the one P.R.B. who, more than any other, was responsible for keeping the Brotherhood intact.

Other exclusions are equally damaging. References to Collinson, for example, tend to be expunged, though his letter of resignation from the P.R.B. is printed (21 July 1850). Indeed, it was probably Collinson's defection, coupled with his broken engagement to Christina Rossetti, that influenced William's decision; however, so little is known of Collinson that any information may prove

material, and the *Journal* mentions several works by him which are not listed in standard sources. Rossetti also omitted references to poems and artistic works by other P.R.B.s which are either not known or no longer extant. Many of these are to works which were never actually executed, but they are of considerable interest as indications of the kinds of projects with which the Pre-Raphaelites were concerned, such as Woolner's intended etching from W. B. Scott's poem on death in the *Edinburgh University Souvenir* (13 March 1850). Several poems by Woolner which do not appear in his published volumes are referred to by title as having been composed; in addition, some of his sculptures that are mentioned do not appear in the 'List of Works' in his daughter's memoir. Many of these works may still survive and one day be located. Related to these omissions are hundreds of missing details pertaining to artistic and poetic compositions and to *The Germ*. Though many of these, admittedly, are trivial—and they are far too numerous to specify—the restoration of others makes it possible to trace with much greater precision the growth of a particular work from inception to completion.

Finally, the most serious *lacuna* in Rossetti's edition is the absence of anything of the boyish humour, the immaturity, and the spontaneity that were so prominent in the P.R.B. By stripping the *Journal* of its most amusing and endearingly naïve entries and focusing on the high seriousness of the group, Rossetti misrepresented both himself and his youthful colleagues. For, as printed, the *Journal* compares in dullness only with Holman Hunt's turgid, pompous, and uninspiring autobiography, though the latter is more a compendium of prejudices than facts. Because of his particular editorial style in his many volumes of family papers and in his own autobiography, *Some Reminiscences*, Rossetti is most often presented in negative or neutral tones. Jerome Thale, in a recent appraisal entitled 'The Third Rossetti', marshalls a veritable glossary of nondescript adjectives to identify him—dull, stodgy, dependable, stable, practical, consistent, responsible, modest, reserved, sensible, prudent, impressive, unenthusiastic, faceless, characterless, level-headed, judicious, normal, well-adjusted, sure, uninteresting, tepid—all of which, for Thale, add up to 'failure'.

When such a style deals with others [Thale concludes], it is not a mirror but a prism which refracts and distorts. Seen through William's

style, Christina, Dante Gabriel, and their circle are pale and sluggish. William tells us the facts . . . but he does not give us the sense—so easy to give with one as flamboyant as Dante Gabriel Rossetti—that behind those facts is a vigorous violent man, a magnetic figure, a genius. (p. 282)

Anyone familiar with William Michael Rossetti will rebel instinctively against Thale's facile oversimplification. Not only was he more complicated than Thale suggests, he was also warmer and more responsive than Thale's limited evidence conveys, as a perusal of his wide correspondence will confirm. And his books are not so devoid of interest as Thale would have it. William Michael Rossetti was the catalytic agent among the Pre-Raphaelites; he did not spark the reaction, but it is indisputable that without his tireless drive, his willingness to undertake the tedious jobs that genius eschews, and his quiet competence the P.R.B. would not have survived gestation, or if it did would soon have died of inertia. He is not remarkable as a man of ideas, but among the P.R.B.s he was almost the only man of action, and without him there would have been no Brotherhood, no *Germ*, no *P.R.B. Journal*, and no movement to leave its mark on the history of English art.

Yet, in fairness, it must be conceded that Thale's evaluation of Rossetti's style accurately epitomizes his partial edition of the *P.R.B. Journal*. It is prismatic, and the omissions do distort by refracting the total context of the *Journal* into lesser segments which tend to mislead. In the whole of his edition, there is only a single humorous episode—that involving Hunt's model who, over a pot of beer, lowered her price for sitting from £5 to a shilling an hour (25 March 1850). All other levity he rejected, along with expressions of bias or prejudice and derogatory asides —about Patmore, Dickens, Collinson, Jerrold, and others; manifestations of his own or others' folly, as in the episodes involving Donovan the Phrenologist (1 and 6 November 1849), or his own suggestion for dispersing *Germs* (29 December 1849); amusing trivia such as the death of Millais's 'poor Tommy' (25 July 1849) or Gabriel's acquisition of a 'toothless scotch terrier' (24 March 1850); passages like that on the obese model (30 May 1849), which in retrospect he found indecorous; and, more inexplicably, many entries which portray the conviviality of the P.R.B. From the entry of 11 May 1851, for example, he deleted this portion

describing what must have been a recurring Pre-Raphaelite scene:

> Having sat up at Hannay's till an advanced hour in the morning, Hunt proposed that we should finish the day with a row up to Richmond, to which Gabriel, Hannay, and I, agreed. We had a fine day; the lovely Spring variations of green in trees and grass were specially delightful. A bottle of champagne and a bottle of claret which we took with us from Hunt's served to drink the P.R.B. and Tennyson and Browning in.

The contrast between the published and unpublished halves of this entry should make clearer than any verbal elaboration the extent of Rossetti's editorial surgery: 'The picture Hunt is purposing to do for next year is a life-sized one on the passage from one of Moses's hymns or exhortations where it is said that God found Jacob honey in the cleft of the rock.'

IV

The significance of the *P.R.B. Journal* as the single most important document of the movement has long been recognized; it is to be hoped that the foregoing discussion of the limitations of the partial edition has made clear the advantages of the complete. The Pre-Raphaelite historian will discover in the unpublished portions some material that is new and a wealth of details which reinforce existing documentation. But novelty is not the principal justification for publishing the extant manuscript *in toto*. Having the whole of the *Journal* enables the student of Pre-Raphaelitism to participate more directly and intimately in the experience of the Brotherhood, and to understand with greater clarity the bonds of friendship and vocation that united them in a common cause. As a complete entity, for all its mutilations and missing leaves, the *Journal* gives a more accurate view of their shared endeavours, of the issues which they confronted, and of some of their solutions. Because the unpublished entries restore more of the social background than has hitherto been available, the P.R.B.s are seen in a truer perspective, at once less serious and more human; but the restored entries also underscore the commitment of most of the brothers to hard work and professionalism. With few funds and little encouragement beyond the

confines of their own fraternity, they devoted themselves to their art with a singularity of purpose unusual in young men. The *Journal* abounds with new designs for pictures and sculptures, new poems, articles and tales, and activities designed to improve their command of their craft. The substance of the P.R.B. was, as they retitled *The Germ*, 'Art and Poetry'. However posterity ultimately assesses their individual and collective achievement, their pre-occupation with these twin concerns is indelibly recorded in William Michael Rossetti's diary of the Pre-Raphaelite experiment, the *P.R.B. Journal*.

# THE P.R.B. JOURNAL

8125054

# THE P.R.B.

| | |
|---|---|
| JAMES COLLINSON | (1825?–1881) |
| WILLIAM HOLMAN HUNT | (1827–1910) |
| JOHN EVERETT MILLAIS | (1829–1896) |
| DANTE GABRIEL ROSSETTI | (1828–1882) |
| WILLIAM MICHAEL ROSSETTI | (1829–1919) |
| FREDERIC GEORGE STEPHENS | (1828–1907) |
| THOMAS WOOLNER | (1825–1892) |

1. 'The P.R.B. Meeting'

[May 1849.

Tuesday 15th. At Millais'; Hunt, Stephens, Collinson, Gabriel, & myself. Gabriel brought with him his design of Dante drawing the figure of an Angel on the 1st anniversary of Beatrice's death,[1] which he completed in the course of the day & intends for Millais. Millais has done some figures of the populace in his design of the Abbey at Caen[2] since last night, & has also continued painting on the beard in the head of Ferdinand listening to Ariel, being that of Stephens. He says he has begun his "Castle-moat" poem,[3] & is to continue it after we left, (1 o'clock.) The plan of writing this diary was fixed, & will, I am in hopes, be steadily persevered in. We minutely ana-lyzed such defects as there are in Patmore's "River" from Gabriel's recitation; who also read his poem (in progress) intended as intro-ductory to the Vita Nuova.[4] In the course of conversation, Millais told me that there is a pool suitable for my Patmore subject on Wimbledon Common. Having settled to our unanimous satisfaction (Compton's identity in appearance with a Llama, we separated.

[Wednesday 16th] Gabriel called to-day on Woolner, who informed him that Cottingham had returned; also that Hancock had come into his studio requesting to be informed whether he might put P.R.B. to his works, & that he had told him that he would propose it to the Council, but that his is only one vote: whereupon Hancock withdrew in considerable reverence. In

1 This pen-+-ink design was quite different from the watercolour of. Dante Rossetti after-wards executed of the same subject.

2. Facsimile of MS. 1452 of PRBJ

# May 1849

*Tuesday 15th.* At Millais's; Hunt, Stephens, Collinson, Gabriel, and myself. Gabriel brought with him his design of *Dante Drawing the Figure of an Angel* on the first anniversary of Beatrice's death, which he completed in the course of the day and intends for Millais. Millais has done some figures of the populace in his design of the Abbey at Caen since last night, and has also continued painting on the beard in the head of Ferdinand listening to Ariel, being that of Stephens. He says he has begun his 'Castle-moat' poem, and is to continue it after we left, (1 o'clock). The plan of writing this diary was fixed, and will, I am in hopes, be steadily persevered in. We minutely analyzed such defects as there are in Patmore's 'River' from Gabriel's recitation; who also read his poem (in progress) intended as introductory to the *Vita Nuova*. In the course of conversation, Millais told me that there is a pool suitable for my Patmore subject on Wimbledon Common. Having settled to our unanimous satisfaction Compton's identity in appearance with a Llama, we separated.

*Wednesday 16th.* Gabriel called to-day on Woolner, who informed him that Cottingham had returned; also that Hancock had come into his studio requesting to be informed whether he might put P.R.B. to his works, and that he had told him that he would propose it to the Council, but that his is only one vote; whereupon Hancock withdrew in considerable reverence. In the evening, Gabriel began redesigning *Kate the Queen*, and I tried to continue my Patmore design, but failed.

*Thursday 17th.* Millais called on us in the evening. He has gone on with his Caen Nunnery design, and has put in some fat men, finding his general tendency to be towards thin ones. He is also progressing with his poem (the Castle-moat subject), and will restore the epithet 'corpulent' of a robin, which his brother had induced him to alter. Whilst at dinner, Gabriel being out, some gentleman in black with a beard called and enquired for 'Mr.

G. D. Rossetti', whence we conclude his business must concern Gabriel's picture; he would not leave his name. The 10 prints due from the Society for the Distribution of Religious Prints came to-day, comprising some filthy Brocky's and a Dobson.

*Friday 18th.* Collinson, (who will leave early to-morrow morning for his family in the Country, where he will remain till near the close of the exhibition) on enquiring to-day, learned that there had been several persons asking particulars of his picture, tho' nothing has yet come of it; whereupon he has reduced the price from £200 to £120. I cannot but think this somewhat too low. In the evening Woolner called with Bernhard Smith, who has finally made up his mind to emigrate, and will consequently leave, in the first place for Yorkshire, on Monday or Tuesday. He wants the P.R.B. to come to him to-morrow. Woolner has written a short love-poem and a song, 'You gazed with such superb disdain' and 'Gone for ever'. Gabriel read them our translations of the Francesca [and] Ugolino, which seemed to delight . . . [them. I considered my Patmore subject and determined as Gabriel] suggests to make Maud merely looking up from her book (omitting the throwing stones into the water) at two children stooping down to look at their faces in the water. I think I shall adopt this, tho' it will require some skill to explain the intention.

*Saturday 19th.* I went in the morning to the Academy where I met Gabriel. In the evening to Woolner's where we all were present, Millais excepted, who was engaged elsewhere. Called in the way on Hunt, who is getting on with his Monk succored by the ancient Britons in time of persecution. Woolner has done four of his heads commissioned by Cottingham, Rafael, M. Angelo, Titian and Leonardo, and is engaged on Vandyck. He has also written another song 'O When and Where?'—B. Smith is to leave on Tuesday morning. Talked much of the worst pictures in the Academy, swimming, dreams, early recollections, and our personal characters. I understand that the *Court Journal*, speaking of a picture by one Walters that has been rejected, exclaims against the injustice, considering that such works as Hunt's and Millais's, which can have been admitted only for charity, are hung.

*Sunday 20th.* Gabriel made considerable progress to-day with his *Kate the Queen* design; and I have attempted a recommencement of mine from Patmore. Woolner came in the evening, and shewed us two verses of a new song he has begun, having the burden 'My Lady rests her heavy heavy rest'. . . .

*Monday 21st.* Millais called in the evening to take Gabriel with him [to] Mr. Bateman's, the Illuminator; they also picked up Woolner on the way. The visit, including Devonshire cream, afforded unqualified satisfaction. Gabriel recited lots of Patmore, Browning Mrs. Browning etc. I again made futile efforts on my Patmore subject; and as everything I do has to be rubbed out the same day, shall not consider it necessary to mention this henceforward, until I have done something better worth doing. We, Gabriel and my-self, presented Bernhard Smith, on his departure, with a Browning, bearing the following inscription, 'Ichabod, Ichabod, the glory has departed. Travels Waring West away?' Smith leaves on Wednesday. Millais has got on with his poem.

*Tuesday 22nd.* Gabriel engaged on his *Kate the Queen* design, the first drawing of which he completed and will transfer to fresh paper. Munro called and has promised us a cast of a bust of his in the Exhibition of a lady with a good early head.

*Wednesday 23rd.* Bernhard Smith left us a cast of his Schoolmaster. In the evening Gabriel and I went by appointment to Millais's, calling in the way on Hunt. He has completed his design of the ancient Britons and Monk, and has resumed the one from 'Isabella': 'He knew whose gentle hand was at the latch.' He has also made a new sketch for his [*Christian Priests Escaping from Druid Persecution.*] . . . [Millais has made] considerable progress with the 'Caen Nunnery', having put in the greater part of the populace. He says his poem is considerably advanced, and that he will work hard on it to-night. He having informed us, almost as soon as we entered, that he had been reading Patmore's 'Wood-man's Daughter' and 'Sir Hubert', and had found several faults of diction etc. therein, we proceeded to a most careful dissection, and really the amount of improvable is surprisingly small, as he also agreed in thinking. Woolner came in about 10 o'clock. He has written another verse of the 'My Lady' song; and is at present

under the painful necessity of requiring a head of Murillo to consult for his bas-relief. In the course of conversation, Millais said that he had thoughts of painting a hedge (as a subject) to the closest point of imitation, with a bird's nest,—a thing which has never been attempted. Another subject he has in his eye is a river-sparrow's nest, built, as he says they are, between three reeds; the bird he describes as with its head always on one side, 'a body like a ball, and thin legs like needles'. He intends soon to set about his subject from Patmore, Sir Hubert, and Mabel, 'as she issues from the trees'. Woolner gave us, on his arrival, an extra-hearty shake of the hand, as proxy for Bernhard Smith, who has started for Yorkshire . . . .

*Thursday 24th.* . . . The day has been most glorious, and they had a very pleasant walk. Hunt called twice this morning, the first time before we were up, and the second when we were both out. Has he any news? Charles Whitehead has sent Gabriel a circular for a volume of his collected poems to be published shortly by subscription, price 10/-. Woolner stayed with us on his return, and has recommended me to follow out one of the designs I had begun, and laid aside, for 'Maud's madness'. This I shall probably do, tho' the idea of painting two children is very frightening. Millais also came; soon after which we fell to portrait-taking. Millais's of Woolner, Hancock, and Hunt, have come highly successful. He has done something to his poem. Passing thro' Newport Market to-day, on my way home, I saw two ox heads truncated and skinned, the muscles of which were moving rapidly and continuously. I also remarked, in the course of the evening, in watching a small moth on the window pane, that it has not the power of walking along glass, as a fly does, but always slips down in the attempt sooner or later.

*Friday 25th.* Hunt called again this morning, when Gabriel learned that the object of his previous visits had been to see Gabriel's tracings of costume. Whilst they were together, enter Wrightson, who, to their agony of smothered laughter, read a poem he has written on the occasion of Lord [Romney hav]ing ordered some soldier to be flogged, bearing the burden, . . . ['Bew]are: Beware, Lord Romney, beware'. . . .

[*Sunday 27th.* . . . . Gabriel and I] went in the morning, by appoint-
ment, to Dickinson's, where we met Ford Brown and Cave
Thomas. Dickinson says that, when Cottingham first mentioned
to him his intention of buying Gabriel's picture, he descanted
glowingly on his genius and expressed his horror at having 'found
him in a garret'. We saw the Academy review in the *Illustrated
News*; very favorable notices of Millais, Hunt, and Collinson.
Gabriel and I were engaged, the greater part of the day, on our
respective designs. After tea, we called at Woolner's, but did not
find him.

*Monday 28th.* I called at Dickinson's in coming home, expecting
to find Hersey the model, who was to be engaged: but it seems
that he is undiscoverable, and so we are to have a Miss Saunders,
whose first sitting is fixed for Wednesday. In the morning I wrote
a letter to Collinson. Gabriel went to Woolner's in the evening,
and found him occupied with Murillo. He has likewise written
some more stanzas of his dirge. I read several of Faber's poems,
many of which are good as second-rate poetry. There is an un-
conscious intensity of conceit about them which is pleasant. There
is a deal of sad trash, however, and frequently an extreme looseness
in the use of words.

*Tuesday 29th.* I went in the morning to the Society of British
Artists, calling in the way, with Gabriel, on Hunt, who was out;—
he having proposed to take a night-walk. Scarcely anything good
at the Gallery. . . . [Later when we called in to] see Woolner
about our night-walk, Hancock came in. [After a] time we
accompanied him to his study, and saw the bas-relief of 'the latter
days' and the enlarged *Una and the Lion* he is occupied with.
Woolner was not at home. Between 10 and 11, Hunt called, when
we finally resolved to postpone our walk. Talked and did portraits.
We have received a letter from Millais, who says that there's a
most splendid critique of his and Hunt's work in the *Builder*.

*Wednesday 30th.* I received this morning a note, dated yesterday,
from Wells, apprizing me that the Model was to come that
evening. On going to the Class in the afternoon, I was told that,
on her unrobing, she was unanimously requested not to give her-
self so much trouble; and we have determined, as the preferable

alternative, to draw her dressed almost entirely. She is very fat
and at least 45. Perhaps, after all, I may find it answer as well to
try what I can do in copying drapery. On coming home, I found
a letter from Collinson, who says he is doing 'a smoky picturesque
little interior' at a high point of finish; that he has thought of a
capital Wilkie subject, sure to sell; and that, on his return to
London, he is determined to 'really do something'; furthermore,
that he has a portrait in hand. Woolner called in the afternoon on
Gabriel. . . .

<p style="text-align:center">★    ★    ★    ★    ★</p>

# July 1849

*Sunday 22nd.* . . . [Williams told me] that this drama [*Joseph and
his Brethren*] gained him great reputation in many literary circles,
tho' not extensively known by the public. That Wells married
some time after a sister of Williams's wife and settled in Brittany,
where he is become a great hunter and fisher; that, having fallen
into some embarrassments, he sent over to Williams, for him to
find a publisher, part of a novel named 'De Clisson' and other
things in prose and poetry; but that he (Williams) failed generally
in his endeavours, an article entitled 'Boar-hunting in Brittany'
having, however, been inserted in *Fraser*. That Mrs. Wells came
over recently to offer the *Stories* and *Joseph* for republication, but
did not succeed. Gabriel hereupon proposed to make etchings for
a new edition, if that might seem likely to be of any avail, and
engaged for Hunt, Millais, and Woolner, to do the same after
Xmas; and Williams says that he has little doubt but what, with
that attraction, a publisher might be procured; also that he is
certain Wells could commit the care of the edition to Gabriel with
complete confidence. Gabriel thinks that, if each were to do 5
etchings and he were to write an elaborate preface (assuming as
an undisputed point the very high character of the work), and if
I, as having more leisure, were to write a full and minute review
soon after the publication, this arrangement would do. Wells is
a most fervent Catholic, but has not retired into a convent, which
he has compelled two of his daughters, however, to do, and urges
the third, who was till lately residing with Williams, to follow

their example, to which she is most strongly opposed. Williams has met Browning, who, he says, is not inordinately short, as we had heard. He (Williams) is reader to Smith and Elder, to whom Browning's poems had been offered for republication, when he told them that the work, as a work, ought to be published, but that he could not advise it as a pecuniary speculation; and he believes that it was published at the expense of Chapman and Hall, not at Browning's own cost. . . . [Woolner made another] small model of the figure of the [Grace] dancing, for Cottingham.

*Tuesday 24th.* Gabriel was engaged in the morning looking over and finishing up his *Vita Nuova.* I drew at the life class at Bond Street. Collinson, who came to us in the evening, says he is about to make a Christian Art design of Zachariah reading the Scriptures to the Holy Family. After he left, Gabriel began translating one of the poems of the *Convito* for the Appendix to his *Vita Nuova.*

*Wednesday 25th.* Gabriel finished the Canzone from the *Convito* and went on looking over the *Vita Nuova.* He began a colored study at his life class, and I drew at mine. I called at Millais's to see whether he were really come back, and find that he is not and is not expected for another fortnight at least; his *Ferdinand and Ariel* was sent down to him the other day. His poor Tommy, about whose fate he was uncertain when last I saw him, was found a lifeless corpse some while ago, being supposed to have been worried by a dog.

*Thursday 26th.* I composed a Sonnet, a few lines of which had come into my head yesterday, entitled 'For the general Oppression of the better by the worse Cause in July 1849'; and drew from the model at Dickinson's. After dinner, I joined Hunt, Collinson and Gabriel, at Stephens's; Woolner was unable to come in consequence of a painful boil on the knee. Stephens wrote the other day to the Superintendent of the Liverpool exhibition, to know whether his picture (the King Arthur) would run a chance of being admitted, the prospectus of the exhibition stating that Artists who have already exhibited are invited to send, but not, as Hunt says, implying any exclusion to others. Hunt has been making the designs for the 'Morning and Evening' commissioned

by Cottingham, which he intends to complete to-morrow morn-
ing and present to him. He says it is his intention, after leaving his
present lodging (which he will do some 3 weeks hence) to go for
a fortnight into the country and work on the landscape of his
Early Britons picture, and from there to Paris for about 3 months
to paint the commissions. At Stephens's we read over his poem of
Arthur, and went carefully thro' Keats's 'Isabella' to discuss every
fault of detail or expression any of us might find, when we agreed
on 24, with a reservation on my part of 11 in addition. . . .

<p style="text-align:center">★   ★   ★   ★   ★</p>

# August 1849

*Monday 13th.* Hunt, with Gabriel's co-operation, removed the
majority of his property to Brown's study, etc., and an arrange-
ment was finally made with the landlord for leaving certain
articles as security, among others a copy of the Gevartius, which
Hunt imposed on them as worth £12. A most cheeky letter re-
ceived from Cottingham in answer to a civil enquiry relative to
the price payable for the 'Morning and Evening' left him in a state
of profound disgust, when he was relieved therefrom by a note
from Egg informing him that he had sold the *Rienzi* picture for
160 guineas to Mr. Gibbons and requesting to see him to-morrow
morning on some other business. Hunt swears that he'll cut
Cottingham altogether, and leave him to find another man of
talent (of whom Cottingham asserts that he knows plenty) to do
two fair-sized pictures for £50. In the evening Gabriel and I went
to Woolner's with the view of seeing North (whom, however,
we did not find at home) about a project for a monthly 6d.
magazine for which 4 or 5 of us would write, and one make an
etching each subscribing a guinea and thus becoming a proprietor.
The full discussion of the subject is fixed for to-morrow at
Woolner's. Hunt showed some verses (descriptive) which he has
written. Woolner has been working at the *Euphrosyne.*

*Tuesday 14th.* Hunt called on Egg and received the money for his
picture. Mr. Gibbons is also to give him a commission for not less

than another 100 guineas, and Egg thinks that, after seeing the picture of the Early Christian Hunt is now engaged on, he will probably select that. Gabriel has settled to go with Hunt to Paris, passing by Ghent and Bruges, which Egg strongly recommends them to see. A second letter to Gabriel from John Orchard, the painter, has been received. He had written for the first time nearly a week ago, expressing the most intense admiration for the *Mary Virgin*, and entering into a long metaphysical disquisition on the principle of adopting the mode of thought and the practice of any preceding age, which he condemns. In his present letter, in answer to Gabriel's reply, he says that he hopes to call and see the picture on Saturday; Gabriel and I drew from the model at Leigh's, I for the first time; after which we went to Woolner's to settle on our contemplated magazine. The title is to be 'Monthly Thoughts in literature, poetry and art' with a sonnet on the wrapper. . . .

*Wednesday 15th.* [. . . After leaving Woolner's] house he went to draw from a model Harris has for his picture. Here it was proposed that the magazine should be increased to 40 pages, 2 etchings and 1/- each number. I wrote the first 8 lines of a sonnet for the wrapper, to be considered with others, but did not finish it, being in a state of sleep.

*Thursday 16th.* Gabriel made a study, from a girl whom Collinson recommended to him, for the head of the Angel in his picture, which head he means to do over again. Woolner, with whom we saw Grisi in the *Huguenots* (a most glorious sight), says he has written 3 stanzas (in the rough) of his 'My Lady, in Life'. Hunt is at Ewell.

*Friday 17th.* Gabriel began painting the head of the Angel; and he wrote 2 stanzas of a French song, 'La Sœur Morte'. We drew at Newman Street.

*Saturday 18th.* Gabriel, being at Woolner's wrote a bout-rimés sonnet called 'Idle Blessedness', and he began a song. He went on with the Angel's head. Woolner also wrote a sonnet, 'The Blue Spot'.

*Sunday 19th.* Hunt, who has returned from Ewell and will remain in town a few days before going to Homerton, came to see us, and showed us another letter he has received from Cottingham as impudent as the preceding one: also his own answer thereto. He has taken his *Rienzi* picture to Brown's study, and is engaged giving it some finishing touches. At Ewell he made a study (in color) of a corn-field. Woolner, who stayed with us a little preparatory to going with Gabriel to North's for further discussion of the magazine project, has written a sonnet on Michael Angelo, which he read us, and a few stanzas of 'My Lady', which (the first part, that is, the second being complete), will be finished in 8 more. It turned out that they did not go to North's, Hunt having called at Woolner's with Brown. I finished my sonnet begun on the 15th with reference to the wrapper of the proposed magazine. In the morning, Gabriel worked a good deal on the Angel's head, and wrote the concluding stanza of his French song.

*Monday 20th.* Gabriel still at the figure of the Angel. Orchard the painter called in the afternoon and left Gabriel two sonnets he has written on his picture. . . .

[*Friday 24th.* . . . Hunt has] put into his picture the figures of a [mother and children coming over the top] of the hill, on which he has painted various buttercups and dandelion puffs. He has painted up the sky, put a plume onto the casque of one of the troopers, etc. Collinson, after drawing some time at Leigh's, went on to Stephens's for the remainder of the evening, Stephens having proposed to go to Oxford for some days next week, and having asked Collinson's company, who, however, thinks he will be unable to leave his picture. Woolner, whom we had seen in the afternoon, says he is working at the hands of his *Euphrosyne*, and expects to finish the group next week, after which he intends to spend a few days at Marlow.

*Saturday 25th.* Gabriel's picture was sent off to the Marchioness of Bath. The daguerreotype will be ready on Monday. I met Hunt in the morning, who says that he will send his *Rienzi* to Mr. Gibbons, the purchaser, on that day.

*Sunday 26th.* Gabriel wrote a sonnet entitled 'For the Things of these Days'. . . .

*Tuesday 28th.* . . . Gabriel thinks of taking, as the incidents for the two side-pieces in his picture the Virgin planting a lily and a rose, and the Virgin in St. John's house after the crucifixion, as illustrating the periods of her life before the birth and after the death of Christ. For the middle compartment, to represent her during his life, he has not yet settled an incident. He went to see Woolner, who has finished the first part of 'My Lady', and the poem is therefore now altogether completed. Gabriel, Collinson, and myself, drew from the model at Leigh's.

*Wednesday 29th.* Gabriel thought of taking for the principal compartment of his commission picture the eating of the passover by the Holy Family, in which he proposes to make Zachariah and Elizabeth joining, as it is said that, if a household were too small for the purpose, those of a neighbouring household were to be called in. He made a preliminary sketch of this. A note from Hunt (who is now at Homerton) came to him. . . .

★   ★   ★   ★   ★

# September 1849

*Tuesday 11th.* My journey to Cowes was unmarked by any particular incident. In the railway I read *Reverberations*, which are but so-so, yet may perhaps afford ground for a review, as there is a degree of good in parts. Collinson has begun two designs for the background of his sacred picture, and has been working 5 or 6 hours each day at them. The day was cool, but fine, and we walked along the beach. After our return home, I read him my review of *The Strayed Reveller.*

*Wednesday 12th.* The morning being rainy, Collinson was prevented from going out to sketch, and he made a chalk-drawing of the view out of window. In a walk we took after dinner, we found in the middle of the road a toad run over. After writing a

letter to Woolner, I sat down to think for a subject for a poem, and, without much trouble, invented one, but which is as yet very incomplete and meagre. I composed 21 lines of it in blank verse.

*Thursday 13th.* Another louring day. As the weather seemed now decidedly to have set in for rain, Collinson felt it useless attempting to continue the out-of-doors study for his background, and we therefore resolved to remove to Ventnor for the time that remains to him. The view of the sea on approaching Ventnor is most striking, and the environs appear truly beautiful. I procured this month's *Blackwood*, which contains a notice of *The Strayed Reveller*, and find, to my delight, that the review is, taken on the whole, highly condemnatory, instead of being, as I expected it would be, approving.

*Friday 14th.* We walked to Shanklin Chine, which is a splendid place exhaustless in beautiful passages, as indeed is the whole road to it. Collinson says he will write something before he returns. I wrote again to Woolner.

*Saturday 15th.* To-day we went, under a splendid sky, to Black-gang-chine, Collinson noting down many things he observed on the way. Black [-gang-chine, like Sha]nklin is lux[urious.] . . .

*Monday 17th.* Collinson left for London. We went over Carris-brook Castle together, and he, on the way, wrote down some-thing, either verses or material for verses. I wrote 21 lines of my poem in the evening.

*Tuesday 18th.* Lying down on the Undercliff all the morning, I found it impossible to get out more than 7 lines. I walked after dinner and wrote no more. I had a letter from Collinson, addressed from Southampton, enclosing me the commencement of my poem, which he had taken away by mistake. Picking up grass-hoppers on the Undercliff, I find them to be very diverse in color, some of them brown, and some quite a clear red mostly.

*Wednesday 19th.* I wrote a letter to Gabriel in the morning; afterwards, went out and lay down on a cliff. Here I did not compose anything, but, in the course of the day, wrote 65 lines.

*Thursday 20th.* I had letters from Woolner and Gabriel. Woolner, who sends me *Sir Reginald Mohun* for reviewing, says that he is to receive the money for *Euphrosyne* from Cottingham to-day, and that Cottingham has actually advised him to execute in marble the figure of St. Luke Gabriel designed some time back for the picture he contemplated doing of St. Luke preaching with the pictures of Christ and the Virgin. Gabriel writes that a printer named Haynes, a friend of Hancock, has introduced him to Aylott and Jones, the publishers, who are quite willing to publish the 'Monthly Thoughts', on condition of a percentage of 10 on the sale; that Deverell is making enquiries as to the equity of this demand; that the [cost of printing and etchings] will be about 2/- or 2/6 a hundred exclusively . . .; that North [has informed him that the printing costs should run no more than £13;] . . . [that Millais] is not yet returned; and that he (Gabriel) has seen Collinson on his return to London, and has some thoughts, guided by his descriptions, of coming hither with Woolner, as they have determined to go at once to some place in the country. I answered both these letters, and did 17 more lines of my poem.

*Friday 21st.* I wrote 104 lines of my tale. After dinner, had a most freshening walk along the cliffs and sands towards Shanklin, in a breeze that blew me about.

*Saturday 22nd.* I got up in the hope and intention of writing hard at my poem, and succeeded in advancing it by exactly 8 lines. Whilst out in the morning, read *Reverberations* thro' again, which shows a just sufficient amount of promise to warrant a review and offers plenty of salient points for a comic article.

*Sunday 23rd.* A letter arrived from Woolner, informing me that, as difficulties in keeping back the ardor of our new proprietors began to rise up, he and Gabriel have determined on at once making me Editor, and that the prospectus has been sent off to the printer's with my name accordingly and the title altered to 'Thoughts towards Nature', (Gabriel's idea) to obviate the many objections that have been made to the old title; that he was to dine to-day with Patmore, who has read his poems and praised them so much that he won't tell me what he said; that he has just 'returned unsuccessfully from Cottingham'; and that he doubts

whether he and Gabriel will join me here, considering the heavy travelling expenses. I answered him, pointing out several reasons why I think the proposal of publishing my name as Editor should be well reflected on before carried out. I took a walk Westerly to see a splendid sunset from the cliffs. After my return, I wrote 100 lines of my poem.

*Monday 24th.* I took a long walk of several hours about a hill facing the Undercliff covered with heath, furze, etc. ferretting out beetles and the like of them. Whilst lying down in the midst of long yellow grass with an intensely blue sky over me, and holding my hand near my face, I was greatly struck with the difference in color resulting from a change in the opening and shutting either eye, my hand appearing red and warm in color in one instance, and quite pale in the other, as well as considerable alteration in the hues of yellow and blue about me. I wrote 39 more lines in the course of the evening.

*Tuesday 25th.* I had a letter from Gabriel in answer to my last to Woolner. He says that the words 'Conducted by Artists', recently proposed to be inserted in the title of our magazine, are now to be left out; and that therefore, as he thinks, there is no further ground for arguing the question of my name being published as Editor; that a definite agreement has been made with Aylott and Jones, the publishers, and that the prospectus is now being printed; that the first number will not appear till December; that he wrote the preceding night to W. B. Scott, requesting his co-operation; and that Patmore has seen and appears much pleased with the prospectus, and has given us a little poem named 'The Seasons' for our first number, but with the proviso that his name shall not transpire, as he means to keep it back in all instances till the appearance of his new volume. He praised Woolner's poems immensely, saying, however, that they were sometimes slightly over passionate and generally sculpturesque in character. He has also seen some of my sonnets, and commended them, but found them wanting in melody. Gabriel and Hunt are to start shortly for the continent, but he proposes to remain till Tuesday, if I will be back by then. I answered his letter, and also wrote a sonnet to rhymes sent me. I had not done anything to my poem up to the afternoon, when, feeling in a walking humor, I resolved to set off

and remain out till next morning, walking about in all kinds of directions. Nothing particularly noticeable in my excursion, the moon having gone down very early. On the way, thought for names to my poem, when the only two at all suitable that suggested themselves were 'News after Absence' and 'An Exchange of News', with the latter of which I shall put up till I find a better one.

*Wednesday 26th.* I was home at 7½ o'clock. Another letter from Gabriel, saying that, as further delay in starting would inconvenience Hunt, they are to set off for France and Belgium tomorrow, and that they will, if possible, pass thro' Brittany, either going or returning, to see Charles Wells. I wrote 146 lines of 'Exchange of News', and also answered the note.

*Thursday 27th.* I had a letter with a message from Gabriel, in answer to my enquiries, that the table of contents for No. 1 of the 'Thoughts' remains as before settled, with the addition of Patmore's poem and Stephens's paper on early art, 'which is at present on divers scraps, in a highly chaotic state'; also that several are proposing to alter the title of the magazine to 'The P.R.B. Journal', and desiring me to write my opinion on the subject to Stephens. This I did accordingly, representing many objections which appear to me quite decisive, especially connected with the share in the magazine of some who are not P.R.B.s; I also wrote Gabriel in the same sense, requesting his and Hunt's views of the matter. In these letters I brought up an old proposal to get 'P.R.B.' printed somewhere on the wrapper, a course to which the same objections do not apply. I did 116 lines more of my poem.

*Friday 28th.* In the morning, I took a walk to and about Niton, having been told that it was the best place in the Island, an assertion which I could not find warranted by fact. I watched for some time a grasshopper with its body broken quite in two and scarcely hanging on at all, which continued walking about, tho' hopping less briskly than is usual. Received a letter from Woolner, informing me that Cottingham promises to pay him to-morrow, and that he has been so bored with this matter that he has not written or done anything; also that Mr. Williams had given Gabriel copies of the *Stories after Nature* and *Joseph and his*

*Brethren*. Gabriel left yesterday morning with Hunt for the continent. I wrote 58 lines of 'Exchange of News'; answered Woolner, and wrote to Stephens, asking him to take care that my sonnet in the pro[spectus is accurately printed.] . . .

★    ★    ★    ★    ★

# October 1849

[*Saturday 6th*. . . . Woolner was here and told of Cottingham's ungenerous attitude] towards him, resulting, after a series of the most shuffling shabbiness, in doing him out of the cast and the copyright of the *Euphrosyne*. He brought with him a letter from Bernhard Smith, who seems knee deep in countryfication. I read Woolner my poem 'An Exchange of News'. On leaving, he took with him 70 copies of the prospectus.

*Sunday 7th*. I sent off a letter to Nussey at Oxford with a prospectus, in the hope of obtaining [so]me subscribers there. Being out all day, the only thing I did was getting one subscriber.

*Monday 8th*. Collinson, to whom I went in the evening, is getting on with his *Emigrant's Letter*. He has done a considerable part of the window and its adjuncts, finishing up the trees outside to a pitch of the extremest minuteness, and he is advanced with the heads of the boy writing and the girl. He has made a sketch in color for the picture, and has introduced another boy looking over the one writing. In *The Pensioner* he has finished the figure of the footman. He has set to working late at night, up to 11 or 12 o'clock. Stephens, who was to have come but had an engagement, [wr]ote to tell me that he has not yet received his prospectuses. Gabriel's poem of his journey to [Pa]ris was sent up to me from Ventnor. This as well as Miss Barrett's 'Drama of Exile' I read to [Co]llinson.

*Tuesday 9th*. I all but finished reading *The Bothie* preparatory to reviewing it. Collinson called, and says he has done about 20 leaves to the ash-tree in his picture and gone on a little with the bushes in the background.

*Wednesday 10th.* A letter came from Gabriel, who gives me an elaborate criticism of my blank-verse poem, and sends me 5 sonnets he has written;—the first suggested by hearing the bells whilst ascending to the summit of Notre Dame; the second written leaning against the July column and musing on the Place de la Bastille; the third concerning 'the rate of locomotion which the style of the old Masters induces in Hunt and himself at the Louvre'; the fourth on a picture by Giorgione of two naked women and two men with musical instruments; the fifth excited by the disgust he experienced at witnessing the cancan at Valentino's. In reference to this last scene, he declares Gavarni to be 'a liar and the father of it'. He has been to see the working of the Gobelin[s] tapestries, which has so altered his ideas concerning the matter that he says he shall probably make an entirely new design for *Kate the Queen* when he is prepared to paint the subject. Woolner came in the evening and we criticized the criticism and the sonnets in company. He (Woolner) has written a small poem of 6 stanzas 'To Emma', done in the intervals of manufacturing some rhymes in conjunction with other people. He has also made a design and begun a clay model for a new idea he means to work out; viz., that the human soul, oppressed with the burden of an effete form of mind, still hopes and trusts in God for the end. This he represents by a woman chained to a mouldering column round which the ivy twines. He took me to see Mr. Bateman, the Illuminator, we dropping into his own study by the way, where I saw the above mentioned. Mr. Bateman got 3 or 4 prospectuses from me, one of which he means to send to a Mr. Heaton, of Leeds, a friend of Mr. Browning's and sympathetic in the same direction. I saw the designs of ivy borders etc. he has made for Woolner's poem on 'Friendship', and looked over the illuminated letters etc. he has copied from old manuscripts. Woolner believes that Millais will be back on Saturday. Mr. Haynes, our printer, whom I happened to meet, tells me that Stephens has got his prospectuses, and that the Publishers have received their share; to one of whom he promises to give me a letter of introduction.

*Thursday 11th.* I wrote back to Gabriel about my poem and his suggestions thereon. 'The rest is silence.'

*Friday 12th.* Stephens wrote to me for the purpose of sending a

letter of Hunt's to me, but enclosed, in lieu thereof, part of
Gabriel's accompanying note to himself. The only news he gives
is that they are going to leave Paris. I answered him fixing to call
to-morrow. I also had Haynes's letter to take to the Publishers.
I made a few alterations in my poem in conformity with Gabriel's
suggestions.

*Saturday 13th.* At Stephens's I saw Hunt's and Gabriel's letters. The
former says that they are to leave Paris on Saturday for Brussels;
the latter sends three sonnets; the first 'whilst waiting for the
train to Versailles', being imitated from the introduction to
Tennyson's 'Godiva'; the second on the ro[ad] to, and in the
gardens of, Versailles; the last on a Dance of Nymphs by Mantegna.
Stephens has 11½ lines of his sonnet for the series to appear in our
first number. John Tupper, who was also present, showe[d me]
a sonnet he has done, which, in general character, might be
adapted for the same series, but will sca[rcely] do as regards the
machinery of it. I recited him my poem, in accordance to Gabriel's
suggestion that [I] should show it to some one conversant with
medical matters.

*Sunday 14th.* I read thro' *Joseph and his Brethren,* which is a
glorious work, but, in passages, decide[dly] too full of images,
labored description, etc. From my old schoolfellow, Nussey, to
whom I went in the eveni[ng] and who is to subscribe to the
'Thoughts' and get me as many subscribers at Oxford as he can,
I heard some particulars of the poet Clough, who had been tutor
in the College to which he (Nussey) belongs. Burbidge, it seems,
is not an Oxonian.

*Monday 15th.* I called at Millais's house, and was told that the
period of his return is quite undecided. He is now at the house of
a Mr. Wyatt, having left Mr. Drury's some weeks ago, who
offered to fit up for him a suite of apartments where he might
establish himself and work. Ford Brown, to whose study I went
in the evening, and Cave Thomas, whom I met there, will sub-
scribe. I am also informed that Seddon has procured us a subscriber.

*Tuesday 16th.* Collinson, who was here, says that the sonnet
Stephens is writing for our series in the first number is coming
about the best of all.

*Wednesday 17th.* P.R.B. news at a discount.

*Thursday 18th.* Woolner, whom I went to see, is working up the model he has begun for sculpture, altering the position of the left leg. He has also begun a medallion portrait of Patmore, who has given him three sittings, beginning on Sunday; and who says he thinks he may probably induce Tennyson, when in London, to sit to him likewise. Woolner has also written some more stanzas of 'Friendship'. Haydon, the sculptor, has requested to be put down for 3 copies of 'Thoughts', No. 1. Being alone together, with Hunt, Millais, and Gabriel, out of hearing, we had some conversation concerning republicanism, universal suffrage, etc. On my return home, I finished *The Bothie*, and read thro' *Sir Reginald Mohun*, making notes.

*Friday 19th.* I began my review of *The Bothie* and *Sir Reginald*, but, not being in much of a writing humor, made but scanty progress. The opening of the notice I wrote of *The Strayed Reveller* etc. is transferred to the other, it being of a general character, and consequently required in the first of the review series.

★    ★    ★    ★    ★

# November 1849

*Thursday 1st.* . . . [I consulted the phrenologist Donovan, who told me] that I have an artistic development with symptoms of poetry, but not the . . . scrofula; also that I am 'too refined', that I have a large share of quiet obstinacy that will make me elude by one means or another doing whatever I have made up my mind not to do, that I am temperate and no smoker. I remained with him so long as to be prevented from joining Hunt, Woolner, and Gabriel, at Collinson's, to whom we had engaged ourselves on Tuesday. In the morning Gabriel called on Millais, and saw a design he has made of the Holy Family. Christ, having pricked his hand with a nail (in symbol of the nailing to the cross) is being anxiously examined by Joseph, who is pulling his hand backwards, while he, unheeding this, kisses the Virgin with his arm round her neck.

Millais thinks of painting this for the Exhibition. I fixed to return to Donovan's for my written character on Monday. Patmore asked Woolner and me for to-morrow evening.

*Friday 2nd.* Woolner's character was sent him by Donovan. It embodies generally the observations he made at the time of consultation, and ascribes to him a large amount of caution, which Woolner considers to be a correct judgement. In some points, however, he appears decidedly mistaken. After discussing this, we went together to Coventry Patmore's. The first thing we heard was that his Doctor has forbidden him to write in the evening for some time. He is now about to read up for two articles on Russia he intends to write for the *North British* and the *British Quarterly* respectively. He says he has some doubt whether one of the little poems he has given us for the 'Thoughts',— which of them he is not certain—did not appear in some musical magazine. We had an argument as to whether Browning would be *the* man some 20 years hence, Patmore expressing an adverse opinion. He remarked that Browning appears to him like a chip from a very perfect precious stone, intense, but not broad in range of subject, not sufficiently finished. He considers 'A Soul's Tragedy' to be a splendid title spoiled (!) *Sordello* he has never read, *Paracelsus* he admires with a reservation; two of the short pieces he particularly remembers with pleasure are 'How they brought the good news from Ghent to Aix' and 'Saul'. Of 'Grr you swine' he has no recollection. He does not place Browning so high as Tennyson. I saw Tennyson's MS. book of elegies on young Hallam, which are to be published some day, and was promised a sight of something Patmore wrote on *The* [*Princess*] . . .

*Tuesday 6th.* . . . I called on Donovan for my character. [Gabriel and Hunt, rain pre]venting their endeavours, looked over a house in Cheyne Walk, Chelsea, with which they and Stephens who was with them were greatly taken. It is capable of furnishing 4 good studios, with a bed room and a little room that would do for a library attached to each. There is also an excellent look out on the river. The rent £70. In the evening we all (except Millais) congregated at Woolner's, and discussed the matter. Gabriel, Hunt and myself, think of going at once, and Stephens and Collinson would join after April. We think likewise of getting Deverell.

'P.R.B.' might be written on the bell, and stand for 'please ring the bell' to the profane. Woolner being engaged out and his stove refusing to be lighted, we came back to this house, where we finished the talk and the evening, Woolner also coming in soon after. Among other subjects, we spoke of admitting any-thing at all referring to politics or religion into our magazine, and decided on cutting out the sonnets 'For the Things of these Days' we have hitherto intended to insert in the first number. My sonnets on 'Death' will be in like manner rejected.

*Wednesday 7th.* We saw Deverell, who is greatly inclined to accompany us, but is not quite certain as to his power of quitting his present quarters at once without notice. This was the evening fixed for Millais's and Gabriel's introduction to Patmore at Woolner's study. Gabriel and I went, and Patmore came, but Millais appeared not. We conversed a good deal of Woolner's poems, which Patmore says are so good that he is surprised they should not be much better. He insists strongly on the necessity of never leaving a poem till the whole of it be brought to a pitch of excellence perfectly satisfactory; in this respect of general equality and also in regard to metre he finds much to object to in Woolner's poem of 'My Lady',—and considers that these defects are far less prominent in some passages of 'Friendship' that were read to him. Henry Taylor, he says, ought to devote 10 more years to *Philip Van Artevelde*, and it would then be qualified to live. He himself spent about a year (from the age of 16 to 17) on 'The River', with which and 'The Woodman's Daughter' he is contented in point of finish. 'Lilian' and 'Sir Hubert' were written in a great hurry for the Publisher. He read Gabriel's sonnets on Ingres's picture of Roger and Angelica, and was much struck with the character they possess of being descriptive of a painting. We talked much of Emerson, who, says Patmore, doesn't know what Christi[anity means.] . . .

*Thursday 8th.* Deverell will manage to join us at once in the house at Chelsea; but, on reflection, the expense begins to look rather formidable. I called on Millais, to ask him to Patmore's, and found him very unwell with a cold, which he caught on Monday in a last century costume. He had written yesterday to excuse himself to Woolner, but his note did not reach in time. I saw his design

of Christ in his childhood, to be painted for next exhibition, and the calotype made of his last picture. He has sent this picture away and been paid for it, having done what little the background etc. required. In *Ferdinand* he has done some of the fur trimmings of the tunic. I engaged to see him again to-morrow. Just before leaving for Patmore's, my character from Donovan's was sent me. Woolner and Gabriel, as well as myself, consider it very acutely judged and generally correct. I left my 'Plain Story of Life' with Patmore. Talking of Philip Bailey, he remarked that he seems to be 'painting on clouds, not having his foot on reality'; Burns he considers more perfect than Tennyson. Gabriel wrote 3 stanzas of 'Bride-chamber Talk'. At Patmore's we heard of the reported death of Edgar Poe, concerning which some suspicions of suicide exist.

*Friday 9th.* I spent the morning with Millais, and read him my blank-verse poem, while he painted on the red tunic and fur trimming in the figure of Ferdinand. As the feasibility of taking the Chelsea house looks very questionable now, considering the expense, Gabriel and Hunt spent all the early part of the day looking for lodgings and studies about Chelsea, Brompton, etc.

*Saturday 10th.* Gabriel found a studio at No. 72 Newman Street. The rent asked is £30, but he succeeded in bringing it down to £28. He is to see further about it to-morrow. He wrote to Hunt to ask whether he can join him in his tenancy. I did a little to my review.

*Sunday 11th.* I went to Millais in the morning, and find that he has altered the position of the legs of Ferdinand. Last night he wrote some stanzas of his poem, of which he says he has now done certainly upwards of 100 lines, perhaps much more, as he has never counted. In the afternoon Gabriel came, and read all the poetry he wrote abroad. He has been to Newman Street, and decided on taking the study. We went to Harris's in the evening, and were told that he had occupied the same study some time at a rent of £40, whereas Gabriel has made the landlord accept £26. I went on somewhat with my review.

*Monday 12th.* Gabriel saw Hancock, who says circumstances have

determined him to withdraw from his proprietorship in the
'Thoughts towards Nature'. This is unpleasant as far as convenience
in money is concerned; however, we must insist on his carrying
out his pledge as regards the first number at least. Woolner and I,
together with Gabriel, looked in at the Newman Street study on
our way to Stephens, to whom we were engaged. A few pre-
liminaries were arranged, and the necessary furniture [found]. . . .
He [Gabriel] will now set about in earnest, and make long enough
for [inclusion in the first number] 'My Sister's Sleep', provided
he finds time to finish it up to the point he intend[s. Continued
my] review of *The Bothie* and *Sir Reginald Mohun*. Stephens will
ask John Tupper to do something for us to supply the deficiency.
We read Stephens's political sonnet, which has attained the length
of 12 lines, with a reservation of a tremendous idea for the final
two. He is now occupied during the day making drawings from
MSS. etc. at the Museum for which he is commissioned. Collinson
has been painting on the head and figure of the man in his picture.
We passed the evening finding out phrenological developments
for the P.R.B.s and others. Woolner has been hard at work these
two days on his new figure in sculpture, which he has blocked out
in clay. Patmore called on him yesterday, and talked of my poem,
in which he finds a most objectionable absence of moral dignity,
all the characters being puny and destitute of elevation. He means,
nevertheless, to read it thro' again, that he may be able to judge
of it in detail without looking so much to the scope,—or want of
scope. These are very much the objections that we had all fore-
seen and acquiesce in. Stephens had been with Millais in the
morning, and found him very considerably advanced with the
legs of his Ferdinand, both of which are much more than laid in,
not having yesterday been so much as touched. Hunt not making
his appearance, Gabriel was left unenlightened as to the likelihood
or otherwise of their working together in Newman Street.

*Tuesday 13th.* Gabriel looked after the furnishings etc. of his study.
He and I saw Hunt, who has suited himself somewhere in Bays-
water. He called last night at Stephens's some time past midnight,
when we were all gone. Munro, who has just returned from
Scotland, has taken a great fancy to the Chain Walk house project,
and would be very glad to become one among its inmates. The
project was therefore revived, and seemed somewhat favorably

regarded; but will probably be finally abandoned, as Munro would have to bring in some one of his friends, to make up the number required.

*Wednesday 14th.* Collinson was at Gabriel's study in the evening, and says that Hunt, after all his wanderings, has at length engaged two rooms in the house he himself lodges at.

*Thursday 15th.* Gabriel got the paper stretched for the nude cartoon he intends to make for his picture of the Passover, and began drawing the figure of Christ from a little boy Collinson discovered some time ago and whom he has painted in his *Emigrant's Letter.* Gabriel wrote to Miss Atwell to come to-morrow, as he wants her for the Virgin. We went in the evening to Calder Campbell, who offers his services for our magazine, and will hunt up subscribers. I at length finished my review of *The Bothie* and *Sir Reginald Mohun,* having taken a most unconscionable time for it.

*Sunday 18th.* The model whom Gabriel had engaged being unable to sit for the figure, Gabriel began at his design for *Paolo and Francesca,* but did scarcely anything; we therefore read away at Browning, Tennyson, Lowell, and the *Stories after Nature.*

*Monday 19th.* Gabriel was occupied about his design. I resumed drawing at Seddon's, where there is a new model. To-night was a P.R.B. meeting at Millais's, at which we were all present with the exception of Woolner. The legs and feet of Ferdinand in Millais's picture, and his hat are done; also a lizard on the ground in the right-hand corner. He means to make the spirits in the air half human and half like birds. His brother has begun painting a little from still life etc., and Millais intends to get him to do landscape pieces. Hunt has gone on with his etching; Stephens is still engaged during the day at the Museum. He offers to draw in the perspective scale in Gabriel's picture, and says that Tupper is writing a first rate poem (a kind of chant), available, in case of need, for our first number. Cave Thomas, also, whom I saw at Seddon's, promises to let me have something of his, of which I may dispose as I please. We discussed two or three points concerning the magazine; first, that of advertizing; and it was unanimously

considered that, as anything of the kind would, to be effective, swallow up some £10 or £15 without doubt, it will be as well to drop it altogether. In the second place, as regards the big 'P.R.B.' printed at the head of the prospectus. To this Hunt now most strenuously objects, as he holds that it will be most detrimental to its circulation among the Acade [my artists]. . . . After our return Gabriel continued making sketches for his design. He intends that the picture should be in three compartments. In the middle, Paolo and Francesca kissing, on the left Dante and Virgil in the second circle; on the right, the spirits blowing to and fro.

*Tuesday 20th.* Gabriel still at the preliminaries of his design, but with frequent interruptions, having been to Deverell's study by appointment for his particular benefit, and not finding him at home. Woolner, we hear, was prevented from being at Millais's yesterday by a prior engagement.

*Wednesday 21st.* Gabriel saw Woolner, who has begun the life-size cast of his figure, and it has been arranged that Patmore shall, at his study, meet Millais to-morrow, and, if possible, Hunt as well. Gabriel and I will attend.

*Thursday 22nd.* Patmore, Cross, Millais, Gabriel, and myself were at Woolner's; Hunt did not appear. A long argument was maintained concerning poetry, Patmore professing that Burns is a greater poet than Tennyson, in which opinion Tennyson himself fully concurs. Patmore instanced, as a line of unsurpassable beauty 'With joy unfeigned brothers and sisters meet', from the 'Cotter's Saturday night'. He says that Tennyson is the greatest *man* he ever came in contact with, far greater in his life than in his writings, perfectly sincere and frank, never paying uncandid compliments; Browning takes more pains to please, and is altogether much more a man of the world. He thinks he does not value himself at so high a point as he is rated by Gabriel and me. Patmore holds the age of narrative poetry to be passed for ever, and thinks that probably none such will again appear; he considers 'Peter Bell', tho' most vexatiously imperfect, to be the opening of a new era. He looks on the present race of poets as highly 'self-conscious' in comparison with their predecessors, but yet not sufficiently so for the only system now possible,—the psychological. The conversation

taking a religious turn, he said that the devil is the only being purely reasoning and analytic, and therefore is the devil; and he would have every man hold to the faith he is born in, as, if he attempts to get beyond its bounds, he will be far more likely to be a rebel than a seeker after truth, and should not attempt to pull down without having something to build anew. He thinks Millais's picture far better than anything Keats ever did, and that he is adapted to usher in a new style which will eventually educate the people into taste, and make his works some day as popular and saleable as Barraud's *We praise thee, oh God*. One of the chief curses of the day he considers to be that every one is critical. Of the poets of this and the last generation he says that they are 'all nerves and no hearts'. He fraternized with Cross, in whom he sees some resemblance to David Scott, the recently dead brother of W. B. Woolner's statue is well advanced, and he had a model for it this morning for the first time. Patmore advises him to have the column against which the soul leans of the Roman architecture instead of the Grecian, which latter, he says, by its fluting etc. always indicates aspiration. Woolner will attend to the suggestion. We had some talk of ghosts, to a belief in which Patmore does not see any obstacles. Millais related a singular story on the subject he heard at Oxford, and Woolner some experiences of his own immediate relations and friend[s]. Millais, as we walked home, unburdened himself of his observations and conclusions, and declared that, if he had seen Patmore's hand alone cut off, he could have sworn to it as that of a man of genius. His sayings concerning Burns, Keats, Tennyson, etc., are bitter in his belly as wormwood. Gabriel and I sat up to read the 'Cotter's Saturday Night', and failed to realize to our apprehensions its extraordinary excellence. At Seddon's, where I drew, I heard that it is not intended to admit pic[tures in the forth-coming exhibition of 1851.] . . .

[*Saturday 24th*]. . . . North also looked in in the evening, and left his pipe behind on his departure,—an ominous sign of a foregone conclusion. Stephens asked Gabriel and me to be with him to-morrow, to meet the Tuppers and some one else. Gabriel is now reflecting on the final settlement of his poem 'My Sister's Sleep', which is to appear in No. 1, and he intends to reject one of two stanzas.

*Sunday 25th.* Gabriel began making a sketch for *The Annunciation.* The Virgin is to be in bed, but without any bedclothes on, an arrangement which may be justified in consideration of the hot climate, and the Angel Gabriel is to be presenting a lily to her. The picture, and its companion of the Virgin's Death, will be almost entirely white. At Stephens's two Tuppers only were present. John Tupper read his poem, which is exceedingly clever; it borders, nevertheless, on the ultra-peculiar, and a few allusions altogether unintelligible by such as are not personally acquainted with him will have to be omitted in printing it. This we propose to do in No. 2, as we are in want rather of prose than of poetry for the first. His prose article is an Essay on poetry and the principles of taste, and is argued on deduction from the most abstract propositions in the manner of a philosophical dissertation. He considers that its entire length will be enough for about 8 pages, and means to divide it into two halves. George Tupper says that, on a pinch, 5 or 6 days would suffice for the printing of a number, but that it will be well to allow a fortnight, and so have comfortable time. Stephens has heard that Hancock, in his recent conversation with Haynes the Printer, gave him to understand that we did not wish to print with him, and that he said something such as might have been expected under the circumstances. This is troublesome, and puts us in a stupid position. Hunt, who came late in the evening, is getting on with his etching, of which there remains now not much to be done. . . .

★    ★    ★    ★    ★

# December 1849

*Friday 7th.* . . . [Millais has executed drawings from Patmore's poems. He] brought with him a second design [illustrating the lines] 'He sometimes, in a sullen tone, would offer fruits', etc.; and has also done two others,—Maud at the water's edge, and Hubert and Lady Mabel. Patmore proposes that the next edition of his poems should be produced with Millais's illustrations, they two sharing the expenses and the profits; he promises moreover to write with us, in case the project of publishing a volume of

poems among us were carried out. Woolner has not done any-
thing except to his statue; he is going to touch up the mouth of
his medallion head of Patmore before giving us our copy. Just as
Tennyson was leaving, Patmore fixed him, and made him promise
to sit to Woolner. Patmore returned to me the MS. of my 'Plain
Story of Life', and said he would talk about it some other time;
we are to come to his house as early as possible, and hear 'The
Storm' read, which Millais heard this morning, and asserts to
contain some slosh(!) Thackeray did not appear, having another
engagement. Gabriel had gone on with his cartoon study; and
Millais has redesigned the subject of Christ in Joseph's workshop;
the picture of *Ferdinand* is not very far from finished.

*Saturday 8th.* Gabriel had Maitland to sit for him to the Angel
Gabriel in *The Annunciation*. He has recently written various new
stanzas of 'Bride-chamber Talk'. Woolner came in the evening,
when Gabriel read *The Princess* thro' to him, and both of them
pronounce it the finest poem since Shakespear, superior even to
*Sordello*. To this latter opinion I demur.

*Monday 10th.* . . . [We called on Hunt], whom we found a martyr
to toothache, which has almost succeeded in preventing him from
working. Since his settlement at Brompton, he has drawn in all
the figures except the old woman, painted five heads in the back-
ground, repainted that of the youth shutting to the door, and
begun the legs of the one kneeling, and the head of the Preacher.
Collinson has done a good deal to the head and figure of the man
in his picture of the *Emigrant's Letter*, to the little girl, and to the
boy looking on. He would not let the *Pensioner* be seen, and says
he intends to introduce another figure into it. After he shall have
finished his paintings for this year, he means to set to work on the
subject of St. Elizabeth of Hungary taking off her crown before
the crucifix. We talked about the magazine, and are quite unani-
mous in considering that the first number must appear; but all
except Stephens and myself are somewhat inclined to drop it
after that, whether successful or no; we are also disposed to abide
by the title 'Thoughts towards Nature', notwithstanding Cave
Thomas's proposal of 'The Seed'. We debated the propriety of
having an article explanatory of the principles in Art of the P.R.B.;
but, as so many papers in the first number are to treat of art, and

as the point will necessarily be brought forward incidentally, it is not thought needful. There was some talk, in case a second number comes out, of printing in it Co[linson's etching.]

*Thursday 13th.* . . . [In evening, several P.R.B.s to]gether. Hunt did not come, and Woolner was [engaged with one of his sittings] from Tennyson this evening, having already been with [him before. The Tennyson] medallion, Patmore says, is coming a very good likeness; it is of rather larger size than that of Patmore's self, which the larger character of Tennyson's head renders necessary. Patmore was at Woolner's last night, and read him Poe's tales to his own great satisfaction. He considers Poe the best writer that America has produced. He is in a state of some indignation at a book that has been lately published in America by Thomas Powell, wherein himself, Tennyson, Browning, and others, with whom he is not conscious of Powell's having ever met, are spoken of. Gabriel showed him 'My Sister's Sleep', which he approves in respect of sentiment, but says that it contains several lines that will not scan, and that it is too self-conscious in parts, as in the 'I believe' of the first stanza, and in 'I think that my lips did not stir'. Among the new things Tennyson is putting into *The Princess* are, I was told, passages to show where one person leaves off and another takes up the story, and that the alterations will be not in abridgement but in extension. He is to leave London shortly for a little while, and to return about Christmas, close upon which the new edition of *The Princess* will be published. Gabriel did something of the preliminaries for his picture.

*Friday 14th.* Gabriel went on with the study for the Virgin's head, and painted at the hair in Deverell's picture part of the morning. I drew at Seddon's. Cave Thomas, whom I saw there, says he has done about half the article on 'Nature' etc. he is writing for our first number. He suggested that a slight introductory exposition would be advisable, and offered to throw together some jottings down that he has by him, and which, he thinks, would be appropriate. Collinson called on Gabriel in the evening.

*Saturday 15th.* Hunt, Gabriel, and I, were at Stephens's, whose article, 'The Revival of the Feeling in Early Art', we read. There is a gap in it towards the end, as he has cut out several [passages].

. . . [Hunt intended to] pass by the house which is to print his etching and leave the pla[te for it] but was prevented by the lateness of the hour. We settled to print the magazine with George Tupper, who took his brother's Article for the purpose; and I am to take him on Monday, and bring Woolner's poem and anything else that may be ready. An objection was raised by Stephens to the publication of his name, and it was arranged that the question should be submitted to the arbitration of the P.R.B. A plan of the wrapper, to include Thomas's device of a Sower and my sonnet, was sketched out all in early English letters, and adopting the title of 'The Seed; Thoughts towards Nature in Poetry, Literature, and Art'; and it was even suggested that the sonnet should be in the same character; but this seems rather difficult, as it is doubtful whether Tupper possesses the necessary types. On making out a list of the materials actually at our disposal, we find we have enough for the second and half of the third numbers, by making a somewhat different arrangement from that at first contemplated, as there is some fear of Gabriel's being unable, thro' press of time as regards his picture, to get the 'Bride-chamber Talk' finished for No. 2. John Tupper says he has spoken to a Medical Man about the scientific requirements for the death of the woman in my 'Plain Story of Life', and that 'congestion and effusion of the ventricle' is the right term. This will adapt itself to rhythm with all ease. Woolner was prevented from coming to Stephens's by having a sitting from Tennyson for to-night, and Millais by having got a bad sore-throat. Hunt's tooth-ache has given him some respite. George Tupper read us something he has written on the faculty of vision; but it is of a character scarcely suitable to the magazine.

*Sunday 16th.* Maitland, the Model, was at Gabriel's study to gild the bordering of his frame; but, after making an attempt, was forced to admit his incompetency; and he has promised to bring some one thither to-morrow, who will do it in time to allow of Gabriel's beginning the picture in the afternoon. As this incident precluded his doing anything to the picture to-day, he drew a little on the design of *Giotto Painting Dante's Portrait*, which he is finishing up for Stephens. Millais dropped in, and says he has been again to the Carpenter's shop for the picture of Christ in his childhood, and that he will begin at it on Thursday. I wrote to a

Mr. Armitage, a Clergyman Millais had met at Oxford, and who takes interest in literary undertakings, enclosing him 6 prospectuses of the magazine in the hope he may do something as regards subscriptions. I also called twice on Woolner to get his poem for the Printer's, but failed to light on him; whereupon I wrote, requesting him to let me have them to-morrow, if in his power. I began reading thro' the new edition of Charles Whitehead's poems with a view to a review, noting down certain points. In the evening Stephens came to Gabriel's study to do his perspective.

*Monday 17th.* The gilding of Gabriel's picture was not brought to a satisfactory termination, and he will get Hunt's aid for its accomplishment; however, he is determined positively to begin painting to-morrow. He resumed writing at his tale 'Hand and Soul', and did some little in continuation. Woolner called on him, but before receiving my note, and without his poem; he is to have a sitting again to-night from Tennyson. Drawing from the model at Seddon's, I saw Cave Thomas, who has written his article in the rough, and will let me have it in a finished state next Monday. He seems to think there will not be time sufficient to get ready the design of the Sower for the wrapper of No. 1, but thinks that it might without difficulty come out with the possible No. 2.

*Tuesday 18th.* Woolner not having made his appearance, I went again to try my chance of finding him, and at last succeeded. His delay has arisen from the second part of his poem not having yet been copied out or considered for final revision. The former task I performed and the latter was achieved by our joint exertions. His medallion of Tennyson is well forward, the head requiring but little more; the hair, however, is only begun. It will have to be suspended for a short time, as Tennyson has left town, and will not be back till about Sunday, when he thinks of remaining for a month or so longer. His poem of King Arthur is not yet commenced, tho' he has been for years past maturing the conception of it; and he intends that it should occupy him some 15 years. His poem 'Thou mightst have won the poet's name' was, he says, written in a fit of intense disgust after reading Medwin's book about Byron. He has seen the poem I have reviewed in our first number, *The Bothie of Toper-na-Fuosich*, and considers it to be

execrable English. He likes Woolner's bas-relief of *Iris* but says he cannot understand the *Puck*. Gabriel began to paint the head of the Virgin in his picture of *The Annunciation*.

*Wednesday 19th.* I delivered to George Tupper Woolner's poem and Patmore's 'Seasons', with which he will make a beginning; but he warns me that we must get our materials together with all possible speed, as next week, being the Christmas week, it is almost impracticable to get his people to work. In the evening we had a meeting at Gabriel's study, where, besides the whole P.R.B., the two Tuppers, Deverell, Hancock, and Cave Thomas, as being persons interested in the magazine, were present. The latter brought the commencement of an opening address he is writing for No. 1; and he promises, on the urgent representations of George Tupper, to get it and his article on 'Nature', ready, if at all possible, by Friday evening. Hunt had the second impression of his etching, which is a marked improvement on the first; he proposes to have some 30 proofs struck off, concerning the distribution of which we had some talk. Ford Brown came in at a late hour, and showed us a sonnet he has composed on 'The Love of Beauty', and which we will find room for in the first number. I gave George Tupper my review which will, he calculates, occupy at least some 18 pages; also our Sister's poem of 'Dreamland'. It was proposed by Woolner, and carried without opposition except a very strong one by myself, that our names should not be published; and another point on which all present came to the vote was the title to be finally adopted. 'The Seed' was set aside in favor of 'The Germ', and this was near being superseded by 'The Scroll', (also Thomas's invention) but was finally fixed on by 6 to 4. Gabriel is to do his best to have 'Hand and Soul' completed in time. His morning had been devoted to painting on the Virgin's head.

*Thursday 20th.* Gabriel set hard to work at 'Hand and Soul',—or at least the spirit was willing, but the flesh was weak against Maitland in the morning, who was engaged in putting together a screen, and against Clayton, North, and Bliss, in the evening.

*Friday 21st.* George Tupper looked in on me, and showed me a proof of the wrapper printed on green paper; also two or three other colored papers, among which I selected one of a rather

salmon hue. I looked over some patterns for borderings, besides, and fixed on one. I went to Seddon's, where Thomas had arranged to meet me with his contributions; but, as he did not come, I, after settling for the Model (this being my last day of drawing) called in at his house. I found him writing the last words of the prefatory address, which I took with me; but he says it has been out of his power to finish his other paper. Gabriel had been all day at his tale, and sat up at it all night as well, without going to bed. By this means he was enabled to finish the narrative, and nothing remained except the epilogue. I copied out such part as required it to be fit for printing and, to supply the space vacant by Thomas's defection, we settled to leave with Tupper Patmore's 'Moon and Stars' and [4] of my miscellaneous poems, 'In Spring and in Summer', 'Noon-rest', 'A Quiet Place', and 'A Fall of Rain'.

*Saturday 22nd.* I left the above with Tupper, who seems, however, to think that, so far from this being required, there will be some difficulty in inserting all that he had already; as my review and his brother's article appear likely to occupy more space than had been allowed for. In the evening, Gabriel having done the epilogue to 'Hand and Soul', we saw him again, and had presented to us the proof of the first sheet which we corrected. It comprises Thomas's Address, Woolner's poem, Brown's sonnet, and begins Tupper's contribution. As Woolner's poem commences at the back of Thomas's Address, and as it is thought desirable that the etching should front what it belongs to, we agreed that it should be inserted opposite the first page of the poem, instead of immediately inside the cover.

*Sunday 23rd.* Gabriel was unable to work at his picture in the morning by reason of Maitland's being still carpentering the screen. He has again got some idea of painting the subject of Francesca of Rimini, instead of what he is now doing, making an alteration in the action, and relinquishing, for want of time, the two proposed side-pieces of Dante and Virgil, and the spirits in hell. His reasons for thinking of giving up the Virgin subjects for the present are the fear of being too late to get them finished, and the want of a satisfactory design for the *Annunciation*, and of any design at all for the Death. Collinson, who came to Gabriel's

study, is still on his picture of *The Pensioner*, but, as he has put in a new figure (that of a second lady) he no longer thinks of having it at the Institution. He intends to finish it, if possible, for the Academy, first providing for the *Emigrant's Letter*. In the evening Stephens was with us, who says that Millais has been doing some wonderful bats. A friend of Deverell's, one Mr. Callum, who was there also, and who is intimate with Philip James Bailey, and will see him shortly, says he should not be surprised if he could get from him something for our magazine; and we are to give him some prospectuses, which he promises to distribute. Deverell is about to begin a tale, and expects to have it ready for our second number. After coming home from the study, I sat thinking for a subject for a prose narrative, and was not long before a vague idea presented itself, at realising which I made a beginning before going to bed. Gabriel made a few corrections for his 'Hand and Soul'.

*Monday 24th*. I sent George Tupper Gabriel's alterations for 'Hand and Soul', and told him that, if necessary, I would cut out the whole of the review of *Sir Reginald Mohun*, leaving that only of *The Bothie* for our first number. At Tupper's, to a Christmas party at whose house Hunt, Stephens, Gabriel, and I, were invited, we received and corrected the proof of the second sheet, which comprises the end of Tupper's article, Patmore's 'Seasons', our Sister's 'Dream-land', Gabriel's 'My Sister's Sleep', and the commencement of his 'Hand and Soul'. Here I was informed that my review must positively be curtailed by about 300 lines, and I took it home with me for that purpose. Tupper has written about half of his second paper on 'The Subject in Art'. Hunt has been told by Millais that Mr. Wyatt of Oxford wants to have some proof impressions of the etching for sale; and Hunt thinks of having some 50 or so printed on fine large paper, to be sold at 3/- or 4/- each. A third impression has been made of the etching, which Gabriel has seen, and considers a most striking improvement. Hunt is about to leave his lodgings at Brompton, which he finds inconveniently small for painting, and will look out for others in the same neighbourhood or at Bayswater.

*Tuesday 25th*. George Tupper called, and left the unprinted portion of 'Hand and Soul', as Gabriel wished to have it back for certain

corrections and alterations, which he made in the evening. I took out from my review all that relates to *Sir Reginald Mohun*, and, as that did not quite make up 300 lines, shortened the notice of *The Bothie* also by some 50 lines of extract. I afterwards went over it, making some final corrections, and wrote in addition a few sentences of my prose tale.

*Wednesday 26th.* I returned the MSS., and expect to have a proof of the last sheet to-morrow. Gabriel continued painting on the head of the Virgin, having resolved to go on with that picture.

*Thursday 27th.* To-night we had the proof of the last sheet, containing the end of Gabriel's tale, and my review. The latter, however, is still, after all my reductions, too long, and exceeds the limits of the number by about a page and a half. Under these circumstances, it is thought advisable to omit Thomas's opening address, especially considering certain strong objections urged against it by Hunt and Stephens. This, besides making room for the whole of the review in its present shape, will enable us to insert Tupper's little poem, 'A Sketch from Nature', and our Sister's 'An End'. The proof being full of blunders, including even various omissions of passages in Gabriel's article—to be accounted for by its having been printed prior to the last emendations—he wrote requesting that a second proof may be sent us of it. He did 4 stanzas of 'Bride-chamber Talk'.

*Friday 28th.* Hunt called here. Having been disappointed of a Model this morning, he has been catching sparrows in a trap, and painting them,—afterwards decorating their heads with green, and sending them on their way rejoicing. He understands from Millais that the Print-seller at Oxford is likely to want not more than some 10 or 12 copies of his etching. Collinson, who was at Gabriel's study, is still at his painting of *The Pensioner*, and expects to have both it and the *Emigrant's Letter* ready for the Academy. We arranged with him that his poem of 'The Child Jesus' shall appear as the opening and illustrated article of No. 2, and that he shall make the etching for it. The subject he will select is where Christ is crowned by his companions, among whom he will introduce John the Baptist. Aleck Tupper brought us the second proof of the last sheet, including the two poems selected; and, as

there is fully space enough at the end of my review, my sonnet, 'Her First Season', will also appear. Thus, then, after many changes and counter-changes, will stand the contents of *The Germ*, No. 1:—Woolner's 'My Lady', Ford Brown's 'Love of Beauty', Tupper's 'Subject in Art', Patmore's 'Seasons', our Sister's 'Dreamland', Gabriel's 'My Sister's Sleep' and 'Hand and Soul', my review of *The Bothie*, and sonnet 'Her First Season', Tupper's 'Sketch from Nature', and our Sister's 'An End'. There is an alteration of '*its* saffron spear' for *his* to be made in Patmore's poem, in consequence of a mistake of mine in copying it; and as the impression is now completed, we must have half a dozen copies printed with the correction, and take care that all persons the copies in whose hands Patmore is likely to come across should have one of these. Stephens and Deverell were with us part of the evening; the former expects to be at work at the Museum upwards of a fortnight yet; the latter is writing a tale in prose for No. 2; also Woolner, who is doing a bust—a commission. Gabriel wrote a short poem, 'Lines and Music'.

*Saturday 29th.* Stephens called at Newman Street, whilst Gabriel was out, and left word that he wants 30 copies of the magazine, in case it is determined to send them round to the subscribers, or 3, if otherwise; I learned from Tupper, however, that they have already engaged to let him have the former number. He also says that he has just met Patmore at Millais's. Millais, who looked in himself, says he has begun his picture from the childhood of Christ, and is going to have a bed in the carpenter's shop he paints from, so as to be able to set to work early in the morning. He is asked to Patmore's for Thursday and Friday, the former to be, he says, a P.R.B. evening; unluckily Gabriel and I, if invited, cannot go, being already promised to the Tuppers. Millais's brother continues to paint still life and objects in Nature with great success, and is determined to become a professional Artist; John is to bully him into doing nothing all next Summer but paint out in the fields. Gabriel had Maitland to sit to him for his picture, but found him useless; and he thinks of beginning to paint from me tomorrow. I discussed with the Tuppers the mode that ought to be adopted in supplying our private subscribers with their copies of *The Germ*. On the one hand, if we were to send them direct, we should obtain the full price for each number, and need not, says

George Tupper, according to established usage, pay percentage to the Publisher on more than at the utmost the trade-price; on the other hand, if the subscribers order it thro' newsmen, it will tend to make the thing known, and will obviate all trouble or uncertainty to ourselves; besides which, many have been already requested to do so. It seems therefore that we must abide by this latter mode. A stroke of genius of the Robert Macaire school suggested itself to my mind for ensuring the sale and extended shop window publicity of the thing; viz., to order a copy of each among 700 stationers, and of course forget to call for it, whereby they would be apt to expose them advantageously for chance sale in addition to buying up the whole edition in the first instance. Perhaps, nevertheless, this would be a little too strong; besides which, George Tupper expresses great doubts as to whether a stationer would order the magazine for a stranger, without exacting the deposit of the price. He advises that copies, with a note from the Editor accompanying each, should be sent to such men as Sir Robert Peel, the Marquis of Lansdowne, etc.

*Sunday 30th.* Gabriel drew in the head of the Angel (from me) in his picture. In the evening we went to Bateman's with Millais, who has finished the *Ferdinand and Ariel* all except some thing more he means to do to the background. He is going to send to the British Institution a small painting he did at Oxford, of Mr. Wyatt and a grand-daughter of his, for which he asks me to write an illustrative sonnet.

*Monday 31st.* To-day before noon 50 copies of *The Germ* were in the hands of the Publishers. I took home with me 12, 3 of which I sold. Collinson and Woolner, who were at Gabriel's study, concur with us in approving of the appearance of the first number. I wrote to Thomas, explaining the circumstances which compelled us to omit his article, and expressing a hope that he would go on with his paper on Nature as applicable in Art.

# January 1850

*Tuesday 1st January 1850.* The 50 India-paper copies of the etching printed off for the magazine having been bound in, I took some of them home; however, they are not generally superior to those on common paper. This was the day appointed (in lieu of yesterday, which was found unsuitable) for our first anniversary meeting at Stephens's fixed on the last day of 1848 for the last day of each succeeding year. Millais and Woolner were prevented from attending. We settled to what magazines and newspapers to send *The Germ*, and to what private Gentlemen and Authors; viz., Sir Robert Peel, Lord John Russell, the Marquis [of Landsdowne.] . . .

$$\star \quad \star \quad \star \quad \star \quad \star$$

*Saturday January 5.* . . . Gabriel went to see Hunt, who removed this evening from Brompton to Prospect Place, Cheyne Walk, Chelsea.

*Sunday 6th.* Gabriel wrote 6 stanzas of 'Bride-chamber Talk'. I looked over my review of *The Strayed Reveller*, and began a few introductory remarks to replace those now transferred to that on *The Bothie of Toper-na-fuosich*.

*Monday 7th.* I left 12 copies of the magazine with a friend, who says he will do his best to dispose of them. Deverell called on Gabriel, and told him that the Porter at Somerset House, who supplies the School of Design Students with stationery etc. would be very likely to get off some of *The Germ*; and it is arranged to let him have 50, on the understanding that, if he succeeds with the whole number, he is to have 10/-, in which case we might probably try it on with another 50. Hunt, in coming to Gabriel, sold 12 copies out of 19; and I left 3 with a Bookseller on trial. I had a letter from Mr. Clapp, the American we met at Patmore's, sending me for insertion a short poem of his own, 'My Gentle Friend', which, he says, has already appeared in an obscure provincial Temperance Paper. If we should not be inclined to put it in, this will be excuse sufficient. I paid for the insertion of a second advertisement in the *Athenaeum*.

*Tuesday 8th.* George Tupper suggested to me the great propriety of sending about *The Germ* to the principal Club-houses. I accordingly made out a list of 21, which I gave to the Publisher. As my stock has been almost exhausted in consequence of Deverell's scheme, I took away 20 more copies from Tupper's. Another letter from Mr. Clapp, who says he has 'enlisted in our behalf some of the most enlightened minds he has met with in England', and that he intends to make *The Germ* subject of 'interfriendly correspondence' in Scotland and America. Gabriel borrowed a lay-figure from Barbe's, and began on the drapery of the Virgin.

*Wednesday 9th.* Gabriel went on with the drapery. I completed the introductory addition to my review of *The Strayed Reveller.* But I find, on reckoning it up, that it will occupy about 14 pages, which is more space than can possibly be allotted to it. I have therefore had to cut out about 130 lines of extract. Some objections have recently been raised by John Tupper to the publication of his 'Spectro-cadaveral Chant', which we had reckoned as one of the contents of our second number, he accordingly left with me a poem he wrote some while ago, beginning 'Sixteen Specials in Priam's Keep', but which appears both to Gabriel and myself decidedly of a more unsuitable character than the other, inasmuch as it contains various political and personal allusions, and is besides, tho' excellent in its way, not free from slang. There is some talk of his giving us some other short poem, tho' we do not at all abandon the intention of printing the 'Spectro-cadaveral' sooner or later. Collinson sent me a first instalment of his poem.

*Thursday 10th.* Gabriel had a large meeting at his studio, including, besides the P.R.B., Thomas, Brown, Tupper, Dickinson, etc. etc. Collinson brought the remainder of 'The Child Jesus'. Two or three matters concerning *The Germ* were resolved on, such as to send out more copies to literary men etc. and to magazines, and to try to introduce it among Artists' Colormen. Ford Brown also will write for No. 2 an article on the painting of a historical picture. For this room must be made somehow, and probably my review will come out.

*Friday 11th.* Gabriel went on with the Virgin's drapery. I copied out and left with Tupper, in conjunction with Collinson's poem,

two little songs of our Sister's, one of which is to be introduced into the second number. Another thing to be put in is a sonnet that Calder Campbell has sent Gabriel.

*Saturday 12th*. All the P.R.B. was at Ford Brown's, with several others, to induct him properly into his new rooms in Newman Street. Stephens gave me his article for No. 2, which he has touched up and altered considerably; the title remains to be supplied. Collinson has quite finished the design for his etching, and will begin it on the copper on Monday. Millais has been knocked up these 2 or 3 days with colds caught at his carpenter's shop. He has sent off his picture to the British Institution, with my sonnet as title. He has thrown up the commission for his *Ferdinand and Ariel*, as Mr. Wethered, among other things on which they did not come to terms perfectly satisfactory to Millais, expressed some doubts of the greenness of his fairies, and wished to have them more sylph-like. Woolner thinks of finishing up for No. 2 his little poem 'Emblems', or some other of his short pieces. Cave Thomas expects to have his article ready by the end of the week, and speaks of letting us have some little poems of his also. With him, Brown, Lucy, and Anthony, the P.R.B.s waged tremendous battle after supper in a discussion arising out of some reflections on Rubens's style of horse. We held out till our departure at nearly 4 o'clock. Stephens says he has by this time disposed of 30 *Germs*.

*Sunday January 13th*. Collinson called at Gabriel's study, and showed us the design (now completed) for his etching to No. 2 of *The Germ*. Afterwards Gabriel and I went to Woolner's to see Bernhard Smith. He got disgusted at the total want of intellectual companionship in Yorkshire, and means to stick to Art. He has taken rooms at 13 Foley Place, and will commence painting, taking figure-subjects. Woolner has been going on with his statue; he has besides got some prospect of having a pupil to teach. He says that Patmore has offered us for *The Germ* an Essay of his on Macbeth, written a short while ago. This we will bring into the second number probably; and, if so, must displace Deverell's tale. It is also proposed that I should finish up with a few more lines the blank verse concerning a Castle that I wrote at Brighton a year and a half ago, and put that in as well.

*Monday 14th*. Stephens, Woolner, and I, being at Tupper's, we read thro', and made one or two alterations in, Stephens's article, leaving it on our departure with Tupper, to be printed. John Orchard, the painter, sent Gabriel a poem of his, called 'On a Whitsunday Morn in the Month of May', for insertion, if approved of. It is generally good, but requires not a little revision.

*Tuesday 15th*. W. B. Scott, to whom Gabriel wrote some days ago, sending a copy of *The Germ* and requesting contributions, answered, enclosing two poems, viz., a Sonnet, 'Early Aspirations', and a blank verse piece, 'Morning Sleep'. The latter, which is gloriously fine, must absolutely come into No. 2. Deverell called on Gabriel with his tale, which he read; but, becoming disgusted with it in the course of the evening, tore it up, and threw it away. Gabriel painted on the drapery in his figure of the Virgin. I consulted with George Tupper about a title for Stephens's Essay, and we shall probably call it 'The Purpose attempted in Early Italian Art'. We also discussed the question of advertizing *The Germ* by posters; and he thinks the more likely way of making such effective would be printing some such thing as—'My Beautiful Lady: See *The Germ*. Aylott & Jones.' The objection to this it its want of dignity.

*Wednesday 16th*. I answered W. B. Scott, and sent him my 'Plain Story of Life', begging for his opinion and suggestions. I made a few corrections in the MS., cutting out the '*worthy*' Coroner, as being of very doubtful newspaper fidelity. Gabriel drew in the skirt of his drapery, and, in the evening, began a rough sketch of a design for my 'Plain Story', which, it is likely, may appear in our fourth number, and which he thinks of illustrating. Collinson was at his studio all day, working on the etching, of which he did about a quarter. Woolner and Hunt were with us in the evening. The former had been to a Gentleman who has small models made from popular engravings etc., among others from the unmentionable F. S. Woolner has some prospect of being employed by him, but hopes to escape the last 'unkindest cut of all' of having to copy the *Cross Purposes* or *The Impending Mate*. Hunt's picture (so *he* says) is getting on but slowly; to-day he was disappointed as usual, of a Model. I had a letter from Stephens, giving me a list of the subscribers he has obtained, and suggesting that we need not

print so many as 700 copies of No. 2; 300 would, he thinks, suffice. In answering him, I concurred in the reasonableness of the suggestion, but consider that 400 will not be too much. He will be unable to come to the P.R.B. meeting at Collinson's on Friday.

*Thursday 17th.* George Tupper gave me the proof of Collinson's poem and of Patmore's 'Stars and Moon', the latter of which I sent to Patmore, who expressly desired he might have it to correct. Collinson is to have his own similarly, as there are some points he wants to look after. Tupper advises that 500 copies should be published of the second number, to which I agreed. I copied out for next number another poem of our Sister's, 'Sweet Death', as it seems doubtful whether there will be an odd corner adapted to either of the little things I had before selected.

*Friday 18th.* This was to have been a P.R.B. meeting at Collinson's; but the day turned out so intensely sloshy that only Hunt and I kept the appointment; and my virtue would have failed, had I not had to deliver some wax to be used in the etching. Collinson has very nearly finished this. We had some argument concerning the limitability of the P.R.B.;—Hunt maintaining that it ought inviolably to consist of the present Members, for which Collinson and I do not see any very cogent necessity.

*Saturday 19th.* Gabriel went on with the drapery in his picture. As we shall now have two blank-verse poems—Collinson's and Scott's—exclusive of my 'Castle', it will be expedient to omit this. I therefore put together 3 little things I did about a year ago, called 'Noon Rest', 'A Quiet Place', and 'A Fall of Rain', giving them the general title of 'Fancies at Leisure'.

*Sunday 20th.* I wrote a 4-stanza poem on Winter. The end of the month now drawing near, it behoves us to get together our articles. I called at Thomas's, who being out, I left a note for him requesting to be informed as soon as his shall be ready; also at Woolner's, who was likewise absent, and from whom I have to obtain Patmore's 'Macbeth' Essay. The copy of *The Germ* that was to be given to Clough has been left with one of the University College Students for the purpose. On Gabriel's coming home at night, I learned that Woolner had been with him when I

called, and that he was under the impression I myself had Patmore's
paper.

*Monday 21st.* By enquiry at the Publisher's, I learn that he has
sold about 120 or 130 copies, which is at least as good as I looked
for. He sent me a letter he has received from a Mr. Bellamy,
Secretary to the National Club, (to which I sent a copy), advising
him to send one to the Proprietor of the *John Bull* with his
(Bellamy's) card attached, as it will thereby be secure of being
attended to next week. He bought 4 copies, 2 of which he says
he has placed in the hands of a literary man and an Artist likely
to be serviceable to the work. Yesterday's *Dispatch* contains a few
words in praise of No. 1. Patmore wrote me returning the proof
of 'Stars and Moon', in which he has made no alteration whatever
save of punctuation. He wishes to have some half dozen impres-
sions of it for private distribution. I went to see Woolner again,
and he promises to let me have Patmore's article to-morrow. I
took a copy of his song 'O When and Where', for insertion, if
practicable, in the new number.

*Tuesday 22nd.* Ford Brown showed Gabriel his article 'On the
Mechanism of a Historical Picture'. He will finish it and copy it
out, and is to let him have it back to-morrow. After dinner, I
went for the first time to see Hunt at his new lodgings, 5 Prospect
Place, Cheyne Walk, Chelsea, where he seems very comfortably
settled. He has made a good deal of substantial progress with his
picture, of which, since I saw it last, he has done some more
figures in the background, the boy listening on the floor, the
straw etc. on the roof with some sparrows in it, and something of
the view outside the hut. The figure he is now painting at is that
of the foremost man pushing at the door. Whilst I was there, he
went on working upon a stump of a beech-tree which forms one
of the supports of the hut, and on which he means to paint a net
hanging. Collinson was also there, and brought the first proof
of his etching. This is very imperfect thro' some defect in the
biting in,—so much so that he felt discouraged at first; but Hunt
says it can certainly be remedied. Stephens too came with John
Tupper, who read, and left with me, a poem of his written on
Penge Wood. This, should there be room for it, will come into
No. 2. At $10\frac{1}{2}$ o'clock, Hunt was requested to allow his gas to be

turned off, as the family were about to go to bed!! which did not
exactly meet his views or intentions. When I got home, I found,
to my dismay, that Patmore's 'Macbeth' had not arrived, and
that Gabriel had not received Brown's paper. Moreover Thomas
has made no sign. All this throws us back dreadfully. I wrote off
a note to Woolner.

*Wednesday 23rd.* Woolner saw Gabriel, and explained that Pat-
more, on looking over his article, found that a page or two was
wanting, which he would not be able to supply without much
trouble. Nor will Thomas, as I learned by calling on him, have
his Essay ready for this Number. We are thus reduced to shift as
we may with what we have by us, and that is all poetry, except
my review of *The Strayed Reveller*, which will fill up part of the
gap. For the rest we shall bring in 3 sonnets of Deverell's, Gabriel's
'Blessed Damosel', our Sister's 'Pause of Thought' and 'Testimony',
and 3 more things of mine, 'In Spring', 'In Summer', and 'Sheer
Waste',—(*olim* 'The Far Niente')—which will be included among
the 'Fancies at Leisure'. In these we made some slight alterations.
North looked in, and nailed us with a promise of contributions,
engaging, however, to bestow very great care on whatever he
may offer us. I wrote to Collinson to send Deverell 2 of his
sonnets, and to Deverell to let Tupper have them with the least
delay possible. A letter to 'the Editor of *The Germ*' reached me
thro' the Publisher. It is from a Mr. G. Bellamy (a relative, I
presume, of the other Mr. Bellamy) addressed from the British
Museum, expressing the highest admiration of the poetry of the
Magazine, and begging the favor of an introduction to the Author,
as he conceives it to be all by the same person. I answered to
thank him, and to say that I would call with Woolner as soon as I
could find time. I corrected the proofs of Stephens's Essay and
Scott's poem. We received Brown's article.

*Thursday 24th.* I left with Tupper Brown's Essay, the 'Testimony',
'O When and Where', and my 3 additional 'Fancies at Leisure', as
well as the proofs. In the evening Woolner, Gabriel, and I, called
on Calder Campbell, one of whose last poems ('in the shade of
the lilacs' or some such name) we read, and fixed to have for some
future number of *The Germ*. Campbell took from me a copy
which he will leave with Heraud, as the one I had originally sent

to him directed to the *Athenaeum* Office was returned to me some while ago.

*Friday 25th.* Woolner received, in answer to a letter he wrote lately to W. B. Scott, one from him, expressing admiration of the 'My Lady' poems. At Tupper's I found proofs ready of my review, Campbell's sonnet, and the first 3 of my 'Fancies at Leisure'. These I corrected; and find that the review occupies 14 pages, instead of 12, for which I had reckoned, in consequence of which the other 3 'Fancies' may be curtailed. The first sheet is now regularly printed in pages, including our Sister's 'Pause of Thought' and the short song of 8 lines I selected originally. Collinson was at Gabriel's study in the evening, and brought the second impression of his etching, which shows a great improvement. He has given Deverell his two sonnets, so that I hope they will be sent in for printing to-morrow. Gabriel finished up his 'Blessed Damosel', to which he added 2 stanzas. A letter came from 'Shirt-collar Hall', acknowledging the receipt of a copy of *The Germ* which was sent him on Saturday, complimenting those engaged in it, who will, he says, be 'the future great Artists of the age and country', and promising that it shall be reviewed in the *Art Journal* for March, as it came too late for next month's number.

*Saturday 26th.* I had a letter from W. B. Scott, returning my 'Plain Story of Life'. He evidently looks on it as a curiosity out of his line of thought and poetic faith, not wanting in good description, but *exceptional* and wrong in delineation of character. A note also came from Heraud, acknowledging a *Germ* which Campbell had left with him, and asking me to tea on Tuesday. Gabriel sent Tupper an additional stanza for the 'Blessed Damozel'. Deverell left me his sonnets.

*Sunday 27th.* Gabriel went on with the drapery of his picture. Stephens called on him in the evening, when it was determined that the Authors' names shall be published in our future numbers. For our Sister Gabriel invented the name 'Ellen Alleyn'. I looked over Deverell's sonnets, in which I found a line missing, besides one or two other points demanding attention; afterwards I made a futile attempt to go on with the prose tale I have in hand for a

future number. I had a letter from Clough, conveying his thanks
to me for the copy of *The Germ*, and the criticism.

*Monday 28th.* Collinson saw Gabriel, and showed him the new
impression (the fourth) of his etching, which is a great advance
on all the preceding ones. Gabriel wrote one more stanza of his
'Blessed Damozel'. Of the beginning of this and all the remaining
articles of the month I saw and looked over proofs at Tupper's,
to whom I gave a table of contents with the names attached, with
one also similarly made out for last month. Collinson having
written to him requesting he would fetch the etchings from the
Printer's on Wednesday morning, under the impression that
would be time enough to get the number out by the evening of
the same day, I sent him a note to urge him to have them ready
earlier, if possible. Whatever haste may now be made, we shall
[be later in publishing than would be] desirable. . . . [Gabriel read
us several stanzas] he has written of late to 'Bride-chamber Talk'.

*Tuesday 29th.* At Heraud's, to whom I went, I met Westland
Marston, who asked me to his house for to-morrow. Heraud
complimented us a great deal on *The Germ*; but he insists on the
incorrectness of the rhymes 'born' and 'dawn' in Gabriel's 'My
Sister's Sleep'. Hervey, the Editor of the *Athenaeum*, came in
rather late. Soon after we had been introduced, he explained to
me that the reason why he had neglected many months ago to
answer the letters that I sent him concerning certain poems I had
offered for the *Athenaeum* was that he wished to call and explain
personally why he had felt unable to insert them, viz., on account
of their being too Tennysonian; and that his many engagements
had prevented him from fulfilling his intention till too late. He
asked me to call on him any Saturday or Sunday. After supper,
Heraud spouted us a transcendental lecture, and Miss Heraud
recited *totidem verbis* Juliet's soliloquy 'Gallop apace, ye fiery-
footed steeds.' George Patten was there, and Miss Glyn, the
Actress, who promised to subscribe to *The Germ*.

*Wednesday 30th.* I found the invitation to Marston's to be a
regular evening-party. On leaving, I presented him a copy of *The
Germ*, and he asked me to call some day when I might find him
alone. Hervey, in talking with me, maintained that *Sordello* is

absolute nonsense, and said he has no patience with men who write in that style. He tells me also that, before publishing it, Browning asked his friends whether it was intelligible; and that they informed him it was; in consequence of which, the result having proved the contrary, he became somewhat indignant against them. I left with the Publisher a list of 25 newspapers, magazines, etc., to which No. 2 is to be sent. He tells me that he has sold some 70 copies of No. 1,—not 120 or 30, as I heard some time back. He will settle about the proceeds from the number at the end of the quarter.

*Thursday 31st.* Appeared No. 2 of *The Germ,* containing Collinson's 'Child Jesus'; 'A Pause of Thought', a 'Song', and the 'Testimony', by our Sister; Stephens's article, 'The Purpose and Tendency of Early Italian Art', Scott's 'Morning Sleep'; a sonnet by Calder Campbell; Patmore's 'Stars and Moon'; Brown's 'Mechanism of a Historical Picture'; my 'Fancies at Leisure' (including the 'Sheer Waste', for which room was found at last) and my review of *The Strayed Reveller*; Deverell's sonnets, 'The Sight Beyond'; and Gabriel's 'Blessed Damozel'. Stephens figures as 'John Seward', as he does not wish his own name to appear; Tupper's articles in the first number also remain by his desire anonymous. . . . George Tupper gave me his bill for No. 1, amounting, on a scale even below his original estimate to £19.1.6, from which he will deduct 5 per cent for discount, leaving £18.2.6. It now becomes a most momentous question whether we shall be in a position to bring out a third number. The chance seems but very doubtful,—quite beyond a doubt, unless No. 2 sells much better than its predecessor, and of this we see but little likelihood. Even if it does appear, we shall probably have to postpone the publication of 'Bride-chamber Talk', which Gabriel cannot write at much, having to paint his picture; in which case, my 'Plain Story of Life' will probably be substituted. I spoke to the Publisher about pushing the sale of No. 2, and he promised to introduce it, on sale or return, among his customers in the trade.

# February 1850

*Friday 1st February.* I had some of the India-paper copies, which are greatly superior to the others. By Campbell's advice, I left one of each number at the house of Mr. Cox, Editor of the *Critic*, to whom Campbell had spoken of it. Richardson, the Catholic book-seller in Fleet Street, to whom I offered copies, says he never takes books on sale or return. Gabriel finished the drapery of the Virgin in his picture; whereupon he immediately deranged the position of the lay-figure, so as to preclude himself from the possibility of working at it any more. I had a letter from Mrs. Patmore, inviting me for Thursday next, when I shall have a chance of being mesmerized by a friend of theirs who will be present.

*Saturday 2nd.* Woolner and I went together to the Museum to see the Mr. Bellamy who had written to me about a week ago concerning *The Germ*. He is quite a young man, and seems to have a fair acquaintance with modern poetry, but depreciates Patmore, and does not know W. B. Scott. He showed us over the library and the Nimroud sculptures, in which are some very fine quaint things, particularly a lion gnashing his teeth, and one crouching; also some birds seizing hold of men. He says that Kingsley, Author of *The Saint's Tragedy*, wrote the tale in *Fraser* named 'Yeast'. In the evening we had a full P.R.B. meeting at Gabriel's. Collinson has set to work at his picture, which occupies him so much as that he is unable to go out to do anything in the way of distributing *Germs*. Millais has had his picture back from the British Institution,—on account of its being in reality a portrait, we conclude; and will send it to the Academy. Hunt is experienc-ing his apparently indispensable bothers with models, and says he can scarcely get on at all with his picture; however, a friend of his from whom he takes one of the Savages came to the study at a late hour, in order to go home with him and sit to-morrow. Woolner goes on steadily with his statue; Tennyson, he says, was in London for a day or two not long ago, but left without seeing any one, and will not be back again for a month or upwards. Stephens has made a design from the story of Griseldis of the Marquis's interview with the father; he means to set about paint-

ing the subject forthwith, and swears he will have it ready for the
Exhibition. Bernhard Smith is painting a woman threading a
needle. Millais has had an offer from Oxford to paint a copy of a
portrait by Holbein, which, as he does not feel disposed to accept,
he offered to Stephens, who will do it after the opening of the
Exhibition. We consulted about *The Germ*, and are unanimously
of opinion that it will not reach another number. Calculating the
number of copies sold among ourselves as 95 (not, I think, more
than in fact) and by the Publisher as 70, from which profits we shall
have to deduct some few personal expenses, which can scarcely
amount to 15/-, it seems that the expense to each of us beyond the
receipts will be £1. 15.5¼. This is a kind of experiment that won't
bear repetition more than once or twice. The next meeting is
fixed for Monday at Millais's. On coming home, I found a letter
from Mr. Cox, of the *Critic*, proposing that, in case *The Germ*
should not continue, as he considers probable, one of the Art-
writers in it or I should write on the same subject for his paper, in
which case he says he would resign the entire management of the
articles on Art, the Exhibitions, etc. He would not be able, how-
ever, to offer any remuneration in cash. This proposal is not, I
think, disadvantageous for the P.R.B., as it would enable us to
review the exhibitions in our own feeling, and might besides lead
to some other literary employment. I answered that I would
consult the others (Brown, Stephens, and Tupper) and, if they
should not undertake it, that I would accept. I asked him to fix a
day for me to call, as on Thursday, which he has proposed, I am
engaged to Patmore.

*Sunday 3rd.* Gabriel began painting on the red cloth on the
embroidery frame in his picture. I went to Hervey's in the evening,
where I met the 'Unmentionable'. Hervey has not yet seen the
second number, as he has not been at the *Athenaeum* Office since
Thursday. I suppose he will find one sent thro' the Publisher, when
he goes next. I wrote to Stephens about Cox's proposal, and also
saw Campbell relative to it. He advises me to accept. If I do so, it
must be kept quite close, as it won't do that it should be generally
known that a P.R.B. writes reviews of the exhibitions.

*Monday 4th.* Gabriel and I went together to the British Institution,
of which this is the first day, as I wish to write something in the

way of notice in the event of my being retained on the *Critic*. There is an amusing work by the Unmentionable; the best things by Anthony, Branwhite, the Danbys, and Wolf, who did *Woodcocks taking Shelter* last year. I made notes as I went thro' the rooms the second time, but had only got thro' about half when the dusk came on, and I left. We had 100 copies of No. 2 from Tupper, of which we sent 20 to Millais, and 15 each to Woolner, Hunt, and Deverell. For Stephens Tupper himself will provide. I left a copy at the *Art-Journal* Office, with a note to S. C. Hall.

*Tuesday 5th*. I began writing my notice of the British Institution. Gabriel assumed the responsibility of F. S. and a few others. I wrote to W. B. Scott, sending a copy of *The Germ*; also received from Tupper the separate impressions of Patmore's 'Stars and Moon' I have had struck off at his request, and left a note for John Tupper about the *Critic* proposal.

*Wednesday 6th*. John Tupper resigns in my favour; and Stephens wrote me to the same effect, but offering his co-operation in any way he might be wanted. He suggests besides that it might perhaps be possible, after the various favorable reviews *The Germ* will have received, to get some other Publisher to take it in hand, should we be unable to continue it on our own resources. I did a little of my exhibition notice.

*Thursday 7th*. Woolner and I went to Patmore's, to whom I gave some *Germs* and his own poems. He likes the 'Testimony', which is, he says, in the style which should be adopted in hymns etc. to make them good; says there are very fine things in Gabriel's 'Blessed Damozel', and speaks highly of Stephens's article. Collinson's and some others he has not yet read. He says that William Allingham has promised some contributions; but these will probably not be available. The Gentleman who was to have mesmerized me (Dr. Calvert Holland) was unwilling to make the attempt, as he says it is many months since he has been out of practice.

*Friday 8th*. Gabriel began painting, from Hersey, the arms of the Angel Gabriel. I paid a second visit to the British Institution, and went on with the notice of it.

*Saturday 9th.* I saw the Publisher about the sale of the second *Germ*, and am informed that some 40 copies or so have sold, and that the first number also continues to go off every now and then. This is the last knock-down blow. We certainly cannot attempt a third number. Woolner and I went to Stephens's. He showed us the design he has made of the Marquis dining in Griseldis' father's house, Griseldis attending, which he means to paint, also two other designs from Chaucer; Griseldis parting from her child; and the Revellers meeting Death. Gabriel got some stuff for the chasuble in which he means to drape his Angel.

*Sunday 10th.* The review of the British Institution was brought to a close, Gabriel co-operating with me to effect that result.

*Monday 11th.* Remembering that I had omitted in my notice all mention of the works in sculpture, I supplied the deficiency, and left the MS. with Mr. Cox, to be dealt with as may be thought fit. This was a P.R.B. night at Millais's, where all were present, except Collinson, who is detained by having to work at his picture. Millais says he has done several hands, feet, legs, etc., in his picture; but it is for the present kept invisible. Stephens has been prevented as yet from beginning his picture, which he was otherwise quite prepared to do, by the unpunctuality of models. Millais has very high accounts, from Oxford and elsewhere, of the estimation in which Collinson's poem is held. Woolner, Bernhard Smith, and I, settled to be at Hunt's on Thursday.

*Tuesday 12th.* Gabriel painted at the Angel's chasuble. In the evening he was engaged with Hannay, Clapp, North, and others, who came to see him, and I with the Museum Mr. Bellamy, who has got us reviewed in the *John Bull* (the Critic himself not having looked at the book, but trusting entirely to Bellamy's report).

*Wednesday 13th.* Gabriel, B. Smith, and I, spent the evening with Woolner, who goes on at his statue. He showed us a daguerreo-type of Tennyson, which has been lent to him. The third edition is out of *The Princess*, which we saw on Monday at Millais's, Stephens having bought it.

*Thursday 14th.* Woolner, Smith, and I, went to Hunt's, at whose study we found John Tupper. Hunt is progressing rapidly. He has

put in two or three more of the figures in the background, has gone on with the two savages at the door, and the girl stooping, begun the rows of cabbages, drawn in the principal woman (whom he has altered from old to young, making the woman behind the chair old), and is now painting the preacher's red drapery. We saw the *Morning Chronicle* review. An argument of frightful intensity concerning what Eastlake says of the properties of sculpture was maintained for some hours; but, when Woolner began to gnash his teeth, we left off. This, however, was not before Tupper had undertaken to prove by mathematical deduction that, if what Woolner asserted were true, it would prove the part to be greater than the whole. Hunt says that Stephens has begun his picture.

*Friday 15th.* Gabriel at the Angel's chasuble. I went in the evening by invitation to the house of Mr. Bellamy, where I read the *John Bull* notice of *The Germ*. Mr. Bellamy seemed really to regret the apparently inevitable death of *The Germ*, and took a copy of each number to send to Justice Talfourd, with whom he is intimate, and who might, he thinks, possibly do something for it. I answered a note I had received from a Mr. Adams, of Rochester, who sent me a poem for *The Germ*, and offered us a review in a local paper for which he writes. This I did not request,—as being useless.

*Saturday 16th.* My review of the British Exhibition (first half) appears in the *Critic* of to-day; also a notice of *The Germ*, quoting 4 of the poems. George Tupper called on me in the morning, and said that he and his brother, looking with regret at *The Germ* failure, propose to carry it on at their own risk for a number or two longer, to give it a fair trial, when it would have a better chance of success thro' their being able to send about the subscribers' copies, to advertize by posters, etc. This I consider a very friendly action on their part. I wrote, at his request, to convene all the hitherto proprietors, and saw the Publisher about the sale of Nos. 1 and 2. It appears from what he says that he must have sold not much less than 100 of the first, but the second, he states, goes off less well. All the P.R.B.s came to Gabriel's study at night to talk the matter over; and the Tuppers [presented their] proposal. It then became a question of material [which various contributors have] . . . promised to have ready [for the third

number.] . . . We thus find ourselves docked of the two poems on which we had to rely for Nos. 3 and 4. However, as there was no help for it, we set to thinking how to manage with this deficiency. The first thing thought of was Gabriel's 'Dante in Exile'; but this he is unwilling to have printed until he shall have been able to give it full consideration as a whole, besides its connexion with his translation of the *Vita Nuova*, separated from which he thinks some allusions in the poem scarcely intelligible. His 'Jane's Portrait' was then discussed; this, however, is too much like Woolner's 'My Lady in Death' as regards subject; nor does Gabriel think it good enough as a specimen of his powers. The last suggestion was that Woolner should look up that part of his old poem of 'Hubert' which describes the lovers' meeting, and see whether it can be got into shape as complete in itself. Gabriel will co-operate with him in seeing about it to-morrow. Except short filling-up poems, my review of *Sir Reginald Mohun* is the only thing ready; and even that requires some putting together. Brown, who happened to come in, will continue his papers on the 'historical picture', John Tupper his on 'Subject', and we must try to get Thomas's article and Patmore's 'Macbeth'. After all, tho', it seems more than doubtful whether the third number can come out at the end of this month. Another point raised was about the Publisher. There was some talk of Tupper's publishing himself, but this does not seem very likely to be carried out. I promised to ask Marston for a letter of introduction to Mitchell of Red Lion Passage, with whom he himself publishes. Collinson left early, begging that he may not again be called from home unless on urgent necessity, as his picture will not bear neglecting. Millais has done several legs and feet etc., and is now painting the Virgin's head; his picture continues for the present invisible. Stephens says he has begun drawing his on the canvas, and would have got on with it more, had he been able to obtain a Model. He has very greatly altered the design, so much so as almost to make it a new thing.

*Sunday 17th.* Woolner and Gabriel looked over the 'Hubert', and find that it cannot possibly [be used in No. 3]. . . . Cottingham called at Gabriel's. . . . I wrote to Marston, asking [whether I might call] on Wednesday, and finished up my review of *Sir Reginald Mohun.*

*Monday 18th.* In default of any adequate poem, I looked up my Sister's old thing named 'An Argument', which is at least long enough and in a narrative form. Tupper, to whom I read it, is very much delighted with it; but the fact is it is not quite up to the mark.

*Tuesday 19th.* I had an answer from Marston, saying that he will not be at home to-morrow, but asking me for Tuesday of next week. I had written to him, mentioning about Mitchell, the Publisher, when Gabriel, coming home from Brown's, told me he had there met Robert Dickinson, who has undertaken the publication of *The Germ.* This is the best thing that could have happened for it, perhaps.

*Wednesday 20th.* Patmore sent me his paper on 'Macbeth', which is devoted to showing that the idea of obtaining the crown was not suggested to Macbeth by the Witches, but had been previously contemplated by him. It is very acute and well written, and will fill some 20 pages. Our difficulties as to illustration continue. The only plans we have thought of are either to make an etching for our Sister's poem in two compartments, one of a girl spinning, and the other of the battle-field, or, as Tupper thinks preferable, of the avalanche—or else to take some subject from Gabriel's 'Hand and Soul' in the first number. Tupper decided to call on Gabriel at his study to talk this over; but it so happened that Gabriel stopped at home touching up his 'Dante in Exile'.

*Thursday 21st.* I left Patmore's 'Macbeth' with Tupper; and he showed me various old articles of his brother's and others which he has collected for insertion, if adapted, in *The Germ* as occasion may serve. I called on Millais, and asked him whether he will be able to do the etching for next month,—in which case the number would, at all events, have of course to come out later than usual in the month; but he says he is now so fully engaged with his picture, having just set a white drapery, that he cannot undertake it, and this is perhaps best. We shall now miss a month altogether, and come out in April properly prepared. Millais has done (or begun) the heads of the Virgin and of Christ. Gabriel received from Orchard the first part of a 'Dialogue on Art', being one of a series he will write, if found suitable. Gabriel read it to Stephens

and John Tupper, by whom, as well as himself, it was highly admired. I put together 5 of my things as a second instalment of 'Fancies at Leisure'. I wrote again to the Mr. Adams of Rochester, who had sent me a note about *The Germ*, and sent him copies of the 2 numbers to be reviewed, as may be worth while now that it is settled to go on. W. B. Scott's book about his brother David arrived; this we mean to review as soon as may be for *The Germ*. A Tragedy named 'Meroth' was sent to the Publisher's for 'T. Woolner Esq., Contributor to *The Germ*', but it seems very poor stuff.

*Friday 22nd.* We settled that it is impossible to bring out a number for March; but there is some talk of a double number in April. Woolner, Stephens, and Bernhard Smith were at Gabriel's study in the evening; and Ford Brown also came in later. He read us the second of his papers on the 'Mechanism of a Historical Picture'; and has thoughts of writing something on the choice of subject. He warned me against being too downright and sarcastic in the Art notices I write for the *Critic*. Gabriel having asked him to do us an etching for the next or some early number, he proposed one of his designs from *King Lear*, which he would execute double the size of the other etchings, requiring a fold down the middle. The subject we last stopped at was the leave-taking of Cordelia and her sisters. Gabriel proposes to write an illustrative poem for it. This etching of Brown's would do capitally for show in Dickinson's window. Gabriel has painted the chasuble of the Angel and the Virgin's arms; he and Brown discussed the background, the bed, and other of the accessories. Stephens is painting his figure of the Marquis.

*Saturday 23rd.* Gabriel spent the evening at Dickinson's, where Brown, Woolner, Thomas, and Hunt were also present. Hunt brought a Hastings paper in which there is a very cleverly written review of *The Germ*, not altogether laudatory. On leaving Dickinson's, Gabriel went home with him to see his picture. There is some thought of changing our magazine's name to 'The Artist' or something of the kind; Gabriel is the chief advocate for this; and, if it is to be done, now is the time certainly, when we are about to begin with a new Publisher etc. I went home to Tupper's, where we disputed about Eastlake's opinions on sculpture.

*Sunday 24th.* Gabriel went with Millais and Brown to see Anthony's pictures, of which some of the unexhibited delighted them greatly. He also called to see Cottingham, but found him out.

*Monday 25th.* I got home from Tupper's Orchard's 'Dialogue on Art', which Gabriel and I read over, making a few alterations in style etc. as authorized by a letter from himself that Gabriel has received. Gabriel continued touching up and adding to his 'Dante in Exile'.

*Tuesday 26th.* This was the evening appointed for me to call on Marston. An invitation had also come from Patmore, but which we had to decline, Gabriel being engaged to Cottingham. At Marston's I met Hervey and Bedingfield, author of *The Peer and the Blacksmith* etc. What Hervey admires most—and that very highly indeed—in the second number of *The Germ* is Gabriel's 'Blessed Damozel', which he has read to Marston, who agrees in admiring it. We talked of Bailey's new poem *The Angel World*, just come out, of Browning, Mrs. Browning, etc. Marston says that Browning, before publishing *Sordello*, sent it him to read, saying that this time the public should not accuse him at any rate of being unintelligible (!!) Browning's system of composition is to write down on a slate in prose what he wants to say, and then to turn it into verse, striving after the greatest amount of condensation possible; thus, if an exclamation will suggest his meaning, he substitutes this for a whole sentence. Mrs. Browning, I find, had published a volume of original poems before her *Prometheus*,— *An Essay on Mind* etc., which came out in '26. Of this Marston showed me a review with extracts in an old magazine named the *Sunbeam* to which he had contributed.

*Wednesday 27th.* I made a miserably vain attempt, for the second or third time to think of some subject for a poem, in the midst of which attempt Wrightson came in. Gabriel read him 'Bride-chamber Talk', and I my 'Plain Story', on which he looked as more than half intentionally comic, and advised me to send it to *Bentley's Magazine*, where he thinks it would have a very fair chance of insertion. Gabriel went on with 'Dante in Exile'.

*Thursday 28th.* Gabriel went to Brown's in the evening, to have a sketch of his head made on copper as an exercise for Brown in

etching. This was done with much freedom of hand. I was at Harris's, where were also Bridgman and Bliss. The conversation turning on mesmerism, concerning which Bridgman related some personal experiences (if they can be trusted) not only in mesmerism, but in clairvoyance as well, I offered myself to be operated upon. After some 10 minutes' practice, I certainly seemed on the point of dropping off, began gasping in my breath, and was falling back in the chair, when Bridgman, apprehensive of catalepsy ensuing, suspended his magnetic influencings. The sensation is not one of drowsiness, nor in the least, up to the point I reached, of unconsciousness, but simply of inability to resist closing the eyes and dropping backwards. After this, Bridgman continued his operations for a long while, but without much result. Some circumstances, however, such as a strong light in my eyes, etc., seemed against him. He also tried Bliss, but unsuccessfully. We agreed to go to Harris's again on Sunday, Bridgman engaging to mesmerize me completely this time.

# March 1850

*Friday 1st March.* The new number of the *Critic* was sent me by the Editor, containing the end of my review, to which, to my surprise and annoyance, I find my initials have been added. This must be taken care of. Gabriel, having had a note from Hunt telling him that Collinson was ill, called to see the latter, who, he found, has been laid up more or less since Saturday with fever, and unable to work at his picture. He is now recovering.

*Saturday 2nd.* Gabriel and I went to Collinson's. He is getting apprehensive that he may at last find himself unable to finish his picture of the *Emigrant's Letter* for the Academy, and seems almost inclined to set about some very small work. He has done a great deal of the background and accessories in his picture, and the figures of the man and three children are considerably advanced. He hopes soon to cut his present lodgings.

*Sunday 3rd.* Gabriel had White, the Model, to sit to him for the arms [of] his Angel Gabriel. He is now looking out for a woman

with red hair for the Virgin. I went to see Millais's picture, at which I found him working, his brother standing to him for the chest of the man knocking out a nail. The figures of St. John and the Virgin, the head of Christ, the legs of the Assistant and of St. Joseph, are done, as well as the ground and some other accessory portions. Alexander Tupper is to be the Assistant. Millais has sold his *Ferdinand* to Mr. Ellison, the Collector, for £150—£50 more than it had been at first commissioned for. I saw the kind and patronizing review which the *Art Journal* gives of *The Germ*, saying that he (the Art-Journalist) must doff the critic, and not dwell on minor faults, lest *The Germ* should not fructify. In the evening I was at Harris's, to be mesmerized, but this time Bridgman's efforts proved abortive. Gabriel went to Stephens, where Hunt, who was also present, read a sonnet of his written at Valentino's in Paris. Stephens's friend Bassett is sitting to him for the figure of the Marquis in his picture, which continues for the time being invisible.

*Monday 4th.* Hunt and Stephens came to Gabriel's, the latter staying only a few minutes, as he had to go off to get Bassett to spend the night with him so as to ensure a sitting next morning. Maitland, who had expected to get some sittings from Stephens, says that he has failed because 'some infatuated character' is sitting for nothing. Hunt has had some more animals' skins lent him.

*Tuesday 5th.* Gabriel painting still at the Angel's arm.

*Wednesday 6th.* I went to see Collinson and Hunt. Collinson, having got pretty well over his illness, has resumed painting, and was engaged on the woman's dress when I came in. He thinks he may yet find himself able to send in to the Academy. After this year he has made up his mind to cut the Wilkie style of Art for the Early Christian, and what he has in his head for the subject of his next picture is his old design (in the days of the venerable Cyclographic)—*The Novitiate*, into which he would probably introduce another figure—that of the Lady Abbess. He has found out new lodgings, still in Brompton (Grove Place) but about a mile nearer London, he says, than Gloucester Grove West is. He expects to find himself very comfortable indeed in them. Hunt

has just finished the wolf-skin on the foremost savage at the door; and, whilst I was with him, painted him a quiver of arrows. He has done the priest's drapery, put in the other priest outside (except the head, hands, etc.) painted Stephens's head for a savage outside, with various others. He thinks, after the picture comes back from the exhibition, of painting out the figure of the second priest, and merely leaving the savages running past, which would, he thinks, sufficiently suggest the subject; he would also put, in the extreme distance, running along the avenue, a priest escaping unobserved. The models who sit to him etc. take the boy on the ground for an unnecessarily ugly girl, and the hindermost savage (his friend Collins) for an old negress (!) 'Sloshy' comes now to see him frequently, and is beginning to look on himself as quite a P.R.B.,—talking of 'we' and saying that Collinson seems quite one of 'us'. It seems, however, that he is really laboring to free himself somewhat from the slough of slosh Hunt found him in at first, and has in consequence quite affronted some Amateur lord's son (or some person of the kind) to whom he showed one of his recent attempts. Hunt says that Herbert is going to *begin* his picture to-morrow. I finished reading for the first time Bailey's *Angel World* which must be reviewed for *The Germ* as soon as possible. It is nothing very wonderful,—very far less great and powerful than *Festus*.

*Thursday 7th*. Woolner and Stephens, with Bassett, were with us in the evening. Woolner gave us the astounding intelligence that Cottingham has written him to say that, if he will call somewhere or other, he will be paid the £4 due for the two medallion heads made last summer. Stephens is still at the figure of the Marquis. I got a letter from R. H. Horne, to whom we had sent the 2 numbers of *The Germ*. He expresses himself pleased with it, and hopes it may succeed, but does not at all expect it will [do] so as regards sale.

*Friday 8th*. Nothing to record, except my continued inability, spite of good will, to find any subject for a poem. This ought to be remedied soon, as there does not seem much probability of anyone else doing an opening poem for No. 4.

*Saturday 9th*. Gabriel went to see Woolner, who has been sticking

hard to his statue of late. Here Gabriel met Cross, who knows some one who will do for the head of his Angel.

*Sunday 10th.* Cross's man called on Gabriel, who found him to have a most splendid head. Not being very well, he did not paint much to-day. He has begun altering the position of the embroidery-stand, and doing the bed, and has nearly finished the blue curtain behind the Virgin's head. In the evening he called on Stephens to look after a Servant-girl of Raymond Tucker's, whom Stephens had promised to get to sit to him for the red hair of the Virgin. As she has not yet made her appearance, they settled to call on Tucker to-morrow about it. Not having yet been able to think of a subject for a poem, I took up my old blank-verse on a Castle, to which I wrote 10 lines; also looked over a collection of Italian tales and the *Gesta Romanorum*, in the latter of which one of two or three tales may perhaps be made to answer.

*Monday 11th.* Stephens and Gabriel called at Tucker's, but found him to be out. Gabriel, however, saw the girl proposed for his Virgin, and thinks she will answer well.

*Tuesday 12th.* A copy of Howitt's paper, *The Standard of Freedom*, was left us by Bateman, in which there is a very favorable review of *The Germ*.

*Wednesday 13th.* The Tuppers came to Gabriel's study to have a talk about our next number. In the first place, it was decided, after a good deal of discussion, to change the name of the magazine; and Aleck Tupper suggested 'Art and Poetry: being Thoughts towards Nature', as a title. This we all think better than 'The Artist', and it was accordingly adopted. Brown expressed some apprehension that he might fail in getting his etching ready, and proposed that Gabriel, Woolner, and Hancock, should each set about one, and that whichever is finished in time should come into this number. Gabriel will take as his subject the painting by Chiaro of his own soul, from the 'Hand and Soul', which appeared in No. 1. Of this he had thought before as a frontispiece to the volume—if one were ever to be completed. Some poems were read over, among them John Tupper's '16 Specials', to which I still object, as being too jocular and technical in style. Hunt is

getting quite confident about finishing his picture, and even in very comfortable time. Stephens came in for a moment to tell Gabriel that Tucker's servant-girl absolutely declines to sit to anyone, and that he must look out for someone else. After they were all gone, Woolner arrived. The subject he thinks of taking to etch is something symbolical from the speech of Death in W. B. Scott's poem published in the *Edinburgh Literary Souvenir*.

*Thursday 14th*. Gabriel having to think about his etching, the task of writing a poem illustrative of Brown's design has been transferred to me. I set my shoulder to the nuisance, and produced— one stanza.

*Friday 15th*. Gabriel and Brown spent the evening together on the designs for their respective etchings.

*Saturday 16th*. Gabriel wrote to Tupper, sending a circular which North, in the days of the *Journal of Mystery*, had sent about to catch advertisers, and suggesting whether anything of same kind might be done for *Art and Poetry*. Tupper thinks of acting on the hint, and has drawn up a form of letter.

*Sunday 17th*. I managed 4 stanzas of 'Cordelia'. Gabriel and Brown at their etchings.

*Monday 18th*. Woolner says that Patmore tells him Browning is about to publish a new poem, and Tennyson his elegies for Hallam, very shortly. Tennyson is back in London again; but Woolner, having called on him recently, failed in obtaining a sitting to finish his medallion. I wrote 2 stanzas more.

*Tuesday 19th*. Woolner wishing to see Scott's poem for the purpose of selecting a subject, I went round with it to him. It seems, however, scarcely possible to find anything, and Woolner doubts whether he will be able to carry out his intention. He gave me his poem 'Emblems' for next number. He has not of late written at all, having stuck to his statue; and he talks, in case he should get a prize for it at the Great Exhibition of 1851, of emigrating to America, and there trying his chance. Gabriel thinks this in some

respects feasible; but I have my doubts of that, and believe, more-over, that, whether or not, it will never actually take place. After coming home, I finished my 'Cordelia' with 3 more stanzas. Gabriel has been engaged on his etching.

*Wednesday 20th.* Orchard sent Gabriel a second portion of his first 'Dialogue on Art', treating herein chiefly of early Christian—or, as he terms it, Pre-Raffaelle—Art, and seeming to out-P.R. the P.R.B. The world is impolitic, and must be altered. Tupper gave me the first proofs of No. 3, comprising Patmore's 'Macbeth', our Sister's poem now called 'So it is', and my review of *Sir Reginald Mohun*. He has written out also a new prospectus, which he gave me to consider.

*Thursday 21st.* I went to Patmore's with the proof of his 'Macbeth'. He has got one out of some half-dozen copies of Tennyson's Elegies that have been printed strictly for private perusal,—the publication of the work being postponed for some while, till about Christmas, Patmore says. Tennyson is too lazy to go to Woolner's for his portrait, but will be at home for him any evening he may call. He learned Italian so as to be able to read Dante, Patmore says, in one fortnight's study; Patmore himself is desirous of making the experiment, and would, if he thought he could suc-ceed equally well. He has been occupied the last month with his poem on Marriage, of which, however, he has not meanwhile written a line; but, having meditated the matter, is now about to do so. He expresses himself quite confident of being able to keep it up at the same pitch as the few astonishing lines he has yet written, and which he read us some time ago. He is now anxious to have published as soon as possible his papers advocating certain principles in architecture, as the subject has of late been treated by others, and he is fearful of finding himself in a certain manner forestalled. He was a good deal struck with the quotations in my notice of *The Strayed Reveller*, and has also a great desire to hear Gabriel's 'Bride-chamber Talk', of which he has heard Woolner and Millais speak.—Brown finished to-day his design for the *King Lear* etching, and Gabriel his of Chiaro's painting. He is now engaged, as regards writing, on a tale entitled 'An Autopsy-chology', originally suggested to himself by an image he intro-duced into 'Bride-chamber Talk'.

*Friday 22nd.* I went to see Collinson, whom I found quite recovered from his recent illness, and in working trim. His picture is now pretty nearly finished with the exception of accessories. He has repainted the head of the woman (from Miss Norton), and done her figure; and has finished the head of the man and the 2 boys; he has had a sitting too for the baby,—of course almost as good as useless. He has again changed his mind as to subjects for his next year's works; and is now resolved to carry out the old sketch of his of 'The New Curate' (entitling it 'The Controversy'), and to paint Tennyson's Dora in the reaping,—the first for the Academy, and the second for the Institution. He speaks resolvedly of setting to work immediately after his present picture is sent in; first making a finished design for 'The Controversy', next finishing up the *Pensioner*, and finally working at his new subjects. The idea of writing for or otherwise contributing to *Art and Poetry* he scouts, insisting that he must stick to Art and to Art only. He moves into his new lodgings on Thursday.

*Saturday 23rd.* Gabriel had the Tuppers to his study; Woolner also was present, and Bernhard Smith. We read over the proofs of John Tupper's 'Sixteen Specials' poem, of two of Gabriel's that will come in, and of Scott's sonnet. A considerable number of the new prospectuses have been printed; and Tupper sent an advertisement to-day for next number of the *Art Journal*. It seems that Brown's article is not likely to be ready; but Tupper's on the 'Subject in Art' will prove longer than had been reckoned for, and we think of bringing in Campbell's 'Among the Lilacs',—getting him to make some required alterations. Gabriel read out some of Browning's and Scott's poems.—Woolner says he called on Tennyson last night about his portrait; but found himself too late, he being on the point of leaving London again. He has received a letter from the great Alfred, the envelope of which I appropriated. In the morning Gabriel had been at work repainting the Virgin's head in his picture. He has begun his etching,—as also has Brown. To-day's *Athenaeum* contains an announcement of the 'new Poem by Mr. Browning',—*Xmas-Eve and Easter-Day*, to appear on the 1st April, price 6/-. There is also a review here, among 'Poetry of the Million', of a volume by a Reverend Mr. Harston, containing decidedly good things, and which deserves to be reviewed in the *Art and Poetry*.

*Sunday 24th.* Gabriel got a dog, a toothless Scotch terrier, from a friend whom he went to see.

*Monday 25th.* I called on Collinson, on my way to see Hunt; and he himself came in while I was there. He has been on a foraging expedition to Battersea Fields, after gipsies, on the recommendation of one who sat to him for his druid's head, and as he wants to get some woman with good hands of a proper savage brownness. He finds himself quite disabused of old ideas concerning 'sloshiness' and commonplace of gipsies, having fallen in with some of the most extraordinary-looking people conceivable. He found a very beautiful woman for what he wants, fit for Cleopatra; she consented to sit for £5 an hour, but finally came down to a shilling, and fixed a day to come. His Cleopatra asked him for a pot of beer, over which she and a most hideous old hag, her mother, made their bargain. Collinson has had a second painting on and finished the woman's head in his picture. In Hunt's there yet remain four heads—those of the monk, the two women, and the boy behind—to be done, as well as the completing that of the girl stooping. Beyond this, and parts of the background, the picture is pretty nearly finished. He was almost entirely prevented from working this morning by failures of his models,—an old woman having neglected to come at the right time, and he sending her away when she did come as he expected a boy, who, after all, failed him likewise.

*Tuesday 26th.* Gabriel and Brown continued at work on their etchings. A letter came telling Gabriel of the death of Orchard on Saturday; it might be well to see about getting together any MSS. he may have left, and publishing them. His death seems to have resulted from the general state of low health in which he always was, as no particular cause is mentioned. If I could get at sufficient materials, I should like to write a notice of him for the *Critic*.

*Wednesday 27th.* Tupper tells me that he went to see Robert Dickinson yesterday about the *Art and Poetry*; and does not seem to think he shows anything precisely identical with enthusiasm in the cause. The two etchings were to have been sent in to-day, but have been delayed, as Brown and Gabriel think it better to have

proofs taken by some printer without sending the plates all the way to Clement's Lane for the purpose. The biting in was done by Shenton by Seddon's advice.

*Thursday 28th.* Brown had his proof taken, which he sent in the evening, together with the plate, to Tupper's. Gabriel's also was taken, but disgusted him; whereat he tore up the impression, and scratched the plate over. I saw proofs of some more of the number, including the termination of Tupper's 'Subject'. George Tupper, being inclined to retain Aylott and Jones as joint Publishers with the Dickinsons, went to see them about it, and settled matters accordingly. He is of opinion that, as Dickinson is a Print-publisher, it is better to have in the concern some one whose business is strictly in books; he talks too of putting an advertisement into *The Times.* Brown, not thinking very highly of his etching, stipulated at first that his name should not be published; but was finally persuaded to allow it,—every one else thinking the work excellent.

*Friday 29th.* Gabriel painted at the feet and arm of the Angel from White. He has Miss Love to sit for the Virgin's hair, and is also repainting the head entirely. He has finished the embroidery-stand; and, of the back-ground, done a curious lamp Brown has got, and a vase. The Angel's head is being painted from a model, Lambert, of whom he has had two or three sittings. We went to Stephens's in the evening, when, finding he had gone on to Tupper's, we followed him thither; Hunt also was to have come, but did not. Here we saw the last proof of the number.—The family lived thro' a whole Act of *Paracelsus*, Tennyson's 'Daydream', 'The Raven', and several of Browning's lyrics, for which Gabriel was called [on by John Tupper.] . . .

[*Saturday 30th.* No. 3 of *The Germ* contains my 'Cordelia'; 'Fancies] at Leisure'; and Review of *Sir Reginald Mohun*; Patmore's 'Macbeth'; our Sister's 'Repining'; and 'Sweet Death'; John Tupper's 'Subject in Art' No. 2; and, in the 'Papers of the M.S. Society', 'An Incident from the Siege of Troy seen from a modern Observatory'; two small things by Aleck and George Tupper, being 2 and 3 of these Papers; Gabriel's 'Carillon', and 'From the Cliffs'; Woolner's 'Emblems'; and Scott's 'Early Aspirations'

sonnet. We ought now to think seriously of sending about circulars to the nobility etc., if this is to be done, and of advertizing by posters.

*Sunday 31st.* I finished with about 20 lines my old blank-verse concerning a Castle.

# April 1850

*Monday 1st April.* Gabriel touched up the head of his Virgin. I went to the British Artists' Exhibition (Suffolk Street) where there are some astounding Anthonys—about the only things not bad in the place. Browning's new poem is out, and Stephens beat us in getting it first. I began reading the ['Xmas-Eve'].

*Tuesday 2nd.* Tupper has made out a form for the posters, which will be sent about to-morrow. Gabriel wrote a little 'Autopsy-chology'. Seddon, who came to see us, has got up a class again at his house, and wants me to join it, which I shall do, if possible.

*Wednesday 3rd.* I began my review for the *Critic*. Gabriel doing the Angel's hair, and finishing up the head.

*Thursday 4th.* Stephens, it seems, has found out the impossibility of finishing his picture in time for the exhibition; but is said to be still working steadily at it. Woolner intends to compete for the designs for the medals now announced as distributable in lieu of pecuniary prizes at the Exhibition of '51. I went on reading *Xmas Eve and Easter Day*; did likewise some more of the Suffolk Street Review.

*Friday 5th.* Tupper is looking up the favorable notices that have appeared of [*The Germ* in] order to make extracts in the circular he intends sending round. . . .

*Sunday 7th.* For this morning I was engaged to sit to Hunt. He had intended to paint from me the head of the monk flying in the

background; but, instead of this, I sat for the working of the head and hands of the principal figure. Earles, the person who had originally promised to sit to him, failed after the first time; and Hunt has had some atrocious nuisances in finding a substitute. He has at last found out an Irishman, a discharged soldier, who does to give a hint of what he wants. He has put in part of a corn-field that cuts across the legs of the outside monk; and there remains now scarcely any uncovered canvas; he has, however, a tremendous deal still to do for so short a time; two or three heads requiring much yet. His frame with four bible-mottos has arrived. Collinson came in, and says he's done a vast amount of work since I saw his picture last. He has had a first painting at a dog, which he is now unable to get again, and will have to finish up entirely without nature. The idea of painting for next year the subject of Saint Elizabeth before the Altar is again strong upon him. I did not get home till too late to sit to Gabriel, who had wanted me for a final retouching of the Angel's head; he has got some spirits of wine and chloride of something to make the flame for the Angel's feet. In the evening, I finished my Suffolk Street notice.

*Monday 8th.* I left my article at the *Critic* Office, with a note explaining that no name initials must appear. Gabriel went to see Millais's picture, which is finished. He himself had to work hard at his background all day, besides doing something to the Virgin's head; and had Deverell to assist him in doing certain things. I finished reading Browning's new poem, and read it the second time aloud to Deverell.

# July 1850

[*Sunday 21st*]. From 8 April up to to-day, Sunday July 21, I have neglected the P.R.B. journal,—to my shame and its detriment, if it be worth anything; inasmuch as events of the highest relative importance, transcending any here recorded have happened in the interval. My excuse is plenty else to do,—the impelling cause —idleness. But I hope henceforth to persevere.

Firstly, the 'Gurm' died with its fourth number—leaving us a legacy of Tupper's bill—£33 odd, of which the greater part, I take it, remains still unpaid. Our last gasp was perhaps the best,—containing Orchard's really wonderful 'Dialogue', Gabriel's sonnets on pictures, etc. etc., with an etching—not very satisfactory in comparison with the standard of our promise—by Deverell. Placards were posted and paraded about daily before the Academy—but to no effect. *The Germ* was doomed, and succumbed to its doom.

Millais's Sacred subject, his *Ferdinand and Ariel*, and his portrait of Mr. Wyatt and his Grandchild, Hunt's *Converted British Family Sheltering a Christian Missionary from the Persecution of the Druids*, and Collinson's *Answering the Emigrant's Letter*, went to the Academy, where they are still exhibiting,—Gabriel having at the last moment elected to send to the National Institution,—formerly Free Exhibition. *The Carpenter's Shop* of Millais, which has now become famous as No. 518, sold, the morning before sending in, for £350, Mr. Farrer, the picture-dealer, being the purchaser. Hunt's picture and this are hung half on the line, the portrait on the line, and the *Ferdinand* to the ground; Collinson's at a height where all its merits are lost. Millais's picture has been the signal for a perfect crusade against the P.R.B. The mystic letters with their signification have appeared in all kinds of papers, —first, I believe, in a letter 'Town-talk and Table-talk', in the *Illustrated News*, written by Reach, who must have derived his knowledge, we conjecture, from Munro. But the designation is now so notorious that all concealment is at an end. The *Athenaeum* opened with a savage assault on Gabriel, who answered in a letter which the editor did not think it expedient to publish; and a conversation Millais had with Frank Stone, and in which the latter, speaking of the picture, introduced several of the observations of the *Athenaeum*, coupled with some other circumstances, make it tolerably evident that he was the author of that and subsequent critiques. In noticing Hunt and Millais, nearly a whole page was devoted to a systematic discussion of (assumed) P.R.B. principles —which F.S. rather overthrew and demolished than otherwise. In all the papers, *The Times*, the *Examiner*, the *Daily News*, even to Dickens's *Household Words*, where a leader was devoted to the P.R.B., and devoted them to the infernal gods, the attack on Millais has been most virulent and audacious; and in none more

than in *A Glance at the Exhibition* published by Cundall, and bearing manifold traces of a German source! Indeed the P.R.B. has unquestionably been one of the topics of the season. The 'notoriety' of Millais's picture may be evidenced by the fact, received from undoubted authority, of the Queen's having sent to have it brought to her from the walls of the R.A., which her recent accouchement had prevented her from visiting.—Hunt's picture, Gabriel's, and Collinson's, remain unsold.

Not long after the opening of the Exhibitions, the Brotherhood had the misfortune to lose one of its members—Collinson, who announced his resolution thus, in a letter addressed to Gabriel: 'Whit Monday.—Dear Gabriel, I feel that, as a sincere Catholic, I can no longer allow myself to be called a P.R.B. in the brotherhood sense of the term, or to be connected in any way with the magazine. Perhaps this determination to withdraw myself from the Brotherhood is altogether a matter of feeling. I am uneasy about it. I love and reverence God's faith, and I love His holy Saints; and I cannot bear any longer the self-accusation that, to gratify a little vanity, I am helping to dishonor them, and lower their merits, if not absolutely to bring their sanctity into ridicule. —I cannot blame any one but myself. Whatever may be my thoughts with regard to their works, I am sure that all the P.R.B.s have both written and painted conscientiously;—it was for me to have judged beforehand whether I could conscientiously, as a Catholic, assist in spreading the artistic opinions of those who are not. I reverence—indeed almost idolize—what I have seen of the works of the Pre-Raffaelle painters; [and this] chiefly because [they fill] my heart and mind with that divine faith which could alone animate them to give up their intellect and time and labor so as they did, and all for His glory who, they could never forget, was the Eternal, altho' He had once humbled Himself to the form of man, that man might be clothed with, and know his love, His Divinity.—I have been influenced by no one in this matter; and indeed it is not from any angry or jealous feeling that I wish to be no longer a P.R.B.; and I trust you will [something torn off] . . ., but believe me affectionately your's, James Collinson.—P.S. Please do not attempt to change my mind.'

# October 1850

Another long gap in this journal, even after having made a beginning with the resumption of it. Let me record no more intentions or promises, but set to work at its continuation once more, being as brief as possible regarding the interval.

Deverell has worthily filled up the place left vacant by Collinson. His work at the National Institution this year was a strong ground of claim; and this has been confirmed by what he has since done and is doing. He hopes to exhibit two pictures next year: Rosalind witnessing the encounter of Jaques and Orlando in the forest,—which is pretty nearly finished; and the ordering of Hamlet's departure for England, of which Gabriel has seen an uncompleted design. Other recent designs of his are the converse of Laertes and Ophelia, Claude du Val dancing with a lady of quality after attacking her carriage (in the possession of Stephens), James 2 in his flight overhauled, and his person rifled by Fishermen, (given to Gabriel), and the flight of an Egyptian ibis.

Millais left town about the beginning of June, and has continued in and about Oxford ever since. He had made a design for—and, I believe, had begun painting before he left—Tennyson's 'Mariana'; in the country he has been engaged on his picture from Patmore:

> He sometimes, in a sullen tone,
>     Would offer fruits: and she
> Always received his gifts with an air
>     So unreserved and free
> That half-feigned distance soon became
>     Familiarity.

His brother, William Millais, is also turning his attention to art; and produced, when in Jersey during the summer, some excellent and most promising landscapes, which he will probably exhibit. I heard from Patmore the other night that Tennyson, on being told that Millais was doing something from 'The Woodman's Daughter', observed: 'I wish he'd do something from me.'

Hunt's *Converted British Family* is now sold, having met with a purchaser, at £150, in Mr. Combe of Oxford, to which place it

was sent on Millais's recommendation, to be kept on view at Mr. Wyatt, the printseller's. Necessity makes us acquainted with strange Art-fellows. Before this, Hunt had—in conjunction with Stephens on his introduction—been cleaning and restoring a ceiling etc. at the Trinity House by Rigaud, an old R.A.—representing the junction of Father Thames and Father Severn, or some such slosh. A guinea a day for cleaning, and two guineas for restoring, were not, however, to be thrown away. Immediately on the opening of the exhibition, Hunt had set about a picture of the interview of Isabel and Claudio in prison, from *Measure for Measure*,—a commission from Mr. Gibbons, the purchaser of his *Rienzi*. This is now nearly finished; and he has made a design for the last scene of the '2 Gentlemen',—'Ruffian, forbear thy rude, uncivil touch'. He left London about a fortnight back for Sevenoaks,—in the neighbourhood of which, at Knowle Park, he is now painting the forest-background of this subject. His other chief designs since the exhibition opened have been the breaking of the spell from 'The Lady of Shalott', and one, not yet finished, of Ruth, at meal-time, receiving corn from Boaz to eat. He has also completed his old design from 'Isabella': 'He knew whose gentle hand was at the latch / Before the door had given her to his eye.' Hunt talks of going to Jerusalem when he can set about the Ruth, and painting it on the spot, and Gabriel is to accompany him;—a project which has become a hissing and a reproach between Woolner and myself, who are infidel concerning it.

Stephens is with Hunt, for the purpose of painting part of the background in his picture of Griselda and the Marquis, to which he has just returned. . . .

<p style="text-align:center">★   ★   ★   ★   ★</p>

. . . Gabriel has a study now in 74 Newman Street, next door but one; Cave Thomas has taken the groundfloor back room at 72 where the dancing used to go on.

*Thursday 24th October.* A most wet, miserable, dreary day, one unintermittent drench. This style of thing began yesterday, the very day Gabriel left for the purpose of out-of-doors painting, and seems now regularly set in. A nice damper for a man's enthusiasm when every moment must be turned to the uttermost

account. Nothing to record beyond this, except my having finished reading the American, Hawthorne's, *Mosses from an Old Manse*,—full of excellent—large and even grand—thoughts happily and singularly worked out, but very unequal; containing a good deal of very bad writing, and stinking occasionally with the worst infection that can be caught from Dickens.

*Friday 25th.* A letter came from Gabriel, saying that he and Hunt were soaked thro' and thro' yesterday in painting, and requesting a further supply of clothes to meet a similar emergency. I answered a letter I received about a fortnight back from W. B. Scott, in which, speaking of *The Bothie of Toper-na-Fuosich* which I had sent him, he terms it 'really a trenchant and remarkable thing—only hastily and carelessly compiled as a work of art'; adding that he considers it quite worthy of my praises (in *The Germ*). I also called on Brown to obtain Hannay's novel, which he is to leave me to-morrow morning, as it was not then by him. Brown has done a very great quantity of his Chaucer picture since I saw it last. He engaged me to call to-morrow evening, when Lucy, Lowes Dickinson, Thomas, etc., are to be with him, in honor of Dickinson's approaching departure for Rome.

*Saturday 26th.* I had a note from Mr. Cox, of the *Critic*, purporting to accompany 3 volumes of poems for me to review,—*Death's Jest-Book*, Cassels's *Eidolon*, and another. The books (by oversight, I presume) did not make their appearance. I spent the evening at Brown's, where I met Thomas, the two Dickinsons, Fairless, Seddon, etc., and Woolner. The business of the meeting was punning; but when, at about 1 o'clock in the morning, we began to think of lighter and less important matters, Woolner and I had to fight fiercely for Tennyson and Browning, against Thomas, Lowes Dickinson, F. Brown, chiefly, as champions for Byron, Pope, etc. The only result of the discussion was that we finally swore it was profanation to continue it on such terms, and we squashed it accordingly. I fixed to call on Woolner to-morrow, with some thought of our going thence to Patmore's, to whom I have to return Wordsworth's *Prelude*.—After leaving Brown's, we looked in at Thomas's study, and saw the sketch, and the pre- paration of a canvas, for the picture, a council of war, he is about to paint. Bernhard Smith says he has begun *his* picture,—a fairy

subject.—This has been the finest day since Wednesday, and Hunt, Gabriel, and Stephens, will probably have been able to work to some purpose out-of-doors.

*Sunday 27th.* I began reading Hannay's novel, making notes for review. In the evening, accompanied Woolner to Patmore's. Found that Woolner had just had a cast taken of his medallion-head of Mrs. Patmore, and that he had brought his poem of 'Amala' (which, at the instance of Masson, is to be offered for publication to the *Leader*) to its final state, adopting some alterations suggested by Patmore. The latter, when we arrived, was reading a translation, by Charles Bagot Cayley, with whom I have lately become acquainted, of some cantos of the *Inferno*, left by me with Patmore, who promised to see whether the *Palladium* would be willing to publish it. He thinks very highly of the translation, and will write fully to the Editor on the subject. He had also just read Browning's *Xmas-Eve and Easter-Day*, and is evidently deeply impressed with it, more than with any other of the great man's works, tho' he does not exactly know 'what to make of it'. He says that Mrs. Browning published in *Blackwood*, very soon after the onslaught there on his own book, an imitation, in incident and termination, of 'The Woodman's Daughter', calling it 'Maud at her Spinning-Wheel'. We talked of Douglas Jerrold, whose punishment in hell, Patmore proposes, should be a compulsory companionship with ladies and gentlemen; of Eliza Cook, who, it appears is very ill, and scarcely expected to recover; of Mackay, etc. He advises Woolner to call on the Russian Vom Bach, in reference to some gentleman of his acquaintance, a Mr. Sartoris, who might be likely to do something towards his carrying out his ideas in sculpture.—Woolner had been to Bateman's last Sunday, with a design of the 'Symbol of the Soul's Strength'.

*Monday 28th.* The books came from the *Critic* Office, with Moile's 'Philip 2' in addition, and 2 others. I continued reading Hannay's book. At Tupper's I saw letters from Hunt, Stephens, and Gabriel,—the latest dated Friday, I think descriptive of the body and soul harrowing state to which they are reduced. Stephens, it seems, is painting his background in the kitchen of their lodgings. —The new edition of Mrs. Browning's poems (2 volumes,

uniform with the last of Browning) is now advertized for early
next month.

*Tuesday 29th.* Woolner and I, with Hannay, spent the night at
Bernhard Smith's. He has made a sketch in color for his fairy
picture, and showed us also designs of other similar subjects.
Hannay informed us that he has had an offer to go over to India
as editor of the *Madras Athenaeum* at a salary of £800 per annum,
the engagement lasting for 3 years. He has accepted, and expects to
depart in six weeks or so. He mentioned besides that he had been
just about connecting himself with a new critical periodical which
Hunt, the author of *The Fourth Estate*, is on the point of establish-
ing; the pay was to be 2 guineas a week, and he thinks perhaps he
could get me an introduction to it. He saw Bon Gaultier lately,
and found him a wild admirer of Gabriel's sonnet to his *Mary
Virgin* picture, published in the Free Exhibition catalogue, saying
that it is one of the finest sonnets in the language, and having even
gone so far as to distribute copies of it among his friends. We
looked over Woolner's poem, 'Amala', with reference to some
points of objection suggested by Patmore; the rest of the evening
passing very pleasantly in Carlylo-Emersonian and suchlike con-
siderations. Woolner purposes to join Gabriel and the others at
Sevenoaks on Saturday; Hannay speaks of accompanying him,
and I may probably do so as well.—I read on to the end of the
second volume of *Singleton Fontenoy*.

*Wednesday 30th.* I finished the perusal of Hannay's novel, which
is a very first rate thing.—The sky again drizzling slush, after two
or three days of fair weather.

*Thursday 31st.* I began reading Cassel's *Eidolon*, sent me for review.
Spent the evening out on an invitation to dinner and dreari-
ness at Mr. Cox's. I find his poetical opinions are very mild on the
subject of Burrington and Eliza Cook, and equally so regarding
Tennyson, Browning, and Mrs. Browning. In this state of things,
my poetry-reviewing will not probably last long without an
explanation, or an abdication of the critical offices in certain cases.

# November 1850

*Friday 1st November.* Brown, I was informed, called last night, having something particular to say. On seeing him in the evening, I learn that on Wednesday he met at Dickinson's Mr. Williams (the brother-in-law of Wells, author of *Joseph and his Brethren*) who is desirous of finding a substitute for writing the art-criticisms in one of the weekly papers—either the *Examiner* or the *Spectator*. The remuneration would amount to about £40 or £50 a year. Brown kindly mentioned me; and I should certainly be glad to do for something and with better prospects what I am now doing for nothing. The critic, [I] understand, would not be pledged to any party in art, nor under any vexatious control. I wrote to Mr. Williams, at Brown's suggestion, stating my views, and with the object of calling on him. Brown's picture is sold to the Dickinsons —for what sum I did not ask. Woolner called, being about to go to Sevenoaks to-morrow. I have made up my mind to remain, chiefly in consideration of the necessity of having a notice of Hannay ready by the middle of next week; the latter, Woolner anticipates, will have changed his mind, and stay as well.—I went on a little with *Eidolon*.

*Saturday 2nd.* I began writing my review of *Singleton Fontenoy*.

*Sunday 3rd.* I did some more of my review, finished *Eidolon*, and looked into three other poems sent me by Mr. Cox, which seem trash. Spent the evening at Patmore's, with whom I left my notice of Allingham; his in the *Palladium* is out. I learn from him —(he having seen some of Keats's letters not published in Milnes's book)—that the lady of whom Keats speaks as being 'not even a Cleopatra', and whom he at first seems to have regarded in the light of a strangely beautiful animal, is the same he was subsequently in love with. His passion must indeed have been a fit of raging sensuality, as Patmore says. Patmore does not believe we have any really great men living in the region of pure intellect,— not even Tennyson, though he might have thought him such, had he not written. He spoke of Gabriel's poem, 'Dante in Exile', which he considers full of fine things; the stanzas on republics he

admires particularly. He talks of keeping open house on every alternate Saturday, and has given me and all the P.R.B. a general invitation. I am engaged to him also for Tuesday. He has written his promised letter to the Editor of the *Palladium* on the subject of Cayley's *Dante*, but has not yet received a reply.

*Monday 4th.* I finished reviewing *Singleton Fontenoy.*

*Tuesday 5th.* Woolner returned from Sevenoaks. His news is of Gabriel, that he gets up at 7 o'clock, is painting his background with mystic feeling, translates canzoni at a great rate of evenings, and will probably be back at the end of the week;—of Hunt, that he is progressing well, painting the ground all covered with the red Autumn-leaves;—of Stephens, that he also is getting on. Beyond this, he says that a letter has been received from Millais, urging the admission of Collins into the P.R.B.; that Hunt acquiesces in Millais's suggestion, Stephens in Hunt's consent, and Gabriel in that of them two. Woolner himself fought the point savagely, being of opinion (in which I fully agree with him) that Collins has not established a claim to P.R.B.-hood, and that the connexion would not be likely to promote the intimate friendly relations necessary bet[ween] all P.R.B.s. Before leaving London, Woolner had called on Mr. Vom Bach in refere[nce] to what Patmore had mentioned on the preceding Sunday; and he has decided to make a design of the oppression of weakness by despotic physical power, and its Salvation by moral and intellectual strength,—a subject the conception of which he has long been maturing. It appears that this kind of treatment in sculpture— emblematic of something beyond the external evident intention, —is in the taste of Mr. Sartoris. The figures in Woolner's group would be a woman, the type of dependence, a strong man, un- elevated in intellect, and therefore using physical means, as oppressor, and another man, strong but less brawny, as the deliverer, whose glance conquers not less than his brave hand.— I revised and dispatched my review of Hannay. A letter reached me from Allingham, who speaks as being well-pleased with my criticism, at some passages of which I had my suspicions he might be offended. He says he has corrected many of the imperfect rhymes in his volume; and, alluding to Gabriel's commenced picture from 'Pippa Passes', urges that the page should not be

made too juvenile or helpless. In the evening I had a letter telling me not to go to Patmore's to-night; and stating that the length of Cayley's *Dante* proves an insuperable obstacle to its publication in the *Palladium*, the editor being willing nevertheless to insert a canto or two as a specimen. A letter also from Mr. Williams, to suggest that I should enable him to show something written by me to the editor of the paper he is connected with. I accordingly looked over my *Critic* critiques (selecting the most mildly expressed, as the note speaks of 'courteous consideration'); and, with these and a copy of *The Germ*, called on Mr. Williams. The paper in question is the *Spectator*, whose editor is a Mr. Rintoul; and it appears that its tactics are somewhat hostile to the Academy, in so far at least as the aim of keeping it up to public responsibility may be so construed. I gather, however, that considerable latitude is allowed to the writer, and that I should be but little hampered with any *antédédens*. The business of the critic extends beyond the mere notice of exhibitions to the general discussion of any matters affecting art, so that, if I obtain the engagement, I may reckon on being pretty constantly occupied. I find Mr. Williams not of very P.R.B. tendencies, and no great admirer of Anthony, my review of whom at Suffolk Street, I had brought with me, fancying it would be appropriate. It seems that a new associate has been elected, which will furnish present matter for an article.—Mr. Williams spoke a good deal of Wells, author of the *Stories after Nature*, who appears to be a most dangerous and insidious person. His whole aim, it appears, is to exercise influence over others; a craving which occupies him to a most morbid degree, and which he gratifies regardless of means or consequences. On one occasion he played upon Thomas Keats by keeping up a correspondence with him in the character of a lady; and induced him to go to France in the idea of meeting his correspondent. The discovery of the fraud produced, it seems, a very serious effect on its victim. John Keats became very indignant hereat, and peremptorily broke off all acquaintanceship with Wells; and Mr. Williams is of opinion that Wells's literary works—written subsequently to this affair—were produced in the hope of pleasing Keats and winning him back. No friendships are safe within the sphere of Wells's influence, his principle being 'divide et impera'; indeed, Mr. Williams describes him as a veritable reproduction of 'honest Iago'. He is now lord and master in the household of some French

lady, whose son, after being given over by the doctors, is supposed to have owed his recovery to Wells's devout prayers.—I brought home with me Ruskin's *Seven Lamps*, which is, I suppose, the canon of *Spectator* opinions in the æsthetics of architecture.

*Wednesday 6th.* I find announced in *The Times* the election of Eastlake as President and of Hook as Associate. Here is ready made to my hand a subject for a *Spectator* article, should such be in demand. In the evening another letter from Mr. Williams, to say that, having himself been asked to write on the point, he mentioned his interview with me to the Editor, Mr. Rintoul, and proposed that I should do it as a specimen. The feeling in which it seems the Editor would wish to speak (disclaiming at the same time the slightest desire of biassing me) is entirely my own. Mr. Williams called to get my answer, which was, of course, affirmative. On his departure, I set about the article, and got thro' it. It had to be ready by to-morrow evening.—The *Critic* notices have been left with Mr. Rintoul.

*Thursday 7th.* Having looked in on Mr. Williams, who says he has told Mr. Rintoul I might probably call to-day at the *Spectator* Office, I went thither with my article after dinner. The Editor, however, was out; so that, being afterwards at the theatre to see Miss Faucit, I made up a note with the slovenly means at my disposal, and dropped it into the editorial box coming home at night.—I answered Allingham's letter with such news as I could, and wrote to inform Cayley of the issue of the *Palladium* matter. He has replied that he would be glad of the publication of a specimen, provided the Editor would send him two or three copies of the number, and would look at some other MSS. of his. He aims at publishing at joint charges with some one else, and is desirous of meeting with a person to undertake the notes, comments, etc.

*Friday 8th.* A note came from Mr. Rintoul, expressing himself much pleased with my paper, of which he sends me the proof. One or two slight verbal differences seem, possibly, intentional, but there is no alteration of the least importance. He asks me to call on Monday, and I answered, proposing to do so in the evening. I presume I may now consider myself engaged.

*Saturday 9th.* I wrote to Gabriel,—a letter asking him to a meeting of a Debating Club to which Hannay belongs having arrived.— The new edition of Mrs. Browning's poems is advertized as out.

*Sunday 10th.* I sat to Brown for the head of a figure in his picture —that of a minstrel or poet, who looks round at Chaucer with a sort of jealous admiration. He would like me to notice in the *Spectator* the sale of this work to the Dickinsons, and thinks it might be well to write an article on the relations of painters and picture-dealers,—a suggestion I propose to adopt. He tells me that, at the election of Hook as Associate, his only competitor brought to the ballot was Harding, who obtained 7 votes out of 16; and that F.S. did not put his name down. I wrote for the *Critic* a notice of three volumes of verse—*The Spirit of the Seasons* etc., *The Mission of Sympathy*; and a selection of Hymns translated from the Welsh; and, in sending it to the editor, asked him whether he would wish me to review Moile's *Philip the Second*, sent me with the others, and of which a scurvy notice appeared in the *Critic* some months back.

*Monday 11th.* Gabriel wrote, saying that he shall probably be at Sevenoaks some while longer. I had a letter from Mr. Rintoul to the effect that he would not be at home this evening at the time I had fixed for calling. He asks me for Wednesday, when he will give me a ticket for a lecture, at the Society of Arts, on the Great Exhibition building, the first of the season, and which he thinks will 'probably furnish me with a short paper'. A letter also from Mr. Cox to say there is no occasion for my noticing Moile's 'Philip 2'. I got the *Spectator*, and find that the phrasing of one sentence is altered—evidently indicating that the editor exercises a power of revision. The literary articles, so far as appears by this number, seem written in a sound spirit. I spent the evening with Woolner, who has sent his poem, 'Amala', to the *Leader*. He says that Patmore speaks very highly of my review of Allingham, much to my gratification. He and I will go to Patmore's next Saturday; but it seems as if no other P.R.B.s would be attainable.

*Tuesday 12th.* I wrote for the *Spectator* a paragraph on Jones's resignation of the Keepership of the Academy.

*Wednesday 13th.* Gabriel wrote again that, after all, he might probably return to-day; and did in fact arrive in the course of the morning. His picture remains for the present at the Inn where the coach stops. Hunt expects to be back to-morrow; and Stephens returned on Sunday. Gabriel brings with him a great quantity of translations from the old Italians, and one or two short original poems; he has also written a stanza or two to a poem he had begun shortly before leaving London suggested by some of the Nineveh sculptures. Millais is supposed, in accordance to something he wrote to Hunt, to be in London.—I called on the editor of the *Spectator*, who appears to be a frank, cordial, and agreeable man, without any pretension to knowledge in art. He asked me whether I understood architecture, and appears to wish me to qualify. We went together to the Society of Arts, to hear a paper by Mr. Paxton on the Great Exhibition building, on which I am to write a short article. He observed that it would not be in the least necessary to get up something about art for every week; and indeed, I think, seemed rather impressed with the notion that I should present him with more than is wanted. He gave me a ticket for the private view, next Saturday, of an 'Exhibition of Modern Art' at the Old Water-Color Gallery; being, I suppose, that which has been announced as to be got together by a body of amateurs.

*Thursday 14th.* Gabriel had his picture fetched and deposited at his study. Deverell has heard of some study in John Street, Mecklenburgh Square, which they propose to visit to see whether it would suit them jointly. Deverell, who called with me at Hunt's whom we did not find at home, says he has begun his picture of the banishment of Hamlet. I wrote the required notice of the paper on the Hyde Park building. We saw Hannay, who thinks he shall probably leave England for India in February. I ought before to-day to have had the proof of my review of his book; and suppose that they must have overlooked sending it me. A poem, 'Wayconnell Castle' in this week's *Household Words*, appears on internal evidence of style to be by Allingham.

⋆   ⋆   ⋆   ⋆   ⋆

[*Saturday 30th.* Millais met Frank Stone the other] evening, who spoke to him about young men, ignorant of the first principles of art, imagining they are going to do something new, and found a

school; and said he supposed Millais and his friends considered *him* altogether wrong in his productions—to which Millais returned a decided affirmative. An absurd lithograph caricature is about to be issued of Millais's last picture, as he is informed by his brother;—something of a big dog sniffing at a cur, with the picture in the background, and some motto to the effect that some one or other fancies he's like nature, but isn't—a work of high art, assuredly, if it be anything like this. There was a very laudatory notice (*per se*) in the *Guardian* he says, of his and Hunt's last pictures; and some persons in Oxford informed him that Ruskin writes in the paper, and that the article may not improbably be his.—Patmore is writing on architectural matters.—Woolner, who passed the evening with Gabriel, was yesterday with Patmore, accompanying Tennyson in the search for a house in the neighbourhood of London, but without result. Tennyson is in a state of disgust at the idea of being presented at court on his appointment to the laureateship.—Patmore says that Tennyson has in his memory, and on occasion recites, an immense quantity of poetry which he never intends to commit to paper.—I had a letter from Mr. Williams, saying that books coming from the *Spectator* remain the editor's property. A review of Mrs. Browning's new edition in the *Athenaeum* contains two new poems, and alterations in passages from some of the old; we must get the book without further delay.—Gabriel finished, all but the last verse, his parody on 'Ulalume'.

# December 1850

*Sunday 1st December.* Gabriel completed the repainting of the Angel's head in his *Ecce Ancilla Domini*. His translation of the *Vita Nuova* has been returned by Tennyson, who says it is very strong and earnest, but disfigured by the so-called *cockney* rhymes, as of calm and arm. Gabriel intends to remove these, before any step is taken towards publication.

*Monday 2nd.* Stephens, whom I had not seen for some months, called. He has painted a little on his picture since getting it back, and hopes to have another ready for the exhibition as well, illustrative of the song—'Take, oh! take those lips away.' We

discussed the shamefully obsolete condition into which P.R.B. meetings have fallen. A tale of a mediæval musician (title forgotten) which he wrote in the Spring, was sent to a magazine started by a friend of his in Edinburgh, and bearing some likeness to *The Germ* in its conduct and impending certainty of failure; and which, indeed, came to an end before the tale could be published. I spent the evening with Hunt, who has painted some more of the foreground of his *Two Gentlemen* picture—fungi and dead leaves. He goes to Lambeth Palace of mornings, to do the cell in his other work, —the *Claudio and Isabella*. While I was there, he fulfilled the pleasant duty of making out an account against the Trinity House for work done on the Rigauds thereof in September to the value, between him and Stephens, of £54 odd. We talked a good deal of the chances of establishing a P.R.B. household, where three or four could live and paint in common. It might probably be to be done, if Millais would join, and he seems very anxious to live out of London.—I bought the new edition of Mrs. Browning, the additions to which do not seem very numerous, nor the alterations extensive.

*Tuesday 3rd.* Gabriel did something on his design—'Music, with a dance of children.' He talks of sending his ballad, 'Denys Shand', to *Tait's Magazine*, having found a good poem of the same class in the last number.—I read thro' almost all the new matter in Mrs. Browning's volumes, included in which is a poem I suppose to be that which Patmore says she borrowed without acknowledgement from his 'Woodman's Daughter'. The resemblance, however, is merely in the moral, the treatment being utterly, and the details of incident considerably, different; nor is the title here printed 'Maud at her Spinning-wheel'. A ticket was sent me by the *Spectator* for the exhibition of water-colors etc. at Grundy's, to-morrow being the private-view day.

*Wednesday 4th.* This exhibition includes some Kennedys, some beautiful water-colors by Poole, and a splendid Turner. There are also on view several glorious photographs taken at Algiers. I wrote an opening notice of it.

*Thursday 5th.* Gabriel painted on the head of the Virgin in his last picture.

*Friday 6th.* Gabriel painted a left hand to his angel Gabriel, thinking it objectionable that one hand only should be visible of each figure.

*Saturday 7th.* Woolner, having written at Gabriel's request, to know the price of the rooms in Red Lion Square lately occupied by Harris, called with a note from North Senior, the landlord, saying that he will 'submit to' £4.4.- monthly or 20/- a week. He stipulates, however, that the models are to be kept under some gentlemanly restraint, 'as some artists sacrifice the dignity of art to the baseness of passion'. This seems a very advantageous prospect for Gabriel and Deverell, on whom we called to acquaint him. Little seems to have been done to his pictures: to the *Hamlet* scarcely anything; to the *As You Like It*, some repainting on Orlando's figure and progress in the head of Rosalind. Leaving Deverell's study, we called at Millais's, having engaged to see his picture and design, but found we had overstayed our time. However, I met him almost immediately, parading Tottenham Court Road, together with Hunt and Collins, on the search for models. They found one or two women adaptable for Millais—the best being in company of two men; but did not muster face to address them, with the likelihood of a cry of 'Police'.—The *Athenaeum* contains a gratuitous ejection of venom at 'the soi-distant Pre-Raffaelite'.

*Sunday 8th.* Woolner called, bringing his head of Tennyson cast in bronze very satisfactorily. He prides himself not a litttle on Bernhard Smith's approval of the execution, and on having rubbed some washing 'blue' into the flat of the medallion, to improve its color. His head of Mrs. Patmore is al[so to be cast] by Mrs. Orme's desire. . . . [Hunt] called [on the] . . . Trinity-House architect. He has been chiefly engaged on the *Claudio and Isabella* during the past week.

*Monday 9th.* A miscellaneous gathering at Stephens's assumed the character of a regular P.R.B. meeting, but for the absence of Millais. We had plenty of talk, adequate Mrs. Browning, and proportionate astonishment when Woolner announced the election of Hancock as one of the Commissioners to decide on the sculpture for the Great Exhibition of next year (!!)

*Tuesday 10th.* Gabriel saw Millais's design and picture,—and pronounces the former to be immeasurably the best thing he has done. The landscape of the picture too is superior to that of the *Ferdinand and Ariel.* I spent the evening with Hunt, being the only one of two or three engaged that did so. Some little has been done to his *Two Gentlemen* picture in which he intends to make an alteration in Silvia's position; and he painted at the dead leaves while I was there. Coming home, I found Millais with Gabriel, who had read several of his translations from the old Italian which had just been saved from consumption in lighting fires. Much serious speech ensued.—After he left, I finished reviewing *Death's Jest Book,*—by no means to my satisfaction, being driven on the last moment. Gabriel began drawing this evening from the model at Seddon's.

*Wednesday 11th.* I began this week's notice of Grundy's exhibition.

*Thursday 12th.* Stephens, writing to me, mentions that he has seen Millais's design, and thinks it 'tremendous'. I finished the Grundy review.

# January 1851

A lapse of upwards of a month during which I have neglected the P.R.B. journal; an omission partly attributable to the nuisance and confusion of moving. However, there has not occurred much requiring record.

Monday last, January 13, was fixed for a P.R.B. meeting at Hunt's with a view to discussing fully the subject of electing any new members in addition to the 6 remaining of the original number; and in order to frame definite rules for the Brotherhood. Millais, Stephens, and myself, only attended, Gabriel being indisposed, and Woolner in the country. In the first place it [was decided that the question] of a new election shall be deferred ['until after the opening of this year's exhibitions'; 'that no rule affecting the P.R.B., can be repealed, or modified, or any finally adopted, unless on unanimous consent of the members'; and that the] principle of unanimity in all matters was declared binding.

[1851 – January.

1767

A lapse of upwards of a month during which I have neglected the
P.R.B. journal; an omission partly attributable to the nuisance & confusion
of moving. However, there has not occurred much requiring record.

Monday last, January 13, was fixed for a P.R.B. meeting at Hunt's
with a view ~ to discussing fully the subject of electing any new members
in addition to the 6 remaining of the original number; & in order to frame
definite rules for the Brotherhood. Millais, Stephens, & myself only attended
. . . being indisposed, & Woolner in the country.] In the first place it
. . . . . . . . . . . . . . . . . a new election shall be deferred

. . . . . . of unanimity in all matters was declared desirable. Rules
were also adopted for holding a P.R.B. meeting on the first Friday
of every month; for fines in case of default; for a general review
of each P.R.B.'s conduct in art at the close of the year; & making
the keeping of this journal obligatory on me as Secretary. Various
other points stand over for settlement.               (1759)

Millais having raised a doubt as to the propriety of our continuing
to call ourselves P.R.Bs, considering the misapprehension which the
name excites, it was determined that each of us should write a
manifesto declaring the sense in which he accepts the name,
to be read all together at our next meeting, which is fixed for
Millais' in accordance with the new rule. I have written down
my declaration in its chief points.

Another matter of interest has arisen, of which a hint was given
some while ago. One Earl has produced an engraving of a china
dog being sniffed at by a real dog, with Millais's picture in the
background. It is entitled "Nature & Art, dedicated, without per-
mission, to the Pre-Raphaelites;" – & is on the eve of publication
by Jones of Piccadilly. Millais called there the other day, incog., with

3. Facsimile of MS. 1767, mutilated leaf of *PRBJ*

Present, at Hunt's, himself,
Millais, Stephens, & W. M.
Rosetti } P. R. B.

13 Jan.ʸ 1851. In consideration of the unsettled
& unwritten state of the rules guiding the
P.R.B., it is deemed necessary to determine &
adopt a recognized system.

The P. R. B. originally consisted of 7 mem-
bers — Hunt, Millais, Dante & Wᵐ Rosetti, Ste-
phens, Woolner, & another; & has been reduced
to 6 by the withdrawal of the last. It was
at first positively understood that the P.R.B.
is to consist of these persons & no others, — se-
cession of any original member not being
contemplated: & the principle that neither
this highly important rule, nor any other
affecting the P. R. B., can be ~~finally adopted,~~ repealed, or
modified, ₍or any finally adopted,₎ unless on unanimous consent
of the members is hereby declared permanent.

4. Facsimile of P.R.B. Rules

Rules were also adopted for holding a P.R.B. meeting on the first Friday of every month; for fines in case of default; for a general review of each P.R.B.'s conduct in art at the close of the year; and making the keeping of this journal obligatory on me as Secretary. Various other points stand over for settlement.

Millais having raised a doubt as to the propriety of our continuing to call ourselves P.R.B.s, considering the misapprehension which the name excites, it was determined that each of us should write a manifesto declaring the sense in which he accepts the name; to be read all together at our next meeting, which is fixed for Millais's in accordance with the new rule. I have written down my declaration in its chief points.

Another matter of interest has arisen, of which a hint was given some while ago. One Earl has produced an engraving of a china dog being sniffed at by a real dog, with Millais's picture in the background. It is entitled 'Nature and Art, dedicated, without permission, to the Pre-Raphaelites',—and is on the eve of publication by Fores of Piccadilly. Millais called there the other day, incog. . . . He has determined to ascertain the law of the case, and to enquire Farrer's opinion as owner of the picture.

Stephens has taken up the art-criticism for the *Critic*, which I had declined because of my connexion with the *Spectator*. His first article (on the Exhibition of Modern Art at the Old Water-Color Gallery) appears in last week's number.

Gabriel has, with Deverell, taken the first-floor of North's house, 17 Red Lion Square.

*Sunday 19th January*. I read the new cantos of *Sir Reginald Mohun*, which the *Critic* has sent me to review.

*Sunday 26th*. On resuming the P.R.B. journal, I find that my present isolated position renders the continuance of it day by day inefficient to any good purpose. I shall therefore write it up weekly, except where anything particular may call for special record of some one day.

Stephens wrote me on Monday, asking to have the volume of the '1001 Nights', [containing] the 'Story of the City of Brass', which he wishes to read again. . . . [Patmore has been sent a copy] of Bennett's poems by the author, who enquired for Mr. Tennyson of Patmore and Allingham; and he has had to stave off a

proposed visit from the poet.—Patmore notifies that he will expect the P.R.B.s henceforward monthly (each first Saturday) in lieu of fortnightly, finding attendance often very thin.—Three short notices of mine appear in yesterday's *Spectator*; this evening I wrote a review for the *Critic* of the 2 new cantos of *Sir Reginald Mohun*. The editor tells me he has various books waiting for me.—Of Woolner, I only know that Gabriel had a letter from him recently, saying he would shortly return.

# February 1851

*Sunday 2nd February.* Woolner returned on Thursday, after about 6 weeks' absence. He has not done anything, even in the way of verse, in the country. There is some prospect of his getting the commission for a monument to Wordsworth to be erected over his grave; Mr. Fletcher, whom he met when with Tennyson at the lakes, having proposed him to a brother of Sir Humphrey Davy, who manages the affair, and some preliminary notes having been exchanged. Hancock also wishes him to do something at 'his bas-reliefs'. He, with Gabriel and myself, spent the evening with Patmore on Saturday. Gabriel left some more of his translations from the Italians before Dante, which, Patmore says, are the only true love-poems he [ever saw]. [To-day I] sat to Deverell. . . . [Millais] has begun a third picture for the Exhibition, postponing the Marriage before the Flood.—An article of Stephens's on Grundy's Exhibition appears in this week's *Critic*, and a short notice of mine in the *Spectator*.

*Sunday 9th.* Friday was the second P.R.B. meeting under the new system, when we assembled at Millais's. All were present—an event which has not happened for months. A few further regulations were made,—involving, at Hunt's suggestion, the important principle that any possible new member is to be re-eligible annually—not permanently admitted in the first instance. An unanimous vote against any P.R.B.—(in the case of one of the original 6, the vote of his fellow foundation-members only)—is to amount to expulsion;—a case not precisely foreseen at present.

Election is to be by ballot. We voted moreover to keep, under the same obligation as a P.R.B. meeting, the birth-day of Shakespear; and that any one contemplating a public course of action affecting the Brotherhood shall mention the matter first to his colleagues. —Millais's new design is of the dove's return to the ark; he has finished a small study from Miss McDowall, illustrating the love-custom of passing cake thro' a ring. . . . —Stephens has made some studies for [his picture illustrating the song 'Take, oh! take those lips] away.' . . . I have for review from the Editor David Scott's designs to the *Pilgrim's Progress*, etched by W.B., and now in course of publication. I commenced a review of them to-night. —Nothing to say of any one except myself, as I have not called or received calls, having been ill of influenza some days. . . .

*Sunday 23rd.* Gabriel, I understand, has a small commission for a portrait. To-day I had a glimpse of what Woolner has done for the Wordsworth monument—himself being out when I called; the head is considerably advanced.—I finished reviewing Scott's designs; and wrote a notice, this evening, of a book by Hay of Edinburgh: *The Geometric Beauty of the Human Figure.*

# March 1851

*Sunday 2nd March.* To-day I sat to Deverell for the hand of his Hamlet; and, with him and Gabriel, spent the evening with Hunt. We found there a cousin of Hannay's who had been sitting for the head of Valentine.—This week has been signalized by Woolner's taking a medallion of Carlyle, who gave him sittings the four first days of the week, and who of course furnishes material for any number of 'nights' entertainments'. Woolner is impressed by him as a perfect development of man in his highest attributes; in contradistinction to the something of diviner element which he feel[s in Tennyson] . . .Woolner intends to compete for the [Wordsworth monument.] . . .

*Sunday 9th.* . . . Stephens showed us his Griselda picture—to which not much remains to be done, except the head and upper part of

Griselda herself; however, he appears rather doubtful whether he will finish it. He has begun a sketch in color for 'Take, oh! take those lips away!' In this we all think that some alteration in scale and disposition is desirable, to obviate the present bareness of the composition.—To-day I called on Woolner, and saw his head of Carlyle, and a first sketch for the Wordsworth monument competition. Wordsworth is seated,—the whole arrangement of the figure being subordinated to the supremacy of the head; on the base of the plinth whereon he sits in a bas-relief of Peter Bell. Two side-plinths are left entirely plain as expressive of the ideal in contrast with the human. Mounted on these are two symbolic groups: the first of Control—a refractory child restrained by the authority of his father; the second of Aspiration—a girl who, showing to her mother a flower which she has gathered, is taught to raise her thoughts to the stars. The manhood of the controlling figure in the first symbol is the suggestion of Carlyle, who expressed his entire approval of the general conception of the monument. There are several excellent names on the Committee for carrying out the subscription and awarding the commission— such as ought to give Woolner a fair chance of success; and the terms of the prospectus promise a certain elevation of principle in the selection.—I sat to Brown in the evening; and, on returning home, found Ruskin's new book—*The Stones of Venice*—left me from the *Spectator*. Early in the week I sent off to the *Critic* a notice of some volumes of verse, including Hannay's satire *The Vision of the Vatican*.

# May 1851

*Friday 2nd May.* After another discreditable lapse, I take occasion to renew the P.R.B. journal—this being the private view day at the Academy, to which I had a ticket thro' the *Spectator*.

The P.R.B. pictures here are Millais's from 'The Woodman's Daughter'; *The Return of the Dove to the Ark*; and *Mariana*; and Hunt's *Valentine Rescuing Sylvia from Proteus*. Millais's two first are on the line—*The Woodman's Daughter* in the old architectural room, from which the architecture has been this year transferred

to the Octagon Room; the two others in the West Room—the *Mariana* being partly below the line. Hunt's has been abominably shirked off into much the same position as his *Rienzi* of 1849 occupied. Collins exhibits two pictures—a portrait, and *Convent Thoughts*—very charming indeed—a strong claim to P.R.B.-hood, which it appears, however, he is now in no hurry to apply for, thinking it should have been offered long ago. Brown's *Chaucer* is here, and attracts much admiration; the other best pictures being Eastlake's, Dyce's, Leslie's, Mulready's (an old one), and Poole's. Stephens's *Griselda* was sent—in the name, as he now informs us, of 'Brown'—but does not make its appearance. The rooms were moderately full to-day—allowing comfortable space and leisure for inspection; and, after making a summary tour of the rooms, I went regularly thro' the first. In my progress I heard some one— by his looks, an Academician—observe, in reference to one of Millais's pictures, that no sarcasm could be too fierce for such absurdities; and another, a Frenchman-cropped monkey looking being, was in exstasies of amusement which he made it his care to communicate. The *Mariana* appeared, nevertheless, to be a great favorite with women, one of whom said it was the best thing in the exhibition. A person there, whom I have met before at picture-galleries—evidently a critic,—got me to take him to the pictures of the 'young men'; and, if his mere words are a type of what his writing is to be, that will prove in the admiring vein. On return-ing home, I wrote a very brief introductory notice for the *Spectator*; and the rest of the evening was spent here, the time happening to have come round, in assembled P.R.B.—Woolner excused himself thro' indisposition, which, he says, will prevent him also from being at Patmore's to-morrow. Millais had heard from Mrs. Collins something about abuse encountered by his pictures, which, it seems, are denounced by Mrs. Jones, and make Jones R.A. walk about in a state of despondency and distress. . . .

<p align="center">★ ★ ★ ★ ★</p>

*Tuesday 6th May.* The *Daily News* of to-day is only conceivably abusive of the P.R.B. pictures, and speaks of Brown with respect. I went on with my review of the Academy—having purposed to speak of all the scriptural and historical works this week; this,

however, feeling peculiarly lazy to-night, I have failed to accom-
plish.—The Editor of the *Spectator*, on whom I called in the after-
noon, alluded, but always in a pleasant way, to the difference of
tone concerning Millais in my preliminary observations of last
week and the reviews of previous years. I, of course, stuck up;
and whether this is to be the beginning of the end, or whether its
end was simultaneous with its beginning, remains to be seen.
However, the opening remarks in my notice for this week will
probably tend to bring the point to an issue. I claim the certain
reversion of supremacy in art for the new-comers; and Brown is
reviewed at a triple allowance of space.

*Wednesday 7th.* The meeting at Stephens's had been deferred from
yesterday to to-day, in consequence of a promise of Gabriel's to
attend a meeting at the Eclectic where Hannay was to talk on
'making the Nigger work'.—However, Hunt and Millais, not
having received warning, came last evening; and, as Gabriel went
to see Woolner who continues unwell, I was the only P.R.B.
present at Stephens's. Collinson and Hannay were there also.
Stephens has received a letter from Cox, to explain the affair of
the intruded notices in the *Critic*. He says that, not receiving a
review in time for press, he set himself about writing on the
British Institution; that his noticing pictures already criticized by
Stephens was the result of an inadvertence; and that the Water-
Color Galleries have *always* been reviewed by a lady, of which,
as he asserts, he had in the first instance informed Stephens. This
last statement is absolutely untrue; I noticed these Galleries during
my connexion with the art in the *Critic*, without the slightest hint
to the contrary, and Stephens denies the assertion in so far as he is
concerned. Moreover, the excuse about the British halts on both
legs. Nevertheless, as the tone of the letter is apologetic, Stephens,
all things considered, intends to resume his criticisms; and this will,
of course, preclude the necessity of my declining to continue mine.

*Thursday 8th to Saturday 10th.* For the two former of these days I
have nothing to record. On Saturday Hunt, Gabriel, and I, met
at Hannay's, when Hunt informed us (having it from Patmore)
that Ruskin had wished to buy Millais's picture of *The Return of
the Dove to the Ark*, which is already sold; and that Patmore has
suggested to him to write something about the P.R.B. The result

is not known yet; but, were Ruskin to do so, this is the very thing we want, evident as it is from the affair of Millais's picture (were it from nothing else) that he must be an admirer of the P.R.B. Indeed, so desirable would something of the kind be, that it has been proposed among ourselves to write to Ruskin requesting him to express his opinion in some public manner. Gabriel says that Woolner, when he saw him on Wednesday, was just getting the better of a severe indisposition; I called at his study this evening, coming to Hannay's, but did not find him in.

*Sunday 11th.* Having sat up at Hannay's till an advanced hour in the morning, Hunt proposed that we should finish the day with a row up to Richmond, to which Gabriel, Hannay, and I, agreed. We had a fine day; the lovely Spring variations of green in trees and grass were specially delightful. A bottle of champagne and a bottle of claret which we took with us from Hunt's served to drink the P.R.B. and Tennyson and Browning in.—The picture Hunt is purposing to do for next year is a life-sized one on the passage from one of Moses's hymns or exhortations where it is said that God found for Jacob honey in the clefts of the rock.

*Monday 12th.* Woolner called, having returned to his study to-day after cold and fever. His model for the Wordsworth monument competition was sent in a few days ago according to the regulations. Among the other models is one, also with symbolical figures, by Behnes. He explains to me that it was Ruskin's father who wanted to buy Millais's picture, but this makes little difference in the state of the case. Ruskin himself has, in conformity with Patmore's suggestion, written a letter to *The Times* on the P.R.B.; and, if it do not appear there, will send it to the *Chronicle*. This ought to be worth something to us.—I resumed my notice of the Academy for the *Spectator*, introducing that of Poole's picture written by Gabriel.

*Tuesday 13th to Thursday 15th.* On Tuesday Ruskin's letter appeared in *The Times*. He says that he believes Millais and Hunt to be at a turning-point of their career, 'from which they may either sink into nothingness, or rise to very real greatness'. The explanation he gives of the name 'Pre-Raphaelite' is very sensible: 'They intend to return to early days in this one point only—that, as far as in them lies, they will draw either what they see, or what they

suppose might have been the actual facts of the scene they desire
to represent, irrespective of any conventional rules of picture-
making; and they have chosen their unfortunate tho' not inaccur-
ate name because all artists did this before Raphael's time, and
after Raphael's time did *not* this, but sought to paint fair pictures
rather than represent stern facts; of which the consequence has
been that, from Raphael's time to this day, historical art has been
in acknowledged decadence.' Ruskin then deals with the non-
sense about 'imitation of false perspective', asserting that the only
error in the five pictures (including Collins's) is that the top of the
green curtain in the distant window (of the *Mariana*) has too low
a vanishing point; and that he will undertake to prove a dozen
worse errors in any 12 of the most popular pictures of the day
containing architecture;—and, as to the accusation of 'drapery
snapped instead of folded', that, 'putting aside the small Mulready
and the works of Thorburn and Sir W. Ross, and perhaps some
others of those in the miniature room which he has not examined,
there is not a single study of drapery in the whole Academy, be
it in large works or small, which, for perfect truth, power, and
finish, could be compared for an instant with the black sleeve of
the Julia, or with the velvet on the breast and the chain-mail of
the Valentine; or with the white draperies on the table in "Mari-
ana," and of the right-hand figure in "The Dove Returning to the
Ark"; and further that, as studies both of drapery and of every
minor detail, there has been nothing in art so earnest or so com-
plete as these pictures since the days of Albert Dürer.' He con-
cludes with objecting to the Silvia and the figures in the *Dove*
picture, on the score of beauty, and hopes 'to be permitted to
enter into more special criticism in a future letter'. Altogether, the
letter is very satisfactory; anything but unqualified praise, which
is well in one sense as doing away with the accusation of partisan-
ship. Ruskin himself expressly disclaims personal acquaintance.
One point which I think it might be advantageous to notice in a
letter from some of ourselves to *The Times* is that Ruskin says
something of P.R.B. 'Romanist and Tractarian tendencies' in
reference to the *Mariana* and to Collins's picture. Such tendencies,
as utterly non-existent in fact, it might not be amiss to repudiate;
the doing which would besides afford an opportunity for entering
into any other details or rectifications seeming advisable. But
perhaps it will be preferable to wait for Ruskin's sequel.—I went

on with the R.A. review for the *Spectator*, and find it necessary to postpone Millais and Hunt till next week, as I had got too far before coming to them to allow the required room.—On Wednesday I had a letter from Gabriel, enclosing a notice of Hunt, and bidding me to Millais's to-morrow.—Brown, Hunt, and Gabriel were there; and we are all agreed that Ruskin's letter will do good. Patmore, at whose instance it was written, thinks we should send Ruskin our thanks; but this seems of doubtful propriety, as it might be interpreted into a making interest with a view to his second letter. When that is out, something of the kind suggested would certainly appear right. Millais has had another request (from a Mr. Boddington) for his *Dove in the Ark*; and a particular invitation from the Birmingham exhibition for him to send it thither. Mr. Combe, also (who bought Hunt's picture of last year) has written to ask the price of the *Valentine and Proteus* and of Collins's. A laudatory review of Hunt and Millais appears in the *Guardian*, devoting to them three or four times as much space as to any other artist; and I am informed that *Bell's Weekly*—(is Saul also among the prophets?)—says much the same as I did in the *Spectator* as to the highest art of the day being among a few of the best Academicians and the most recent artists. It seems scarcely possible that this can apply to any but the P.R.B., but the sequel will show. As to abuse, it seems to be in the air, so much does the infection spread among critics in word and print. —The editor of the *Spectator*, on whom I called to-day, asks me to restrict myself, as far as possible, to pictures eminent for good or evil; as the length of my Academy notices leaves scanty space for the Great Exhibition to figure in. I shall therefore cut short the profane, and concentrate my force on the P.R.B.—A nuisance which has revived within these three days is the buried *Germ*; George Tupper having called on me to say that he is winding up its money-matters, and finds himself a clear loser by some £30. Outstanding accounts are of course in requisition; and I find that the copies of Nos. 3 and 4 with which he credits me have so almost entirely disappeared, that, what with making good their value—(the money *value* of *The Germ*!)—and paying for the etching-plates, which I could scarcely leave Tupper to defray, I have still a pretty sum to fork up; while most of the other quondam proprietors have to look up their share of the expenses of Nos. 1 and 2.

*Friday 16th to Friday 23rd.* A hit at the P.R.B. (conscientiously speaking, very stupid) appears in *Punch* of Wednesday, introducing caricatures of the *Mariana* and of Collins's picture. It is admitted, however, with a reference to Ruskin, that the P.R.B. pictures are *true*; and the article is directed in part against supposed romanizing tendencies.—On the 16th Woolner, Gabriel, and myself, were at Tupper's; this being the first day since his illness that Woolner has returned to work, doing something on the minor Wordsworth monument for which he was commissioned. He is to be introduced next week at Carlyle's to Ruskin; who, as Patmore informs him, had written his second letter to *The Times*, but now thinks of withholding it, on the consideration that it casts so strong a slur on all non-P.R.B. living painters. It may be inferred from this that he spoke out very decidedly in our favour; and it would be proportionately desirable that the letter should appear. Perhaps Woolner may be able to do something towards this result. Carlyle, the other night, in talking with Woolner, was speaking of 'Alfred' (as he calls Tennyson) and Browning, in reference to their embodying their thoughts in verse, when there is so great need of doing things in the directest way possible: 'Alfred', he said, 'knows how to jingle, but Browning does not.' He spoke, however, of Browning's intellect in the highest terms. He then referred to the P.R.B.: 'These Pre-Raffelites they talk of are said to copy the thing as it is or invent it as they believe it must have been; now there's some sense and hearty sincerity in this. It's the only way of doing anything fit to be seen.' Woolner's medallion pleased him very greatly.—We saw Tupper's bas-relief, which the Academy rejected. It is illustrative of the 'Merchant's Second Tale', by, or ascribed to, Chaucer, and represents the chessplaying between the Merchant and the old man he meets in the strange city. It is at the extremest edge of P.R.Bism, most conscientiously copied from Nature, and with good character. The P.R.B. principle of uncompromising truth to what is before you is carried out to the full, but with some want of consideration of the requirements peculiar to the particular form of art adopted. According to all R.A. ideas it is a perfect sculpturesque heresy, whose rejection—especially seeing that it is the *introductory* sample of P.R.B. system in sculpture—cannot be much wondered at, though certainly most unjustifiable. It seems that, on hearing of its rejection, Tupper wrote rather a

sharp letter to Knight, and there has been some talk of his entering on some course of public opposition to the Academy, but this does not seem likely to come on. He intends to place the bas-relief in Saint George's chess-club, and will get something else ready for next year. He read us a rather lengthy and mystic poem, full of admirable thoughts and images.

*Saturday 24th.* The engraving of Millais's *Return of the Dove*, appears to-day in the *Illustrated News*: the accompanying notice is of a very qualified order of compliment; and Collins is abused outright. Last week this paper had a very admiring notice of Brown, aptly comparing the character of his picture to that of Scott's historical romances; it is very incompetently noticed in to-day's *Athenaeum*. My notice for the *Spectator* of the P.R.B. pictures (in which I have entered into a brief statement of general principles) is postponed this week in favour of a review of the Bridgewater Gallery.—Gabriel, who has given notice to quit his present studio in Red Lion Square, has received from Brown the offer of a share in his, and purposes to accept it. He is inclined to paint this year, instead of the Meeting of Dante and Beatrice on earth and in paradise (which he is redesigning) some other Dantesque subject—probably from the *Vita Nuova*.

# January 1853

I at last resume the P.R.B. journal, not too sanguine of continuing it for long.

Our position is greatly altered. We have emerged from reckless abuse to a position of general and high recognition just so much qualified by adverse criticism as suffices to keep our once would-be annihilators in countenance. I limit myself to the briefest recapitulation of last year's public doings, and our present state.

Hunt, Millais, Stephens, and Woolner, exhibited at the R.A.— Hunt sent *The Hireling Shepherd*; Millais *Ophelia* and *A Huguenot on the Eve of Saint Bartholomew* etc.; Stephens a small portrait of his mother; Woolner his cast for the competition monument to

Wordsworth, and medallion heads of Carlyle, Wordsworth, and Miss Orme. Gabriel exhibited three designs (water-color) in the Exhibition of Sketches opened in December—*Giotto Painting Dante's Portrait, Beatrice Denying Dante her Salutation*, and a lady in Venetian costume.

At present Hunt is preparing for next exhibition. He purposes exhibiting his old picture from *Measure for Measure*, Christ at the door, a picture of sheep commissioned by Maude, a portrait, and probably two others of which I shall be able to speak more certainly hereafter. Soon after sending in, he intends to go to Syria. Millais is painting two subjects of invention—one of the Stuart period, the other named *The Ransom*. Gabriel has in hand a picture in two compartments, symbolizing in life-sized half-figures, Dante's resolve to write the *Divina Commedia* in memory of Beatrice. Woolner is absent from England since July last, having gone to the diggings in Australia, where he hopes to make money sufficient to enable him to return in a few years, and pursue sculpture with endurable prospects. Stephens is doing a portrait of his father. I am still on the *Spectator*.

*Monday 17 to Saturday 22.* Better than art-news signalizes this week —that, namely, of the arrival of Woolner's vessel, the 'Windsor', at Melbourne, on the 22nd October last. It is the first we have heard about him since he reached Plymouth on his passage out. The Howitts, whom he had gone to join with Bernhard Smith and Bateman, had started into the interior of the country only two days before. Thus much is gathered from the shipping-news in *The Times* and Howitt's letters to his family; from Woolner himself we have yet to wait for news.—Another item of information is rather sad. Poor Collinson, our once P.R.B., is said to be on the eve of relinquishing art and entering a Jesuit college—as a 'working brother', I am told, whatever that may mean among the titles of their dreary simulacra. Goodbye to a man that has had fine capabilities in him, never allowed fair play by himself.— Gabriel has been giving the finishing touches to some alterations he has made in his old *Annunciation*-picture, consequent on an offer from McCracken, of Belfast, to buy it, on Hunt's recommendation, for the original price £52.10.—I have been sitting to him to assist his repainting of the Angel's head.—Friday was to have been a P.R.B. night at Stephens's, but no one attended

except myself. Hunt had to take advantage of the moonlight night for his picture of Christ at the door; Gabriel went to Hunt's; and Millais was non-apparent. Stephens, who has been valiantly attending the last course at the R.A. antique school, has had his heroism crowned with success: he is at length admitted a student of the life-school. Besides his portrait, before mentioned, he is engaged in making a finished sketch in oils from Hunt's *Hireling Shepherd*.—(The only change in domicile that has taken place since I dropped this journal is that Gabriel and I now have chambers overlooking the river at Blackfriars Bridge, 14 Chatham Place)—This digression is inapposite just now: for I should not have forgotten to premise that, tho' both Preraphaelism and Brotherhood are as real as ever, and purpose to continue so, the P.R.B. is not, and cannot be, so much a matter of social intercourse as it used to be. The P.R.B. meeting is no longer a sacred institution,—indeed is, as such, well-nigh disused; which may explain the quasi-non-attendance at Stephens's. And the solemn code of rules which I find attached to these sheets reads now as almost comic. In fact, it has been a proof of what Carlyle says in one of his *Latter-Day Pamphlets* that the formulating of a purpose into speech is destructive to that purpose—for not one of the new rules has been acted on, and the falling-off of that aspect of P.R.Bism dates from just about the time when those regulations were passed in conclave.

*Sunday 23 to Saturday 29.* Gabriel finished and sent off the Annunciation picture. It has now lost its familiar name of *The Ancilla*,—the mottoes having been altered from Latin to English, to guard against the imputation of 'popery'. He is now possessed with the idea of bringing out his translation of the *Vita Nuova*, revised and illustrated. He had intended photographed designs a short time ago, but now again purposes etchings.

# APPENDICES

# APPENDIX 1

# Rules of the P.R.B.

IN January 1853, when William Rossetti was writing the penultimate entry in the *P.R.B. Journal*, he admitted that the 'Rules' of the Brotherhood, formulated only two years previously, then seemed comic. Not one had ever been acted upon, and the desuetude of the P.R.B. had begun at just about the time that the 'Rules' were 'passed in conclave'. It is probably true to say that they were a last-ditch attempt to revive the dying group, whose members were beginning to move out from the Pre-Raphaelite nucleus and to follow their own directions. Still, as Rossetti says when introducing them in the *Memoir* of his brother, the 'Rules' do indicate 'not only what we then intended to do, but a great deal of what had been occupying our attention since the autumn of 1848' (i. 139). The manuscript copy of the 'Rules', from which the text is taken, forms an important adjunct to the manuscript *Journal*.

## P.R.B.[1]

Present, at Hunt's, himself, Millais, Stephens, and W. M. Rossetti —13 January 1851.

In consideration of the unsettled and unwritten state of the rules guiding the P.R.B., it is deemed necessary to determine and adopt a recognized system.

The P.R.B. originally consisted of 7 members—Hunt, Millais, Dante and William Rossetti, Stephens, Woolner, and another;[2] and has been reduced to 6 by the withdrawal of the last. It was at first positively understood that the P.R.B. is to consist of these persons and no others,—secession of any original member not being contemplated: and the principle that neither this highly important rule, nor any other affecting the P.R.B., can be repealed, or modified, or any finally adopted, unless on unanimous consent of the members is hereby declared permanent and unalterable.

[1] Published in *FLM*, i. 139–41. The MS. of the Rules is in the Angeli Papers at U.B.C.
[2] James Collinson, whose Catholicism interfered in some undefined way with his membership in the Brotherhood. For Collinson's letter of resignation from the P.R.B. see *PRBJ* 21 July 1850, page 71 above.

*Rule 1.* That William Michael Rossetti, not being an artist, be Secretary of the P.R.B.

2. Considering the unforeseen vacancy, as above stated, resolved that the question of election of a successor be postponed until after the opening of this year's art exhibitions:—this rule to be acted on as a precedent in case of any future similar contingency. That, in case a new election be voted, the person named as eligible be on probation for one year; enjoying meanwhile all the advantages of full membership, except as to voting.

3. That, on the first Friday of every month, a P.R.B. meeting, such as has hitherto been customary, be held.

4. That the present meeting be deemed the first in rotation under the preceding rule; and that the future meetings be held at the abodes of the several members, in order as follows: Millais, Dante Rossetti, William Rossetti, Stephens, Woolner.

5. That, in event of the absence of the member at whose house any meeting falls due, or other obstacle—to be allowed as valid by the others—, the Secretary be made aware of the fact; and that the member next in rotation act for the absent member:—the ensuing meetings to follow as before provided.

6. That unjustified absence under such circumstances subject the defaulter to a fine of 5/-.

7. That a probationary member be not required to take his turn in this rotation.

8. That, at each such monthly meeting, the Secretary introduce any business that may require consideration,—to the exclusion of other topics until such business shall have been dispatched.

9. That any member unavoidably absent be entitled to send his written opinion on any subject fixed for consideration.

10. That, failing full attendance at a meeting, or unanimously expressed opinion, the members present may adopt resolutions,— to remain in force until a dissenting opinion shall be made known.

11. That any member absent from a meeting, without valid excuse,—to be allowed by the others—shall forfeit 2/6; and that no engagement with any other person whatever be held to supersede the obligation of a P.R.B. meeting.

12. That the January meeting of each year be deemed the anniversary meeting.

13. That the application of fines accruing as before specified be determined, by majority of votes, at each such annual meeting.

*14.* That, at each annual meeting, the conduct and position of each P.R.B. during the past year in respect of his membership be reviewed; it being understood that any member who shall not appear to have acted up to the best of his opportunities in further-ance of the objects of the Brotherhood is expected, by tacit consent, to exert himself more actively in future.

*15.* That the Secretary be required, as one chief part of his duty, to keep a journal of the P.R.B.

*16.* That the journal remain the property of the Brotherhood collectively, and not of the Secretary or any other individual member; that it be considered expedient, in ordinary cases, to read the journal at each meeting at the Secretary's residence; and that any member have the power to require its production when-ever he may think fit.

*17.* That any election that may be hereafter proposed be determined by ballot.

*18.* That any such election be renewable annually by the vote of the 6 original members.

*19.* That, any member considered unworthy to continue in the Brotherhood cease to be a P.R.B. on the unanimous vote of his peers,—i.e. of those in the same class as regards date of election as himself.

*20.* That the fines be received by the Secretary.

*21.* That the [23rd of] April be kept sacred annually to Shaks-peare, as an obligation equally binding as that of a P.R.B. meeting.[1]

*22.* That, in case any P.R.B. should feel disposed to adopt publicly any course of action, affecting the Brotherhood, the subject be in the first instance brought before the other members.[2]

[1] In the famous P.R.B. 'List of Immortals' (Appendix 2) Shakespeare was given three stars, sharing honours only with the author of the Book of Job. Three was maximum, with the exception of Christ who was awarded four.

[2] Rules 16–18, 20, and 21 were adopted on Friday, 7 February 1851 at a full meeting of the P.R.B. See *PRBJ* 9 Feb. 1851, pp. 88–9 above.

# APPENDIX 2

## List of Immortals

WRITING to his brother William on 30 August 1848—probably just before the formation of the P.R.B.—D. G. Rossetti informed him that 'Hunt and I have prepared a list of Immortals, forming our creed, and to be pasted up in our study for the affixing of all decent fellows' signatures. It has already caused considerable horror among our acquaintance. I suppose we shall have to keep a hairbrush' (DW 35). This serio-comic document, which has always been associated with the Pre-Raphaelites, was preserved by Hunt and published in his autobiographical history of the movement, from a copy made by his father. The original, he says, contained many more names, 'amongst them many contemporaries now utterly forgotten'. Like the 'Rules of the P.R.B.', their poetry on each other, and even to some extent the *Journal* itself, the 'List of Immortals' is a highly self-conscious document, at once characteristic of the immaturity of the young artists, but at the same time a testament to their conviction and to the seriousness of their purpose. The 'List' and Hunt's prefatory account, which differs slightly from Dante Rossetti's, are taken from the revised edition of *Pre-Raphaelitism and the Pre-Raphaelite Brotherhood* (1913, i. 110–11).

Once in a studio conclave, some of us drew up a declaration that there was no immortality for humanity except in reputation gained by man's own genius or heroism. We had not yet balanced our belief in Voltaire, Gibbon, Byron, and Shelley, and we could leave no corners or spaces in our minds unsearched or unswept. Our determination to respect no authority that stood in the way of fresh research in art seemed to compel us to try what the result would be in questions metaphysical, denying all that could not be proved. We reflected that there were different degrees of glory in great men, and that these grades should be denoted by one, two, or three stars. Ordinary children of men fulfilled their work by providing food, clothing, and tools for their fellows; some, who did not engage in such labour, had allowed their minds to work without the ballast of common-sense, but the few far-seeing ones revealed vast visions of beauty to mankind.

Where these dreams were too profound for us to fathom, our new iconoclasm dictated at least a suspended judgment, if not

distrust; for of spiritual powers we for the moment felt we knew nothing, and we saw no profit in relying upon visions, however beautiful they might be.

Arguing thus, Gabriel wrote out the following manifesto of our absence of faith in immortality, save in the perennial influence exercised by great thinkers and workers—

We, the undersigned, declare that the following list of Immortals constitutes the whole of our Creed, and that there exists no other Immortality than what is centred in their names and in the names of their contemporaries, in whom this list is reflected—

Jesus Christ★★★★
The Author of Job★★★
Isaiah
Homer★★
Pheidias
Early Gothic Architects
Cavalier Pugliesi
Dante★★
Boccaccio★
Rienzi
Ghiberti
Chaucer★★
Fra Angelico★
Leonardo da Vinci★★
Spenser
Hogarth
Flaxman
Hilton
Goethe★★
Kosciusko
Byron
Wordsworth
Keats★★
Shelley★★
Haydon
Cervantes
Joan of Arc
Mrs. Browning★
Patmore★

Raphael★
Michael Angelo
Early English Balladists
Giovanni Bellini
Giorgioni
Titian
Tintoretto
Poussin
Alfred★★
Shakespeare★★★
Milton
Cromwell
Hampden
Bacon
Newton
Landor★★
Thackeray★★
Poe
Hood
Longfellow★
Emerson
Washington★★
Leigh Hunt
Author of *Stories after Nature*★
Wilkie
Columbus
Browning★★
Tennyson★

# APPENDIX 3

## Criticism Sheets of the Cyclographic Society

THE history of Pre-Raphaelitism includes a series of more or less formal organizations of which the P.R.B. is the most famous and important. The immediate precursor was the Cyclographic Society, to which all the Pre-Raphaelites with the exception of W. M. Rossetti belonged. Deverell, who was almost elected to P.R.B. membership to succeed Collinson, was one of the founders, along with N. E. Green and Richard Burchett.

The purpose of the Cyclographic, like the Sketching Club which Dante Gabriel joined as early as 1843, was to circulate for criticism among the members a portfolio of drawings and sketches. It was in some sense an exercise in Self-Help designed to supplement the instruction available in the various art schools and in the several training divisions of the Academy.

During the period of the Cyclographic, Dante Gabriel attempted to launch a parallel literary club in which he, his brother, Collinson, Hunt, and even Christina Rossetti would participate. Though the literary club failed to material-ize, the Cyclographic lasted into September 1848, when, with the defection of the P.R.B.s, it disappeared. Long after the demise of the Brotherhood, Millais attempted, in 1854, to revive the old Cyclographic pattern in the new Folio Sketching Club, but it was not until the formation of the Hogarth Club in 1858 that the Pre-Raphaelite artists again found a coterie structure with which a substantial number of them could identify.

Because so little is known about the Cyclographic Society, and because it was a forerunner of the P.R.B., it seems appropriate to preserve along with other Pre-Raphaelite documents in this edition, the three surviving Criticism Sheets of the Club. Though the sheets all relate to pictures by D. G. Rossetti, there are written critiques by no fewer than ten Cyclographic members—three eventual P.R.B.s, two associates, and five other artists who have no other role in the history of the movement. The three sheets are dated March, 27 July, and 14 September 1848. The pictures are: *La Belle Dame Sans Merci, Faust: Gretchen and Mephistopheles in Church*, and *Genevieve* (Surtees 32, 34, 38).

The earliest of the sheets is on plain writing paper ($6\frac{3}{8} \times 8$ inches) blocked out and lined with sections for the artist's name and the description of the picture at the top and for the critic's name and his remarks, below. The other two are printed foolscap sheets ($8\frac{1}{4} \times 13\frac{1}{4}$ inches), with the heading 'Cyclographic Society. / Criticism Sheet'. Space is provided at the top for the 'Subject of Picture or Quotation' and for the number of the sheet, the date, and the signature of the artist. Immediately beneath this space, there appears (within rules) the following admonition: 'The Members of the C.S. are requested to write their remarks *in Ink*, concisely and legibly, avoiding SATIRE or RIDICULE, which ever defeat the true end o fcriticism, and are more likely to produce unkindly feeling

and dissension.' Each of the three sheets is signed G. C. or Gabriel C. Rossetti. Critiques occupy both sides of the sheets. Of the twenty-three critiques, only that by Millais on *Faust* has been published (*FLM*, i. 121). So far as is known, these are the only surviving sheets from the Cyclographic Society.

## 1. *La Belle Dame Sans Merci*

J. E. MILLAIS. Girl's drapery towards lower part scantily composed and man's left leg badly drawn—composition *excellent*—worth painting.

W. H. HUNT. To insist upon careful *drawing* it must be criticized, so here goes: dog bony and bare, legs not good form. Beautifully designed, good subject and possessing many other excellences, would paint well.

JOHN HANCOCK. A most admirable subject well treated, sunny, wild, and like Spenser.

WILLIAM DENNIS. A subject that gives great scope for the imagination, *well conceived*; rather weak in drawing, but in expression *excellent* especially the wild girl. I do not like the action of the left arm of the male figure—the composition would be better if it were not seen, the hand being just visible round her waist. The dog breaks the line of the male figure with some advantage—but catches the eye too much.

N. E. GREEN. Upper half—in expression, drawing and light and shade *very fine*—lower, weak in drawing, and would be much improved by shadow.—Mouth of lady too small to be truly expressive.

J. COLLINSON. Begin to paint this subject as soon as you can—it is first rate. I think Mr. Hancock's remarks just, but of course they do not apply to the dog—which if not mentioned in the poem I would certainly annihilate in the picture. The remarks of Millais, Hunt, and Green worthy of attention.

J. T. CLIFTON. Very clever indeed in conception; and generally, excepting as before excepted.

J. B. KEENE. Composition excellent in many respects. Upper half especially. The action of the legs of the two figures too much the counterpart of each other. No objection to the dog (though

not mentioned in the text), if treated better. I cannot add more without repeating what others have expressed. With the rest I say 'Paint it'.

R. BURCHETT. The Figures appear stationary—caused I think by the proximity of the stem of the tree to the back of the lady. More archness of expression would improve the face of the 'Fairy's Child'—'give the poor dog a bone.' The instinctive dread of supernatural presence expressed in his head is very well given.

## 2. Faust: Gretchen and Mephistopheles in Church

J. E. MILLAIS. *A very clever and original* design, *beautifully executed.* The figures which deserve the greatest attention are the four figures moving to the left. The young girl's face is very pretty but the head is too large; the other three are full of piety. The Devil is in my opinion a mistake; his head wants drawing and the horns through the cowl are common-place and therefore objectionable.—The right arm of Margaret should have been shewn; for by hiding the Devil's right hand (which is not sufficiently prominent) you are impressed with idea that he is tearing her to pieces for a meal. The drawing and composition of Margaret are original and expressive of utter prostration.— The greatest objection is the figure with his back towards you who is unaccountably short; the pleasing group of lovers should have occupied his place.—The girl and child in the foreground are exquisite in feeling—the flaming sword well introduced and highly emblematical of the subject which is well chosen and with a few alterations in its treatment should be painted. Chairs out of perspective.

W. H. HUNT. This design is in such perfect feeling as to give me a far higher idea of Goethe than I have before obtained either from a translation, or the artificial illustrations of Retsch. The Margaret here is wonderful. Margaret enduring the taunting of the evil spirit who is pressing her weight of sin into her crouching and repenting self.—The children are beautifully introduced, without in the slightest interfering with the principal figures, and the holy heads around are beautifully devotional. Through Mr. R. never having seen the evil one, he has not got it sufficiently

# CYCLOGRAPHIC SOCIETY.

## CRITICISM SHEET.

Subject of Picture or Quotation :—

[Margaret, having abandoned virtue and caused the deaths of her mother and brother, is tormented by the Evil Spirit at Mass, during the chaunt of the "Dies Iræ." — (Goethe's Faust)

Evil Spirit.— How different, Margaret, it was with thee when full of innocence, thou camest before the altar, and didst kneel thee at its first lisping thy prayers out of the well-thumbed book, half in the playfulness of childhood, half as if a sense of God were in thy soul. How is it with thee now? Within thine heart what guilt and evil doing? &c

Margaret.— Woe woe, these dreadful thoughts! they seem to hold me and come o'er me spite of myself ! —

choir (chaunting) — Dies iræ, dies illa Solvet sæclum in favilla

Evil Spirit.— The glorified then countenance turn away from thee, to stretch to thee the hand the pure & stainless shudder thee to touch!

Date July 27 /48    Signature Gabriel C. Rossetti

The Members of the C. S. are requested to write their remarks *in Ink*, concisely and legibly, avoiding SATIRE or RIDICULE, which ever defeat the true end of criticism, and are more likely to produce unkindly feeling and dissension.

---

A very clever & original ~~cast~~ design, beautifully executed —
The figures which have deserve the greatest attention are the four figures praying to the left : The young girl's face is very pretty but the head is too large ; the other three are full of piety —
The Devil is in my opinion a mistake ; his head wants drawing & the horns through the cowl are common-place & therefore objectionable — The right-arm of Margaret should have been shewn, for by hiding the Devils right-hand, (which is not sufficiently prominent) you are impressed with the idea that he is tearing her to pieces for a meal. The drawing & composition of Margaret are original & expressive of utter prostration — The greatest objection is the figure with his back towards to you who is unaccountably short ; the pleasing group of lovers. should have occupied his place — The Girl & child in the fore-ground are exquisite in feeling — the flaming sword well introduced ^highly emblematical of the subject which is well chosen & with a few alterations in its treatment should be painted Chairs out of perspective — Jn E Millais

[This design is in such perfect feeling as to give me a far higher idea of Goethe, than I have before obtained either from a translation, or the artificial illustrations of Retzch, the Margaret here is wonderful, Margaret enduring the tauntings of the evil spirit who is pressing her weight of sin into her crouching and repenting self — the children are beautifully introduced, without in the slightest interfering with the principal figures, and the holy heads around are beautifully devotional through never having seen the evil one, he has not got it sufficiently grand, or near so good as the other parts, excepting the elevated hand which most appropriately accords with the utter prostration of Margaret
WHHunt ]

5. Criticism sheet of the Cyclographic Society

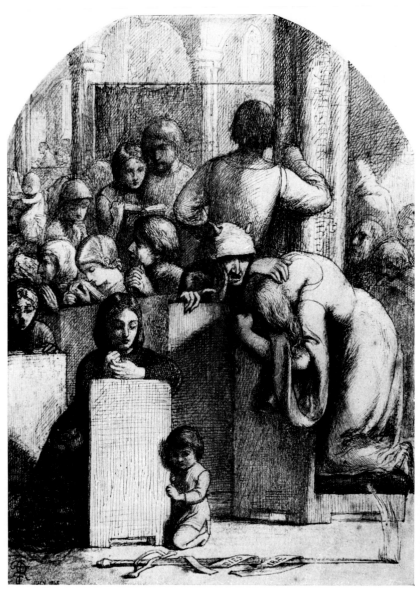

6. *Faust: Gretchen and Mephistopheles in the Church*
by D. G. Rossetti (1848)

grand or near so good as the other parts, excepting the elevated hand which most appropriately accords with the utter prostration of Margaret.

JOHN HANCOCK. The whole of this sketch is admirable with two little exceptions, viz., the figure with his back turned (behind the evil spirit) is too large and short, and I think the square *pew* to which the children are kneeling wants something to carry off the extreme squareness of it such as drapery hanging over it or perhaps some gothic ornament slightly indicated upon it as it seems to interrupt and hinder a proper view of the figures which compose the whole picture, principally by catching the eye very offensively. It is a most beautiful sketch.

WILLIAM DENNIS. I cannot do much more than echo the praises of those who have so ably criticised this work. I should like however to observe that this subject is much injured by the disregard of perspective—in the arrangement of the chairs—and also the design of the evil spirit. The expression of devotion is most wonderfully varied, and the little episode of the lovers is most beautiful—and artful—as it forms a striking contrast to the guilty loves of Margaret and Faust.

N. E. GREEN. The design as a whole does great credit to Mr. R. There is certainly a want of perspective. The lost spirit might not be sufficiently spectral; he looks rather like an old woman. The feeling very fine—the legs of Margaret too short.

J. T. CLIFTON. My modicum of praise is scarcely necessary to swell the bulk which has preceded it.

W. H. DEVERELL. I can do nothing but repeat the well deserved eulogies of the preceding members. The few errors that have been pointed out are mostly judicious—the members have never been more unanimous in pointing out the defects and beauties of a sketch than in the present instance.

J. B. KEENE. We have here an evidence of great talent on the part of the artist. The principal faults are in the conception of Mephistopheles who is here an old woman with horns, and in the figure behind who is short if standing and comes awkwardly behind the devil. Margaret is finely treated.

T. WATKINS. I quite agree with the praise bestowed on this sketch and think the girl and child lovely; a good effort on it would make it a grand subject.

## 3. *Genevieve*

J. E. MILLAIS. There is a degree of calm and melancholy pervading this beautiful outline which is very striking and reflects high credit on its able author. The love of St. Genevieve growing simultaneously with the strains of the minstrel's touch is well expressed; but the latter is apparently too deeply absorbed in his occupation and thus seems heedless of her sympathy. The figure of the armed knight is solemn and highly characteristic.

W. H. HUNT. This is a very beautiful and original treatment of as beautiful a subject. The position of Genevieve [is] excessively graceful (so is also the lover)—indeed the whole design is full of the most appropriate feeling which is carried out wonderfully to the smallest object.

N. E. GREEN. The feeling kept up throughout is exquisite and beyond praise—in so beautiful a sketch. I could wish for more drawing on the limbs of the female figure—her toes are *painfully* pointed outwards—the ancle of the male figure nearest the eye is also weak.

W. H. DEVERELL. Upon reflection I do not agree with Mr. Millais in his objection to the absorbed attention of the minstrel. I cannot express better than the two first criticisms my earnest admiration of this sketch. Mr. Rossetti will be glad to hear that our opinions have been confirmed by Mr. Herbert, who accidentally saw it, and who expressed his admiration of the depth of feeling.—Mr. Green's remark about her feet is just; are not the figures also too thin, her elbow, narrow shoulders and his thin arms?—If painted the solemnity of the pine wood, the dying lustre of the sky and the evening flight of birds would make splendid passages.

J. B. KEENE. I must add my meed of admiration to this beautiful sketch. The feeling is delightfully expressed; there is still a something on the minstrel capable of improvement.

# APPENDIX 4

## Titles for *The Germ* and Cover Sonnet

ALTHOUGH a Pre-Raphaelite magazine was projected as early as 13 August 1849, and the P.R.B.s were hectically assembling the contents of a first number throughout the autumn, it was not until 19 December that the controversy over the title was finally resolved. The original suggestion was to call it 'Monthy Thoughts in Literature, Poetry, and Art'; a month later, this title was modified, on D. G. Rossetti's advice, to 'Thoughts towards Nature'. In late September, after a publisher had been signed and a prospectus printed, a proposal was made to alter this title to 'The P.R.B. Journal', a change with which even the editor did not agree, though he was not, as was Holman Hunt, averse to having the letters 'printed somewhere on the wrapper'. On 10 December, it was unanimously determined to bring out at least a first number; and five days later, after an arrangement had been made to print the magazine with the Tuppers' firm, a design for the wrapper was drawn up which contained William Rossetti's sonnet, William Cave Thomas's device of a sower, and the title: 'The Seed: Thoughts towards Nature in Poetry, Literature, and Art'. Had Thomas been able to complete his device in time for the first number, the magazine in all probability would have appeared as 'The Seed'; however, when he announced on the 17th that he could not, the Brothers and others associated with the journal met on the 19th and (by a vote of 6–4) christened it *The Germ*, barely defeating another title suggested by Thomas—'The Scroll'.

That Cave Thomas proposed the name of *The Germ* is absolutely confirmed in several of William Rossetti's published accounts. In his edition of the *Journal* he records that on 4 December Thomas proposed 'no less than 65 alternative titles', and the sheets on which these titles are written are still extant (one of them was printed in facsimile and most of the names published in 1897, in G. B. Hill's edition of Rossetti's letters to Allingham). Some confusion, however, attaches to Rossetti's various accounts. In his Introduction to the Stock facsimile of *The Germ* (which was probably written in 1883, when the reprint venture was first broached), he says merely that the title was proposed at the meeting in his brother's studio on 19 December, and mentions Thomas's list of 65 titles. In his *Memoir* of Dante Rossetti (1895), he states that 'Mr. Cave Thomas had some while before proposed *The Seed*; and he now offered (with others) two new names, *The Scroll*, and *The Germ*'. In *Dante Gabriel Rossetti: Designer and Writer* (1889) he introduces a completely different story which G. B. Hill inaccurately paraphrases: 'The title of the magazine, *The Germ*, was not my brother's invention. I recollect a conclave which was held one evening in his studio with a view to settling the title of the forthcoming publication, and other points affecting it. A great number of titles were proposed, and jotted down on a fly-sheet which I still possess. Mr. William Cave Thomas the painter

. . . suggested *"The Germ"*, and after due pondering this sufficiently apposite title was adopted' (pp. 132–3).

A careful scrutiny of the surviving lists, taken in conjunction with the *Journal* account, makes it possible to trace with greater precision the evolution of the title, for the 'two fly-sheets' which Hill borrowed from Rossetti do not seem to be a single document. Though William dated both 4 December, one, containing 31 titles written on one side of the sheet, is on larger paper; the other, containing 34 titles, occupies both sides of a single sheet of normal-sized writing paper, and appears, in fact, to be a fragment of a letter. Rossetti dated it on the verso, but in the upper right-hand corner, there appears, in faint writing, the date 19/12/49. That the documents are distinct is further evidenced by their both being signed with Thomas's initials, by the proposed titles themselves, and by the chronological sequence recorded in the *Journal*.

If this deduction is correct, the evolution can be summarized thus: on 4 December, Thomas sent to W. M. Rossetti a list of 31 proposed titles for the magazine, including 'The Seed'. Owing to missing leaves and mutilations in the manuscript, there are no journal entries for the first six days of December, nor for the 9th, 11th, or 12th; and those for the 7th, 8th, and 10th are truncated. During this period, however, the P.R.B. must have discussed Thomas's proposals, for on the 15th the title 'The Seed', which had been rejected on the 10th, was settled. On the 17th, Thomas informed Rossetti that he could not have his device ready until the second number; and on the 19th a meeting was held to reconsider the title. Presumably, in preparation for this meeting, Thomas made his second list, the first title of which is *The Germ*. Interestingly, 'The Scroll', which Rossetti says ran *The Germ* a close second, does not appear on either of Thomas's lists and must have been an impromptu suggestion made at the meeting.

Thomas's two lists are printed separately below. In List 1, all but eight names have been lined out; three of these—'The Sower', 'The Seed', and 'Aspects of Nature' are circled. 'The Anti-Smudge' has been hatched as well as lined out and may have been rejected by Thomas. 'The Dawn', which appears twice on the list, has not been duplicated. List 2 has no names, other than one false start, lined out.

## List 1: 4 December 1849

The number of Notes of Admiration represent my notion of the value of each—Five being the highest value. W.C.T.

| | |
|---|---|
| The Sower!!!!! | The Dawn |
| The Progressist!!!! | The Well |
| The Seed!!!!! | The Spring |
| Aspects of Nature!!!! | The Fountain |
| The Guide to Nature!! | The Anti-Smudge |
| The Prospective!! | The Messenger |
| The View | The Chariot |

| | |
|---|---|
| The Alert | The Wheel |
| The Opinion | The Spur |
| The Mediator!!! | The Goad |
| The Reflector | The Bud |
| The Effort | The Acorn |
| The Attempt | The Gatherer |
| Aspirations toward Truth!!! | The Gleaner |
| The Truth seeker!! | The Reaper |

The first four names are the best.

## List 2: 19 December 1849

The Germ—Qy. better than Seed
  Several words expressing Progress—
The Accelerator
The Precursor!!!
The Advent
The Harbinger!!!
The Innovator

### Modest titles

| | |
|---|---|
| The Point | The Casket |
| The Action | The Repertory |
| The Ant | The Investigator |
| The Lantern | The Enterprise |
| The Adventurer | First Thoughts |
| The Student | Earnest Thoughts |
| The Scholar | Accumulator |
| The Chalice | The Aspirant |

---

| | |
|---|---|
| The Expansive | The Prism |
| The United Arts | The Lustre |
| The Mirror of Nature | The Illuminator |
| The Anti-Archeologist | The Appeal |
| The Circle | The Die |
| The Sphere | The Mould |

The Principle

—As your brother Gabriel was speaking of christening the journal, I've sent you all that I can think of which may perhaps suggest something to you or yours which may be much better than anything I've thought of.

—It is an important matter—There is something in a name. Yours W.C.T.

### W. M. Rossetti's Cover Sonnet for *The Germ*

When whoso merely hath a little thought
  Will plainly think the thought which is in him,—
  Not imaging another's bright or dim,
Not mangling with new words what others taught;
When whoso speaks, from having either sought
  Or only found,—will speak, not just to skim
  A shallow surface with words made and trim,
But in that very speech the matter brought:
Be not too keen to cry—'So this is all!—
  A thing I might myself have thought as well,
But would not say it, for it was not worth!'
  Ask: 'Is this truth?' For is it still to tell
  That, be the theme a point or the whole earth,
Truth is a circle, perfect, great or small?

No. 2. *(Price One Shilling.)* FEBRUARY, 1850.

With an Etching by JAMES COLLINSON.

# The Germ:

## Thoughts towards Nature

## In Poetry, Literature, and Art.

When whoso merely hath a little thought
　Will plainly think the thought which is in him,—
　Not imaging another's bright or dim,
　Not mangling with new words what others taught;
When whoso speaks, from having either sought
　Or only found,—will speak, not just to skim
　A shallow surface with words made and trim,
But in that very speech the matter brought:
Be not too keen to cry—"So this is all!—
　A thing I might myself have thought as well,
　But would not say it, for it was not worth!"
Ask: "Is this truth?" For is it still to tell
That, be the theme a point or the whole earth,
Truth is a circle, perfect, great or small?

## London:

AYLOTT & JONES, 8, PATERNOSTER ROW.

G. F. TUPPER, Printer, Clement's Lane, Lombard Street.

7. Front Wrapper of *Germ* 2

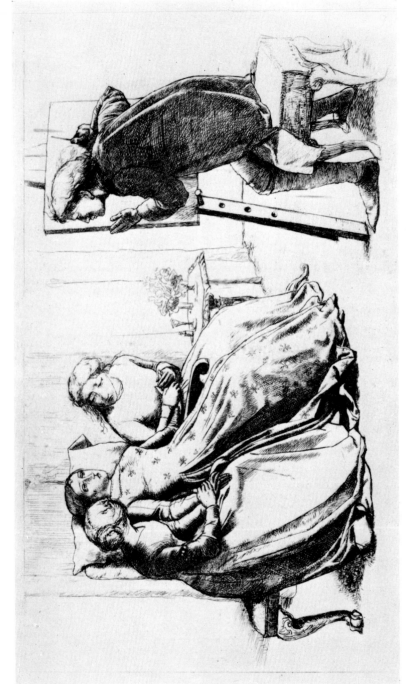

8. Etching for Rossetti's 'St. Agnes' by J. E. Millais

# APPENDIX 5

## Chronology of *The Germ*

*The P.R.B. Journal* is the primary source for information regarding the publication of *The Germ*. Except for mutilations and missing pages, it provides virtually a day-by-day account of the activities connected with the magazine through the first three numbers. After that, not the mutilations but the dereliction of the diarist defeats all efforts to secure hard facts about the last issue and ultimate demise of the venture. The details here recorded derive primarily from the *Journal*, supplemented by material gathered from other sources. Only the actual publication history is surveyed, as any attempt to incorporate the many details relating to the contributors and their works would unnecessarily duplicate entries in the *Journal*.

### 1849

13 Aug.  First reference in *PRBJ* to a 'proposed monthly 6d. magazine . . .' with an etching. Proprietors to subscribe one guinea.

14 Aug.  Title determined as 'Monthly Thoughts in Literature, Poetry, and Art'—with a sonnet on the wrapper.

15 Aug.  Proposed magazine to be 40 pages long, with two etchings; price advanced to one shilling.

19 Aug.  WMR finishes the sonnet for the wrapper that he began on the 15th.

20 Sept.  DGR introduced to Aylott and Jones, who are willing to publish the magazine for 10 per cent of sales; DGR seeking printing cost estimates from Haynes and others. Now nine proprietors—including Hancock and Herbert. —Plans for prospectus discussed.

23 Sept.  WMR appointed editor (by DGR and TW); title altered to 'Thoughts towards Nature' (by DGR).

24 Sept.  Prospectus at the printers.—In deference to WMR's objections vis-à-vis his editorship, the words 'Conducted by Artists', which it was originally intended to print on the prospectus and wrapper, are excluded.—

Date of publication deferred from November until December (DW 45).

27 Sept.  Table of Contents for No. 1 'remains as before settled' with the addition of Patmore's poem and FGS's paper on early art. Movement to change title to 'The P.R.B. Journal'.

6 Oct.  By this date prospectus issued by Aylott and Jones with 'P.R.B.' prominently displayed (TW had 70 copies of prospectus from WMR).

6 Nov.  Decision to exclude from No. 1 any contributions of a political or religious nature, including the series 'For the Things of these Days'. See Explanatory Notes Aug. 49 26.1.

12 Nov.  Hancock resigns proprietorship.

19 Nov.  P.R.B.s decided to abandon idea of advertizing magazine owing to expense. 'Big P.R.B.' dropped from prospectus.

25 Nov.  Hancock told Haynes the P.R.B. did not want to print with him.

4 Dec.  Thomas submits his first list of proposed titles to WMR.

10 Dec.  Title 'Thoughts towards Nature' retained despite Cave Thomas's proposal of 'The Seed'.—Plan to have in the first number 'an article explanatory of the principles in Art of the P.R.B.' no longer thought necessary.

15 Dec.  P.R.B.s settled to print magazine with George Tupper. —Question of whether contributions should be signed or anonymous to be submitted to arbitration of P.R.B. —Plan of the wrapper, included Thomas's device of a sower and WMR's sonnet sketched out.—Title, 'The Seed: Thoughts towards Nature in Poetry, Literature, and Art', adopted.

17 Dec.  Thomas announced that he would not have ready his design of the Sower for the wrapper of No. 1 (but could have it by No. 2).

19 Dec.  WHH gets second proof of etching,—Anonymity of contributions voted by P.R.B.—Title altered finally (from Thomas's second list of proposed titles) to *The Germ*.

21 Dec.  Proof of wrapper on green paper; WMR chose paper with salmon hue, and selected bordering.

22 Dec.  Corrected proof of first sheet, including Cave Thomas's opening address; his nature essay was not finished.

24 Dec.  Third impression of WHH's etching.—Received and corrected second sheet.

27 Dec. Proof of last sheet.—Owing to excess material, it was decided to omit Thomas's address.—Proof of last sheet full of blunders; second pull requested by DGR.

28 Dec. Second proof of last sheet.

31 Dec. 50 copies of *The Germ* received by Aylott and Jones.

## 1850

1 Jan. First number of *The Germ* published (700 copies printed, 50 with etchings on India paper).

15 Jan. P.R.B.s discuss advertizing *Germ* by posters.

17 Jan. Proofs of JC's 'The Child Jesus' and Patmore's 'Stars and Moon'; Tupper advises that 500 copies be printed of No. 2; WMR agrees.

20 Jan. WMR started collecting together the articles for No. 2.

21 Jan. WMR hears that publishers have sold 120–130 copies of No. 1.

23 Jan. Corrected proofs of FGS's essay and WBS's poem.

25 Jan. Proofs of WMR's review, of Campbell's sonnet, and of WMR's 'Fancies at Leisure'.—First sheet of No. 2, printed in pages.

27 Jan. Decision to publish contributors' names in future numbers. DGR invented name 'Ellen Alleyn' for CGR.

28 Jan. WMR looked over proofs of remaining articles; supplied Tupper with Table of Contents with names attached, also one for January. JC's fourth proof.

30 Jan. WMR gave publisher list of 25 newspapers and magazines to which *Germ* to be sent for review.—Publisher says he sold 70 copies (not 120–130 as reported) of No. 1.

31 Jan. No. 2 appeared (500 copies, an unspecified number with etchings on India paper).—FGS figures as 'John Seward'. —George Tupper renders bill for No. 1: £19. 1. 6 less 5 per cent discount, making £18. 2. 6.

2 Feb. P.R.B. unanimously of the opinion that *Germ* will not reach a third number.—Estimates of sales of No. 1 are 95 by P.R.B., 70 by publisher. Expenses to each proprietor will be £1. 15. $5\frac{1}{4}$.

9 Feb. Only 40 copies or so sold of No. 2; 'We certainly cannot attempt at Third number.'

| | |
|---|---|
| 16 Feb. | George Tupper and his brother express willingness to carry on *The Germ* at their expense for a number or two longer; will undertake to send copies to subscribers, to advertize by posters, etc.—Publishers announce sale of 100 copies of No. 1; No. 2 selling less well.—Doubtful whether No. 3 can come out at end of February. |
| 19 Feb. | Firm of Dickinson arranged for as publishers. |
| 23 Feb. | Some thought of changing the title to 'The Artist'. |
| 13 Mar. | Name changed to *Art and Poetry: Being Thoughts Towards Nature* (name suggested by Alexander Tupper). |
| 16 Mar. | Tupper drew up circular letter to be sent round on *Art and Poetry*. |
| 20 Mar. | First proofs of No. 3.—Tupper's new prospectus given to WMR. |
| 23 Mar. | New prospectus printed.—Tupper sent advertisement for next number of *Art Journal* (seems not to have appeared). |
| 28 Mar. | Proofs of second sheet.—George Tupper retained Aylott and Jones as joint publishers with Dickinson's. |
| 29 Mar. | Proof of last sheet of No. 3. |
| 31 Mar. | No. 3 appeared, as *Art and Poetry*, with announcement that 'future numbers will appear on the last day of the month for which they are dated'. |
| 2 Apr. | Tupper made a form for posters advertizing *The Germ*, which were sent out the following day. |
| 30 Apr. | No. 4 appeared, dated May. April pasteovers were subsequently issued, as were *Art and Poetry* labels for the title, 'for placing on the old wrappers, so as to make them comformable to the new'. |
| 23 May | George Tupper, reporting the total sales of No. 4 to WMR as 106 copies—there is nowhere recorded the number of copies printed of Nos. 3 and 4—concluded: 'I do not feel myself justified in bringing out another number' (letter in AP). |
| 21 July | WMR reported: 'Firstly, the "Gurm" died with its fourth No.—leaving us a legacy of Tupper's bill—£33 odd, of which the greater part, I take it, remains still unpaid.' Tupper was trying to collect on this outstanding debt from Deverell as late as 27 Oct. 1852 (see July 50 21.7, p. 231 below). |

# APPENDIX 6

## Poems on the P.R.B.

In his anthology, *The Painter-Poets*, Kineton Parkes included examples by
Rossetti, Brown, Collinson, Deverell, Scott, and Woolner, mainly taken from
*The Germ*, but reflecting that tendency among the Pre-Raphaelites to persuade
men of one talent to express themselves in the medium of another. During the
period of the P.R.B., all the Brothers experimented with verse; and the reading
of poetry dominated many P.R.B. gatherings. Nor was their interest in poetry
limited to the serious; the brothers Rossetti engaged in *bouts-rimés* composition,
and both indulged themselves with the writing of parodies and doggerel
verse-letters.

Given the Pre-Raphaelites' self-conscious preoccupation with their own
doings, it is not surprising that several poems survive which either commemo-
rate the Brotherhood or describe in a lighter vein some aspect of their activities
—a P.R.B. evening, the death of *The Germ*, or a prototypical response to an
old master. Many of these poems are the literary counterparts the many
caricatures and self-portraits that abounded during the heyday of the Brother-
hood.

The following poems have been gathered from various sources. Most are
well known, but they have never before been made available together. Two of
the pieces by the Rossetti brothers are unpublished, but they are not of an order
to add lustre to the canon of either writer. The three D. G. Rossetti sonnets are
in *Works*; Christina's are taken from the 1904 standard edition. 'A Quiet
Evening' was included by William Michael Rossetti in his edition of Tupper's
poems (1897); his mock elegy on the death of *The Germ* comes from the same
editor's *Memoir* of D. G. Rossetti. Scott's sonnet first appeared in his *Poems by
a Painter* (1854), and the text is taken from that volume rather than the revision
introduced in *Poems* twenty years later. The two verse-letters are printed from
manuscripts in the Bodleian (MS. don. e. 75, ff. 40–1; MS. don. e. 76, ff. 5–6).

## a. Eight Poems

### To the P.R.B.

Woolner and Stephens, Collinson, Millais,
 And my first brother, each and every one,
 What portion is theirs now beneath the sun
Which, even as here, in England makes to-day?
For most of them life runs not the same way

Always, but leaves the thought at loss: I know
Merely that Woolner keeps not even the show
Of work, nor is enough awake for play.
Meanwhile Hunt and myself race at full speed
Along the Louvre, and yawn from school to school,
Wishing worn-out those masters known as old.
And no man asks of Browning; though indeed
(As the book travels with me) any fool
Who would might hear Sordello's story told.

(D. G. Rossetti, 1849)

## Last Visit to the Louvre

The Cry of the P.R.B., after a careful Examination of the
Canvasses of Rubens, Correggio, *et hoc genus omne*.

*Non noi pittori!* God of Nature's truth,
If these, not we! Be it not said, when one
Of us goes hence: 'As these did, he hath done;
His feet sought out their footprints from his youth.'
Because, dear God! the flesh Thou madest smooth
These carked and fretted, that it seemed to run
With ulcers; and the daylight of thy sun
They parcelled into blots and glares, uncouth
With stagnant grouts of paint. Men say that these
Had further sight than man's, but that God saw
Their works were good. God that didst know them foul!
In such a blindness, blinder than the owl,
Leave us! Our sight can reach unto thy seas
And hills; and 'tis enough for tears of awe.

(D. G. Rossetti, 1849)

## St. Wagnes' Eve

The hop-shop is shut up: the night doth wear.
Here, early, Collinson this evening fell
'Into the gulfs of sleep'; and Deverell
Has turned upon the pivot of his chair
The whole of this night long; and Hancock there

Has laboured to repeat, in accents screechy,
  'Guardami ben, ben son, ben son Beatrice';
And Bernhard Smith still beamed, serene and square.
By eight, the coffee was all drunk. At nine
  We gave the cat some milk. Our talk did shelve,
    Ere ten, to gasps and stupor. Helpless grief
Made, towards eleven, my inmost spirit pine,
  Knowing North's hour. And Hancock, hard on twelve,
    Showed an engraving of his bas-relief.

<div align="right">(D. G. Rossetti, 1851)</div>

## The P.R.B.

### 1

The two Rossettis (brothers they)
And Holman Hunt and John Millais,
With Stephens chivalrous and bland,
And Woolner in a distant land—
In these six men I awestruck see
Embodied the great P.R.B.
D. G. Rossetti offered two
Good pictures to the public view;
Unnumbered ones great John Millais,
And Holman more than I can say.

William Rossetti, calm and solemn,
Cuts up his brethren by the column.

### 2

The P.R.B. is in its decadence:
  For Woolner in Australia cooks his chops,
    And Hunt is yearning for the land of Cheops;
  D. G. Rossetti shuns the vulgar optic;
While William M. Rossetti merely lops
  His B's in English disesteemed as Coptic;
    Calm Stephens in the twilight smokes his pipe,
      But long the dawning of his public day;
    And he at last the champion great Millais,
Attaining academic opulence,
  Winds up his signature with A.R.A.

So rivers merge in the perpetual sea;
So luscious fruit must fall when over-ripe;
And so the consummated P.R.B.

<div align="right">(C. G. Rossetti, 1853)</div>

## A Quiet Evening

From mere *ennui* the very cat
Walked out—it was so precious flat.
Due on the sofa Gabriel sat,
And next to him was Stephens found;
I think, but am not certain, that
The fender William's legs were round.

However, all was drowsy, mild,
And nothing like to break the charm,
Though John essayed in some alarm
To read his latest muse-born child;
Then Gabriel moved his active arm,
And some believe that Stephens smiled.

But certain 'tis that Aleck, who
Had watched that arm, as anglers do
Their quiet float, an hour or two,
Was pleased to find it move at last.
He therefore filled his pipe anew,
And doubled the mundungus blast.

The poem yet went on and on:
The poet kept his eyes upon
The paper till the piece was done;
And then the coke-fire's roof fell in.
Another accident, which one
Should mention, William scorched his shin.

And nothing more till supper time:
Except that Gabriel read a rhyme
Of Hell and Heaven and ghosts and crime
That gave the room a kind of chill,
And rapture followed—so sublime
That forty minutes all was still.

Till all the solemn company
Went down to supper—verily
The supper went off quietly.
Trying to talk was all in vain:
And then we went up silently
Into the lonesome room again.

Oh was it quiet? I can swear
I heard the separate gas lights flare,
The creak of the vibrating chair
The balanced Aleck swung upon:
The balanced Aleck swinging there
Knew it, and so went swinging on.

Six men, each seated in his seat,
With body, arms, and legs complete—
A passive mass of flesh, alack!
That none but human cattle make!
The wonder was that they could meet
So silent and so long awake.

But Gabriel coiled himself, at last,
Upon the sofa—Stephens cast
His weary arms out, William past
A thoughtful hand across his eyes,
And George has blown a fainter blast
To listen till the snores arise.

And somewhat quickly they arose—
He could distinguish Gabriel's nose
From William's mouth in sweet repose,
Whose measured murmurs now began;
While John L. Tupper, half in dose,
Was crooning as he only can.

And Stephens—no, he took to flight
Before he slept. Then Aleck's sight
Denied his pipe was yet alight;
He put it down and grimly stared,
Then crammed it to the muzzle tight,
And listened—that was all he dared.

For not a waking P.R.B.
Was left; a blinding mystery
Of smoke was over all the three
Enduring souls that kept awake.
They listened—'twas the harmony
Of cats!—or there was some mistake.

Then looking on the garden plot
Without, they verified the not
Unwelcome fact: the cats had got
Convivial, sure enough; and we
Could recognize friend Thomas hot
In mirth like Burns 'among the three.'

But if the cats held conference,
What then? We might not make pretence
To such—witness the prudent sense
Of Stephens getting up to go.
I'd give my cat the preference,
Who left us somewhat sooner, though.

(J. L. Tupper, 1850)

Dedicated to the P.R.B. on the Death of *The Germ*, otherwise
known as *Art and Poetry*.

Bring leaves of yew to intertwine
  With 'leaves' that evermore are dead,
Those leaves as pallid-hued as you
  Who wrote them never to be read:
  And let them hang across a thread
Of funeral-hemp, that, hanging so,
Made vocal if a wind should blow,
  Their requiem shall be anthemèd.

Ah rest, dead leaves!—Ye *cannot* rest
  Now ye are in your second state;
  Your first was rest so perfect, fate
Denies you what ye then possessed.
For you, was not a world of strife,
  And seldom were ye seen of men:
If death be the reverse of life,
  You never will have peace again.

Come, Early Christians, bring a knife,
  And cut these woful pages down:
  Ye would not have them haunt the town
Where butter or where cheese is rife!
  No, make them in a foolscap-crown
For all whose inexperience utter
  Believes High Art can once go down
Without considerable butter.

Or cut them into little squares
  To curl the long locks of those Brothers
Præraphaelite who have long hairs—
  Tremendous long, compared with others.
As dust should still return to dust,
  The P.R.B. shall say its prayers
  That come it will or come it must—*

A time *Sordello* shall be read,
  And arguments be clean abolished,
And sculpture punched upon the head,
  And mathematics quite demolished;
And *Art and Poetry* instead
  Come out without a word of prose in,
And all who paint as Sloshua did
  Have all their sloshy fingers frozen.

                    (J. L. Tupper, 1850)

* 'A line seems to be wanting in this stanza'    (WMR)

## To the Artists Called P.R.B.

I thank you, Brethren in Sincerity!
I, who, within the circle of this Art,
The charmed circle, humbly stand apart,
Scornfully, also, with a listless eye,
Sick of conventional vitality:
For ye have shewn with youth's brave confidence,
The honesty of true speech, that intense
Reality uniting soul and sense.

When Faith is strong, Art strikes its roots far down,
And bears both flower and fruit with seeded core,
When Faith dies out, the fruit appears no more,
But the flower bears a worm within its crown:
Rejoice, and shrink not; once again Art's way
Shall be made odorous with new showers of May!

<div align="right">(W. B. Scott, 1851)</div>

## b. Two Verse-Letters

'Remember me to Gabriel; I fear he has quarrelled with me.'—
genuine extract from the 'Diary and Letters of a Maniac'

He says that I am wroth with him
Which reading, I should have been wroth
Indeed, if the strange overgrowth
Of downright nonsense & crude whim

Which straggles once & yet again
From page to page of that wild note
Had not first proved him, beyond doubt,
Quite irresponsibly insane.

Was this well, brother, to have rear'd
Thy pen against me? I would come
To Lambeth through the heat & hum
And beard thee—had'st thou any beard.

Bravo! Go at him! Crushing, this!
Revenge, folk say, is sweet. It is.
Ha! ha! ha! He! he! he!
Thus much from Dante Rossetti
To Frederick Stephens, P.R.B.

<div align="right">(D. G. Rossetti, undated)</div>

It is now Past the hour of 12;
Gabriel's dozing in his chair.
And so this letter I will shelve,
As soon, as may be, dear Brother.

Not that I mean to go to bed
    Quite yet. I have the P.R.B.
Diary to write up instead.
    Tho' there is nothing verily.

I yesterday bought Woolner's Keats'
    Letters & Life for seven & six:
You will agree this somewhat beats
    Giving 14 for it—(or licks,

As Schoolboys say): by this last rhyme
    You'll see how most hard up I am:
Indeed this writing against time,
    If not i' vein, is a mere sham.

Cordiality can speak in prose,
    And say good morning & good bye
For Ave & Adieu. Suppose
    That I to do so now should try.

And yet, dear brother, I confess
    Your full-leafed letter would deserve
A better answer. Nevertheless
    Take this. And think it but a curve

Of the broad circle wherewith I
    Encircle you in P.R.B.-
-hood. And so, truly now, Good bye.
    Yours, I to you as you to me,
        W. M. Rossetti
      (to F. G. Stephens, 30 June 1849)

# APPENDIX 7

## 'Mrs. Holmes Grey'

DURING September 1849, while he was on holiday in the Isle of Wight, W. M. Rossetti was mainly occupied in composing his blank verse narrative, which, until its length grew to more than 800 lines, he intended to include in *The Germ*. Originally entitled 'An Exchange of News', later altered to 'A Plain Story of Life', the poem is unquestionably Rossetti's most important creative production and a document of the Pre-Raphaelite Brotherhood that deserves to be preserved. WMR says quite explicitly that 'Mrs. Holmes Grey' was modelled on Pre-Raphaelite naturalistic principles, 'excluding (in literature) exalted descriptive matter from any speech which professed to be a speech uttered in ordinary real life' (*SR*, i. 81):

The informing idea of the poem was to apply to verse-writing the same principle of strict actuality and probability of detail which the Præraphaelites upheld in their pictures. It was in short a Præraphaelite poem. The subject is a conversation about the death of a lady, a surgeon's wife, who had died suddenly in the house of another medical man for whom she had conceived a vehement and unreciprocated passion; and a newspaper report of the coroner's inquest occupies a large space in the composition (*FLM*, ii. 63).

In 1868, Rossetti published the poem in *The Broadway* and *The Broadway Annual* as 'Mrs. Holmes Grey', with an illustration by Arthur Boyd Houghton and a tail-note explaining the Pre-Raphaelite genesis of the work. Although three anthologies of Pre-Raphaelite poetry have been published in the past few years, 'Mrs. Holmes Grey' has never been reprinted; it seems particularly apposite that it should appear with the *Journal*, in which the compositional history of the poem is so thoroughly detailed. The background and relevance of the poem, together with a brief analysis, appear in William E. Fredeman's 'A Key Poem of the Pre-Raphaelite Movement', in *Nineteenth-Century Literary Perspectives* (Durham, N.C., 1974). Rossetti's accompanying note makes sufficiently clear his intended purpose in writing the poem:

The reader will observe the already remote date at which this poem was written. Those were the days when the præ-Raphaelite movement in painting was first started. I, who was as much mixed up and interested in it as any person not practically an artist could well be, entertained the idea that the like principles might be carried out in poetry; and that it would be possible, without losing the poetical, dramatic, or even tragic tone and impression, to approach nearer to the actualities of dialogue and narration than had ever yet been done. With an unpractised hand I tried the experiment; and the result is this blank-verse tale, which is now published, not indeed without some revision, but without the least alteration in its general character and point of view.

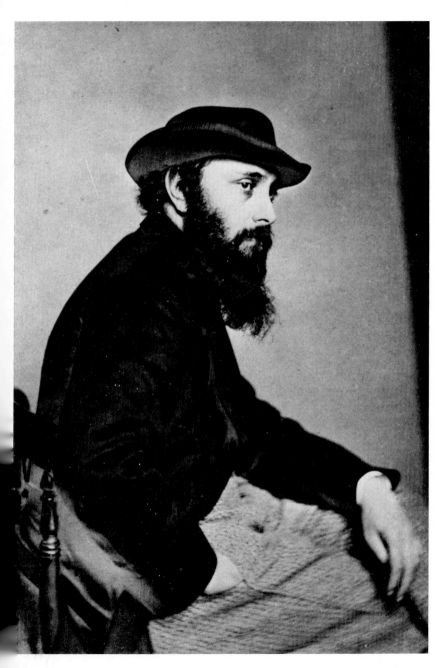

9. W. M. Rossetti in the 1860's

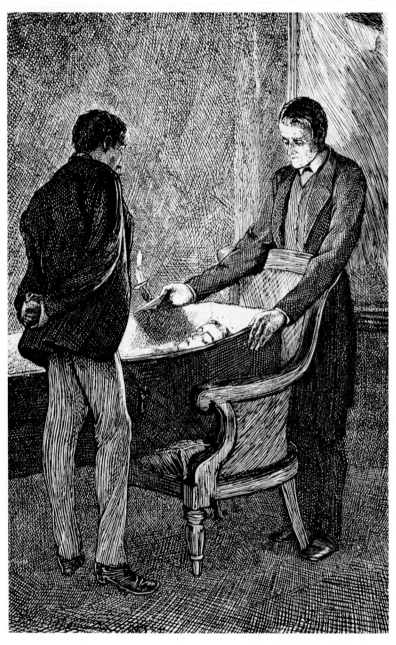

10. Illustration for 'Mrs. Holmes Grey' by Arthur Boyd Houghton

# Mrs. Holmes Grey

BY WILLIAM M. ROSSETTI.

'Perverseness is one of the primitive impulses of the human heart; one of the indivisible primary faculties or sentiments which give direction to the character of man.'—EDGAR POE.

RAIN-WASHED for hours, the streets at last were dried.
Profuse and pulpy sea-wood on the beach,
Pushed by the latest heavy tide some way
Across the jostled shingle, was too far
For washing back, now that the sea at ebb
Left an each time retreating track of foam.
There were the wonted tetchy and sidelong crabs,
With fishes silvery in distended death.

No want of blue now in the upper sky:—
But also many piled-up flat grey clouds,                    10
Threatening a stormy night-time; and the sun
Sank, a red glare, between two lengthened streaks,
Hot dun, that stretched to southward; and at whiles
The wind over the water swept and swept.

The townspeople, and, more, the visitors,
Were passing to the sea-beach through the streets,
To take advantage of the lull of rain.
The English 'Rainy weather' went from mouth
To mouth, with 'Very' answered, or a shrug
Of shoulders, and a growl, and 'Sure to be!                20
Began the very day that we arrived.'

'Yes,' answered one who met a travelling friend;
'I had forgotten that in England you
Must carry your umbrella every day.
An Englishman's a centaur of his sort,
Man cross-bred with umbrella. All the same,
I say good-bye to France and Italy,
Now that I'm here again. Excuse me now,
As I was going up into the town
To feast my eyes on British tiles and slates.'             30

So on he walked, looking about him. Rows
Of houses were passed by, irregular;
Many compacted of the shingle-stones,
Round, grey or white—with each its garden patch
Now as the outskirts neared; and down the streets
Which crossed them he was catching glimpses still
Of waves which whitening shattered out at sea.

The road grew steep here, climbing up a slope
Strewn with October leaves, which followed him,
Or drifted edgeways on. The grey advanced,                    40
Half colour and half dusk, along the sky.

A dead leaf from a beech-tree loosed itself,
And touched across his forehead. As he raised
His eyes, they caught a window, and he stopped—
An opened upper window of a house
With close-drawn blinds. A man was settled there,
Eager in looking out, yet covertly.
He watched, nor moved his eyes from that he watched.

The passenger drew close beside the rails,
Looking attentively. 'Why, Grey,' he cried;                    50
'Can that be you, Grey? I had thought you'd been——'
The face turned sharply on him, and the eyes
Glanced down, and both hands pulled the window shut.

Pushing a wicket-gate, the other went
On to the door, expecting it to unclose.
The garden was but scantly stocked with flowers,
And these were fading mostly, thinly leaved,
The earth-plots littered with the fall of them.
Stately some dahlia-clusters yet delayed,
Crimson, alternating with flame-colour.                    60
He stretched his fingers to the velvet bloom
Of one, and drew a petal 'twixt them. Then
The plaited flower fell separate all to earth
By ring and ring; only the calyx stood
Upon its stalk. The autumn time was come.
Out of the bordering box stiff plantain grew.

Scarce would the loose trees have afforded shade,
So lessened was the bulk between their boughs,
Had there been sun to cast it. In the grass
Rested the moisture of the recent rain.          70

No one seemed coming; so he walked some steps
Backward, and peered: no sign of any one.
He knocked, and at the touch the door unclosed.

'Don't you remember, years ago, your friend,
And correspondent since, John Harling?'

                          'Oh,
I know you, sir, of course—I did at once.'

'*Sir!* Why, how now? Between old friends like us?
How many letters that begin "*Dear John*,"
In your handwriting, I have asked after,
These eight years, in some scores of *postes-restantes!*          80
Too many, I should hope, for us to *Sir*
Each other now. But only tell me, Grey——'

Grey said, 'Come up, come up.'

                    There was a haste
About his words and manner, and he seemed
To half forget what first he meant to do.
He paused at the stairs' foot; then, with a glance
Thrown backward at his friend, who stayed for him,
He mounted hurriedly, two steps at once.
They had not shaken hands yet. Harling his
Had proffered with the words he uttered first,          90
But Grey had not appeared to notice it.

Harling had caught the look of the other's face
Where twilight in the doorway glimmered fresh,
And he had fancied it was pale and worn,
And anxious as with watchings through the night.
But in the room the light no longer served
For one to see the other, how the weeks
Had changed him, and the months and years. The room
Was dim between the window-blinds and dusk.

Now seated—'As you see, John,' Grey began,     100
'This is a bed-room. I have not had time
To trouble myself yet about the house.'

'You are but just arrived, then?'

               'Yes, but just.'
He was about to say some more, but stopped.

'And now,' said Harling, 'you shall tell me all
About yourself. And how and where's your wife?
What is it brought you down here? Have you left
Oxford, in which your practice was so good?
Or are you here on holidays? I come
Upon you by an unexpected chance.     110
There must be something to be learned, I know;
Chances are not all chance-work. Tell me all.'

His friend rose up at this; and Harling saw
His knuckles on his forehead, at his hair,
And thought his eyes grew larger through the dark.
Grey touched him on the shoulder, drawing breath
To speak with, but he then again sat down.

'Why, first I ought to hear *your* news, I think,'
At last he answered, swallowing the gasps
Which came into his mouth, and clipped his words.     120
'Though travellers have a vested right to lie,
I'll take it all on trust.' He forged a laugh.

Harling grew certain there was something now
His friend had got to tell, and must, but feared.
He knew how such a fear, by yielding grows,
And would have had him speak it out at once.
Nevertheless he answered, 'As you will.
And yet I have but little left to say
Since my last letter. But the whole is this.
But let us first have light before we talk,     130
That we may know each other once again.
I shall not flatter you if grizzled hairs
Prove to outnumber your original brown,
But tell you truth. You tell the truth of me.

I am more than half a Frenchman, I believe,
By this time. That's no compliment, say I,
For a John Bull at heart, and I am one;
Thank God, a Tory, and hang the Marseillaise!'

'No lights, no lights,' Grey answered, moodily.                    140
'Can we not talk again as once we used,
Through twilight and through evening into night,
Knowing, without a light, it was we two?—
I little thought then it would come to this,'
He added, and his voice was only sad.
'And it is well too, that the light should come,
For then perhaps you will have made a guess,
By seeing me, before I tell it you.
My dear old friend, it's needless now to attempt
To hide it. I am wretched—that's the word.
I am a fool not to have got the thing                    150
Over already, for it has to come
At last. But there's a minute's respite still,
For first you were to tell me of yourself;
So, Harling, you speak now. But first the light.'

The other, leaning forward, took his hand,
And tried to speak some comfort; but the words
Faltered between his lips. For he was sure
That, if he had already heard this grief,
He would not talk of comfort, but sit dumb.

The lights were come now, and each looked on each.                    160
The traveller's face was bronzed, and his hair crisp
And close, and his eyes steady—all himself
Compact and prompt to any chance. And yet
He was essentially the same who went,
To find his level, forth eight years ago,
Unformed, florid-complexioned, easy-tongued:
Travel and time had only mellowed him.
Grey was the same in feature, not in fact.
His face was paler that was always pale;
The forehead something wrinkled, and the lips                    170

Arid and meagre, faded, marked with lines;
The eyes had sunken further in the head,
With a dark ridge to each, and grizzled brows;
His hair, though as of old, was brown and soft.
The difference was less, but more the change.
Each looked on each some minutes: neither spoke.
His friend was clothed in black, as Harling saw,
Who now resumed the thread of his discourse.

'As for my own adventures, they are few:
For, after I left Rome—the storm will burst,　　　　　180
Be sure, at Rome, before the year is done—
I went straight back to Paris. Politics,
You know, I've stood aloof from all the year;
But even with me, too, they have done their work.
My poor Louise was dead—shot down, I learned,
Upon the people's barricades in June:
She turned up quite a Red Republican
After their twenty-fourth of February;
And my successor in her graces fell
With her—both fighting and yelling side by side.　　　190
I could not but curse at them through my teeth
With her own *sacré-Dieu's*—the whole of them
Who get up revolutions and revolts.
And then they swore I was an Orleanist,
An English spy, or something; and indeed
I found myself, the scanty days I stopped,
A centre-piece for all the blackest looks.
At least I thought so. Many of my friends,
Besides, were gone, waiting for better times
When next they come to Paris. So I left　　　　　200
Disgusted, and crossed over. Why should I
Quit England and dear brother Tories? still,
Although I do now think of settling here,
Perhaps, before another twelvemonth goes,
The South will tempt me back—sooner, perhaps.
I must, I think, die travelling in the South.'

He made an end of speaking. Grey looked up.
'Is there no more?' he asked. He said, 'No more.'

Grey's face turned whiter, and his fingers twitched.
'It is my turn to speak, then':—and he rose,                    210
Taking a candle: 'come this way with me.'

They stepped aside into a neighbouring room.
Grey walked with quiet footsteps, and he turned
So noiselessly the handle of the door
That Harling fancied some one lay asleep
Inside. The hand recovered steadiness.

The room was quite unfurnished, striking chill.
A rent in the drawn window-blind betrayed
A sky unvaried, moonless, cloudless, black.                     220
Only two chairs were set against the wall,
And, not yet closed, a coffin placed on them.

Harling's raised eyes inquired why he was brought
Hither, and should he still advance and look.
'It is my wife,' said Grey; 'look in her face.'
This in a whisper, holding Harling's arm,
And tightened fingers clenched the whispering.

Harling could feel his forehead growing moist,
And sought in vain his friend's averted eyes.
Their steps, suppressed, creaked on the uncovered boards:
They stood beside the coffin's foot and head.                   230
Both gazed in silence, with bowed faces—Grey
With bony chin pressed into bony throat.

The woman's limbs were straight inside her shroud.
The death which brooded glazed upon her eyes
Was hidden underneath the shapely lids;
But the mouth kept its anguish. Combed and rich
The hair, which caught the light within its strings,
Golden about the temples, and as fine
And soft as any silk-web; and the brows
A perfect arch, the forehead undisturbed;                      240
But the mouth kept its anguish, and the lips,
Closed after death, seemed half in act to speak.

Covered the hands and feet; the head was laid
Upon a prayer-book, open at the rite
Of solemnizing holy matrimony.
Her marriage-ring was stitched into the page.

Grey stood a long while gazing. Then he set
The candle on the ground, and on his knees
Close to her unringed shrouded hand, he prayed,
Silent. With eyes still dry, he rose unchanged.                     250

They left the room again with heeded steps.
On friendly Harling lay the awe of death
And pity: he took his seat without a sound.
Some of the hackneyed phrases almost passed
His lips, but shamed him, and he held his peace.

'Harling,' said Grey, after a pause, 'you think
No doubt that this is all—her death is all.
Harling, when first I saw you in the street,
I feared you meant to come and speak to me;
So hid myself and waited till you knocked;                          260
Waited behind the door until you knocked,
Longing that you, perhaps, would go. When I
Had opened it, I think I called you *Sir*—
Did you not chide me? Do you know, it seemed
So strange to me that any one I knew
Before this happened should be here the same,
And know me for the same that once I was,
I could not quite imagine we were friends.
It is not merely death would make one feel
Like this—no, there is something more behind                        270
Harder than death, more cruel. Let me wait
Some moments; then no help but I must tell.'

He gathered up his face into his hands
From chin to temples, only just to think
And not be seen. He had not seated him,
But leaned against the chair. Nor Harling spoke.

'Two months are gone now,' Grey pursued. 'We two
Lived lovingly. I had to come down here,

And here I met a surgeon of the town.
Hell only knows—I cannot tell you—why, 280
I asked him to return with me, and spend
A fortnight at our house. Perhaps I wrote
The whole of this to you when it occurred.
His name is Luton.'

               Here he chose to pause.
'Perhaps: I am not certain,' Harling said.

'I think you might be certain,' answered Grey,
'If you're my friend.' But then he checked himself,
Adding: 'Forgive me. I am not, you see,
Myself to-night—this night, nor many nights,
Nor many nights to come. Well, he agreed. 290
Of course, he must agree; else I should not
Have been like this, disgraced, made almost mad.'

At this he found his passion would be near
To drive him to talk wildly: so he kept
Silence again some moments—then resumed.

'How should I recollect the days we passed
Together? There must surely have been enough
To see, and yet I never saw it once.
Besides, my patients kept me out all day
Sometimes. It was in August, John, was this— 300
The end of August, reaping just begun.
We've had a splendid harvest, you'll have heard.'

'Indeed!' the other said, shifting the while
His posture—and he knew not what to say.

'Yes, you detect me,' Grey cried bitterly;
'You know I am afraid of what's to come—
A coward. Now I do hope I shall speak,
And tell you all of it without a stop.
There was a lady staying with us then,
A cousin of my wife's—but older, much; 310
So that you understand how I could ask
This Luton down. Before his time was up,

He seemed to grow uneasy, and he left,—
Merely explaining, business called him home.
I said I had not noticed anything
Unusual; and yet I sometimes found
Mary in tears, and could not gather why.
One day she told me when I questioned her
It was for thinking of our girl that died
Months back—for that her cousin would begin          320
Often to talk to her about her own;
So that would make her sad. I thought it strange
She had not so informed me from the first.
Her cousin, when I named the point, appeared
Surprised; but then to recollect herself,
And answered—I could see, a little piqued—
She should not cry again because of her.

'These fits of tears continued. We were now
Alone together, for the cousin went
Away soon after. Then I could not help          330
Seeing her health and strength were giving way:
Her mind, too, seemed oppressed. She'd hardly leave
At nights the chair she sat in, for she said
"This is the only place where I can sleep."
Yet her affection for me seemed to grow
A kind of pity for its tenderness.
Oh! what is now become of her, that I,
After to-morrow, shall not see her more,
But have to hide her always from my sight?'

He took some steps, meaning to go again          340
And see her corpse; but, meeting Harling's eye,
Turned and sat down.

                              'Is it not,' he pursued,
With floorward gaze, 'hard on me I must tell
This business word by word, the whole of it,
While I can see it all before me there,
And it is clear one word could tell it all?
Can you not guess the rest, and spare me now?'

'I will not guess; but you,' said Harling, 'keep
All that remains unspoken; for it wrings
My heart, dear Grey, dear friend, to see you thus.'          350

'No, it is better I should speak it out,
For you would fancy something; and at least
You will not need to fancy when you know.
She came to me one morning—(this was like
A fortnight after he had gone away,
This Luton)—saying that she found it vain
Attempting to compose her mind at home;
That every place made her remember what
The baby had done or looked there, and she felt
Too weak for that, and meant to see her friends          360
(That is, two sisters some few miles from here).
She spoke more firmly than I had heard her talk
A long time past—because I thought it long—
And I believed she had determined right,
And so consented. But she only said
"I have made up my mind"—thus waiving all
Consent on my part—mere sick wilfulness
I took it for. She left the house. I might
Have told you she'd a lilac dress, and hair
Worn plain. And so I saw her the last time—          370
The last time, God in heaven!' He seized his fists
Together, and he clutched them towards his throat.

'Many days passed. She had begged me, feeling sure
It would excite her, not to write a line,
And said she would not write, nor let her friends.
I think I did not tell you, though, how pale
Her cheeks were; and, in saying this, she sobbed,
For such a lengthened silence looked like death.

'Three weeks, or nearly that, had passed away:
A letter on black-bordered paper came.          380
It was from Luton. Then I did not know
The hand, but shall now, if it comes again.
He wrote that I must go immediately,
That I was "to prepare myself"—some trash:
He "dared not trust his pen to tell me more."

'On Thursday I arrived here. I cannot
Attempt to tell you all about it. When
You've read this, only call me, and I'll come;
But I will not be by you while you read.
On the first day I heard it all from him,                    390
And loathe him for it. I am left alone,
And all through him.'

                            He took a newspaper
From underneath his pillow, and he showed
The place to read at. Then he left the room;
And Harling caught his footfall toward the corpse,
And touching of his knees upon the boards.

And this is what he feverishly perused:—

'*Coroner's Inquest—A Distressing Case.*

An inquest was held yesterday, before
The County Coroner, into the cause                    400
Of the decease of Mrs. Mary Grey,
A married lady. Public interest
Was widely excited.

                        'When the Jury came
From viewing the corpse, in which are seen remains
Of no small beauty, witnesses were called.

'Mr. Holmes Grey, surgeon, deposed: "I live
In Oxford, where I practise, and deceased
Had been my wife for upwards of three years.
About the middle of September, she
Was suffering much from weakness, and a weight                    410
Seemed on her mind. The symptoms had begun
Nearly a month before, and still increased,
Until at last they gave me great alarm,
Of which we often spoke. On the eighteenth
She told me she would like to stay awhile
With two of her sisters, living on the coast,
At Barksedge House, not far from here. She went
Next day. I cannot speak to any more."

'The Coroner: "How were you first apprised
Of this most melancholy event?"—"By note                    420
Addressed to me by Mr. Luton here."

'A Juror: "Could your scientific skill
Assign some cause for this debility?"
"No. I believed it was occasioned (so
She intimated) by a domestic grief
Quite unconnected with the present case."

'The Coroner: "You'll know how to excuse
The question which I feel compelled to put:
I have a public duty to perform.
Had you, before the period you described,                    430
Any suspicions ever?"—"Never once:
There was no cause for any, I swear to God."

'The witness had, throughout his testimony,
Preserved his calm—though clearly not without
An effort, which augmented towards the close.

'Jane Langley: "I keep lodgings in the town.
On the nineteenth September the deceased
Engaged a bed-room and a sitting-room.
The name I knew her by was Mrs. Grange.
I saw but very little of her; she kept,                    440
As much as that well could be, to herself,
And she would frequently leave home for hours.
I cannot say I made any remark
Especially. I found a letter once—
Just a few words, torn up. "Holmes," it began.
"This letter is the last you ever will . . ."
No more, I think. I threw the bits away.
That was, perhaps, four days before her death.
On that day, I suppose, as usual,
She left the house: I did not see her, though.                    450
She was brought home quite dead."

                                        'Upon the name
Of the next witness being called, some stir
Arose through persons pressing on to look.

After it had been silenced, and the oath
Duly administered, the evidence
Proceeded.

                    'Mr. Edward Luton, surgeon:
"I lately here began for the first time
In my profession. I was introduced
To Mr. Grey in August. When he left
The seaside, he invited me to pass                           460
A fortnight at his house, and I agreed.
On seeing Mrs. Grey, I recognized
In her a lady I had known before
Her marriage, a Miss Chalsted. We had met
In company, and, in particular,
At some so-called 'mesmeric evenings,' held
At her remote connection's house, the late
Dr. Duplatt. But now, as Mrs. Grey
Allowed my presentation to pass off
Without a hint of knowing me, I left                         470
This point to her, and seemed a stranger: till
We chanced, the sixth day, to be left alone.
I talked on just the same, but she was silent.
At last she answered, and began to speak
Familiarly of when she knew me first;
Without explaining—merely as one might talk
Changing the subject. But I let it pass.
And yet, when we were next in company,
Once more she acted new acquaintanceship.
Then, two days after, I believe—one time                    480
Her cousin, Mrs. Gwyllt, was out by chance—
The same thing happened; but she spoke of love
Now, and the very word half passed her lips.
Our talk ended abruptly. Mrs. Gwyllt
Came in, and by her face I saw she had heard.

'"This instance was the last we talked alone.
And I began to hear from Mr. Grey
His wife was far from well, and had the tears
Now often in her eyes. This made me feel
Hampered and restless: so I took my leave                   490

After my first eleven days' stay was gone,
Saying I had affairs that could not wait.

'"Between the seventh of September, when
We parted, and the twenty-third, I saw
No more of the deceased. Towards seven o'clock
That evening, I was told a lady wished
To speak with me. She entered: it was she—
Deceased. I can't describe how pained I was
At finding she had left her home like this.
She said she loved me, and conjured me much        500
Not to desert her; that she loved me young;
That, after we had ceased to meet, she knew
And married Mr. Grey. Also, that when
He wrote to her in August I should come,
Guessing who I must be, she thought it well
To treat me as a stranger—dreading lest
Her love (so she assured me) should revive.
All this through sobs and blushes. I could not
Make up my mind what conduct to pursue:
I begged her to be calm, and wait awhile,          510
And I would write. She left unnerved and weak.

'"I took five days, bewildered how to act.
But on the evening of the fifth, I saw
While looking out of window—(it was dusk,
And almost nightfall)—Mrs. Grey, who paced,
Muffled in clothes, before my door. I knew
By this how dangerous it must be to wait
For a day longer; so I wrote at once
She absolutely must return to her home.
Nothing was known as yet—all might be well;       520
In time she would forget me; and besides
I was engaged to marry, and must regard
Our intercourse as ended.

'"She returned
Next day, the twenty-ninth; and, falling down
Upon her knees, she cried, with hardly a word,
Some while, and kept her face between her hands;

But at the last she swore she would not go,
But rather die here. It continued thus
Six days. For she would come and seat herself,
When I was present, in my room, and sit,                     530
An hour or near, quite silent; or break out
Into a flood of words—and then, perhaps
Between two syllables, stop short, and turn
Round in her chair, and sob, and hide her tears.

'"The sixth day, after she had left the house,
I had an intimation we were watched,
And certain persons had begun to talk.
I thought it indispensable to write
Once more, and tell her she could not remain—
I owed it to myself not to allow                             540
This state of things to last; that I had given
The servant orders to deny me, should
She still persist in calling.

                      '"Towards mid-day
Of the sixth instant, the deceased once more
Was at my house, however;—darted through
The door, which happened to be left ajar,
And flung herself right down before my feet.
This day she did not shed a single tear,
Nor talk at all at random, but was firm:
I mean, unalterably resolute                                 550
In purpose, and her passion more uncurbed
Than ever: swore it was impossible
She should return to live with Mr. Grey
Again; that, were she at her latest hour,
She still would say so, and die saying so:
"Because" (I recollect her words) "this flame
All eats me up while I am here with you;
I hate it, but it eats me—eats me up,
Till I have now no will to wish it quenched."
I hope to be excused repeating all                           560
That I remember to have heard her say.
She bitterly upbraided me for what
I last had written to her, and declared

She hated me and loved me all at once
With perfect hate as well as burning love.
This must have lasted fully half an hour.
However fearful as to the results,
I told her simply I could not retract,
And she must go, or I immediately
Would write to Mr. Grey. I rose at this                    570
To leave the room.

     '"She staggered up as well,
And screamed, and caught about her with her hands:
I think she could not see. I dreaded lest
She might be falling, and I held her arm,
Trying to guide her out. As I did so,
She, in a hurry, faced on me, and screamed
Aloud once more, and wanted, as I thought,
To speak, but, in a second, fell.

     '"I raised
Her body in my arms, and found her dead.
I had her carried home without delay,                      580
And a physician called, whose view concurred
With mine—that instant death must have ensued
Upon the rupture of a blood-vessel."

'This deposition had been listened to
In the most perfect silence. At its close
We understand a lady was removed
Fainting.

    'The Coroner: "You said just now
That, in your former letter to deceased,
You told her nothing yet was known. Was not
Her absence traced, then, and suspicion roused?          590
Did she inform you?" "She informed me that
Would not be, for that Mr. Grey and she
Had mutually consented not to write.
I have forgotten why."

     'The Coroner:
"Is Mr. Grey still present?" Mr. Grey:
"Yes, I am here." "You heard the last reply;
Was such the case?" "It was; we had agreed

To exchange no letters, that her mind might have
The benefit of more complete repose."

'A Juror to the witness: "Did no acts          600
Of familiarity occur between
Deceased and you?"

                              'Here Mr. Grey addressed
The Coroner, demurring to a reply.

'The Coroner: "It grieves me very much
To pain your feelings; but I feel compelled
To say the question is a proper one.
It is the Jury's duty to gain light
On this exceedingly distressing case;
The public mind has to be satisfied;
I owe a duty to the public. Let          610
The witness answer."

                         'Witness: "She would clasp
Her arms around me in speaking tenderly,
And kiss me. She has often kissed my hands.
Not beyond that."

                         'The Juror: "And did you
Respond——" The Coroner: "The witness should,
I think, be pressed no further. He has given
His painful evidence most creditably."

'The Juror: "Did deceased, in all these days,
Not write to you at all?" "She sent me this:
It is the only letter I received."          620

'A letter here was handed in and read.
It ran as follows, and it bore the date
Of twenty-sixth September.

                         '"Dearest Friend,—
Where is your promise you would write me soon
My sentence, death or life? This is the third
Of three long days since last I saw you. Oh!
To press your hand again, and talk to you,

And see the moving of your lips and eyes!
Edward, I'm certain that you cannot know
How much I love you; you must not decide                    630
Until convinced of it—— But words are dead.
That, Edward, is a love in very truth
Which can avail to overcome such shame
As kept me four whole days from seeing you—
Four days after my coming quite resolved
To strive no more, but tell you all my heart.
As daylight passed, and night devoured the dusk,
The first time, and the second, and the third,
I doubted whether I could ever wait
Till dawn—yet waited all the fourth day too,                640
Staring upon my hands, and looking strange;
Yes, and the fifth day's twilight hastened on.
But love began then driving me about
Between my house and your house, to and fro.
At last I could no more delay, but wept,
And prayed of Christ (for He discerns it all),
That, if this thing were sinful unto death,
He would Himself be first to throw the stone.
So then I came and saw you, and I spoke.
Did I not make you understand how I                         650
Had loved you in the budding of my youth;
And how, when we divided, all my hope
Went out from me for all the future days,
And how I married, just indifferent
To whom I took? Perhaps I did not clear
This up enough, or cried and troubled you.
Why did I ever see your face again?
I had forgotten you; I lived content,
At peace. Forgotten you! that now appears
Impossible, yet I believe I had.                            660
Then see what now my life must be—consumed
With inner very fire, merely to think
Of you, and having lost my heartless peace.
How shall I dare to live except with you?"

'The Coroner to Witness: "Had you known
When you were first acquainted with deceased,

Before her marriage, that she entertained
These feelings for you?"—"Friends of mine would talk
In a light way about it—nothing more—
And in especial as to mesmerism.                              670
I knew that such a match could never be;
Her friends would have been sure to break it off—
Our prospects were so very different.
I did not think about it seriously."

'"The letter says that you divided: how
Did that occur?"—"I left the neighbourhood
On account solely of my own affairs."

'"You have deposed that you received a hint
Your meetings with deceased had been observed.
How did you learn this?"—"Through the brother-in-law  680
Of a young lady that's engaged to me."

'The witness here retired. He looks about
The age of twenty-seven,—in person, tall
And elegant. His tone at times betrayed
Much feeling.

                            'Mrs. Celia Frances Gwyllt:
"Deceased and I were cousins. In the month
Of August last I spent a little time
With her and Mr. Grey. In the first week
Of last month, I remember hearing her
Speak in a manner I considered wrong        690
To Mr. Luton, and she seemed confused
When she perceived me. Shortly afterwards,
I took occasion to inform her so.
This she at first made light of, and alleged
It was a mere flirtation. I replied
I deemed it was my duty to acquaint
Her husband; when she begged that I would not,
So that at length I yielded. Then came on
Some crying fits, which Mr. Grey was led
To ascribe to things I chanced to talk about.        700
This and my pledge of silence vexed me much,
And so, soon after that, I took my leave."

'Anne Gorman: "I am Mr. Luton's servant.
On Tuesday was the sixth I had to go
Out on an errand, with the door ajar,
When I remembered something I had left
Behind. On coming back, I saw deceased
Race through the lobby, and whisk into the room.
I had been ordered not to let her in."

'The evidence of Dr. Wallinger                            710
Ended the case. "I was called in to see
The body of deceased upon the sixth:
Life then was quite extinct; the cause of death,
Congestion and effusion of the ventricle.
Death would be instantaneous. Any strong
Emotion might have led to that result."

'The Coroner, in course of summing up,
Commented on the evidence, and spoke
Of deceased's conduct in appropriate terms;
Observing that the Jury would decide                      720
Upon their verdict from the testimony
Of the professional witness—which was clear,
And seemed to him conclusive. He could do
No less than note the awful suddenness
With which the loss of life had followed such
A glaring sacrifice of duty's claims.

'The Jury gave their verdict in at once:
"Died by the visitation of God."

                                        'We learn
On good authority that the deceased
Belonged to a distinguished family.                       730
Her husband's scientific eminence
Is fully and most widely recognized.'

As Harling finished reading this, he rose
To call his friend; but, shrinking at the thought,
He read it all again and lingeringly.

But, after that, he called in undertone;
And he received the answer, 'Come in here.'
He entered therefore.

                             Grey was huddled o'er
The coffin, looking hard into her face.
'You know it now,' he said, but did not move.        740

'We long have been old friends,' Harling replied.
'Words are of no avail, and worse than none.
I need not try to tell you what I feel.'

Grey now stood straight. 'I am to bury her
The day after to-morrow: I alone
Shall see her covered in beneath the earth.
May God be near her in the stead of men,
And let her rest. Yet there is with her that
Which she shall carry down into the grave;
Still in the dark her broken marriage-vow       750
Under her head; they shall remain together.
How can I talk like this?' And he broke off.

'This is a crushing grief indeed, I know,'
Said Harling; 'yet be brave against it. When
This few day's work is over, Grey, go home,
And mind to be so occupied as must
Prevent your dwelling on it. If you choose,
I will accompany and stay with you.'

But he replied: 'My home will now be here;'
And all the angles of his visage thinned.       760
'*He* is here I mean to ruin. Shall he still
Be free to laugh me in his sleeve to scorn,
And show me pity—pity!—when we meet?
I have no means of harming him, you think?
There's such a thing, though, as professional fame,—
I have it. Where's the name of Luton known?
This is my home: I mean to ruin him.'

'Why, he,' objected Harling, 'never did
One hair's-breadth wrong to you: his hands are clean
Of all offence to you and yours. For shame!                    770
It was blind anguish spoke there—not yourself.'

'Ah! you can talk like that! But it is I
Who have to feel—I who can see his house
From here, and sometimes watch him out and in,
And think she used to be with him inside.
And he could bear her coming day by day,
And see the sobs collecting in her throat,
And tresses out of order, as she fell
Before his feet, and made her prayers, and wept!
He bore this! What a heart he must have had!                    780
Must I be grateful for it? Did he not
Admit inopportune eyes were watching him?
He was engaged to marry—yes, and one
For whom he's bound to keep himself in check,
And crouch beneath her whims and jealousy:—
Not that I ever saw her, but I'm sure.
Besides, he told me she would not be his
Unless he gains the standing deemed her due,—
And I'll take care of that.'

      His friend was loath,                    790
Seeing the burden of his agony,
To harass him with argument and blame;
Yet would he not be by to hear him rave,
And said he now must go.

      'One moment more,'
Said Grey, and oped the window. Overhead
The sky was a black veil drawn close as death;
The lamps gave all the light, prolonged in rows:
And chill it blew upon them as they gazed,
Mixed with thin drops of rain, which might not fall
Straight downward, but kept veering in the wind.
There was a sounding of the sea from far.                    800

Grey pointed. 'That beyond there is the house,
Turning the street—that where a candle burns

In the left casement of the upper three.
That is, no doubt, his shadow on the blind.
Often I get a glimpse of it from here,
As when you saw me first this afternoon.
Shall he not one day pay me down in full?
John, I can wait; but when the moment comes . . .!'

He shut the sash. Harling had seen the night,
Equal, unknown, and desolate of stars. 810

# CRITICAL APPARATUS

# EDITORIAL INTRODUCTION

THE copy text for this edition of the *P.R.B. Journal* is the mutilated fragmentary manuscript in the Angeli Papers housed in the Special Collections Division of the University of British Columbia Library. The manuscript, in the holograph of William Michael Rossetti, consists of forty-nine leaves, written front and back, plus three sets of wrappers. The leaves measure $8\frac{7}{8} \times 7\frac{1}{4}$ inches ($226 \times 184$ millimetres). The paper is blue-grey in colour and handmade, watermarked either with the device and initials of 'B & L' or with the words . . . 'Backhouse & Co.' Ten of the leaves have a watermark dated 1848, one is dated 1847; the remainder are undated. Though the leaves are now separate, the evidence of the watermarks and the unevenness of the inner margins point to their having been originally part of a quarto notebook from which they were disjoined; or they may have been foolscap leaves that were folded to form doublets that were later divided.

Each page of the manuscript is closely written, the number of lines varying between twelve (on one of the mutilated pages) and thirty-eight. Since the *Journal* was kept over a period of five years, there is some variation in the hand, but Rossetti's writing is always legible; and given that the manuscript is a diary, consisting in the main of spontaneously written entries—a few are retrospective—the pages are surprisingly clean (see facsimiles). In fact, apart from a few crossings-out, over-line insertions, and corrections, most of the impediments of the manuscript are those introduced by Rossetti when he was preparing his partial edition. At that time, he added to the existing pagination within each section an editorial number, placed within square brackets the passages to be published, inserted a few new readings to improve clarity, and added at the bottom of several pages explanatory notes, most of which are printed in his edition. The majority of his editorial notes, however, appear on separate cards which are incorporated into his editorial numeration scheme. Many of these are no longer with the manuscript.

Of the forty-nine leaves of text, twenty are mutilated. Of these, sixteen have sections ranging between one and four inches torn from either the top or bottom; three have two- to three-inch strips ripped from the middle of the leaf; and a few others have small pieces missing from the inner margins which affect only a few words. These

mutilations cause some confusion—even Rossetti transposed the entries for two months—but in terms of the over-all lacunae they are much less important than the twenty leaves that can be shown to be missing from the manuscript. In the Collation, where an attempt is made to reconstruct the complete original manuscript, full details of both the mutilations and the missing leaves are provided.

In editing the manuscript, I have made no attempt to produce a diplomatic text. The *Journal* is not, after all, a work of imaginative literature, and its content is much more important than its physical appearance. Thus, I have not restored palimpsests or presented over-line insertions or deletions typographically. Where possible, I have offered, within square brackets, reconstructed readings, but stray words or whole lines in the mutilated areas that could not be worked into a sensible context have not been transcribed, though they are recorded as 'Recoverable' in the notes in order that the reader may have access to the complete extant *Journal*. Mutilations are also described in the notes with appropriate leaf numbers so that the interested reader can, with the aid of the Collation, form a sense of the physical manuscript.

In the Textual Notes, variations between the manuscript and the published edition are cited, except for obvious typographical errors or purely mechanical variants. In the text, however, it has seemed pre-ferable to refrain from indicating the unpublished sections of the *Journal*. Since Rossetti published only about half the extant manu-script, angled brackets or other sigla would unnecessarily clutter the page and interrupt the reader, and the advantage would be marginal. The unpublished portions are recorded in section three of the Critical Apparatus. For similar reasons, no superscripts are employed. Readers will find full textual and explanatory notes in the appropriate sections. Both kinds of notes are keyed into the text by means of entry date and line numbers. The explanatory notes provide detailed identifications and discussions of references and proper names in the *Journal*, including the more important and interesting of Rossetti's own notes, which have been retained. Each of the note sections is introduced by a headnote outlining procedures.

In transcribing the manuscript, it has been impossible to escape certain arbitrary decisions, especially as regards the mechanics of Rossetti's style, affecting such matters as abbreviations, punctuation, capitalization and spelling, and the handling of numerals and titles. Each of these categories, particularly the last, presented problems that could be avoided only by a meticulously literal transcription. In keep-ing the *Journal* Rossetti was understandably indifferent to consistency. When he came eventually to edit his manuscript for publication, he attempted to impose conventions (perhaps those of his publisher) more

suitable to a printed text, but these are now outdated and they would be inappropriate in a scholarly edition.

The principal advantage of a literal transcription would be to preserve the flavour or character of the original manuscript; yet this gain would, in my opinion, be eroded by the distracting effect which such an array of inconsistencies would have on the reader and by the unsightliness of the printed page which would result. More important than this aesthetic consideration, however, is the fact that the nature of the text itself does not warrant a slavish fidelity to mechanical minutiae; the integrity of the manuscript is in no way violated by alterations which do not change the actual wording. My object has been to produce an accurate and readable text in which purely mechanical aspects are regularized with as little loss as possible to the spontaneity and short-hand style of the original.

The major changes in the transcription involve abbreviations and titles. All ampersands and most other abbreviations have been expanded; however, 'P.R.B.' and 'No.' for number when it occurs with a numeral (as in references to *The Germ*) have been allowed to stand, as have one or two others for effect. Titles are more difficult. In his edition, Rossetti tended to italicize all forms of titles (including poems), whereas in the manuscript, titles appear variously—with no indication other than capitalization, within quotation marks, or underlined. There is little consistency, though the majority are quoted. Modern conventions have been imposed in this edition: separate publications and periodical titles are italicized; titles of poems and articles are placed within quotation marks. The names of pictures, when they are the actual full or truncated titles, are also italicized. However, in many entries Rossetti resorts to free paraphrase or descriptive titles, and in these instances his form (with or without quotation marks) is retained. Some of the pictures referred to were never completed; others are merely ideas, designs, or studies; still others are unknown or not extant: all such are normally transcribed without italics, as Rossetti wrote them.

In italicizing titles quoted in the manuscript it has sometimes been necessary to alter slightly the designation of a work: 'the Strayed Reveller' or 'the Bothie' require capitalization of the article; it must be removed from 'The Spectator', since only in *The Germ* and *The Times* is the definite article italicized in this edition. Similarly, an occasional quotation mark (or italics) has had to be expanded to include a word omitted from the title of a poem or an article.

In the matter of numerals, punctuation, and spelling, I have in general followed Rossetti's practice, but there are exceptions. In *Præraphaelite Diaries and Letters* he was not consistent in transcribing

numerals or words. Because they seem so integral a characteristic of
the manuscript, cardinal numbers have been allowed to stand; ordinals,
such as 1st or 2nd, as abbreviations, are spelled out. Punctuation has
been altered only for clarity, and most changes involve transforming
colons, which abound in the manuscript, into semi-colons or commas.
Dashes, which are part of Rossetti's journalistic style and which tend
to indicate shifts within the entries, are retained, even when, as is
frequently the case, they are preceded by another mark of punctuation.
Rossetti's spelling, including his persistent use of '-or' for '-our'
(except in 'favour') has not been modernized; though he changed these
fifty years later, they are not without some period interest, a considera-
tion that has also influenced me to leave untouched his erratic (and
Victorian-Germanic) tendency to sprinkle the manuscript liberally with
capital letters, many on nouns referring to unidentified persons—
Models, Editors, Artists, and the like. All such follow WMR's usage,
when clear, except for the word 'Sister' (referring to Christina
Rossetti), which is capitalized throughout.

A few obvious mis-spellings have been silently corrected, but all
editorial interpolations are clearly identified by square brackets. Simple
ellipse marks are used when the mutilations affect the continuity of the
text; missing portions of the manuscript are denoted by a row of
asterisks, as in the Collation.

Finally, I should reiterate that I am following the manuscript and
not the partially printed text. I have, naturally, consulted Rossetti's
transcription for guidance in several details, but I have not felt in any
sense bound to adhere to his practice. In fact, with its numerous errors,
unremarked ellipses and interpolations, faulty dating, and transposition
of entries, the diarist's own edition did scant justice to the living docu-
ment he had created as the Secretary of the short-lived Pre-Raphaelite
Brotherhood. It is that document which it has been my purpose to
restore in this new edition.

## II

## COLLATION

The extant leaves of the *P.R.B. Journal* are divided into five distinct
sections or quires, easily identifiable by their original pagination. These
numbers, distinct from Rossetti's consecutive editorial enumeration
(with significant lacunae), begin anew in each quire and make possible
a hypothetical reconstruction of the complete manuscript of the *Journal*.
The six surviving leaves forming the wrappers to three of the quires

(A, B, and D) strengthen the probability that previous to Dante Rossetti's mutilation of the manuscript each of the quires was contained within wrappers. Only in Quire D, where the missing portion occurs at the end, is there less than absolute certainty about the number of leaves missing from the extant manuscript. The following synopsis combines a numerical description of the physical make-up of the extant manuscript with a hypothetical reconstruction of the complete manuscript as it probably appeared in 1853. Wrappers, are not included in the totals, as they were not numbered by Rossetti.

SYNOPSIS

| Quire | Dates | Extant Ms. | | | | |
|---|---|---|---|---|---|---|
| | | Leaves | Pages | Pagination | Missing | Orig. Ms. |
| A | 1849: 15 May–21 Aug. | 6 | 12 | 1–30 | 9 (18 pp.) | 15 (30 pp.) |
| B | 1849: 22 Aug–1850: 12 Jan. | 14 | 28 | [1]–40 | 6 (12 pp.) | 20 (40 pp.) |
| C | 1850: 13 Jan.–14 Nov. | 18 | 36 | 1–40 | 2 (4 pp.) | 20 (40 pp.) |
| D | 1850: 15 Nov.–1851: 5 May | 5 | 10 | [1]–14 | 3 (6 pp.) | 8 (16 pp.) |
| E | 1851: 6 May–1853: 29 Jan. | 6 | 12 | 1–12 | None | 6 (12 pp.) |
| Totals | | 49 | 98 | 136 | 20 (40 pp.) | 69 (138 pp.) |

*Summary*: The original manuscript of the *Journal*, then, consisted of 69 leaves, or 138 pages, plus ten wrappers, making a total of 79 leaves. Twenty leaves, or 40 pages, and two sets of wrappers are missing. The extant manuscript, consisting of three sets of wrappers and 49 leaves, or 98 pages, of actual text, constitutes therefore roughly 70 per cent of the original, discounting mutilations, which together amount perhaps to three or four leaves.

## Quire A (May–August 1849)

| | Leaf | Page | WMR Ed. no. | WMR Page no. | WMR Ed. note no. | Entries |
|---|---|---|---|---|---|---|
| | | | | | | |
| | I = Front wrapper (dated 15 May/49–21 August/49)[1] | | | | | |
| | | | | | 1451[2] | |
| May 1849 | 2 | I | 1452 | I | | 15–16 May |
| | | | | | 1453 | |
| | | 2 | 1454 | 2 | | 16–18 May |
| | 3*[3] | 3 | 1455 | [3] | | 18–20 May |
| | | | | | 1456 | |
| | | 4 | 1457 | [4] | | 21–3 May |
| | 4* | 5 | 1458 | 5 | | 23–[4] May |
| | | 6 | 1459 | 6 | | 24–5 May |
| | 5* | 7 | [1460] | [7] | | [27]–9 May |
| | | 8 | [1461] | [8] | | 29–30 May |

★ ★ ★ ★ ★ Wed. 30 May–Sun. 21 July 1849: 6 leaves missing = 12 pp. [9–20][4]

| | Leaf | Page | WMR Ed. no. | WMR Page no. | WMR Ed. note no. | Entries |
|---|---|---|---|---|---|---|
| July 1849 | 6* | 9 | 1466 | [21] | | 22 [July] |
| | | | | | 1467 | |
| | | 10 | 1468 | [22] | | 24–6 July |
| | | | | | 1469 | |

★ ★ ★ ★ ★ Thurs. 26 July–Sun. 12 Aug. 1849: 3 leaves missing = 6 pp. [23–8]

[1] The front wrapper is headed 'P.R.B.' with the dates. William Michael Rossetti's signature appears in the upper right-hand corner. At the foot of the wrapper are written the names of Frederic G. Stephens, Dante G. Rossetti, and W. M. Rossetti. On the verso of the back wrapper, WMR has written in pencil: 'This is the Wrapper of the 1st Instalment of the PRB Journal kept by me.'

[2] For a general discussion of WMR's editorial numbers see the description of the manuscript. The 38 extant note-cards—many containing more than one note—are worked into the consecutive numbering scheme with the manuscript, and are indicated in this column. However, it is clear that WMR did not follow his system consistently. Several notes on the cards are not incorporated in *PDL*; and of the 124 notes in *PDL*, 76 are not carded. Many of the notes on cards have been greatly revised. The cards, therefore, are of primary interest as they assist in the numerical collation of the manuscript. Note 1451 is in the Troxell collection at Princeton.

[3] An asterisk indicates a mutilated leaf.

[4] A row of asterisks between leaves indicates a break in the MS. owing to missing leaves. Wherever possible, the inclusive dates are given, and the number of missing leaves (and corresponding pages within the numbering scheme) is estimated. Numbers in brackets continue the pagination. The disparity between the editorial numbers and missing pages between Leaves 5 and 6 is due to WMR's misnumbering.

| | Leaf | Page | WMR Ed. no. | WMR Page no. | WMR Ed. note no. | Entries |
|---|---|---|---|---|---|---|
| Aug. 1849 | 7* | 11 | 1460[A]¹ | 30 [29]² | | 13–14 [Aug.] |
| | | | | | 1461[A]³ | |
| | | 12 | 1462[A] | 30 | | 15–20 Aug.⁴ |
| | | | | | 1463 | |
| | 8 = Back wrapper | | | | | |

## Quire B (August 1849–January 1850)

| | Leaf | Page | WMR Ed. no. | WMR Page no. | WMR Ed. note no. | Entries |
|---|---|---|---|---|---|---|
| | 9 = Front wrapper (dated 22 Aug./49–12 Jan./50) [WMR ed. No. 1556/423]⁵ | | | | | |
| Aug. 1849 | 10* | 13 | 1464 | [1] | | [24]–6 Aug. |
| | | 14 | 1465 | [2] | | 28–9 Aug. |
| | | | | | 1469 | |

★ ★ ★ ★ ★ Wed. 29 Aug.–Tues. 10 Sept. 1849: 2 leaves missing = 4 pp. [3–6]

| | Leaf | Page | WMR Ed. no. | WMR Page no. | WMR Ed. note no. | Entries |
|---|---|---|---|---|---|---|
| Sept. 1849 | 11* | 15 | 1470 | 7 | | 11–15 Sept. |
| | | | | | 1471 | |
| | | 16 | 1472 | 8 | | 17–20 Sept. |
| | 12 | 17 | 1473 | 9 | | 20–5 Sept. |
| | | 18 | 1474 | 10 | | 25–8 Sept. |

★ ★ ★ ★ ★ Fri. 28 Sept.–Fri. 5 Oct. 1849: 1 leaf missing = 2 pp. [11–12]

| | Leaf | Page | WMR Ed. no. | WMR Page no. | WMR Ed. note no. | Entries |
|---|---|---|---|---|---|---|
| Oct. 1849 | 13* | 19 | 1475 | 13 | | [6]–10 Oct. |
| | | 20 | 1476 | 14 | | 10–19 Oct. |

★ ★ ★ ★ ★ Sat. 20 Oct.–Wed. 31 Oct. 1849: 1 leaf missing = 2 pp. [15–16]

| | Leaf | Page | WMR Ed. no. | WMR Page no. | WMR Ed. note no. | Entries |
|---|---|---|---|---|---|---|
| Nov. 1849 | 14* | 21 | 1477 | [17] | | 1–2 Nov. |
| | | | | | 1478 | |

¹ WMR became confused in his numbering at this point, owing to the breaks in the MS., which caused him in *PDL* to transpose the entries for July and August. These two pages of Leaf 7 are indicated [A] to distinguish them from the sequence begun with Leaf 5, above.
² WMR gave the number 30 to both the recto and verso of Leaf 7.
³ The context of the note and its placement in *PDL* make it certain that it belongs between pages 11 and 12, rather than between 7 and 8.
⁴ The lower half of MS. 1460/2[A], the last leaf in Quire A, is missing, so that the last dated entry is 20 Aug.
⁵ The front wrapper of Quire B is headed 'P.R.B.' with the dates, beneath which WMR has added in square brackets: 'The P.R.B. Journal, by William Rossetti.' His signature appears in the upper right-hand corner. On the verso of the front wrapper, in WMR's hand, are listed the names of the seven P.R.B.s in alphabetical order. For the editorial numbering on this wrapper see p. 167 n. 2.

| | Leaf | Page | WMR Ed. no. | WMR Page no. | WMR Ed. note no. | Entries |
|---|---|---|---|---|---|---|
| | | 22 | 1479 | [18] | | 6–7 Nov. |
| | | | | | 1480 | |
| | 15★ | 23 | 1481 | [19] | | 8–12 Nov. |
| | | | | | 1482 | |
| | | 24 | [1483] | [20] | | 12–15 Nov. |
| | | | | | 1484 | |
| | 16★ | 25 | 1485 | [21] | | [17]–19 Nov. |
| | | | | | 1486 | |
| | | 26 | 1487 | [22] | | 19–22 Nov. |
| | 17★ | 27 | 1488 | 23 | | 22 Nov. |
| | | | | | 1489 | |
| | | 28 | 1490 | 24 | 1491 | [24]–5 Nov. |

★ ★ ★ ★ ★ Sun. 25 Nov.–Fri. 7 Dec. 1849: 1 leaf missing = 2 pp. [25–6]

| | Leaf | Page | WMR Ed. no. | WMR Page no. | WMR Ed. note no. | Entries |
|---|---|---|---|---|---|---|
| Dec. 1849 | 18★ | 29 | 1492 | [27] | | [7]–8 Dec. |
| | | 30 | 1493 | [28] | | 10 Dec. |
| | 19★ | 31 | 1494 | [29] | | 13–15 Dec. |
| | | 32 | 1495 | [30] | | 15 Dec. |
| | 20 | 33 | 1496 | 30 [31][1] | | 16–18 Dec. |
| | | 34 | 1497 | 31 [32] | | 18–21 Dec. |
| | | | | | 1498 | |
| | 21 | 35 | 1499 | 32 [33] | | 21–3 Dec. |
| | | 36 | 1500 | 33 [34] | | 24–8 Dec. |
| | 22 | 37 | 1501 | 34 [35] | | 28–9 Dec. |
| | | 38 | 1502 | 35 [36] | | 29 Dec. 1849–1 Jan. 1850 |
| | | | | | 1503 | |

★ ★ ★ ★ ★ 1 Jan.–5 Jan. 1850: 1 leaf missing = 2 pp. [36–7 (37–8)]

| | Leaf | Page | WMR Ed. no. | WMR Page no. | WMR Ed. note no. | Entries |
|---|---|---|---|---|---|---|
| Jan. 1850 | 23 | 39 | 1557[2] | 39 | | 5–9 Jan. |
| | | 40 | 1558 | 40 | | 9–12 Jan. |

24 = Back wrapper

## Quire C (January 1850–November 1850)

| | Leaf | Page | WMR Ed. no. | WMR Page no. | WMR Ed. note no. | Entries |
|---|---|---|---|---|---|---|
| Jan. 1850 | 25 | 41 | 1559 | 1 | | 13–16 Jan. |
| | | 42 | 1560 | 2 | | 16–19 Jan. |
| | 26 | 43 | 1561 | 3 | | 19–22 Jan. |

[1] Proper sequence numbers are indicated in square brackets to offset WMR's misnumbering.

[2] No explanation for the break in editorial numbering at this point is possible.

| | Leaf | Page | WMR Ed. no. | WMR Page no. | WMR Ed. note no. | Entries |
|---|---|---|---|---|---|---|
| | | 44 | 1562 | 4 | | 22–5 Jan. |
| | 27★ | 45 | 1563 | 5 | | 25–8 Jan. |
| | | | | | 1564 | |
| | | 46 | 1565 | 6 | | 28–31 Jan. |
| | | | | | 1566 | |
| Feb. 1850 | 28 | 47 | 1567 | 7 | | 31 Jan.– 2 Feb. |
| | | 48 | 1568 | 8 | | 2–4 Feb. |
| | 29 | 49 | 1569 | 9 | | 4–10 Feb. |
| | | | | | 1570 | |
| | | 50 | 1571 | 10 | | 11–15 Feb. |
| | 30★ | 51 | 1572 | 11 | | 15–16 Feb. |
| | | 52 | 1573/74¹ | 12 | 1575 | 16–20 Feb. |
| | | | | | 1577 | |
| | 31 | 53 | 1576 | 13 | | 20–2 Feb. |
| | | 54 | 1578 | 14 | | 23–7 Feb. |
| Mar. 1850 | 32 | 55 | 1579 | 15 | | 27 Feb.– 2 Mar. |
| | | | | | 1580 | |
| | | 56 | [1580A] | 16 | | 3–6 Mar. |
| | 33 | 57 | 1581 | 17 | | 6–10 Mar. |
| | | | | | 1582 | |
| | | 58 | 1583 | 18 | | 10–14 Mar. |
| | | | | | 1584 | |
| | 34 | 59 | 1585 | 19 | | 15–21 Mar. |
| | | 60 | 1586 | 20 | | 21–2 Mar. |
| | | | | | 1587 | |
| | 35 | 61 | 1588 | 21 | | 22–5 Mar. |
| | | 62 | 1589 | 22 | | 25–9 Mar. |
| | 36★ | 63 | 1590 | 23 | | 29 Mar.– 3 Apr. |
| | | | | | 1591 | |
| | | 64 | [1591A] | 24 | | 4–7 Apr. |
| July 1850 | 37 | 65 | 1592 | 25 | | 8–21 July² |
| | | 66 | 1593 | 26 | | 21 July |
| | 38 | 67 | 1594 | 27 | | 21 July– 24 Oct.³ |
| Oct. 1850 | | 68 | 1595 | 28 | | 24 Oct. |

★ ★ ★ ★ ★ 24 Oct. 1850: 2 leaves missing = 4 pp. [29–32]

| | Leaf | Page | WMR Ed. no. | WMR Page no. | WMR Ed. note no. | Entries |
|---|---|---|---|---|---|---|
| | 39 | 69 | 1596 | 33 | | 24–6 Oct. |
| | | 70 | 1597 | 34 | | 26–9 Oct. |

¹ Three leaves of *PRBJ* are in two pieces (Leaves 30, 36, 45). In this instance, WMR has given separate editorial numbers to the two pieces of the verso of Leaf 30; he did not do so for the recto. See Textual Note Feb. 50 16.16.

² Between these dates WMR discontinued his entries in *PRBJ*.

³ Another long discontinuance of the entries in *PRBJ*. In neither instance is any portion of the *Journal* missing.

|  | Leaf | Page | WMR Ed. no. | WMR Page no. | WMR Ed. note no. | Entries |
|---|---|---|---|---|---|---|
|  |  |  |  |  | 1598 |  |
| Nov. 1850 | 40 | 71 | 1599 | 35 |  | 29 Oct.– 1 Nov. |
|  |  | 72 | 1600 | 36 |  | 1–5 Nov. |
|  | 41 | 73 | 1601 | 37 |  | 5 Nov. |
|  |  |  |  |  | 1602 |  |
|  |  | 74 | 1603 | 38 |  | 5–7 Nov. |
|  | 42 | 75 | 1604 | 39 |  | 7–11 Nov. |
|  |  | 76 | 1605 | 40 |  | 11–14 Nov. |

## Quire D (November 1850–May 1851)

|  | Leaf | Page | WMR Ed. no. | WMR Page no. | WMR Ed. note no. | Entries |
|---|---|---|---|---|---|---|

43 = Front wrapper (dated 15 Nov./50–5 May/51) [WMR ed. No. 1766/445][1]

★ ★ ★ ★ ★ Thur. 15 Nov.–Sat. 30 Nov. 1850: 2 leaves missing = 4 pp. [1–4]

|  | Leaf | Page | WMR Ed. no. | WMR Page no. | WMR Ed. note no. | Entries |
|---|---|---|---|---|---|---|
| Dec. 1850 | 44 | 77 | 1606 | 5 |  | 30 Nov.– 2 Dec. |
|  |  |  |  |  | 1607 |  |
|  |  | 78 | 1608 | 6 |  | 2–7 Dec. |
|  |  |  |  |  | 1609 |  |
|  | 45* | 79 | [1610][2] | 7 |  | 7–12 Dec.[3] |
|  |  |  |  |  | 1611 |  |
|  |  | 80 | 1767/69[4] | 8 |  | Jan. 1851 |
|  |  |  |  |  | 1768 |  |
| Jan. 1851 | 46* | 81 | 1772 | [9] | 1771 | 19/26 Jan.[5] |
|  |  | 82 | 1770[6] | [10] |  | 26 Jan./2 Feb. |
| Feb. 1851 | 47* | 83 | 1773 | 11 |  | 2–9 Feb. |
|  |  |  |  |  | 1774 |  |

[1] Identical with Quire B wrapper save for dates and editorial numbers (see p. 167 n. 2). On the verso, WMR has written the names of the P.R.B.s, substituting Walter H. Deverell for Collinson, and then deleted Deverell's name.

[2] A duplicate leaf, numbered 1610, exists with the MS. on which WMR has copied out the legible portions of the entries for 8 and 10 December (on the recto of Leaf 45). This number has been used to identify the page.

[3] WMR discontinued the journal for 'upwards of a month' at this point. No break in MS.

[4] Leaf 45 is in two halves, the verso of which WMR has assigned two editorial numbers (see p. 165 n. 1 above). Again, there is no explanation for the break in editorial numbering.

[5] At this point WMR began keeping the *PRBJ* weekly rather than daily.

[6] WMR's confusion in numbering.

| | Leaf | Page | WMR Ed. no. | WMR Page no. | WMR Ed. note no. | Entries |
|---|---|---|---|---|---|---|
| Mar. 1851 | | 84 | 1775 | 12 | | [16]/23 Feb.–2 Mar. |
| | | | | | 1776 | |
| | 48 | 85 | 1777 | 13 | | 9 Mar./2 May[1] |
| May 1851 | | 86 | 1778 | 14 | | 2 May |
| | | | | | 1779 | |

★★★★★ Fri. 2 May–Mon. 5 May 1851: probably 1 leaf missing = 2 pp. [15–16]

49 = Back wrapper

## Quire E (May 1851–January 1853)

| | Leaf | Page | WMR Ed. no. | WMR Page no. | WMR Ed. note no. | Entries |
|---|---|---|---|---|---|---|
| May 1851 | 50 | 87 | 1780 | [1] | | 6–7 May |
| | | 88 | 1781 | 2 | | 7–11 May |
| | 51 | 89 | 1782 | 3 | | 11–15 May |
| | | 90 | 1783 | 4 | | 13–15 May |
| | 52 | 91 | 1784 | 5 | | 13–15 May |
| | | 92 | 1785 | 6 | | 13–23 May |
| | 53 | 93 | 1786 | 7 | | 16–23 May |
| | | 94 | 1787 | 8 | | 16–24 May |
| Jan. 1853 | 54 | 95 | 1848[2] | 9 | | 23 Jan. 1853[3] |
| | | 96 | 1849 | 10 | | 17–22 Jan. |
| | 55 | 97 | 1850 | 11 | | 17–22 Jan. |
| | | 98 | 1851 | 12 | | 17–22/23–9 Jan. |

[1] 'Another discreditable lapse' but no break in MS.

[2] No explanation for this break in numbering can be offered. In addition to the regular Editorial Number, this page is numbered 465—see wrappers of Quire B and D which are numbered 423 and 445 in addition to assigned editorial numbers—apparently a third numbering scheme inaugurated by WMR to sign the leaves.

[3] The final and longest break in the keeping of the *PRBJ* is preceded by an introduction. The entries for 17–22 Jan. were clearly written on the 23rd.

## III

## GUIDE TO THE UNPUBLISHED PORTIONS
## OF THE *P.R.B. JOURNAL*

In *Præraphaelite Diaries and Letters*, William Michael Rossetti published just over half the extant manuscript of the *P.R.B. Journal*. The following list, arranged by month and day entry, will enable the reader to distinguish the unpublished sections without recourse to the earlier edition. Figures in parentheses beneath the month are totally unpublished entries. Inclusive line numbers are given in parentheses following the key words of omitted passages; an asterisk indicates the end of an entry. Terminal punctuation is not included.

### MAY 1849
### (18, 22, 25, 28–30)

| | | | |
|---|---|---|---|
| 15 | In . . . separated (14–17★) | 23 | Bernhard . . . on (1–3) |
| 16 | Gabriel . . . evening (1–6) | | He (3) |
| | and . . . failed (7–8★) | | He . . . *Persecution*] (5–7) |
| 17 | and . . . Dobson (4–11★) | | Woolner . . . bas-relief (15–18) |
| 19 | I . . . on (1–4) | | |
| | who (4) | | Woolner . . . Yorkshire (26–8★) |
| | He . . . characters (7–11) | | |
| 20 | and . . . Patmore (2–3) | 24 | The . . . frightening (1–9) |
| 21 | including . . . cream (3) | | also (10) |
| | I . . . doing (5–8) | | Passing . . . later (12–18★) |
| | Millais . . . poem (12★) | 27 | We . . . him (6–10★) |

### JULY 1849
### (25)

| | | | |
|---|---|---|---|
| 22 | has . . . (Williams) (27–8) | 24 | I . . . *Vita Nuova* (2–6★) |
| | and (31) | 26 | and . . . others (3–11) |
| | Woolner . . . Cottingham (33–4★) | | At . . . addition (18–21★) |

### AUGUST 1849
### (18, 24)

| | | | |
|---|---|---|---|
| 13 | and . . . £12 (2–4) | 17 | We . . . Street (2–3★) |
| | Hunt . . . written (20–1) | 19 | Who . . . He (1–4) |
| 14 | Gabriel . . . which (14–15) | | Woolner . . . Brown (7–13) |
| 15 | after . . . Here (1–2) | 25 | I . . . day (2–4★) |
| | but . . . sleep (5–6★) | 28 | Gabriel . . . Leigh's (8–9★) |
| 16 | Woolner . . . Ewell (3–6★) | 29 | A . . . him (6–7★) |

### SEPTEMBER 1849
(11, 13–15, 17–19, 21–2, 24)

| | | | |
|---|---|---|---|
| 12 | The . . . over (1–4) | 26 | I . . . o'clock (1) |
| 20 | Who . . . reviewing (1–2) | | I . . . note (5–6) |
| | that . . . poem (12–19★) | 27 | 'which . . . state' (4–5) |
| 23 | I . . . poem (14–16★) | 28 | In . . . *Brethren* (1–11) |
| 25 | He . . . melody (16–18) | | I . . . printed] (12–14★) |
| | but . . . one (19–29★) | | |

### OCTOBER 1849
(6–7, 9, 11–12, 16–17, 19)

| | | | |
|---|---|---|---|
| 8 | In . . . [Co]llinson (6–13★) | 15 | I . . . subscriber (7★) |
| 10 | Woolner . . . introduction | 18 | whom . . . He (1–3) |
| | (16–35★) | | also (3) |
| 13 | Stephens . . . matters (7–13) | | Woolner . . . No. 1 (5–8) |
| 14 | Burbidge . . . Oxonian (7–8★) | | On . . . notes (11–12★) |

### NOVEMBER 1849
(14, 20–1, 24)

| | | | |
|---|---|---|---|
| 1 | [I . . . Tuesday (1–8) | 12 | Gabriel . . . others (1–20) |
| | I . . . evening (14–16★) | | Stephens . . . Street (28–33★) |
| 2 | Of . . . recollection (21–2) | 13 | looked . . . etc. (1) |
| | and . . . [*Princess*] (24–5★) | | He . . . required (3–10★) |
| 6 | I . . . endeavours (1–2) | 15 | I . . . it (8–10★) |
| | Woolner . . . after (12–15) | 18 | The . . . figure (1–2) |
| | My . . . rejected (18–19★) | 19 | I . . . model (1–2) |
| 7 | We . . . notice (1–3) | | The . . . He (4–6) |
| | We . . . means (21–3★) | | and . . . please (11–15) |
| 8 | and . . . time (3–6) | | as . . . artists] (21–2★) |
| | He . . . with (8–14) | 22 | He (10); he (11) |
| | he [before 'remarked'] (15) | | Woolner's . . . suggestion |
| 9 | I . . . Ferdinand (1–3) | | (33–7) |
| 10 | I . . . review (4–5★) | | At . . . 1851 (48–50★) |
| 11 | I . . . review (10★) | 25 | and . . . position (8–23) |

### DECEMBER 1849
(14, 25)

| | | | |
|---|---|---|---|
| 7 | [Millais . . . copy (1–11) | 13 | [In . . . necessary (1–6) |
| | Patmore . . . and (13–18) | | and that (19) |
| 10 | We . . . Preacher (1–6) | | Gabriel . . . picture (22–3★) |
| | has . . . it (7–10) | 15 | Hunt . . . hour (1–6) |
| | he (11) | | who . . . ready (7–9) |
| | There . . . etching (22–3★) | | A . . . types (12–18) |

John . . . ease (23–7)
and . . . magazine (29–32★)    23
16   Maitland . . . of (1–4)
's [in Gabriel's] beginning . . .
he (5–6)    24 / 26
I . . . points (10–18)    27
17   The gilding of (1)
's [in Gabriel's] picture . . . He
(1–4)    28
called . . . He (5–6)
Drawing . . . No. 2 (7–13★)
19   the (4)
and . . . talk (10–15)
21   George . . . one (1–5)
after . . . drawing (7)
but . . . paper (9–10)
and . . . Rain (14–18★)
22   I . . . us (1–6)

which . . . It (7)
was . . . He (1–3)
Collinson . . . Soul (10–26★)
I . . . Art (1–12)
I . . . to-morrow (1–2)
The . . . in (10–11)
's [in Gabriel's] article . . . He
(11–14)
Collinson . . . Baptist (6–13)
including . . . appear (14–16)
There . . . commission (22–31)
29   Stephens . . . Millais's (1–6)
who . . . himself (6–7)
He . . . Tuppers (9–12)
I . . . etc. (18–39★)
31   3 . . . number (2–4)
and . . . Art (6–7★)

## JANUARY 1850

### (6, 9, 13–14, 19–20, 24)

7   I . . . them (1–2)
8   As . . . Tupper's (3–5)
10   For . . . out (8–9★)
11   Gabriel . . . drapery (1)
12   Stephens . . . Monday (3–6)    23
Woolner . . . o'clock (13–20)
15   Deverell . . . dignity (5–15★)    25
16   I . . . fidelity (1–4)
drew . . . and (4–5)    26
of . . . Model (8–16)
He . . . Friday (20–1★)    27
17   gave . . . Tupper (1–5)    28
I copied . . . selected (6–9★)    29
18   and . . . this (3–5)
21   with . . . work (5–9)    30
Patmore . . . number (10–16★)
22   him (3)

Collinson . . . remedied (14–
17)
too (17)
When . . . Woolner (20–6★)
Woolner . . . possible (1–17)
I . . . article (24–5★)
Woolner . . . to-morrow (1–
13)
I . . . character (1–4)
Deverell . . . sonnets (7–8★)
I . . . number (4–8)
Of . . . talk (4–14★)
but . . . Sleep (3–5)
After . . . steeds (13–16)
's [in 'Marston's'] (1)
He . . . quarter (13–14★)

## FEBRUARY 1850

### (3, 8, 10, 13–14, 17, 24, 27)

I . . . others (1–2)
Richardson . . . return (4–6)
I . . . present (9–12★)
Woolner . . . 'Yeast' (1–10)

Collinson . . . *Germs* (11–13)
Hunt . . . needle (15–27)
I . . . Patmore (49–51★)
There . . . Hall (4–11★)

| | | |
|---|---|---|
| 5 | I . . . proposal (2–6★) | |
| 6 | He . . . notice (3–7★) | |
| 7 | Collinson's . . . read (6) | |
| | The . . . practice (8–11★) | |
| 11 | Remembering . . . fit (1–4) | |
| | who . . . models (5–9) | |
| | Woolner . . . Thursday (11–12★) | |
| 12 | painted . . . chasuble (1) | |
| 15 | Gabriel . . . chasuble (1) | |
| | I . . . useless (6–9★) | |
| 16 | and . . . number] (14–17) | |
| | Gabriel . . . tho' (31–7) | |

| | |
|---|---|
| | I . . . thing (41–50★) |
| 19 | I . . . when (1–4) |
| 21 | I . . . serve (1–4) |
| | will be (4) |
| | I . . . on (15–19) |
| | A . . . stuff (21–3★) |
| 22 | but . . . April (2) |
| | Stephens . . . Marquis (17–18★) |
| 23 | him (5) |
| | I . . . sculpture (9–10★) |
| 26 | An . . . Marston's (2–4) |
| 28 | I . . . time (3–19★) |

MARCH 1850

(1, 2, 4–5, 8, 11, 15–19, 22, 24, 30–1)

| | |
|---|---|
| 3 | In . . . invisible (13–19★) |
| 6 | having . . . Academy (2–4) |
| | he (5) |
| | He . . . them (9–12) |
| | and . . . unobserved (14–22) |
| | affronted (29) |
| | Hunt . . . to-morrow (31–2) |
| 7 | Woolner . . . Marquis (1–5) |
| 10 | In . . . answer (5–13★) |
| 13 | Stephens . . . *Souvenir* (17–22★) |

| | |
|---|---|
| 14 | I . . . stanza (3–4★) |
| 20 | comprising . . . *Mohun* (5–7) |
| 23 | Gabriel . . . appropriated (1–15) |
| | The (22) |
| 25 | Collinson . . . likewise (13–22★) |
| 27 | Tupper . . . cause (1–4) |
| 28 | I . . . 'Subject' (4–5) |
| | he . . . *Times* (10–11) |
| 29 | Hunt . . . number (8–9) |

APRIL 1850

(2–5)

| | |
|---|---|
| 1 | the [*Xmas-Eve*] (5★) |
| 7 | He . . . for (1–3) |
| | Earles . . . and (4–9) |

| | |
|---|---|
| | Collinson . . . him (13–18) |
| | In . . . notice (21–2★) |
| 8 | I . . . appear (1–2) |

JULY 1850

| | |
|---|---|
| 21 | to . . . interval (2–5) |

OCTOBER 1850

(28, 30–1)

| | |
|---|---|
| Note | next . . . on (65–7★) |
| 24 | Nothing . . . Dickens (6–11★) |
| 25 | I . . . him (3–10) |
| | He . . . Rome (12–14★) |
| 26 | The . . . appearance (3–4) |
| | where . . . matters (5–8) |
| | The . . . out-of-doors (11–21★) |

| | |
|---|---|
| 27 | I . . . review (1–2) |
| | and . . . by (4–7) |
| | The latter (7) |
| | We . . . Strength (19–28★) |
| 29 | He . . . subjects (2–3) |
| | informed . . . He (4–11) |
| | We . . . *Fontenoy* (15–22★) |

## NOVEMBER 1850

### (2, 4, 9, 11–12, 14)

| | | | |
|---|---|---|---|
| 1 | in art (11) | 10 | and . . . back (9–15★) |
| | Woolner . . . *Eidolon* (14–19★) | 13 | Millais . . . London (9–10) |
| 3 | I . . . trash (1–3) | | He . . . article (12–16) |
| | I . . . says (4–10) | | He . . . amateurs (19–22★) |
| | I . . . reply (17–19★) | 30 | a . . . this (10–11) |
| 5 | Before . . . Hannay (14–27) | | *per se* (12) |
| | indeed . . . Iago (70–2) | | Patmore . . . matters (15) |
| | I . . . architecture (74–6★) | | I . . . delay (22–7★) |
| 7 | I . . . etc. (7–14★) | | |

## DECEMBER 1850

### (4, 9, 11–12)

| | | | |
|---|---|---|---|
| 2 | He . . . away' (2–4) | | They . . . Pre-Raffaelite (16– |
| | A . . . published (6–11) | | 20★) |
| | I . . . extensive (21–3★) | 8 | [Hunt] . . . week (6–8★) |
| 3 | A . . . day (10–12★) | 10 | in which . . . there (6–8) |
| 7 | to [after;] . . . study (10–12) | | After . . . moment (11–13) |

## JANUARY 1851

### (19)

| | | | |
|---|---|---|---|
| Note | In . . . binding (10–15) | 26 | Stephens . . . return (6–18★) |
| | His . . . number (37–9) | | |

## FEBRUARY 1851

### (23)

| | | | |
|---|---|---|---|
| 2 | He . . . country (2–3) | | To-day . . . *Spectator* (12–16★) |
| | Hancock . . . bas-reliefs, (8–9) | 9 | Stephens . . . days (16–22★) |

## MARCH 1851

### (2)

| | | | |
|---|---|---|---|
| 2 | Woolner . . . monument (7–11★) | 9 | Stephens . . . composition (1–7) |
| | | | I . . . *Vatican* (24–8★) |

## MAY 1851

### (7)

| | | | |
|---|---|---|---|
| 2 | Stephens's . . . first (18–22) | 8–10 | For . . . record (1–2) |
| | A . . . and (29–34) | | Gabriel . . . in (12–15★) |
| | which . . . to-morrow (36–7) | 11 | Having . . . in (1–7) |
| | The . . . accomplish (1–6) | 12 | I . . . Gabriel (10–12★) |

| | | | |
|---|---|---|---|
| 13–15 | I . . . room (47–50) | 16–23 | It . . . result (13–17) |
| | a (56) | | It . . . images (40–6★) |
| | and . . . show (65–70) | 24 | The . . . Gallery (1–10) |
| | The . . . P.R.B. (72–6) | | |

### JANUARY 1853

| | | |
|---|---|---|
| 17–22 | among . . . himself (12–14) | This . . . for (31) |
| | Gabriel . . . *Shepherd* (22–8) | |

*Entries Missing from* PRBJ *Owing to Mutilations*

Besides those entries which WMR chose not to print in *PDL*, and those on the leaves missing from the extant manuscript, many others are affected by the mutilations. Fifteen of the eighteen entries listed below are totally unrecoverable, save for stray words and phrases. The brief passages from the remaining three which have been incorporated into adjacent entries are indicated in the Textual Notes.

| | |
|---|---|
| 26 May 1949 | 16–17 Nov. 1849 (18.1) |
| 23 July 1849 (22.33) | 23 Nov. 1849 |
| 21–3 Aug. 1849 | 9 Dec. 1849 |
| 27 Aug. 1849 | 11–12 Dec. 1849 |
| 16 Sept. 1849 | 6 Apr. 1850 |
| 3–5 Nov. 1849 | Week of 16 Feb. 1851 (9.18) |

## IV

## TEXTUAL NOTES

The textual notes are arranged by entry date and line number within each month. Those to the Rules of the P.R.B. are by Rule number. Sigla are of three sorts: key words (without quotation marks), date, and ellipses or asterisks—in each case followed by a colon. All MS. references are to the Collation. Following the colon, words from the transcribed text are placed within quotation marks; all others, including deleted words and those which could not be put into a context owing to the mutilations, are italicized. These latter are identified as 'Recoverable:'. Only those over-line insertions which are clearly associated with the mutilations are cited in the notes; the others are too numerous to record, and it is not always possible to distinguish those which were made during the writing of the entry and those added in the process of revision. All important deletions are recorded as are all variants between the MS. and the previous edition. No account is taken of purely formal differences, however, such as the expansion of a title or abbreviation. Similarly, no mention is made of individual words or

phrases that WMR omitted from *PDL*; these are recorded in section three of the Critical Apparatus.

## MAY 1849

15.1     Date: In editing *PRBJ*, WMR initially inserted superscripts, presumably intending to place the notes on the MS., but he quickly discovered that his margins were inadequate and abandoned the practice. Neither the superscripts nor the dozen notes on the MS. are recorded in the apparatus.

18.13    Francesca [and] Ugolino: *&* or *of* deleted in MS.

18.14    [them . . . Gabriel]: MS. 1455/7 mutilated at top (part of one line missing).

18.15    Maud's: *Maude's* in MS. but incorrect.

19.4     Monk: *English Missionary* deleted in MS.

19.12    Walters: *Daniels* deleted in MS. See corresponding Explanatory Note.

20.5     Ellipses: MS. 1455/7 mutilated at bottom (2 inches missing); 'heavy, heavy rest' inserted over line. The first line of MS. 1457 is legible; 'to' supplied in *PDL*.

21.2     The Illuminator: In parentheses in *PDL*.

21.9     departure, with: *Tuesday* deleted after in MS.

23.6     [*Christian* . . . made]: Mutilation at bottom of MS. 1457 precludes further reconstruction; conjectural reading at top of MS. 1458 is supplied in *PDL* but not in MS.

23.9     considerably advanced: *nearly finished* deleted in MS.; *and probably completed it* deleted in MS. after 'to-night' (line 10).

23.22    they are: *always* deleted between in MS.

23.24    ball: Inserted over line; deleted word illegible.

23.28    Ellipsis: MS. 1458/9 mutilated at bottom (1–2 inches missing). Recoverable: *Woolner & Gabriel we*[*nt*] (bottom MS. 1458).

24.1     Ellipsis: Recoverable: *faded* (top MS. 1459). Date inserted over line.

24.8     Maud's madness: *Maude's* in MS. but incorrect.

24.13    ox: *oxen's* deleted in MS.; 'saw' is mistakenly written *say*.

25.5     Romney: Originally *Rodney* in MS.

25.6     Ellipsis: Recoverable: *Steph*[*ens*] (bottom MS. 1459).

27.1     [*Sunday* . . . I]: MS. [1460/1] mutilated at top (2 inches missing); conjectural reading is supplied in *PDL* but not in MS. WMR deleted '1460' in MS. but the sequence in clear. Owing to the mutilation, there is no entry for the 26th.

27.5     expressed . . . having: *said that on calling on him,* '*he* deleted in MS.

29.4     [*Later* . . . a]: The last sentence of MS. [1460] is interrupted by the mutilation at the top of MS. [1461].

30.14    Ellipsis: MS. break (30 May–21 July).

## JULY 1849

22.1     Date: WMR dates this section August in MS. and in *PDL*; from internal evidence in *PRBJ*, it is clear that all entries so dated should read July, and vice versa.

22.1    Asterisks (preceding entry): MS. 1466/8 mutilated at top (2½ inches missing). Recoverable: *work was of so high merit that, altho' . . . was published accordingly* (top MS. 1466). [*Joseph and his Brethren*] added for clarity.

22.4    a sister . . . wife: Inserted over line.

22.9    an article: *some* articles deleted in MS.

22.23   has not retired: '(as rumoured)' inserted before 'retired' in *PDL*.

22.33   Ellipsis: Recoverable: *Gabriel spent the* (bottom MS. 1466). The last sentence of this entry probably belongs to 23 July.

26.21   Asterisks (following entry): MS. break (26 July–12 Aug.). Recoverable: *Gabriel also recited the* (bottom MS. 1468). WMR's confusion over the dating may account for his misnumbering of the MS.

### AUGUST 1849

13.1    Date: For WMR's misdating of this section, see July 22.1 above; July is inserted in MS. Recoverable: *message that Hunt has removed his painting and other articles* (top MS. 1460[A]).

14.6    passing: *call[ing]* deleted in MS.

14.11   adopting: *following* deleted in MS.

14.18   Ellipsis: MS. 1460/1462[A] mutilated at bottom (2 inches missing).

15.1    Ellipsis: Owing to mutilation bottom of MS. 1460[A], continuity is not quite clear.

20.3    Ellipsis: Recoverable: *& went over various other parts of the picture* (bottom MS. 1462).

24.1    Ellipsis: MS. 1464/5 mutilated at top (4¾–5½ inches missing). Recoverable: *Collin[son]* (top MS. 1464).

24.11   next week: *early* deleted in MS.

26.2    Ellipsis: Recoverable: *which he proposes* (bottom of MS. 1464).

28.1    Ellipsis: Recoverable [*com*]*missioned . . . instead of the . . . to do the 'Morning & Evening' . . . proposed to Hunt* (top MS. 1465). Date inserted in MS.

29.7    Ellipsis: MS. break (29 Aug.–10 Sept.). Recoverable: *saying* (bottom of MS. 1465).

### SEPTEMBER 1849

12.1    Date: *September* inserted in MS.

12.5    for a subject: 'as to a subject' in *PDL*.

12.6    which: 'it' in *PDL*.

12.7    21 lines: *20* deleted in MS.

13.3    the: *his* deleted in MS.

15.3    Ellipsis: MS. 1470/2 mutilated at bottom (3¼ inches missing).

20.5    Gabriel designed: 'which' inserted before in *PDL*.

20.7    Virgin: In *PDL* an ellipsis is indicated after but nothing has been omitted from MS.

20.9    publish: *print* deleted in MS.

20.11   that Deverell: 'and' inserted before in *PDL*.

20.13　Ellipsis: Conjectural reading supplied from DGR's extant letter (DW 43).
20.15　(Gabriel): Inserted over line in MS.
23.14　carried out: 'being' inserted before in *PDL*. In MS. there is an illegible deletion of 1½ lines between the last two sentences of this entry.
25.16　sculpturesque: Placed within quotation marks in *PDL*.
27.1　Thursday: Mistakenly dated Tuesday in *PDL*.
27.3　Patmore's poem: Appears twice as over-line insertion in MS., deleted before 'which' (line 4).
28.11　yesterday: *this* deleted in MS.
28.14　Asterisks (following entry): MS. break (28 Sept.–5 Oct.).

### OCTOBER 1849

6.1　[*Saturday* . . . attitude]: Break in MS. necessitates reconstruction.
6.6　Woolner: *him* deleted in MS.
7.2　[so]me: MS. 1475/6 mutilated at inner margin (½ inch missing, affecting entries for 7–8, 13–14 Oct.); WMR supplied some missing words in MS.; others [bracketed] are reconstructions.
8.1　Date: *October* inserted in MS.
10.4　whilst: 'while' in *PDL*.
10.9　two men: *some* deleted in MS.
10.13　Gobelin[s]: singular in MS.; text follows *PDL*.
10.32　Mr. Haynes: Illegible word deleted before in MS.
13.3　three: *two* deleted in MS.; *& another little piece of poetry* deleted after 'sonnets'.
13.5　second: *latter* deleted in MS.
13.6　last: *second sonnet* deleted in MS.
19.5　Asterisks (following entry): MS. break (20–31 Oct.).

### NOVEMBER 1849

1.1　[I . . . me]: MS. 1477/9 mutilated at top (3–3¾ inches missing). Recoverable: *proves like[ly] . . . on Saturday* (top MS. 1477). WMR originally dated section October.
1.14　Millais: *he* deleted in MS.
2.7　has: 'had' in *PDL*.
2.25　[*Princess*]: The last sentence of MS. 1477 is interrupted by mutilation at the top of MS. 1479.
6.1　[Gabriel . . . pre]: Recoverable: [re]*sumed their . . . clear when the rest* (top MS. 1479). Date is inserted over line in MS.; WMR mistakenly wrote December for November.
6.3　Cheyne: *Chain* deleted in MS. See below 13.5.
6.15　admitting: 'not' inserted before in *PDL*.
7.7　so good: *as* after in MS.; text follows *PDL*.
7.23　Ellipsis: MS. 1481/[3] mutilated at top (1½ inches missing).
8.7　of: *for* deleted in MS.
8.8　calotype: *daguerreotype* deleted in MS.
8.18　'Bride-chamber Talk': WMR writes this title variously in MS.; text follows *Works* (see p. 647).

9.6     studies: 'studios' in *PDL*.

11.3    done: *wrote* deleted in MS.

12.1    circumstances: *his* deleted before in MS.

12.3    'Thoughts': *Monthly* deleted before in MS.; 'towards Nature' inserted over line.

12.6    the: *his* deleted in MS.; 'Newman Street' inserted over line.

12.8    Ellipsis: The last sentence of MS. 1481 is interrupted by mutilation at top of MS. [1483].

13.1    Date: Mistakenly dated Thursday 15th in *PDL*, making two entries for that day; entry garbled.

13.5    Chain: 'Cheyne' in *PDL*. See above 6.3 and 13.5 in Explanatory Notes.

15.3    boy: *beg[gar]* deleted in MS.

18.1    Date: MS. 1485/7 mutilated at top (4½–5 inches missing). Recoverable (from entry of 17th): *first No. of the Monthly Thoughts, in [illustration of which] . . . design of Christ & St. John watering a rose* (top MS. 1485).

19.1    about: *by* deleted in MS.

19.6    He means: 'Millais' substituted for in *PDL*.

19.22   Ellipsis: Last sentence of MS. 1485 interrupted by mutilation at top of MS. 1487. Recoverable: *ranges between . . . new stove* (top MS. 1487). Date inserted in MS.

22.11   He . . . he: 'Patmore . . . Browning' in *PDL*. Above the top line of MS. 1488 (which begins 'at so high . . .'), *Thursday December 23* is deleted in MS.

22.20   therefore: Italicized in *PDL*; *that* and *he* deleted before and after in MS.

22.50   Ellipsis: MS. 1488/90 mutilated at bottom (3 inches missing). Recoverable: *he wore—A careless surcoat, glanced some missive o'er,—Propped on his truncheon in the public way'* (top MS. 1490).

24.1    Date: Supplied owing to mutilation.

25.1    Sunday: Mistakenly dated Saturday in *PDL*.

25.25   Asterisks (following entry): MS. break (25 Nov.–7 Dec.). Recoverable: *He was in a state of some elation & triumph, having found a passage in the British Cyclopoedia, which states . . . production of the English soil, & being thus enabled to cl[en]ch Stephens . . .* (bottom MS. 1490).

### DECEMBER 1849

7.1     Ellipsis: MS. 1492/3 mutilated at top (4½–5 inches missing). Recoverable: *much . . . did not . . . [se]veral new songs* (top MS. 1492).

7.11    Just: Date inserted over line before in MS.

10.1    Ellipsis: Recoverable: *was engaged to go & hear . . . incident to his position. With this exception* (top MS. 1493).

10.6    Preacher: *Mon[k]* deleted in MS.; date inserted after.

13.1    Ellipsis: MS. 1494/5 mutilated at top (2½–3½ inches missing).

13.7    Patmore: Date inserted before in MS.

15.4    Ellipsis: Recoverable: *might not finish up for . . . which would take him about a month, & . . . perhaps a portrait, as he has a subject of one in his eye* (top MS. 1495).

16.1    Sunday 16th: *December* inserted in MS.; not transcribed.

17.4    resumed: *also* deleted before in MS.
18.4    former . . . latter: *latter . . . former* deleted in MS.
19.9    is: *has* deleted in MS.
19.12   Friday: *Thursday* deleted in MS.
19.17   first number: *George Tupper is becoming offi[cious]* deleted after in MS.
19.19   'Dreamland': Normally 'Dream-land' in MS.; published as 'Dream Land' in *Germ.*
19.25   fixed on: *adopted* deleted in MS.
21.5    Thomas: 'Cave' inserted before in *PDL.*
21.16   [4]: *3* in MS.
22.12   opposite: *in* deleted in MS.
23.16   one: *a* deleted in MS.
24.10   about: *some* deleted in MS.
24.14   the: *his* deleted in MS.
24.16   each. A: There is an illegible half-line deletion between in MS.
28.22   our: *my* deleted in MS.
30.3    thing: *finis[hing]* deleted in MS.
30.5    of Mr. Wyatt: Deleted in MS. and *Drury* added. 'Drury' also in *PDL*; Wyatt restored in text; *port[rait]* also deleted before 'of'.
31.7    paper: *art[icle]* deleted in MS.

### JANUARY 1850

1.11    Asterisks (following entry): MS. break (1–5 Jan.). Conjectural reading based on last line of *PRBJ* entry for 29 Dec. 1849. WMR's comment that 'here comes a tear in the manuscript' (*PDL*, p. 245) is inaccurate.
5.1     Date: Inserted over line in MS.
12.1    Date: Mistakenly dated Friday 11th in *PDL*, making two entries for that day.
13.1    Date: Sub-heading *1850* not transcribed.
21.10   in: *of* deleted in MS.
22.3    him: 'Gabriel' in *PDL.*
22.8    the straw: *better part* deleted between in MS.
22.12   beech-tree: *poplar-* deleted in MS.
22.20   No. 2: In *PDL* an ellipsis is indicated after but nothing has been omitted from MS.
23.9    'Blessed Damosel': 'Damozel' in *PDL*. See corresponding Explanatory Note.
23.15   Deverell: *Wool[ner]* deleted in MS.
27.1    Gabriel: *Deverell left me his* deleted before in MS.
28.13   Ellipsis: MS. 1563/5 mutilated at bottom (¾ inch missing). Recoverable: (*I understand that, after* (bottom MS. 1563). Conjectural reading occurs at top of MS. 1565.
29.15   Gallop: *travel* deleted in MS.
30.4    Hervey . . . maintained: Originally read in MS., *talking with Harvey he maintained.*
30.12   70: *Thursday 31st* deleted after in MS.; the entry must have extended beyond WMR's intention.

31.11   Ellipsis: Recoverable: *Twenty cop[ies were sent to . . . mon]th* (bottom MS. 1565).

31.11   George Tupper: Inserted over line in MS.

## FEBRUARY 1850

2.38    found: *find* deleted in MS.

2.48    consult: *some* deleted after in MS.

3.7     relative: *abo[ut]* deleted in MS.

9.6     Marquis . . . paint: *Sunday 10th* deleted above this line in MS. That this kind of deletion recurs in the MS. suggests that WMR may have written in his dates previous to composing the entries, estimating beforehand the amount of space each day's activities would require to record.

12.2    evening: In *PDL* an ellipsis is indicated after but nothing has been omitted from MS.

12.4    Parentheses: omitted *PDL*.

13.4    on Monday: *last* deleted in MS.

15.5    Talfourd: *Talford* in MS.

16.17   Ellipsis: MS. 1572/3/4 mutilated (1–1¾ inches missing from centre, the leaf being in two pieces). Recoverable: *that will apply equally to my 'Plain Story'* (top of bottom half MS. 1572). In editing the MS. for *PDL*, WMR confused the two halves of the leaf, dividing the long entry for the 16th into two days and omitting completely the entry for the 17th, which is clearly marked in the MS. and which can be partially reconstructed. By transcribing the top halves of the leaf as a continuous entry, he also transposed two sections of the entry for the 16th, dating the second the 17th.

16.17   We . . . itself (line 30): Dated Sunday 17th in *PDL*, where this passage is placed after the one below, commencing 'it seems' and continuing through 'carried out' (lines 37–41).

16.26   'My Lady: *Beautiful* deleted between in MS.

17.2    Ellipsis: Recoverable: *Stephens came . . . T[up]per who has some old poem . . . [su]itable,—some* (bottom of top half MS. 1573) . . . *putting together* (top of bottom half MS. 1573).

19.2    Tuesday: *Wednesday* deleted in MS.

20.8    as . . . preferable: in parentheses in *PDL*.

21.2    brother's: *brothers* in *PDL*.

21.4    will be: 'was' in *PDL*.

21.8    set: *about* deleted after in MS.

22.10   from: *for* deleted in MS.

23.3    cleverly written: Hyphenated in *PDL*.

23.5    him: 'Hunt' in *PDL*.

25.1    Dialogue on Art: *&* deleted between in MS.

27.1    Date: *Monday* deleted in MS.

## MARCH 1850

3.2     [of]: *in* in MS.; text follows *PDL*.

6.29    affronted: *offended* in *PDL*.

7.1     Date: *6* deleted in MS.
7.8     [do]: Not in MS.; text follows *PDL*.
9.2     Gabriel: *he* deleted in MS.; before entry *March* inserted in MS.
20.2    or . . . Pre-Raffaelle (line 3): In parentheses in *PDL*.
20.7    written out: *begun* deleted in MS.
21.16   advocating: *concern*[*ing*] deleted in MS.
22.2    His: Originally read *he is* in MS.
22.8    and is: *he* deleted between in MS.
22.14   working: *starting to* deleted in MS.
23.1    Date: *24th* deleted in MS.
23.20   among: *of* deleted in MS.
23.22   *Art and Poetry*: *Ge*[*rm*] deleted in MS.
25.15   four: *three* deleted in MS.
27.2    *Art and Poetry*: *Ger*[*m*] deleted in MS.
29.12   Ellipsis: MS. 1590/[91A] mutilated (1–1¾ inches missing from centre, the leaf being in two pieces). Recoverable: *tim*[*e*] . . . *Deverell* . . . *being* (top of bottom half MS. 1590). The top half of this leaf became separated from the MS. sometime between 1963 and 1966 and exists only in photocopy.
30.1    [Saturday . . . Fancies]: Reconstruction based on contents of *Germ* 3; listing excludes FMB's etching.

### APRIL 1850

1.5     ['Xmas-Eve']: Reading conjectural; word in MS. is illegible.
4.2     exhibition: *picture* deleted in MS.
5.3     Ellipsis: Recoverable: *Tuesday, & to bring with him* (top of bottom half MS. [1591A]).
7.3     working: *finish*[*ing*] deleted in MS.
7.6     Hunt: *he* deleted in MS.
7.15    get again: *it* deleted between in MS.
7.19    head: 'hand' in *PDL*. WMR may have confused the two pictures for which he was sitting; in the *Ecce Ancilla Domini*, he served as model for the head of the angel.
8.7     Deverell: *Tuesday 9th* is deleted in MS. following this entry; a wavy line separates the April and July entries, during which period *PRBJ* was not kept.

### JULY 1850

21.1    Date: There is no date heading in MS. or *PDL*. For '8 April' WMR originally wrote *this point* in MS. and for 'July 21', *July 14*.
21.11   Wyatt: *Drury* in MS. and *PDL*; see above Dec. 49 30.5
21.26   to: 'on' in *PDL*.
21.35   which . . . expedient: *it was* not *thought* deleted between in MS.
21.37   speaking of the picture: In parentheses in *PDL*.
21.39   he: Italicized in *PDL*.
21.50   by: *from* deleted in MS.
21.58   Catholic: Lower case in MS.; text follows *PDL* (also in line 71).
21.61   withdraw myself: *altogether* deleted after in MS.

21.73   the Pre-Raffaelle painters: *such of* and *as I know* deleted before and after
        in MS. The three bracketed sections in the remainder of JC's letter are
        WMR's reconstructions.
21.83   mind: *Whit Munday* deleted after in MS.

### OCTOBER 1850

line 1   In the MS. and in *PDL*, WMR dates this introduction 24 October;
         to avoid confusion with the next entry, the date has been omitted.
line 51  at Knowle Park: Originally after 'Sevenoaks' in MS.
line 63  Griselda: 'Griseldis' in *PDL* and in earlier MS. references. In *PRBJ* for
         2 May 1851, WMR writes, 'Stephens's "Griselda" was sent [to the
         R.A. exhibition] . . . but does not make its appearance' (lines 18–19).
line 64  Ellipsis: MS. break (2 leaves missing). WMR does not indicate the
         break in *PDL* (p. 279). Recoverable: *but the bother is over tant mal que
         bien, & need not be dwelled on* (top MS. 1596).
26.15    Wordsworth's: *Wool[ner's]* deleted in MS.
29.7     had been just: *was j[ust]* deleted in MS.

### NOVEMBER 1850

1.10    [I]: MS. 1599/1600 has slight tear in lower left corner, affecting also
        two words in the entry for the 5th.
1.16    having a notice: *revie[wing]* deleted in MS.
5.20    this: Originally *these* in MS.
5.34    go: *come* deleted in MS.
5.35    proves: *is* deleted in MS.
5.45    it up to: *them up migh[t]* deleted in MS.
5.48    beyond: *to* deleted in MS.
5.57    to be: *have* deleted in MS.
7.4     being afterwards: *as I spent the evening* deleted in MS.
7.12    aims at: *thinks of* deleted in MS.
8.4     least: *slig[htest]* deleted in MS.
11.6    of the: *a series to be delivered* deleted between in MS.
13.8    suggested by: *relative to* deleted in MS.
13.9    sculptures: Singular in *PDL*.
13.12   whether: *if* deleted in MS.
13.22   together: *up* deleted in MS.
14.12   Asterisks (following entry): Break in MS. (15–30 Nov.).
30.1    [Saturday . . . other]: WMR's date and conjectural reading in *PDL*. Only
        the date, inserted over line after 'matters' below (line 15) appears in MS.
30.16   yesterday: *looking* deleted in MS.
30.23   books: *the* deleted before in MS.

### DECEMBER 1850

2.6     musician: *painter* deleted in MS
2.17    value . . . of: In *PDL*, 'of' placed after 'value' and the intervening phrase
        in parentheses.

3.5     is a: *I found the* deleted in MS.

7.4     monthly: *by* and *payments* deleted before and after in MS.

8.5     [so to be cast]: WMR's reconstruction in *PDL*; not in MS.

8.6     Ellipsis: MS. [1610]/1767/9 mutilated ($\frac{3}{4}$–$1\frac{1}{2}$ inches missing from centre, the leaf being in two pieces). Recoverable: *Millais* (bottom top half MS. [1610]).

10.8    Millais: Underlined in MS.; text follows *PDL*.

### JANUARY 1851

line 6    view to: *of* deleted in MS.

line 10   bracketed material: Reconstruction, necessitated by mutilation, is based on Rules of P.R.B. (see Appendix 1).

line 16   Rules: Date (1851 January 13) inserted in red before and deleted in MS.

line 24   declaring: *of our* deleted in MS.

line 29   Earl: *Earles* in MS.; text follows *PDL*.

line 32   is on: *publis*[*hed*] deleted between in MS.

line 34   Ellipsis: MS. 1772/70 mutilated top and bottom (3 inches missing). Recoverable: *With* (bottom MS. 1769) . . . *However this may be* (top MS. 1772).

26.2    renders: *it* deleted in MS.

26.8    Ellipsis: Recoverable: *from it* . . . *He is desirous, too, of reviewing* (bottom MS. 1772) . . . *day* (top MS. 1770)

### FEBRUARY 1851

2.12    Ellipsis: Recoverable: *says* (top MS. 1773). '[ever saw]' in WMR's silent reconstruction in *PDL*, where no indication of ellipsis is given.

9.1     Date: *February* is not transcribed.

9.16    custom: Originally before 'love' in MS.

9.18    Ellipsis: MS. 1773/5 mutilated at bottom ($3\frac{1}{4}$–$3\frac{3}{4}$ inches missing). Recoverable: *Woolner* (bottom MS. 1773); [*Spec*]*tator* (top MS. 1775). The remaining portion of this entry may belong to the week of 16 Feb.

9.19    designs: *etchings* deleted in MS.

### MARCH 1851

2.5     gave him: Illegible word deleted between in MS.

2.10    Ellipsis: Mutilation at bottom of MS. 1775 precludes further reconstruction.

9.1     Ellipsis: Recoverable: *having, with another small female head, been already sold* (top MS. 1777). Date inserted in MS.; month not transcribed.

9.4     begun: *made* deleted in MS.

9.17    manhood: '(rather than womanhood)' inserted after in *PDL*.

### MAY 1851

2.12    exhibits: 'exhibited' in *PDL*.

2.25    another: [*Chorley I believe*] inserted over line and deleted after in MS.

2.34    the . . . round: In parentheses in *PDL*.

2.40    walk: *wander* deleted in MS.

2.41    Asterisks (following entry): Break in MS. (2–5 May). Recoverable: *Regarding Stephens, a new state of matters.*

8.1     Date: WMR originally wrote *9* for *8* in MS.

8.4     Ruskin: A deleted note in the MS. to the effect that it was Ruskin's father who wished to buy the picture is incorporated into the entry for 12 May.

8.13    Wednesday: *Satur[day]* deleted in MS.

11.10   Jacob: *Joseph* deleted in MS.

13.5    'Pre-Raphaelite': 'Praeraphaelite' in *PDL*; WMR's spelling of this term varies throughout his published writings. The quotations from Ruskin are, save in matters of punctuation, generally accurate. However, in one or two instances words and phrases have been omitted, and to his concluding statement WMR has added the words 'to be permitted' (line 35). In line 24, indirect is substituted for direct discourse by the alteration of 'I' to 'he'. See *The Works of John Ruskin*, ed. E. T. Cook and Alexander Wedderburn (London: Allen, 1904), xii. 319–23.

13.21   and: *that* deleted in MS.

13.22   folded: *finished* deleted in MS.

13.35   beauty: 'deficient' inserted before in *PDL*.

13.46   seeming: *which* deleted before in MS.

13.60   invitation: *request* deleted in MS.

13.60   for him to: *that he will* deleted in MS.

13.81   copies: *Nos.* deleted in MS.

13.85   up; while: 'out; whilst' in *PDL*.

16.35   requirements peculiar to: Originally read in MS. *peculiar requirements of.*

16.38   of P.R.B.: 'the' inserted between in *PDL*.

24.10   notice: *his* deleted before in MS.

### JANUARY 1853

line 1   Date: In the MS. and in *PDL*, WMR dates this introduction 23 January, though it is overwritten and may read 29; to avoid confusion with the next entry the date has been omitted. This last section is headed: 'Wm. Rossetti—The P.R.B. Journal'.

17.1     Date: A sub-heading, *January 1853*, has not been transcribed.

17.13    dreary: Originally before *titles* in MS.

17.28    (The . . . Place): Parentheses deleted in *PDL*.

17.40    formulating: 'formulation' in *PDL*.

### RULES OF THE P.R.B.

line 13  or: *nor* in *FLM*.

2.1      Rule 2: In MS. there are 22 rules. When editing the MS. for publication, WMR divided Rule 2, making a separate rule of the last sentence, which is written crosswise on the paper. As a consequence, there are

23 rules in the published version in *FLM*, the numbers altered accordingly after Rule 2.

2.2      election: 'the election' in *FLM*.

2.3      this: 'the' in *FLM*.

2.4      in case: *any* deleted between in MS.

2.5      a new: *of ultimate* deleted in MS.

2.6      eligible: *elected* deleted in MS.

3.2      be held: *the Secretary giving convenient notice in all instances, as a reminder* deleted after in MS.

8.1      each: *all* deleted in MS.

10.1     a: *any* deleted in MS.

10.2     resolutions: *any* deleted before in MS.

17.1     that: 'which' in *FLM*.

17.1     proposed: *resolved* deleted in MS.

21.1     Date: Supplied in *FLM*; a space is left before *April* in MS.

21.1     Shakespeare: 'Shakespear' in *FLM*.

22.3     before the: *his* deleted in MS.

# EXPLANATORY NOTES

# EXPLANATORY NOTES

THE explanatory notes are arranged by entry date and line number within each month, using cues from the text. Titles of pictures and literary works, proper names, and other allusions in the *Journal* are all glossed; minor works of art or writings that cannot now be identified are so indicated. In general, notes follow initial citations and are not repeated, but frequent cross-references are employed; these are either to the *Journal* entry (see *PRBJ* 28 Aug.) or to an earlier or later note (see Aug. 28.2), omitting the year unless it differs from that of the entry in which the cross-reference occurs. If the reference is to the same month, only the date and line number are provided (see 28.2 above). Dates of birth and death and relevant biographical details are given for the more obscure persons mentioned in the *Journal*, unless the name occurs only in conjunction with a literary or artistic work mentioned in passing; for all others, notes are restricted to the clarification of specific allusions. Thus, such figures as the P.R.B.s themselves, Arnold, Ford Madox Brown, the Brownings, Clough, Patmore, Ruskin, and Tennyson are not glossed; nor are Faber, Cassel, G. J. Cayley, and Moile—all authors of books considered for review by Rossetti. Many of Rossetti's own notes in *Præraphaelite Diaries and Letters* are preserved, both those which require further elaboration and others, such as those identifying minor figures, which are sufficiently informative to stand alone.

## MAY 1849

**15.2.** DGR's *Dante*: 'This pen-and-ink design was quite different from the water-colour which Dante Rossetti afterwards executed of the same subject. The design was sold in 1898 among other works which had remained in the hands of Sir John Millais up to his death' (*PDL*, p. 209). For details of the drawing, inscribed 'Dante G. Rossetti to his P.R. Brother, John E. Millais', see Surtees 42.

**15.6.** JEM's Abbey at Caen: 'This design (we all considered it a very fine one, and with good reason) represented the spoliation of the grave of Queen Matilda, wife of William the Conqueror. It was included in the Millais Exhibition of 1886' (*PDL*, p. 209). For details of the picture, entitled *The Disentombment of Queen Matilda*, see Millais 243.

**15.7.** JEM's Ferdinand: For *Ferdinand Lured by Ariel*, in the collection of Lord Sherfield, who also owns the study of FGS's head, see Millais 22 and 251.

**15.8.** JEM's 'Castle-moat' poem: 'About this poem I remember now next to nothing. I suppose it was never finished' (*PDL*, p. 209). Three doggerel poems by JEM are included in *LLJEM* but not this one. There is, however, in the same volume (i. 67–8), an outline of a tale which JEM's son says his father wrote for a fifth number of *The Germ* that must follow closely the line of the 'castle-moat' poem:

> A knight is in love with the daughter of a king who lived in a moated castle. His affection is returned, but the king swears to kill him if he attempts to see his lady-love. The lovers sigh for each other, but there is no opportunity for meeting till the winter comes and the moat is frozen over. The knight then passes over the ice, and, scaling the walls of the castle, carries off the lady. As they rush across the ice sounds of alarm are heard within, and at that moment the surface gives way, and they are seen no more in life. The old king is inconsolable. Years pass by, and the moat is drained; the skeletons of the two lovers are then found locked in each other's arms, the water-worn muslin of the lady's dress still clinging to the points of the knight's armour.

**15.12.** CP's 'River': The opening poem in *Poems* (1844); reprinted in *Amelia* (1878).

**15.13.** DGR's *Vita Nuova* poem: 'Dante at Verona' (*Works*, pp. 6–16); referred to in later entries as 'Dante in Exile'.

**15.15.** WMR's CP subject: Subsequent entries reveal that WMR was making a design illustrating 'The Woodman's Daughter', from CP's *Poems* (1844). Not extant.

**15.16.** Compton: Charles Compton (1828–84), early associate of the P.R.B. and a student at the R.A. Schools, who may have served as a model for one of the figures in JEM's *Isabella*. Later a civil servant and amateur painter (see *Millais* 'Footnotes', p. 45). DGR proposed Compton to WHH for membership in the literary club which was being discussed just prior to the founding of the P.R.B. See DGR's letter to WHH (DW 37): 'By the bye, I mentioned the matter (under the seal of the profoundest secrecy,) to Compton, whom I should like to have, as he is a very nice and a very clever fellow, and as I know he writes. He seems rather shy of it at present, but I hope we shall get him. I wish you also would make use of your power of persuasion, as I think you would be likely to have some influence with him. I should like gradually to include all the nice chaps we know who do anything in the literary line.'

**16.2.** Cottingham: Nockalls Johnson Cottingham (1823–54), an architect who 'first came into our circle by offering to buy Rossetti's earliest picture, *The Girl-hood of Mary Virgin*. He never did buy it, and his transactions with the P.R.B. were considered anything but satisfactory' (*PDL*, p. 210). He obtained from TW at a reduced price a statuette which he later sold as his own (see below July 22.34), and commissioned from WHH pictures for which he never paid (see *PRBJ* 13 Aug. and 6 Oct.). JEM wrote to WHH that it would be 'an act of charity to chastize that snob Cottingham. I never liked the look of the fellow; he was *sloshy* and behaved so at first with Gabriel about his picture' (unpublished letter in AP). If WHH's account is correct, only DGR managed to get the better of him: 'Not long after it turned out that the gifted genius had left his

native shores for America, and we then found on comparing notes that, although he had been too clever for others, Rossetti had proved his match by exacting some money in advance for drawings never to be claimed by the patron, for the ship in which the miserable man sailed (*The President*) was never heard of' (*PR & PRB*, i. 125–6). According to the *DNB*, Cottingham perished in the wreck of the *Arctic*.

**16.2.** Hancock: John Hancock (1826–69), 'a sculptor then of some mark and promise' (*PDL*, p. 220). A member of the Cyclographic Society, Hancock, according to WMR, met DGR as early as 1847. Although WMR records in *PFG* that Hancock, who was a proprietor of *The Germ*, 'contributed nothing to [it], either in work or in money' (p. 9), he was closely involved in the planning stages and was one of the members who voted on the title (see *PRBJ* 19 Dec.). WMR's biographical summary and description of Hancock is the fullest available, the *DNB* record being merely a perfunctory summary of *The Times* obituary (23 Oct. 1869): 'He was related to the old-established family engaged in the business of silversmiths and jewellers; and he made an early success with a bas-relief, *Christ's Entry into Jerusalem*, which won a prize offered by the Art Union, and was engraved. His success after this was not often considerable; and, owing partly to unfortunate circumstances into which it is not my affair to enter, he gradually sank out of observation, and he died in middle age. One of his youthful works was a medallion-head of my brother. . . . Hancock was an ungainly little man, wizened, with a long thin nose and squeaky voice [immortalized in DGR'S 'St. Wagnes' Eve']; at times he occupied the same sculptural studio with Thomas Woolner. Someone—it must have been Dante Gabriel—put him down as a co-proprietor in *The Germ*; but any practical work in that enterprise was not in Hancock's line, and he did not respond to the call' (*SR*, i. 150). Hancock was one of the commissioners to decide the sculpture in the Great Exhibition (see *PRBJ* 9 Dec. 50), and he exhibited three works in the International Exhibition of 1862. See also July 50 21.7.

**16.7.** DGR's *Kate the Queen*: 'From a song in Browning's *Pippa Passes*' (*PDL*, p. 210). The design is probably one for the *Rossovestita*, a water-colour signed 'Dante Rossetti Fece in Londra 1850', which was originally given to FMB. See Jan. 53 line 16 and Surtees 45 and 49.

**17.5.** JEM's brother: William Henry Millais (1828–99), exhibited at R.A. 1853–92 and elsewhere. Though he has been totally eclipsed by his brother, William Millais's landscapes are competent and very much in the Pre-Raphaelite manner. Few of his pictures have been reproduced; some slight drawings are illustrated in *LLJEM*. A number of his landscapes were shown at Agnew's in 1971.

**17.7.** 'gentleman in black': Unidentified; perhaps N. J. Cottingham.

**17.10.** Religious Prints: By Charles Brocky (1807–55) and William Charles Thomas Dobson R.A. (1817–98), both portrait and subject painters. Though Dobson had visited Germany in the 1840s, where he was influenced by the pictures of the Nazarene school, his attempt to inaugurate a vogue for sentimental scriptural subjects painted with 'prettiness, simplicity, and refinement'

did not endear him to the P.R.B. Many of his religious pictures were 'popu-larized by engraving' (*DNB*).

**18.4.** JC's picture: This could refer to any of three works exhibited at the R.A. between 1847 and 1849: *The Charity Boy's Debut, The Rivals,* or *Italian Image Makers at a Roadside Ale House.*

**18.7.** Smith: Bernhard Smith (1820–85), a minor painter and sculptor who shared a studio with TW. From 1842 to 1848 he exhibited sixteen sculptures at the R.A., and around 1850 he exhibited several pictures, but WMR doubted whether in either art Smith had any remarkable facility. His popularity with the Brotherhood sprang from his 'healthy, hearty English look and manner'— the 'serene and square' nature described by DGR in 'St. Wagnes' Eve'. 'Not to like him at first sight', declared WMR, 'would have been impossible, and he "wore well" besides' (*SR*, i. 150). In 1849, when Smith was on the point of emigrating to America—a venture which both DGR and TW also considered (see *PRBJ* 19 Mar. 50)—the Rossetti brothers presented him with a copy of Browning inscribed 'Bernhard Smith, P.R.B.' (see 21.10 below), which Smith and his descendants used as evidence of his membership of the P.R.B. WMR admitted that Smith 'came near to being enlisted as a P.R.B.' (*FLM*, ii. 83), but he dis-missed the inscription as 'one of the rather arbitrary acts in which my brother indulged himself now and again; for in truth Smith never was a P.R.B.; he was not elected, nor even put up for election . . .' (*SR*, i. 151). In 1852, Smith emigrated with Bateman and Woolner to Australia, where he virtually aban-doned art for a career as a minor public official, later becoming a police magis-trate. He never returned to England. On 10 September 1886, in response to an unsigned letter in the *Pall Mall Gazette*, which had appeared a week before and which contained a letter from Smith written in 1881, WMR addressed himself to the question, 'Who were the Pre-Raphaelite Brothers?' When the magazine reached Australia four years later, Smith's son, Bernard, wrote to WMR for clarification, asking him to provide details of the early history of the movement,

with which, even if, as you say, my father was not actually associated, he was at any rate very intimately connected and to which he was regarded by your brother and yourself, at the time, as actually belonging, for otherwise it is difficult to see why you should have gone out of the way to address him as P.R.B. My Father was the last man in the world to trade on the reputations of others, and it was for this reason that he steadily and consistently refused to make any public claim to recognition as being in any way connected with the Pre-Raphaelite movement— he said that as he had done no serious work as an artist since he had been in this country he would not attempt to lay claim to having been connected with the P.R.B.'s.

'I desire nothing', Smith's son concluded, 'but the truth, whether it be for or against my Father, and you can doubtless give a better explanation of your reason in addressing him as a P.R.B. than appeared in the necessarily meagre note in *Pall Mall*' (unpublished letter, dated 8 Sept. 1890, in AP). WMR's reply must have failed to convince the family, for many years later, in 1917, Smith's daughter, Minnie, in a typescript memoir of her father which is the principal source for the little that is known about the artist, wrote: 'The 7 were privately banded together to work faithfully avoiding trickery or short cuts in art.

Others followed their ideals (Bateman, Collins, Deverell, Stephens, Burne-Jones, etc.). But there were 7 and no more of the original P.R.B.'s' (see *Pre-Raphaelitism* 77.57). It is worth noting also that among the photographs illustrating her father's work is one of a portrait medallion signed 'Bernhard Smith P.R.B.'.

**18.11.** TW's poems: Unidentified, but probably early drafts later incorporated into 'My Beautiful Lady', first printed in *The Germ* and separately published in expanded form in 1863.

**18.13.** Francesca [and] Ugolino: *Inferno*, Cantos 5 and 33; translations not extant.

**19.4.** WHH's Monk: Variously titled; exhibited R.A. 1850 as *Christian Brothers Escaping from Druid Persecution*. See *Hunt* 15.

**19.6.** TW's heads: Not listed among TW's sculptures in the 'List of Works' in *TWLL*.

**19.8.** TW's song: 'O When and Where', published in *Germ* 2.

**19.11.** *Court Journal*: 12 May 1849, p. 438. 'It will be understood that the year 1849, to which the beginning of this Journal belongs, was the first year when pictures pertaining to the "Præraphaelite" movement were exhibited. Hunt's picture was *Rienzi* . . .; Millais's was the *Lorenzo and Isabella*. . . . Though that distinguished authority, *The Court Journal*, was thus contemptuous, the general tone of press-opinion . . . was moderate and sometimes laudatory; the systematic abuse developed in 1850' (*PDL*, p. 211).

**19.12.** Walters: The artist whose rejection was lamented by the *Court Journal* was 'Walton, the clever historical and portrait painter', probably John White-head Walton (fl. 1834–65). For WMR's confusion see the corresponding textual note. The pictures by WHH and JEM are mentioned at the conclusion of the notice, among other 'pictorial sins of such magnitude and hideousness, that they are less a disgrace to the perpetrators than to the good easy academic souls' who selected them.

**20.4.** TW's poem: 'The first beginning of *My Beautiful Lady*' (*PDL*, p. 211).

**21.2.** Bateman: Edward La Trobe Bateman (1816–97), a decorative artist who, by 1849, was a friend of JEM's and the Rossettis. Generally referred to as an 'illuminator', Bateman assisted Owen Jones in his decorations for the Great Exhibition of 1851. In 1852, he emigrated with Smith and TW to Australia, where his cousin was the Governor of Victoria. He remained there until 1868. Bateman eventually settled in Scotland, where, among other activities, he carried out interior and landscape designs for the Marquess of Bute. JEM's letter to DGR is in AP; the purpose of the visit was to look over Bateman's 'missal letters'.

**21.10.** 'Ichabod, Ichabod': The lines are misquoted from Browning's 'Waring', first published in *Dramatic Lyrics* (1842). The substitution of 'west' for 'east' must have been in anticipation of Smith's intention to emigrate to America. See 18.7 above.

**22.3.** Munro: Alexander Munro (1825–71), Scottish-born sculptor who began his career as an assistant to Sir Charles Barry doing sculptural work on the Houses of Parliament. Munro early came into the Pre-Raphaelite circle; he shared a studio with Arthur Hughes in the fifties, and he participated in the decoration of the Oxford Union murals. His best-known work is *Paolo and Francesca*, after a design by DGR, now in the main Pre-Raphaelite room at Birmingham, where, as John Gere says, 'it finds its proper context, for it is the only known piece of sculpture which expresses anything like the same degree of poetic intensity as the paintings which surround it' (*Burlington Magazine*, cv [Nov. 1963], 509). The specific work mentioned in *PRBJ* is not identified. Between 1849 and 1870, Munro exhibited five or six works in every R.A. annual showing, mainly busts, medallions, and small groups. WBS, discussing Munro's many busts, remarks that 'these, indeed, especially of ladies, were executed with surprising celerity, and while possessing the character of a portrait, striking at the first moment, had an elegance and sweetness, united with high breeding, that made them much prized. His men were scarcely so good . . .' (*The British School of Sculpture* [London, 1872], p. 136).

**23.1.** Smith's Schoolmaster: Not identified.

**23.5.** WHH's 'Isabella': For a brief listing of Keats-inspired Pre-Raphaelite pictures see G. H. Ford, *Keats and the Victorians* (New Haven, 1944), Appendix to Chap. 8. This drawing must be the same as that described in the introductory section to *PRBJ* Oct. 50, and it probably belonged to the intended series of etchings planned by WHH and JEM for an illustrated edition of Keats's poem (see *PR & PRB*, i. 98 and 110). JEM's *Isabella* was exhibited at the R.A. in 1849 (*Millais* 18); WHH's *Isabella and the Pot of Basil* was painted at Florence in 1867 (*Hunt* 41).

**23.11.** CP's poems: Both included in *Poems* (1844); revised and reprinted in *Amelia* (1878), 'Sir Hubert' retitled 'The Falcon'. WMR notes that 'Dante Rossetti read the volume soon after its publication, delighted in it much, and must have introduced it to other P.R.B.'s' (*PDL*, p. 212). See also *PR&PRB* (i. 137), where WHH makes it clear that it was DGR's readings from CP that led the P.R.B.s, through TW, to make the poet's acquaintance. On this point WMR says: 'I am not now quite sure how Woolner came to know of him, but I think it may have been through Mr. Vom Bach, a Russian gentleman who had some employment in the British Museum, to which Mr. Patmore also belonged' (*PDL*, p. 221). See also Champneys, Chap. 7.

**23.17.** TW's Murillo: For his commission from Cottingham; see *PRBJ* 19 May.

**23.25.** JEM's CP subject: Mary Bennett (*Millais* 29) speculates that JEM's *The Woodman's Daughter* 'may have taken the place of this idea'.

**24.4.** Whitehead: Charles Whitehead (1804–62), poet, novelist, and dramatist, who is best known for his novel *Richard Savage* (1842). The volume advertised is *The Solitary and Other Poems* (London, 1849).

**24.8.** 'Maud's madness': WMR's design for CP's 'The Woodman's Daughter'. See 15.15 above.

**24.10.** portrait-taking: One of the favourite pastimes at P.R.B. gatherings as the many illustrations in *PR & PRB* and *LLJEM* demonstrate. For the best account of one such episode see Richard Ormond, 'Portraits to Australia: A Group of Pre-Raphaelite Drawings', *Apollo*, lxxxv (Jan. 1967), 25–7, with seven black-and-white portrait-drawings executed among themselves by the Pre-Raphaelites and sent to TW in Australia.

**25.3.** Wrightson: Perhaps Joseph Wrightson (1797–1856), editor of the *Weekly Dispatch* for eighteen years. It is more likely, however, that the reference is to the unidentified Wrightson mentioned in DGR's letter to WMR in 1852 (DW 73), whom WMR glossed as 'a Commercial Traveller, who made Gabriel's acquaintance somehow. He had literary tastes, and performed the rather considerable feat of buying at a sale for £101 the original MS. of Gray's Elegy' (DW, i. 105). His poem is not identified.

**27.2.** Dickinson: Lowes Cato Dickinson (1819–1908) and his brother Robert were members of the family long established as printsellers and photographic agents in New Bond Street. Robert was head of the firm during the period of *The Germ*, the last two issues of which were published jointly by Dickinson's and Aylott & Jones. Lowes Dickinson became a successful portrait painter, who, in 1854, helped F. D. Maurice to found the Working Men's College, where DGR also taught. He married the daughter of William Smith Williams and remained for many years a friend of the Rossettis. See 28.1 below.

**27.2.** Thomas: William Cave Thomas (1820–1906), historical genre painter, teacher, and writer on artistic topics. WCT began his career as a Nazarene, studying in Munich; later he came under the influence of FMB, who remained convinced of his artistic potential (see FMB's Diary 28 Aug. 1854 in *PDL*). WCT seems, however, to have been primarily interested in art education, and he was for many years Master of the North London School of Drawing and Modelling. He exhibited regularly at the R.A. from 1843 to 1862 and at other galleries until 1884. Writing in 1906, WMR observed that 'In Germany he would long ago have found his proper level and recognition in some professorship of art' (*SR*, i. 138). WCT not only named *The Germ* (see Appendix 4), he also wrote an opening address, which was set in print but withdrawn, in which, as he says in a letter to FGS in 1883 (BSP, MS. don. e. 57, ff. 66–7), 'I attempted to moderate the extreme views'. He also projected a long article on 'Nature', but he seems never to have finished it. Long after the demise of the Brotherhood, WCT published a polemical treatise entitled *Pre-Raphaelitism Tested by the Principles of Christianity*, in which he examined the movement as a religious, moral, and ethical phenomenon. If the view expounded in this paper reflects at all the ideas advanced in his now lost preface to *The Germ*, the P.R.B.'s decision to drop the piece is perfectly understandable. See *PRBJ* 22 Dec.

**27.6.** DGR 'in a garret': 'This would be the room appropriated to my brother and myself at the top of the family residence, 50 Charlotte Street, Portland Place. It was certainly an anti-luxurious apartment, but we had of course the run of the rest of the house' (*PDL*, p. 213). WMR's identification notwithstanding, it seems more likely that the 'garret' was the studio at No. 7 Cleveland

Street, Fitzroy Square, shared by DGR and WHH which is so graphically described by FGS in his *Dante Gabriel Rossetti* (London, 1894, pp. 13–14).

**27.6.** *Illustrated News* notice: *ILN* 26 May 1849, pp. 345–60, R.A. supplement.

**28.1.** Dickinson's: 'Towards 1849 [the Dickinsons] promoted the formation of a drawing-class in Maddox Street, Regent Street, and I joined it for some little while. My brother thought rather well of my drawings from the life. I was always conscious however of their being stiff and ungenial, and I never deceived myself into thinking that I possessed an artistic aptitude worth developing' (*SR*, i. 139).

**28.2.** Hersey: Neither Hersey nor Miss Saunders is identified.

**28.7.** TW's dirge: The second part of 'My Beautiful Lady', entitled 'Of My Lady in Death'.

**28.7.** Faber's poems: Presumably the enlarged edition of F. W. Faber's hymns, published in 1849 as *Jesus and Mary: or, Catholic Hymns*. WMR did not review the volume.

**29.6.** Hancock's sculptures: Not identified.

**29.11.** *Builder* critique: 26 May 1849, pp. 244–5. JEM's *Isabella* is described as 'a singularly clever reading of Keats's poem. . . . As the work of a young artist, it may be called extraordinary.' WHH's *Rienzi* is 'scarcely less clever; perhaps there is even a higher feeling about this that promises well for the hereafter.'

**30.2.** Wells: Henry Tanworth Wells (1828–1903), portrait painter and miniaturist, intimate of the Pre-Raphaelites, and among WMR's earliest artistic acquaintances. DGR commemorated him in the limerick commencing, 'There is a dull Painter named Wells / Who is duller than any one else.'

**30.11.** Wilkie: See Mar.50 6.5.

### JULY 1849

**22.1.** Williams: William Smith Williams (1800–75), 'who preceded myself up to November 1850 as art critic to *The Spectator*, and who, as literary adviser of Messrs. Smith and Elder, secured the publication of *Jane Eyre*' (*PDL*, p. 217).

**22.3.** Wells: Charles Jeremiah Wells (1800–79), poet and verse-dramatist. Overpraised by DGR, who succeeded in winning the poet some belated recognition, Wells was required reading for all the lesser Pre-Raphaelite poets. Swinburne edited *Joseph and his Brethren*, with a prefatory note, in 1876; reprinted in the World's Classics series (1908) with a note by T. Watts-Dunton on 'Rossetti and Charles Wells'. WMR reports a scathing analysis of Wells's character by his brother-in-law, Williams, in *PRBJ* 5 Nov. 50.

**22.7.** 'De Clisson': Apparently never published, this novel was probably among those works which Wells burned following the death of his wife in 1874. *Stories* refers to Wells's first work, *Stories After Nature* (1822).

**22.12.** DGR's design: 'The proposal of republication with etchings etc. did not take effect' (*PDL*, p. 218).

**22.29.** Browning's poems: The first collected edition of Browning was published in two volumes by Chapman & Hall in 1849.

**22.34.** TW's Grace dancing: In *PR&PRB*, WHH states that from Woolner Cottingham 'bought at a very much reduced price—in consideration of future commissions from millionaires—a statuette of a female figure [*Euphrosyne*] just modelled and cast ready for the marble reproduction' (i. 124). Later, Woolner saw the statuette in a shop window repeated in Minton ware and was told that it was by the rising sculptor Nockalls Cottingham, from whom the firm had bought the copyright. See *PRBJ* 6 Oct. and above, May 16.2.

**24.4.** JC's Zachariah: There are no further references in *PRBJ* to this work, which is not listed in the only account of JC, by Thomas Bodkin in *Apollo*, xxx (May 1940), 128–33.

**25.3.** DGR's life class: DGR was at this time studying at Leigh's school in Newman Street. See below, Aug. 14.15.

**25.3.** WMR to JEM's: JEM was visiting in Oxford, first with Mr. Drury (see *PRBJ*, 15 Oct. 49); later with the picture dealer Wyatt. During the summer, he painted the background to his *Ferdinand* (see *Millais* 22).

**26.1.** WMR's sonnet: Published in *Germ* 4 as 'The Evil Under the Sun'; much later reprinted in the two sonnet collections edited by Hall Caine (1882) and William Sharp (1886) as 'Democracy Downtrodden'—a title suggested by DGR. In *Democratic Sonnets* (1907), the sonnet appeared with the title 'Hungary and Europe, 1849'. In *PFG*, WMR mistakenly dated the sonnet 'August 1849', an error resulting from his having confused the entries for July and August in editing *PRBJ*. WMR's sonnet was the only one written for the projected series which appeared in *The Germ* (see Aug. 26.1).

**26.7.** FGS and Liverpool exhibition: Although Pre-Raphaelite artists took the annual Liverpool Prize awarded to the best picture by a non-Liverpool artist in six of the eight years between 1851 and 1858—WHH (1851, 1853), JEM (1852, 1857), FMB (1856, 1858)—there is no record of FGS having submitted his unfinished *Mort d'Arthur* (now in the Tate). See Mary Bennett's two essays on the Pre-Raphaelites at Liverpool in *Apollo* (1962) and *Burlington Magazine* (1963).

**26.12.** WHH's 'Morning and Evening': Designs for a decorative panel commissioned by Cottingham and never executed (see *PR&PRB*, i. 125–6). Originally there were to have been four panels; for two versions of 'Morning' see *Hunt* 110–11 and Plates 6 and 8.

**26.18.** FGS's poem of Arthur: unidentified; perhaps a poem to accompany his Arthurian picture. That FGS wrote verse is confirmed by a letter to him from WMR in BSP (MS. don. e. 76, ff. 5–6).

AUGUST 1849

**13.1.** WHH's move: An amusing description of the Cleveland Street Studio which DGR shared with WHH from late August 1848 is given by FGS (*Rossetti*, pp. 13–14). He continued to share WHH's studio until after the opening of the Free Exhibition in late March 1849. After DGR's departure, WHH, in financial straits engendered by his disastrous association with Cottingham (see *PR&PRB*, i. 126–7), was ejected by his landlord, who seized all his possessions, and he had to return to his father's house. In the autumn (from 27 Sept. to the last week in Oct.), DGR and WHH travelled in France and Belgium; on their return, DGR proposed establishing a P.R.B. retreat in Tudor House, No. 16 Cheyne Walk (see *PRBJ*, 6 Nov. 49); but, as WHH says, 'remembering my experience in Cleveland Street, and that my resources and chances would not warrant an uncertain expenditure, I relinquished the idea' (*PR & PRB*, i. 135). It was at this juncture that DGR set up his studio at 72 Newman Street on 10 Nov. 1849; WHH later secured rooms at 5 Prospect Place, Chelsea.

**13.5.** Cottingham's letter: Dated 11 Aug. 1849, this letter is printed in *PR&PRB* (i. 125). When WHH refused to execute the commission without an advance on the agreed price of £50—he planned to do the work in Paris—Cottingham replied, 'You will find hereafter in life that a man may be too grasping and greedy, and so overreach himself.' WHH was never paid for his work. For Cottingham's second letter, a portion of which is quoted in *PR&PRB*, see *PRBJ* 19 Aug.

**13.9.** Egg: Augustus Leopold Egg, R.A. (1816–63), historical genre painter, 'influenced by the Pre-Raphaelites, to whom he gave advice and encouragement' (*Wood*, p. 43).

**13.9.** *Rienzi* picture: Exhibited R.A. 1849 (No. 324; see *Hunt* 12). WMR (in both MS. and *PDL*) cites the price as £160; however, WHH says Mr. Gibbons gave him £100, 'generously making the cheque for £5 extra to pay for the frame' (*PR & PRB*, i. 127).

**13.15.** North: William North (1824–54), novelist, poet, translator, and editor; a political radical and an atheist. Although the author of four novels—*The Anti-Coningsby* (1844), *The Imposter* (1845), *The City of Jugglers* (1850), and a posthumously published work, *The Slave of the Lamp* (New York, 1855)—and a long speculative poem, *The Infinite Republic*, modelled on Poe's *Eureka*, the translator of Lamartine's *Méditations poétiques*, and the editor of several short-lived magazines, North has virtually escaped the notice of literary historians. He appears in none of the standard biographical dictionaries or bibliographies, and only the scrappiest of information is available on his life and work. He was introduced to WMR by James Hannay around 1847–8, and he was involved in the early planning stages of *The Germ*. According to Lona Packer (*Christina Rossetti*, Berkeley, 1963), Christina refused to join the staff of the magazine because it included 'a rabid Chartist' (p. 36); and on 19 Sept. 1849, Christina wrote congratulating WMR on 'the retirement of Messrs. North and Bliss from your literary concern: without them it appears to me to have more

prospect of success' (*FLCGR*, p. 10). North's usefulness to the P.R.B. in their publishing venture lay mainly in his past experience in starting, and editing briefly, what WMR calls 'comic papers and other serials' (see Mar. 50 16.2). In March 1852, North decided to go to America, and he spent one of his last evenings in England with DGR and WMR (see DW 72). Two years later, 'after various struggles, determined to struggle no more', he committed suicide. WMR summarizes North as 'a "clever fellow", who might even be credited with a spark of genius. . . . Spite of his harum-scarum methods of life, he had the habits and feelings of a gentleman, and held his head high' (*SR*, i. 167–8). But DGR's report to Allingham on North's death (23 Jan. 1855, DW 196) is probably truer to the spirit of the man: 'Poor North! There was a long account of that doleful affair in the *Daily News*. He appears to have been going on in his usual style up to the very last, with a new comic paper in prospect, an advertisement of which in MS. was just written and lying on his table. It (the advertisement) concluded comically enough by saying:—"Agents wanted in New Zealand, Australia, Polynesia &c. N.B.—No cannibals need apply." '

**13.16.** monthly *6d.* magazine: The first reference to *The Germ*.

**13.20.** WHH's verses: In *PR & PRB*, WHH reports that DGR 'drew from me the confession that I wrote verses, which indeed I did only to record impressions of Nature, in simple couplets, or at most in the Spenserian stanza. These would not be mentioned except as prelude to the confession that his proficiency effectually discouraged any further indulgence by me in verse of any form whatever' (i. 78). Writing to FGS on 30 June 1849, WMR asked, 'Have you seen Hunt's verses? If not, it must be by a kind of second-sight intuition that you know them to be "Sombre, grand, like plumes on hearses"; for I did not tell you so, and indeed I am not very clear as to their subject or mode of treatment' (BSP, MS. don. e. 76, ff. 5–6).

**13.21.** TW's *Euphrosyne*: In *TWLL*, a work entitled *Eros and Euphrosyne* (reproduced in black Wedgwood) is dated 1848 (p. 5). The figure commissioned by Cottingham (see *PRBJ* 22 July; 20, 23, 28 Sept.; 6 Oct.) may have been taken from this work.

**14.2.** Mr. Gibbons's commission: In the introductory note to *PRBJ* for Oct. 1850, WMR states that Gibbons commissioned from WHH the *Claudio and Isabella*; however, Mary Bennett says that the picture was purchased for £50 in 1853 by Augustus Egg. In a note removed from the second edition of *PR & PRB*, WHH says that Gibbons's purchase of *Rienzi* was 'an act of generosity, for the gentleman never valued the work, but hid it away in a closet, and on his death the family sold it without distributing his general collection' (1905, i. 183). See *Hunt* 12.

**14.5.** DGR and WHH to Paris: The pair were abroad from 27 Sept. until the last week in October.

**14.7.** Orchard: John Orchard (died 1850), 'a young painter, of very feeble physique, whose brief and harrassed term of life barely allowed him to do more than show that there was something in him much beyond the commonplace.

I have a faint recollection of one exhibited picture which I believe to have been his—*Thomas à Becket Escaping from England*' (PDL, pp. 214–15). Elsewhere, WMR suggests that Orchard was probably twenty-seven or twenty-eight when he died, previous to the appearance of his 'Dialogue on Art' in *Germ* 4 (PFG, p. 25). For Orchard's sonnets on DGR's *Girlhood of Mary Virgin* see 20.2 below; for his death see Mar. 50 26.2.

**14.15.** Leigh's: The art school in Newman Street run by James Matthews Leigh (1808–60), which was a competitor to Sass's and is deservedly famous for the number of illustrators of the 1860s trained there. For a brief account of Leigh, his drawing school, and his contribution to nineteenth-century art education see Allan R. Life, 'Leigh of Newman Street', *Journal of the London House and William Goodenough House Fellowship*, iii, no. 7 (1972), 36–40.

**15.1.** he: D. G. Rossetti.

**15.2.** Harris: John Harris, 'a painter of some promise, who about this time took a great interest in Egyptian antiquities. His face is very exactly re-produced in Millais's picture of *Lorenzo and Isabella*—the brother who is kicking out at a dog. He died towards 1853' (PDL, p. 230).

**15.2.** here: That is, at TW's.

**15.3.** 40 pages: Each number of *The Germ* contained 48 pages plus one etching.

**16.2.** Angel in DGR's picture: *The Girlhood of Mary Virgin*, shown at the Free Exhibition 1849, where it was bought by the Dowager Marchioness of Bath for £80. At this time, DGR was repainting the head of the angel, preparatory to dispatching the picture to its new owner on 25 Aug. See Surtees 40.

**16.4.** Grisi: Giulia Grisi (1811?–69), Italian operatic soprano who performed in London.

**16.5.** 'My Lady, in Life': Part I of 'My Beautiful Lady', published in *Germ* 1 but without subtitle.

**16.5.** Hunt at Ewell: Rectory Farm at Ewell, the home of WHH's uncle, was a frequent retreat for the artist; he visited there with JEM and many of his early subjects were painted in the vicinity.

**17.2.** 'La Sœur Morte': 'Of this song no trace now remains. It had not, I think, any definite relation to his English poem, written ere now, *My Sister's Sleep*' (PDL, p. 216).

**18.2.** 'Idle Blessedness': One of the *bouts rimés* sonnets, printed for the first time in *Works* (p. 267). DGR's song is unidentified, as is TW's sonnet.

**19.7.** WHH's study of a cornfield: Not identified.

**19.9.** TW's sonnet on Michael Angelo: Bound into the Beinecke copy of *The Germ*, formerly in the Library of H. Harvey Frost, are various manuscripts of poems by TW, in his autograph, including 'Amala' (see Oct. 50 27.5); an early

draft of the second part of 'My Beautiful Lady' entitled 'In Death', which differs substantially from the printed version and which contains some manuscript corrections in DGR's hand that were incorporated in *The Germ* printing; and the sonnet on Michael Angelo. Also bound in is a short critique of TW's poems by CP (see Sept. 49 25.14). The sonnet is unpublished.

### Michael Angelo

As grows a range of clouds till they fill our
    Whole gaze with their enormous bulk-black, vast,
    And looming like wrath imminent, white fast
The terror-stricken fowl winging by, or cower
Tight in close places sheltered from the shower,
    Far wreaths of dust show the approaching blast,
    Then over-swollen, the storm bursts forth at last
In tortuous fires, and wrenched trees speak its power.
So grew he on men's souls and so his strength was
    Uttered out to them. He had long ceased
    Ere men snuffed the clear air, and were released
From his loud roarings; but they were at length:—
    Tho still he curtains out the light from some
    And echoes of his thunder hold them dumb.

**19.13.** WMR's sonnet: Beginning, 'When whoso merely hath a little thought', this wrapper-sonnet appeared on all four numbers of *The Germ* in 'a rather aggressively Gothic type' (*PFG*, p. 15). WMR's unpublished letter to his mother, dated 23 Sept. (AP) provides background not specified in *PRBJ*:

I'm glad you like my sonnet for the wrapper of the 'Thoughts'. It was a point of some delicacy to bring out the general intention and aim which are to actuate all of us, without entering too much into details and individual preferences. We had intended originally to write a sonnet each, and to choose from all those the one that might appear most suitable. But mine is the only one done yet, and the others have not thought it necessary to disturb it from its 'bad eminence'.

Of this sonnet, which was designed to express the principles of the P.R.B., WBS wrote, 'it would almost need a Browning Society's united intellects' to master it (*AN*, ii. 324). As WBS's interpretation suggests, however—and WMR found it 'differing not essentially from my own' (*PFG*, p. 16)—the sonnet was not totally devoid of merit, even to WBS. He wrote to WMR on 11 December 1878: 'I sent my ancient copy of the "Germ" to the binder's the other day to get it made splendid, and the varmint has thrown away the covers and returned the book full bound, but wholly without a title of course. Have you such a thing as a spare cover? It is your sonnet I regret, a sonnet so characteristic of the so-called P.R.B. movement and principles. If you could give me a cover I would get it bound in yet, as a title. If you have not such a thing can you lend me one, which I could copy neatly out and make a title page?' (unpublished letter in AP). WMR must have acceded to WBS's request; a copy of *The Germ* with the front wrapper of No. 1 mounted in front as a title-page was among the Penkill items sold at Sotheby's 3 December 1962 (Lot 103). WMR's sonnet is printed on p. 116.

**20.2.** Orchard's sonnets: Of Orchard, WMR wrote: 'In our circle he was unknown; but, conceiving a deep admiration for Rossetti's first exhibited picture (1849), "The Girlhood of Mary Virgin", he wrote to him, enclosing a sonnet upon the picture—a very bad sonnet in all executive respects, and far from giving promise of the spirited, if unequal, poetic treatment which we find in the lines in "The Germ", "On a Whit-Sunday Morn in the Month of May" ' (*PFG*, p. 25). WMR's judgement is not unfair—though Orchard sent two interlaced sonnets on the picture rather than a single one; however, since so little is known of Orchard, it is perhaps worth quoting them here from the extant manuscript in AP.

<div align="center">

Sonnets

To the Painter Dante G. Rossetti
Suggested by his picture, the 'Girlhood of Mary Virgin',
exhibited in the Hyde Park Gallery this year, 1849

———————

</div>

> Musing, not seldom to my eye of mind
>   Thy Picture comes; from thence, (transition sure.)
>   Thy mind I read, and feel reflection pure.
> Each of the other is. Christ-entwined,
> Thy placid Faith,—from worldly taint refined—
>   Is shown in Mary Virgin's lilied purity.
> And by the Books, whereon the Lily's shrined,
>   To hold—broad-vased—past all obscurity,
> The Virtues thou believe'st thou must Act.
>   The Palm with Briar embraced, doth express
>   Heaven thy aim, though death-toils hedge the way.
> In holy Joachim, of eye exact,
>   Is known thy rigid Truth can lop excess
>   Without; the Spirit-Presence, doth pourtray,
>
> Thy guileless modesty of Soul; full sure
>   It prompts thy flight; but, not too vain,
>   Yet, i' the porch thou mindeth and remain:
> Unless the Spirit freely doth endure,
> Well thou deem'st no God-ward course secure.
>   Thy lily-watering Angel doth explain,
>   To childlike Innocence thou can'st attain.
> Also i' the work he doeth, is shown, mature
> In wisdom, quiet and earnest, all thy heart
>   Is set to do thy Task. By lily white
>   Is told the chasteness of thy sensuous Eye
> And 'pictur'd whole—its symbols, doth impart—
>   That all of Earth for thee hath Tongues of Light,
>   Christ-Utterances and Truths God-High.

<div align="center">

———————

</div>

August 1849                              John Orchard

**24.1.** WHH's picture: The background of *Rienzi*, which WHH was giving some finishing touches. See *PRBJ* 19 Aug.

**25.2.** daguerreotype: Of DGR's *Girlhood of Mary Virgin*. Given to WHH in Dec. 1853 on his departure for Syria, with the printed texts of the two sonnets

on the picture pasted into the case, together with four lines from Henry Taylor's *Philip van Artevelde*, commencing 'There's that betwixt us been, which men remember / Till they forget themselves. . . .' Reproduced *PR & PRB*, i. 268.

**26.1.** DGR's sonnet: 'Must be the same as *On the Refusal of Aid between Nations*' (*PDL*, p. 216). It is: in BSP (MS. don. e. 75, ff. 1–3), there are holographs of both this sonnet, beginning 'Not that the earth is changing, O my God!', and of 'Vox Ecclesiæ, Vox Christi', beginning 'Not 'neath the altar only,—yet, in sooth' (both printed in *Works*, p. 175). The two poems were intended for inclusion in a series in *The Germ* but on 6 Nov. 1849 they were rejected along with other religious and political material. The full title of the BSP holograph of the first sonnet is 'For the things of these *years* [my italics] and more particularly for the general oppression of the better by the worse cause in the Autumn of 1849'. From the later *PRBJ* entry, it would seem that 'For the Things of these Days' was to be the title of the whole series of sonnets. See Nov. 6.17.

**28.2.** DGR's side-pieces: 'My brother did not ever paint these subjects, as forming "side pieces" in a larger composition. He did, however, at a later date, paint an important water-colour named *The House of John* (the second proposed subject); and I believe that, soon after our present date in 1849, he executed the first subject also, though I do not recollect it' (*PDL*, p. 217). See Surtees 40; also 87 and 110.

**29.2.** DGR's Passover picture: Though DGR was projecting the design this early (see also *PRBJ* 15 Nov. 49), the picture was not completed until 1855–6. See Surtees 78.

<div align="center">SEPTEMBER 1849</div>

**11.2.** *Reverberations*: Poems by J. Chapman, issued in two parts (London, 1849); not reviewed by WMR.

**11.5.** JC's sacred picture: May refer to Zachariah subject (*PRBJ* 24 July), *The Child Jesus*, an etching for which appeared in *Germ* 2, or possibly even the *Novitiate* design (*PRBJ* 6 Mar. 50).

**11.8.** *The Strayed Reveller*: WMR's review of Arnold's poem appeared in *Germ* 2.

**12.5.** letter to TW: Not extant, but two letters written from TW to WMR while he was at Ventnor are printed in *TWLL* (pp. 8–9).

**12.5.** WMR's subject for poem: Many of the subsequent entries treat the composition of this blank-verse poem, 'Mrs. Holmes Grey', which went unpublished until 1868. The two titles in *PRBJ* are, first, 'An Exchange of News', later, 'A Plain Story of Life'. Although written to exemplify Pre-Raphaelite techniques as applied to poetry, the poem did not finally appear in *The Germ*. See Appendix 7.

**13.7.** *Blackwood* review: In lxvi (Sept. 1849), 40–6, by W. E. Aytoun (*Wellesley*). WMR may have been delighted to be able to differ from the *Blackwood's* reviewer, for his notice in *Germ* 2 is highly favourable: Arnold's style he found

'clear and comprehensive', eschewing 'flowery adornment' though influenced somewhat by Tennyson. The author, he thought, had 'little, if anything, to unlearn'. His arrangement was careful and consistent; the 'reflective, which appears the more essential form of his thought, does not absorb the due observation or presentment of the outward facts of nature; and a well poised and serious mind shows itself in every page' (p. 96).

**20.2.** *Sir Reginald Mohun: Some Account of the Life and Adventures of Sir Reginald Mohun, Bart.* Done in Verse by George John Cayley. Canto 1 (London, 1849); reviewed by WMR in *Germ* 3.

**20.5.** St. Luke design: In *Works*, WMR says that DGR's sonnet 'St. Luke the Painter' was written in 1849 'to illustrate a picture (never painted) of St. Luke preaching, having beside him pictures, his own work, of Christ and the Virgin Mary' (p. 656). See Surtees 102. TW's projected design was 'not executed' (*PDL*, p. 220).

**20.7.** DGR's letter: DW 43, dated [18 Sept.].

**20.8.** Haynes: In none of his writings on *The Germ* does WMR ever provide the printer Haynes with a Christian name; in DGR's letter (DW 43), he is said to have been a friend of Hancock's.

**20.11.** Deverell: Walter Howell Deverell (1827–54), a painter very much in the Pre-Raphaelite tradition, a founder of the Cyclographic Society, and an intimate of the P.R.B. In the unpublished Huntington manuscript, 'The P.R.B. and Walter Howell Deverell', prepared by Frances E. Deverell, the wife of WHD's brother, Wykeham, from surviving letters and a diary, there is a note by WMR, who edited the manuscript in 1899, stating that 'if there was one man who, more than others, could be called the "pet" of the whole circle, it was Deverell' (HDP, p. 80). Yet WHD was never formally elected to replace JC in the Brotherhood (see Jan. 51 line 6). WHD attended Sass's where he met DGR, was admitted to the Antique School of the R.A. in Dec. 1846, and two years later was appointed assistant master at the Government School of Design, where his father was Secretary. From Jan. to May 1851 he shared a studio with DGR in Red Lion Square. WHD exhibited a total of only nine pictures (Wood, p. 38); probably his best-known work is *The Pet*, which was bought jointly by WHH and JEM from the Liverpool exhibition in 1853. One of the proprietors of *The Germ*, WHD contributed one etching, three sonnets, and a narrative poem to the magazine, appearing in two of the four issues. He also designed the title-page vignette for Allingham's *Day and Night Songs* (1854). The discoverer of Elizabeth Siddal, who posed for his *Twelfth Night*, WHD was especially close to DGR, who wrote of him to TW after his death: 'Our friendship has been long enough to make me now feel old in looking back to its source: and yet if I live even to middle age, his death will seem to me a grief of my youth' (DW 144).

**23.2.** proprietors: Although DGR in his letter of 18 Sept. (DW 43) speaks of nine proprietors counting Hancock and Herbert, when the reckoning for the first two numbers of *The Germ* was made, costs were shared out by eight, including WHD and Hancock, who defected. In *PFG*, WMR explains that

'All the P.R.B.'s were to be proprietors of the magazine: I question however whether Collinson was ever persuaded to assume this responsibility, entailing payment of an eventual deficit. We were quite ready also to have some other proprietors. Mr. Herbert was addressed by Collinson, and at one time was regarded as pretty safe. Mr. Hancock the sculptor did not resist the pressure put upon him; but after all he contributed nothing to "The Germ", either in work or in money. Walter Deverell assented, and paid when the time came. Thus there seem to have been eight, or else seven, *de facto* proprietors—not one of them having any spare cash, and not all of them much steadiness of interest in the scheme set going by Dante Rossetti' (p. 9).

**25.1.** DGR's letter: DW 44, dated [24 Sept.].

**25.2.** 'Conducted by Artists': The wrappers of *Art and Poetry* (*Germ* 3 and 4) contain the sub-title: 'Conducted Principally by Artists'.

**25.7.** prospectus: No copy of the prospectus with 'P.R.B.' on it is known to me, though WMR says unequivocally that the letters were first printed on it; they were omitted, largely owing to WHH's objections, in November (*PFG*, p. 9 and *PRBJ* 19 Nov.). Two variant prospectuses for *Art* and *Poetry* are reproduced in facsimile in *PFG*. Writing to FGS on 3 Oct. 1849 (BSP, MS. don. e. 76, ff. 11–12), WMR discussed the business arrangements for the prospectuses:

> Mr. Haynes' estimate is for 3000 £2.7.6., for 4000 £2.18.6. I have ordered 4000.
> I must confess I begin to feel nervous at voting away my colleagues' money; but I hope all will give me credit for good intentions, and will perceive that I find it out of my power to consult them in every emergency. The estimate, you will see is, for double the number, less than the price previously named to you. He says that the 3000 are already in hand.

**25.8.** December: In an undated letter to FGS in BSP (MS. don. e. 75, ff. 12–14, not in DW), DGR writes: 'The first number may not possibly make its appearance on the first October, as we had intended . . . but, as far as I can judge at present, it is my real belief without any nonsense that it will be forthcoming on the first of November.' The letter was probably written before 15 September since DGR refers to WHD 'seeing about Chapman and Hall as publishers' and to 'our having got rid of North' so that 'It will now be altogether an emanation of the P.R.B.' WMR and JC went to the Isle of Wight on the 11th; CGR's letter mentioning North was written on the 19th (see Aug. 13.15); and Aylott and Jones were secured as publishers on the 25th.

**25.9.** Scott: William Bell Scott (1811–90), engraver, painter, and poet; lifetime intimate of the Rossettis, whom he met first in 1850, following correspondence inaugurated by DGR in 1847. Two contributions by WBS appeared in *The Germ*. DGR's letter to WBS is not in DW and not excerpted in *AN*.

**25.14.** CP on TW's poems: Bound into the Beinecke copy of *The Germ* (see Aug. 19.9) is the following undated manuscript note signed 'C. K. P.': 'These poems are crowded with acute natural observations. The substance is almost

always good; the form seems to me to be very often questionable. I think that, if I had not known that the author was a sculptor, I should at once have determined in my mind that he was fit to be one. The poems seem to me to be *too* sculpturesque. The picturesque is consistently admissable in poetry; the sculpturesque rarely I think.'

**25.17.** CP on WMR's sonnets: From DGR's report: 'The *First Season* he said was in all points quite equal to Wordsworth, except in this one [melody]. The sonnets on Death he admired as poetry, but totally eschewed as theory, so much so indeed that he says it prevented him from enjoying them in any regard. This of course will not keep you awake at nights, since Shelley was with you, and watches (perhaps) from his grave' (DW 44).

**26.1.** DGR's letter: DW 45, dated 25 Sept., in which DGR also asks WMR to undertake the job of distributing the prospectuses and urges him to 'look sharp about advertising'.

**26.5.** Wells: DGR and WHH did not see Wells on their trip.

**27.1.** DGR's letter: Dictated to CGR, dated 26 Sept.; printed *FLCGR* (pp. 11–12), not in DW.

**27.7.** WMR to FGS: The letter in BSP (MS. don. e. 76, ff. 7–10), is too long (10 pp.) to quote in full, but the principal portion is central to the history of *The Germ*:

I have just received a message from Gabriel that several of us are thinking of calling our Magazine 'The P.R.B. Journal', and requesting me to give you my opinion at once. I guess that you, Hunt, and, if he is returned, Millais, are the originators of the idea.

I will give you an unbiased and uncomplimentary opinion. I think it would be most injudicious. A man passing thro' the street sees a pamphlet lettered 'The P.R.B. Journal': it may be the transactions of a scientific society for anything he knows to the contrary. But it may be said that, for one who sees the mere wrapper, twenty will see the etching and the first page; also that the majority will come prepared beforehand, either by advertisements or hearsay, for the real character of the book. Granted; but I verily believe there is a not inconsiderable section of the public who don't like walking into a shop and asking for a book by a title with the meaning of which they are totally unacquainted,—so far even as not to know whether it be really expressed in letters or whether the purport of these be matter of general certainty. Thus far for the public and the magazine merely: now for the effects that would ensue to ourselves internally. The thing is *not*, strictly speaking, a P.R.B. Journal: we have two, I presume, active proprietors, Deverell and Hancock, who are not such. Deverell may probably become so at no very distant period, but Hancock, I conceive, works on principles of Art that must render himself unwilling if he knows what the letters mean, ever to add them to his name. If this name be adopted, be sure that difficulties will arise. The public will be at once entitled to regard these two as P.R.B.s; they will themselves almost have a right to do so by implication and by the force of the *fait accompli*. Such Artists and critics as have begun to recognize you as a body tending towards definite aims in art will not know what to think of it: you will lose the distinctive character you possess,—your real character. You will observe that, being myself unaffected personally by these considerations, I speak solely from an outward

point of view, as an observer. Again. In a letter Gabriel wrote me recently, he says that we have now 9 proprietors *including Herbert*. Probably what Herbert said on the subject will never produce any actual result: but, if it is to do so, I am satisfied that he would most strongly object to become in any manner publicly connected with any section in art, more especially a section which, proceeding on somewhat the same sympathies as himself, seeks to out-Herbert Herbert. Nor is this all. Unless the magazine realizes a success greater, I admit, than I anticipate for it at least at the opening of its career, we must do our best to look out for more proprietors,—concerning whom the same remarks as I have offered in the case of Hancock and Deverell will most certainly apply,—and probably with much greater force, even to the extent either of inducing them to decline joining us in the publication, or of literally precluding you, with any regard to the bearing of P.R.B. upon your position as Artists, from requesting their co-operation.

It appears to me that there is a very easy way of compromising the matter, obviating all these difficulties, and, at the same time, meeting our own desire (and no one is more anxious, or can be so, on the point than myself) to connect the 'P.R.B.' with our names in every possible way, artistic and literary; viz: to have 'P.R.B.' printed on the cover, not as the title of the work, but by itself, as a kind of device or designation: thus for instance

<div align="center">December</div>

| No. 1 | P.R.B. | Price 1/- |
|-------|--------|-----------|

this will lead to an inference. When the public see the names of certain of us it will remind them that these are the painters of certain works in a certain style; and, at the same time, it will not affect those who either are not artists or are not recognized as P.R.B.s in art. This proposal was made long ago, and has never that I know of, been abandoned, tho' it has been suffered to lie in abeyance: and it seems to me that now, when a step is thought of being taken in the same direction, a step that would jump over much more ground than P.R.B. actually covers, is the moment for finally adopting or relinquishing it. . . .

In a postscript, WMR summarizes the issues so far as the non-P.R.B.s are concerned:

One word more about the magazine. The adoption of the title 'the P.R.B. Journal' appears to me to be, as regards ourselves, a virtual exclusion of Hancock and Deverell and any others who might join us in a similar position from their proprietorship; as regards the public, a virtual recognition of their P.R.B. hood. If they do not combat the project, considering the former point of view, it can only be because they look to its results in the latter. An admission of this, I cannot but think, is an utter and unanswerable rejection of the idea, which carries in it injustice to them and a false position to ourselves.

If our original wish (of course far the most desirable, but, under the present circumstances, impossible) to confine proprietors to P.R.B.s could have been followed out, I should still think 'the P.R.B. Journal' an objectionable title as concerns the public: as it is, I conceive the advantage to be most problematic, not to say unexistent; the obstacles altogether overwhelming. . . .

<div align="center">OCTOBER 1849</div>

**6.4.** TW's copyright: See July 22.34.

**7.1.** Nussey: Edward Nussey, the son of the Queen's apothecary and a school friend of WMR's who went to Oxford.

**8.2.** JC's *Emigrant's Letter: The Emigration Scheme*, exhibited at the R.A. in 1850 as *Answering the Emigrant's Letter.*

**8.7.** JC's *The Pensioner*: Not identified; see Mar. 50 6.5.

**8.11.** DGR's poem: WMR in *Works* groups together nineteen poems written on the continental tour as 'A Trip to Paris and Belgium' (pp. 176–88). See DW 46, which consists solely of three 'travel' poems.

**8.12.** 'Drama of Exile': The opening work in Elizabeth Barrett's *Poems*, 2 vols. (London, 1844), and the title of the American edition published the following year.

**9.1.** *The Bothie*: Reviewed by WMR in *Germ* 1.

**10.1.** DGR's letter: DW 48, dated [8 Oct.].

**10.11.** Gavarni: Pseudonym of Sulpice Guillaume Chevalier (1801–66), French caricaturist; much admired by DGR, who imitated his style in many of his early pen-and-ink drawings. In printing DGR's 'The Can-Can at Valentino's' (*Works*, p. 268), WMR confessed that he has 'been compelled to omit some phrases which express, in terms unprintably energetic, the writer's disgust at the grossnesses of the scene' (*FLM*, ii. 63). Actually, he omitted two complete lines; the unexpurgated text is printed in DW 48. DGR apparently found Gavarni's drawings of Valentino's more decorous than the real thing, hence his comment.

**10.13.** Gobelin[s] tapestries: 'The composition of *Kate the Queen* included various figures of women occupied in tapestry or embroidery work' (*PDL*, p. 224).

**10.18.** TW's 'To Emma': Not identified.

**10.20.** TW's allegorical sculpture: Not in the 'List of Works' in *TWLL*.

**10.27.** Mr. Heaton: John Heaton, father of Ellen Heaton, patroness (on Ruskin's advice) of DGR.

**10.29.** Bateman's designs: Not identified; nor is TW's poem 'Friendship', which WMR says 'remained, I think, a mere fragment' (*PDL*, p. 228).

**12.3.** DGR's note to FGS: Not among letters in BSP nor in DW.

**13.3.** DGR's sonnets: All published in *Works*; see 8.11 above.

**13.7.** FGS's sonnet: See below, 16.1.

**13.8.** Tupper: John Lucas Tupper (1826–79), brother of George and Alexander Tupper, managers of the firm that printed *The Germ*. JLT studied sculpture at the R.A. schools where he met WHH and FGS; when WMR met him he was an anatomical designer at Guy's Hospital. From 1865 until his death he was drawing master at Rugby; while there, under the pseudonym 'Outis', he published two books—*The True Story of Mrs. Stowe* (on Byron) and *Hiatus, or the Void in Modern Education*. Closely affiliated with the P.R.B., Tupper was, WMR says, as zealous as they regarding 'the need for serious inventive thought

in works of art, and for care and detailed study of nature in their carrying out' (*SR*, i. 160). Tupper contributed four poems to *The Germ* in addition to his two papers on 'The Subject in Art'. In 1871, he published an article on TW in the *Portfolio*. WMR edited *Poems by the Late John Lucas Tupper* in 1897, with a brief prefatory notice which is the basic source for biographical information on him. Summarizing Tupper, WMR said in *FLM* that he was 'a very capable conscientious man, quite as earnest after truth in form and presentment as any P.R.B., learned in his department of art, and with a real gift for poetry' (i. 151).

**14.7.** Burbidge: Thomas Burbidge (1816–92), poet, published his poems jointly with A. H. Clough in *Ambarvalia* in 1849.

**15.3.** Mr. Wyatt: James Wyatt (1774–1853), print-seller in Oxford, of which city he was mayor 1842–3. Early patron of JEM, who painted a portrait of Wyatt and his granddaughter in 1849. Wyatt purchased JEM's *Cymon and Iphigenia* in 1848 and was instrumental in interesting Thomas Combe in the works of the Pre-Raphaelites. JEM's companion portraits of Wyatt's grandchild are reproduced in Gere (Plates 46 and 47).

**15.3.** Mr. Drury: Of Shotover Park, Oxford, 'a quaint, benevolent old gentleman, who loved the fine arts and everything connected with them. He made a great pet of the young artist, and insisted on his accompanying him wherever he went in his pony-cart' (*LLJEM*, i. 36; a rough sketch of Mr. Drury and JEM taking the air is reproduced on p. 41).

**15.7.** Seddon: Thomas Seddon (1821–56), furniture designer and painter, brother of John Seddon, the architect who wrote his memoir (*Pre-Raphaelitism* 57.2). Seddon, whom WHH described as 'an amateur friend of our circle' (*PR & PRB*, i. 265), was devoted to the Pre-Raphaelite concern with meticulous detail, and he is reported as once having said that 'three months was not too long to draw properly a single branch of a tree' (Gere, p. 25). Coming late to art, Seddon accompanied WHH to the east in 1853 for instructional purposes; he died on a return visit three years later and is buried in Cairo. Through a public subscription held in 1857, of which Ruskin was secretary, his *Jerusalem and the Valley of Jehoshaphat* was purchased for the nation (now in the Tate Gallery). Of this work, WMR wrote: 'A more conscientiously presented portrait of the scene could not be found. . . . I hardly know whether, in the present days of photography, fine art of this kind is greatly needed. It was still needed then; and at a rather earlier date, when no one painted on so punctilious a principle, it was still more requisite' (*SR*, i. 143). See Nov. 22.48.

**16.1.** FGS's sonnet: Not identified; see *PRBJ* 12 Nov.

**18.3.** TW's medallion of CP: See Dec. 7.11.

**18.7.** Haydon: Samuel J. B. Haydon (1815–91), sculptor, who became a solicitor and later a print-seller and art dealer in Knightsbridge. Between 1878 and 1881 he was friendly with DGR; in 1880 he produced an etching of DGR's *Hamlet and Ophelia*, 'doing it with skill and with great fidelity, but rather heavy-handedly' (*FLM*, i. 367).

### NOVEMBER 1849

**1.1.** Donovan: Cornelius Donovan, phrenologist who achieved considerable notoriety in the 1850s. WMR, TW, JEM, and WHH all had 'written characters' from him following his famous 'reading' of Tennyson in which he predicted that the poet possessed powers 'that ought to make him the greatest poet of the age'. WHH, whose *PR & PRB* contains the fullest account of his connection with the P.R.B.s (i. 183–6), called him the 'High Priest of Craniology'. Donovan published a *Handbook of Phrenology* in 1870.

**1.9.** JEM's design: *Christ in the House of His Parents* (or *The Carpenter's Shop*), which was to become the target for so much abuse when it was exhibited in 1850. See *Millais* 26.

**2.9.** CP's articles: Although WMR wrote 'Russia' in *PRBJ* and so transcribed it in *PDL*, he may have intended to write 'Ruskin'. In the most complete listing of CP's contributions to periodicals (J. C. Reid's *The Mind and Art of Coventry Patmore* [London, 1957]), there is no reference to his having published anything on Russia. CP did, however, publish an article on Ruskin's *Seven Lamps of Architecture* in the *North British Review* for Feb. 1850.

**2.11.** CP's poems: CP contributed two poems to *The Germ*—'The Seasons' in No. 1, 'Stars and Moon' in No. 2. The first was reprinted in *Tamerton Church Tower* (1854); the second was never reprinted by CP.

**2.21.** 'Grr you swine': The closing line of Browning's 'Soliloquy of the Spanish Cloister', first published in *Dramatic Lyrics* (1842).

**2.23.** Tennyson's MS. elegies: William Allingham comments in his *Diary* (18 Aug. 1849) that Tennyson gave Emily Patmore the original manuscript of *In Memoriam*, which she had copied out for the press. However, Tennyson's well-known letter to CP about his lost 'butcher-ledger-like book' (28 Feb. 1850), printed in Champneys, casts doubt on Allingham's record. Certainly, as Tennyson's letter suggests, the MS. was frequently in CP's possession. For the extant MSS. see Christopher Ricks' edition of *The Poems of Tennyson* (London, 1969, pp. 857–8). For the 'trial edition' see *PRBJ* 21 Mar. 50.

**2.24.** Hallam: Arthur Henry Hallam (1811–33), poet and friend of Tennyson commemorated in *In Memoriam*.

**2.25.** CP on *The Princess*: CP's article on 'Tennyson's *Poems—The Princess*' appeared in the *North British Review* for May 1848.

**6.3.** Cheyne Walk house: Tudor or Queen's House, 16 Cheyne Walk, Chelsea, which DGR later occupied for twenty years, from 1862 until his death. For a time the house was shared by Swinburne, Meredith, and WMR. The idea of a P.R.B. commune survived for some time—in imitation perhaps of the Nazarenes—but it never materialized.

**6.17.** 'For the Things of these Days': 'Days' may be a mistake for 'Years'; see Aug. 26.1.

**7.13.** TW's 'Friendship': For WMR's note see Oct. 10.29.

**7.14.** Taylor: Henry Taylor (1800–86), poet, author of *Philip Van Artevelde* (1834; 5th ed. 1849) and other volumes. CP shared Taylor's interest in metrics.

**7.17.** CP's poems: All four appeared in *Poems* (1844), published by Edward Moxon.

**7.19.** DGR's sonnets: *Works* (p. 189), in a series of sonnets on pictures written while DGR and WHH were on their continental tour.

**8.8.** Calotype: Presumably of *Isabella*, exhibited at R.A. 1849.

**8.14.** WMR's 'Plain Story': 'Mrs. Holmes Grey'; see Sept. 12.5.

**8.15.** Bailey: Philip James Bailey (1816–1902), poet, best known for his spasmodic work *Festus* (1839).

**8.18.** DGR's 'Bride-chamber Talk': Intended for *The Germ*, this poem remained unpublished until 1881, when it appeared in *Poems: A New Edition* as 'The Bride's Prelude'. The poem was never completed. See *Works* (pp. 17–35 and WMR's note, pp. 647–8).

**8.19.** Poe: Died 7 Oct. 1849 in Baltimore.

**10.1.** Newman Street: See Aug. 13.1.

**10.3.** DGR's letter: Not in DW.

**11.3.** JEM's poem: Presumably the 'Castle-moat' poem mentioned in the first entry of *PRBJ*. See May 15.8.

**12.10.** DGR's 'My Sister's Sleep': Published in *Germ* 1 as No. 1 of the 'Songs of One Household'; no further poems were written for this series.

**12.18.** JC's picture: Probably either *The Emigration Scheme* or *The Pensioner*.

**13.5.** Chain Walk: Cheyne Walk. 'Chain' appears twice in MS., once corrected. Although WMR altered the spelling in *PDL*, he may have been intentionally punning.

**15.5.** Miss Atwell: Unidentified model.

**15.7.** Campbell: Robert Calder Campbell (1798–1857), Major in the Indian army who retired in 1839. He was introduced to the Rossettis in 1847 by Munro. Campbell was a minor writer who contributed to the literary annuals and published three volumes of poems, a novel, and his recollections. He contributed one sonnet to *Germ* 2, though WMR excludes it in his listing of the contents in *PFG*. He encouraged DGR in his writing and was influential in securing WMR his position with the *Critic*. Summarizing his influence, WMR wrote: 'To pretend that he was an author of high mark, or capable of something greatly better than what he gave forth, would be futile; but he was a lively writer in a minor way, an amusing chatty talker, who had seen many things here and there, and knew something of the publishing world, and a straightforward, most unassuming gentleman, whose society could do nothing but good to a youth like Rossetti' (*FLM*, i. 110–11).

**18.2.** *Paola and Francesca*: An early study of the subject, executed in water-colour in 1855. This version, described in the next entry, may be Surtees 75D.

**19.9.** WHH's etching: For TW's 'My Beautiful Lady' in *Germ* 1.

**19.12.** JLT's chant: The 'Spectro-Cadaveral Chant', published as No. 4 of the 'Papers of "The M.S. Society"—Smoke' in *Germ* 4, which WMR found 'exceedingly clever' but 'ultra-peculiar' (*PRBJ* 25 Nov.).

**19.19.** Big 'P.R.B.': See Sept. 25.7.

**21.2.** TW's figure: Unidentified but perhaps the allegorical sculpture described in *PRBJ* 10 Oct. See next *PRBJ* entry.

**22.1.** Cross: John Cross (1819–61), painter famed for his *Clemency of Richard Cœur-de-Leon*, exhibited in the Westminster competition in 1847.

**22.4.** Tennyson on Burns: Hallam Tennyson quotes his father as saying, 'Burns did for the old songs of Scotland almost what Shakespeare had done for the English drama that preceded him' (*Tennyson: A Memoir*, ii. 202).

**22.23.** rebel . . . truth: 'This is somewhat noticeable. Patmore, who became a fervent Roman Catholic towards 1863, was in 1849 a strict and indeed pre-judiced Protestant' (*PDL*, p. 233).

**22.28.** Barraud: Henry Barraud (1811–74), genre painter, collaborated with his brother William, who died in 1850 (see Wood, p. 8). Of the engraving, WMR queries, 'Is this performance at all remembered now? The engraving from it (a very poor engraving from a very poor picture) was endlessly popular in its day' (*PDL*, p. 234).

**22.32.** Scott: David Scott (1806–49), Scottish painter in the grand style; brother of WBS who published a memoir of him in 1850.

**22.48.** Seddon's: Thomas Seddon conducted on and off a drawing class in Gray's Inn Road which WMR attended (*SR*, i. 139).

**25.1.** DGR's *Annunciation*: First called *Ecce Ancilla Domini!*; see Surtees 44 and *PRBJ* 23 Jan. 53. The companion picture on the death of the Virgin was never painted.

**25.7.** JLT's poem: 'I think this was the grotesque poem named *An Incident in the Siege of Troy*, published in *The Germ*' (*PDL*, p. 235).

**25.12.** JLT's essay: WMR's description might refer to JLT's two-part *Germ* essay (Nos. 1 and 3) but that contribution is on 'The Subject in Art', not poetry.

**25.16.** Tupper: George Tupper, brother of JLT and Alexander Tupper and partner in the firm that printed *The Germ*. Not only was he responsible for financing the continuation of *The Germ* after the first two numbers, he also contributed two short pieces to 'The Papers of "The M.S. Society" '. As late as 1852, George Tupper was trying to reclaim his losses on the magazine (see July 50 21.7).

**25.20.** Haynes: Though the P.R.B. had settled with Aylott and Jones as early as 25 Sept. to publish their magazine, there is no indication in *PRBJ* or in DW of any firm arrangements for printing, with Haynes or anyone else; Haynes probably did print the prospectus. WMR suggests that Hancock's tactlessness caused some embarrassment; doubtless Hancock was piqued at not being allowed to escape his commitment on the first number (see *PRBJ* 12 Nov.), and Haynes had been instrumental in helping the P.R.B.s secure a publisher. In any event, *The Germ* was printed by the Tuppers.

<div align="center">

DECEMBER 1849

</div>

**7.1.** JEM's CP subject: See *PRBJ* 23 May. The lines are from 'The Woodman's Daughter'.

**7.6.** Illustrated CP: No such volume was ever done; nor was there ever a joint volume of Pre-Raphaelite poetry.

**7.11.** TW's medallions: The CP is reproduced in Champneys (i, facing p. 89). TW's plaster medallion of Tennyson was completed in 1851 and remodelled in 1856; the latter is reproduced in *TWLL* (facing p. 42), the former in *PR&PRB* (ii. 94).

**7.16.** CP's 'The Storm': Published in *Tamerton Church Tower* (1854).

**8.1.** Maitland: Unidentified model who appears elsewhere in *PRBJ*.

**10.12.** JC's St. Elizabeth: *The Renunciation of Queen Elizabeth of Hungary*, shown at the National Exhibition, 1851 (see Gere, p. 26).

**10.17.** title: See Appendix 4.

**13.4.** TW's Tennyson: Besides the two medallions (see 7.11 above), TW also did an early (1857) and late (1876) bust and a three-quarter medallion (1867). WMR's observation about Tennyson's head size recalls the caption to Max Beerbohm's caricature of 'Woolner at Farringford' in *Rossetti and His Circle* (London, 1922): 'Mrs. Tennyson [to TW who is sculpting Tennyson's bust]: "You know, Mr. Woolner, I'm one of the most un-meddlesome of women; but—when (I'm only asking), *when* do you begin modelling his halo?"'

**13.11.** Powell's book: Probably *The Living Authors of England* by Thomas Powell (1809–87), published in New York in 1849.

**13.13.** CP on 'My Sister's Sleep': In *The Germ*, 'I believe' was retained in stanza one; the second phrase was altered to 'Perhaps tho' my lips did not stir'. In 1870, the poem was completely revised and shortened by four stanzas, one of which contained the line to which CP objected. In general, it was precisely the 'self-conscious' quality of the poem that DGR removed.

**13.17.** *The Princess*: In the third edition, Tennyson made important changes to the poem and added the songs. The volume appeared in Feb. 1850.

**14.4.** article on 'Nature': No contribution by WCT appeared in *The Germ*, though at this time he was working on two pieces.

**15.2.** FGS's article: Subsequently entitled in *Germ* 2 'The Purpose and Tendency of Early Italian Art'.

**15.7.** JLT's article: Perhaps owing to the printing connection—especially after the firm took over the financing—*The Germ* contains many more contributions by the Tuppers than might be expected from non-P.R.B.s. Only No. 2 is free of Tuppers.

**15.10.** FGS and anonymity: See Jan. 50 28.6.

**15.12.** WCT's device: Never used; redundant, if completed, after the later decision to alter the title of the magazine. See Appendix 4.

**15.26.** right term: WMR actually used the line in 'Mrs. Holmes Grey' (l. 714).

**16.7.** DGR's *Giotto*: DGR's water-colour is dated 1852, but there is no study in Surtees as early as 1849 (see 54 ff.).

**16.11.** Mr. Armitage: Not identified.

**16.17.** Whitehead's poems: *The Solitary and Other Poems* (London, 1849). WMR did not review the volume.

**17.4.** DGR's 'Hand and Soul': Begun earlier, but in the main written during the course of a single day and night. See *PRBJ* 21 Dec.

**18.13.** Tennyson's poem: 'To —, After Reading a Life and Letters'. The poem is now generally thought to be a response to Lord Houghton's *Letters and Literary Remains of Keats*, published in 1848. See Ricks, *The Poems of Tennyson* (p. 846).

**18.16.** *Bothie*: The original form of the title, later altered to *The Bothie of Tober-na-Vuolich*.

**18.17.** TW's *Iris*: Not identified; of *Puck* (reproduced *TWLL*), WMR writes: '. . . an early work by Woolner; I should say a good one, and easy to "understand" ' (*PDL*, p. 239).

**19.16.** FMB's sonnet: Included in *Germ* 1.

**19.22.** title: See Appendix 4. 'Mr. Thomas presented me on 4 December with a list of no less than 65 alternative titles' (*PDL*, p. 240).

**20.4.** Clayton: John Richard Clayton (1827–1913), artist. By the time he met the P.R.B.s at the R.A. schools in 1849, Clayton was already established. During the 1850s he designed on wood for the Dalziels. Around 1855, he founded the firm of glass painters, Clayton and Bell.

**20.4.** Bliss: '. . . a son of a Q.C. and had some literary tendency: he emigrated [to Australia] not long after this date' (*PDL*, p. 240).

**21.2.** proof of wrapper: No copy of this is known to me.

**21.16.** CP's 'Moon and Stars': Published in *Germ* 2 as 'Stars and Moon'.

**21.16.** WMR's poems: All poems in the series 'Fancies at Leisure'. The last three titles appeared in *Germ* 2, the first as two separate poems in No. 3.

**22.8.** WCT's Address: No copy of this has been discovered. See May 27.2.

**22.11.** WHH's etching: Since the contents were altered, and WCT's address dropped, *Germ* 1 begins with TW's poem, faced by WHH's etching.

**23.4.** Francesca of Rimini: *Paola* and *Francesca*, a water-colour in three panels, was executed in 1855 (Surtees 75); see Nov. 49. 18.2.

**23.16.** Mr. Callum: Not identified.

**23.17.** Bailey: He did not contribute anything to *The Germ*.

**23.21.** WHD's tale: WHD's tale was destroyed (see *PRBJ* 15 Jan. 50); WMR's 'prose narrative' is not identified.

**24.3.** WMR's review: *Sir Reginald Mohun* was held over until No. 3.

**24.13.** proof impressions: An unknown number of proofs were struck for separate sale; in *PRBJ* 28 Dec., the figure of '10 or 12' is mentioned. There is a presentation copy (to FGS) of one of the separate proofs in the Tate Gallery (see *Hunt* 62). For India-paper copies 'bound in' see *PRBJ* 1 Jan. 50.

**28.11.** JC's etching: 'The Child Jesus'—the only instance in *The Germ* of a literary work illustrated by its author.

**28.23.** CP's poem: Actually, there were two errors in the *Germ* version; however, the presence of an *errata* list on the inside back wrapper of No. 2 makes it questionable whether WMR's plan to print a corrected sheet to be bound into a few copies only was ever carried out.

**28.31.** TW's bust: Not in the 'List of Works' in *TWLL*.

**28.32.** DGR's poem: First published in *Ballads and Sonnets* (1881) as 'Song and Music'.

**29.28.** Robert Macaire: A bold rogue in the French comedy *L'auberge des Adrets* (1823).

**30.5.** JEM's portrait: Exhibited R.A. 1850; William Millais made a replica for the family (see *Millais* 20).

**30.7.** WMR's sonnet: See *PRBJ* 12 Jan. 50.

## JANUARY 1850

**1.1.** WHH's etching: Of WHH's frontispiece for *Germ* 1, illustrating TW's 'My Beautiful Lady' Burne-Jones, in his 'Essay on the Newcomes' (*Oxford and Cambridge Magazine*, i [1856], 6), says that the illustration has so little to do with the poem that 'it may well stand for an independent picture, truly a song without words, and yet not wholly speechless, for out of its golden silence came voices for all who would hearken, telling a tale of love'. For the India-paper copies see also *PRBJ* 1 Feb.

**1.8.** Magazines: For a brief listing of reviews of *The Germ* see *Pre-Raphaelitism*, 72.1. Excerpts of contemporary notices appear in *PFG* (pp. 11–15).

**7.10.** Clapp: Henry Clapp (1814–75), American journalist and humourist; met the P.R.B.s through CP. There are three letters from Clapp in AP (dated 4, 8, and 12 Jan. 1850), including the one referred to. Neither the poem nor the Temperance paper is identified.

**7.15.** *Athenaeum*: Advertisements appeared in *The Athenaeum* on 5 Jan. (No. 1158, p. 5) and 12 Jan. (No. 1159, p. 53). 'Art and Poetry No. III' was announced as 'now ready' on 6 Apr. (No. 1171, p. 362), with the explanation that the title of *The Germ* 'has been dropped, in consequence of some misapprehension'.

**8.10.** Barbe: Lechertier Barbe, an artists' colourman patronized by the P.R.B.

**9.7.** JLT's poem: This is the first reference by title to JLT's poem (see Nov. 49 19.12). In his doggerel letter of Apr. 1850 (DW 52), DGR addressed JLT as 'Spec-cadav Rex'—the Spectro-cadaveral King. The poem 'Sixteen Specials' is JLT's 'An Incident in the Siege of Troy, Seen from a Modern Observatory', the first of the 'Papers of "The M.S. Society" ', published in *Germ* 3.

**9.16.** JC's poem: 'The Child Jesus' was written as early as Sept. 1848 (see DW 36), but WMR's comment suggests that it was revised for publication in *The Germ*.

**10.9.** WMR's review: Both WMR's review of *The Strayed Reveller* and FMB's 'On the Mechanism of an Historical Picture' appeared in *Germ* 2.

**11.3.** CGR's songs: 'A Testimony' appeared in *Germ* 2, as did Campbell's sonnet.

**12.2.** FMB's rooms: On settling in London, FMB first took a studio in Clipstone Street, Kensington. After his second marriage in 1848, he established a household in Hampstead, taking in addition a studio in No. 17 Newman Street, the home of the sculptor Baily. In May 1851, DGR, between moves from No. 17 Red Lion Square (which he shared with Deverell) and 14 Chatham Place, Blackfriars Bridge, stayed for a period in FMB's studio in Newman Street, during which time he modelled for the head of Chaucer.

**12.9.** WMR's sonnet: 'I wrote the sonnet—don't now recollect it' (*PDL*, p. 244). JEM's portrait of Mr. Wyatt and his granddaughter was exhibited in the R.A., after having first been refused by the British Institution (see *PRBJ*, 2 Feb. 50). See also *PRBJ* 30 Dec. 49.

**12.10.** Mr. Wethered: Not identified; JEM sold the picture to Richard Ellison in 1850 for £150 (see *Millais* 22). See *PRBJ* 3 Mar.

**12.14.** TW's 'Emblems': An eight-stanza poem published in *Germ* 3.

**12.15.** WCT's article: WCT's essay on Nature, not to be confused with his opening address 'explanatory of the principles in Art of the P.R.B.', which was

o have appeared in *Germ* 1 but which was rejected on the strong urging of
WHH and FGS (see *PRBJ* 27 Dec. 49). WCT's failure to complete the essay
on Nature greatly inconvenienced WMR in preparing *Germ* 2 for publication
(see *PRBJ* 22–3 Jan. 50). The poems are unidentified.

**12.17.** Lucy: Charles Lucy (1814–73), painter of historical subjects and portraits.
His contact with the P.R.B. came through FMB.

**12.17.** Anthony: Henry Mark Anthony (1817–86), landscape painter, very
much admired by the P.R.B.s and FMB, whose special friend he was. Of him,
WMR said, 'He became anxious to graft something of Præraphaelitism upon
the style which came natural to him and in which he excelled. This did not
really improve his work, and later on he seldom produced paintings wholly
worthy of his prime' (*SR*, i. 141).

**13.10.** CP's Macbeth essay: Published in *Germ* 3. Although WMR says it was
'written a short while ago', CP made a different claim: '. . . at fifteen, I cared
little for any but the classics of English literature. At this age I had read almost
all the standard poetry and much of the best secular prose in our language, and
was in the habit of studying it critically; in proof of which assertions I may
mention an "Essay on Macbeth", which was written by me when I was between
fifteen and sixteen, and which was published, without a word of alteration, in
the "*Germ*"—a periodical issued by the "Pre-Raphaelites"—some years after-
wards' (Champneys, ii. 43).

**13.13.** WMR's castle poem: 'To the Castle Ramparts', included in *Germ* 4.

**14.4.** Orchard's poem: Published in *Germ* 4, presumably revised.

**15.3.** WBS's poem: 'Morning Sleep' did come in *Germ* 2; the sonnet 'Early
Aspirations' appeared in *Germ* 3.

**16.6.** DGR's illustration: There is no record of an illustration having been done
by DGR, who offered WMR a long critique on the poem in Oct. 1849, when
WMR sent it to him in Paris (DW 48).

**16.11.** The unmentionable F.S.: Frank Stone (1800–59), artist and art critic for
the *Athenaeum*; in subsequent *PRBJ* entries simply 'the Unmentionable'. *Cross
Purposes* and *The Impending Mate* are 'popular engravings' undoubtedly by the
'Unmentionable', which Woolner naturally would have little relish in trans-
forming into models. See Feb. 5.2.

**16.19.** WMR's letter to FGS: Extant in BSP (MS. don. e. 76, ff. 13–14), this
letter summarizes the information contained in the entries for 15–16 Jan. For
publication details of *Germ* 2 see Appendix 5.

**17.7.** CGR's poem: 'Sweet Death' and 'Repining' appeared in *Germ* 3. See
Feb. 18.2 and Mar. 20.6.

**18.6.** limitability of P.R.B.: The reference is probably to the attempt to get
WHD elected to the Brotherhood. See Jan. 51 line 6.

**19.6.** 'Fancies at Leisure': A fourth, 'Sheer Waste', was also included under
this general title in *Germ* 2. See 23.6 below.

**20.1.** WMR's poem: The manuscript of this unpublished poem is in AP.

> What time the winter closes in,
>   There came the pale chrysanthemums.
> The mists are raw, the hedges thin;
>   The winter comes, and ever comes;
>     No insect hums.
>   The time of pale chrysanthemums:
>   The time of pale chrysanthemums.
> What time the winter closes in
>   Is time for pale chrysanthemums.
>
> November weeps his bloody leaves
>   Along the earth in sodden damps:
> East Wind in chinks and corners grieves,
>   And Cloudland wars in broken camps.
>     Burn early lamps
>   In time of pale chrysanthemums,
>   The time of pale chrysanthemums:
> November weeps his bloody leaves
>   In time of pale chrysanthemums.
>
> When now the dahlias all are gone,
>   The Garden decks her peaking face—
> For any glimpse, surprised and wan,
>   The Sun may grant her, of his grace,
>     From out his place,—
>   With flowers of pale chrysanthemums,
>   In time of pale chrysanthemums:
> When now the dahlias all are gone
>   Is time for pale chrysanthemums.
>
> And oh! man's life at winter-dawn!
>   The vain unfragrant blooms at last.
> And strange the many faces gone,
>   Strange the bleared faces going fast,—
>     Yes passing,—passed.
>   The time of pale chrysanthemums,
>   The time of pale chrysanthemums.
> And oh! man's life at winter-dawn,
>   Oh! time of torn chrysanthemums!

**21.2.** 120–30 copies: An overestimation; see *PRBJ* 30 Jan.

**21.3.** Mr. Bellamy: Not identified. *The Germ* was reviewed in *John Bull*, xxx, No. 1522 (11 Feb. 1850), 91. A prospectus issued to advertise the new *Germ, Art and Poetry* included a quotation from the review. According to WMR (*PFG*, p. 13), Bellamy was also responsible for the short notice in *Bell's Weekly Messenger*, No. 2784 (20 Apr. 1850), 7. See below, 23.18.

**21.9.** *Dispatch* review: The review appeared in the *Weekly Dispatch*, No. 2515 (20 Jan. 1850), 38.

**21.11.** CP's poem: No copies of this offprint are known to me, but it was issued (See *PRBJ* 5 Feb. 50).

**21.15.** TW's song: Published in *Germ* 2.

**22.1.** FMB's article: Published in *Germ* 2.

**22.7.** WHH's picture: *Christian Priests Escaping from Druid Persecution*, begun in early 1849. See May 49 19.4.

**22.18.** JLT's poem: 'It did not come in' (*PDL*, p. 249). In *Poems by JLT* (1897), the only poem similar in subject is 'A Warm February', dated 1850.

**23.6.** all poetry: WHD's sonnets were included in *Germ* 2 under the title 'The Sight Beyond'. In all, WMR published nine 'Fancies at Leisure', four in *Germ* 2 and five in *Germ* 3. The first two mentioned here do not appear in *Germ* 2.

**23.9.** 'Blessed Damosel': In the first two references to DGR's poem in *PRBJ*, WMR writes Damozel with an 's', which may point to an earlier spelling. About this point there has been some controversy in the criticism on the poem. See W. E. Fredeman, 'Rossetti's "The Blessed Damozel": A Problem in Literary History and Textual Criticism', in *English Studies Today*, 5th Ser. (Istanbul: I.A.U.P.E., 1973), pp. 239–69.

**23.18.** G. Bellamy: 'He was in fact the son of this gentleman' (*PDL*, p. 249). This letter, dated Tuesday 22nd from the British Museum is extant in AP, but the author is E. rather than G. Bellamy. His assumption regarding the single authorship of the poetry was due to the anonymity of all the contributions in *Germ* 1:

> I have read the 1st no. of 'The Germ' with very great interest and pleasure and I cannot forbear personally anticipating the public sympathy and support which I trust will be its meed when more generally known and spoken of. There is more originality and fire in one stanza of the poetry than in all that of the other magazines put together and the simple sketches (a style which I trust will not be departed from) have caught and embodied its spirit and feeling in a very sweet and perfect manner. You have made one or two warm friends and I trust not altogether useless ones.
>
> As a stranger and without an introduction to yourself I scarcely dare ask for one to the writer of those poems (for I judge them all or all but one to be by the same hand) yet that is the chief hope and object of this letter; and if you do not quite consider it a mere idle wish on the part of a young man I would ask this favour of yourself and him. . . .

**24.4.** Campbell's poem: Only Campbell's sonnet, mentioned in the next entry, appeared in *The Germ*; for 'Among The Lilies' see *PRBJ* 23 Mar.

**24.7.** Heraud: John Abraham Heraud (1799–1887), poet, dramatist, and critic; drama critic for the *Athenaeum* and the *Illustrated London News*. See 26.5 below.

**25.12.** JC's sonnets: These did not appear in *The Germ*. WMR notes that 'Collinson . . . was hardly a writing man, and I question whether he had produced a line of verse prior to undertaking ['The Child Jesus'] . . . the *only* poem of any importance that he ever wrote' (*PFG*, pp. 20–1).

**25.13.** 'Blessed Damosel': DGR had clearly not finished the poem; as subsequent entries show, he added two further stanzas on 26 and 28 Jan. For the complicated history of 'The Blessed Damozel' see Paull F. Baum's edition (Chapel Hill, 1937), and the article by W. E. Fredeman cited above (23.9).

**25.14.** Shirt-collar Hall: 'As I have said elsewhere, this was a name bestowed by Madox Brown upon Mr. Samuel Carter Hall [1800–89], then Editor of the *Art Journal*. Brown intended thus to mark the extreme decorum of appearance maintained by Mr. Hall, whose face, it may be added, was a very fine one' (*PDL*, p. 250). 'A pat on the back, with a very lukewarm hand' (*PFG*, p. 11), incommensurate with the extravagance of praise in the portion of Hall's letter quoted in *PRBJ*, did appear in the March number of the *Art Journal* (xii. 96).

**26.1.** WBS's letter: In Durham University library. WBS's letter is not without praise but it is as wordy and pompous as WMR's abstract is admirable.

**26.5.** Heraud's letter: On the reverse of Heraud's letter (in AP), beginning, 'I am much pleased with the *Germ* No. 1 and hope that it will succeed', WMR records the following anecdote from one of Douglas Jerrold's repartees: 'A.B. to Jerrold—"Have you seen Heraud's Descent into Hell?" J— "No, but I only wish I had."' Although Heraud was drama critic for the *Athenaeum*, and advertisements were placed there, *The Germ* seems not to have been reviewed in that journal.

**27.9.** criticism: 'i.e. My criticism of Arthur H. Clough's poem *The Bothie of Toper-na-fuosich*' (*PDL*, p. 251). No letter to WMR appears in *The Correspondence of Arthur Hugh Clough*, ed. F. Mulhauser (Oxford, 1957), nor is one listed in the 'Catalogue of All Known Letters'. For Clough's reaction to WMR's review see his letter to Dr. Adolph Hiemann published by Roger Peattie (*TLS*, 30 July 1964, p. 665).

**28.6.** contents: A contents sheet identifying the contributors to *Germ* 1 was published on the inside back wrapper of *Germ* 2. CP's and JLT's contributions in all numbers remained anonymous. CGR's poems appeared under the pseudonym given her by DGR, 'Ellen Alleyn'; FGS, insisting on pseudonymity, appears as 'John Seward' in *Germ* 2 and as 'Laura Savage' in *Germ* 4.

**29.1.** at Heraud's: In his letter of 26 Jan., Heraud had written, 'I shall on Tuesday Evening have a few friends whom you might not dislike meeting with, and I am sure that I should feel honoured with your company—(about 8 o'clock). We are, however, but humble people in our means of giving entertainment. We make the heart go the greater part of the way. . . .' (Unpublished letter in AP.)

**29.2.** Marston: John Westland Marston (1819–90), poetic dramatist, father of the blind poet, Philip Bourke Marston. See 30.1 below.

**29.4.** incorrect rhymes: Although DGR was not enamoured of his poem 'My Sister's Sleep' (see *PFG*, p. 18), the poem received, as did 'The Blessed Damozel', considerable textual attention and revision. The incorrect rhymes referred to by Heraud exist only in *The Germ* version (Stanza 11):

> 'Glory unto the Newly Born!'
> So, as said angels, she did say;
> Because we were in Christmas-day,
> Though it would still be long till dawn.

From 1870 on, this stanza (now 9) reads *morn* instead of *dawn* in the last line.

**29.5.** Hervey: Thomas Kibble Hervey (1799–1859), poet and critic; editor of the *Athenaeum* (1846–53).

**29.8.** WMR's poems: 'I don't now remember about these poems. Some verses of mine had at an earlier date, 1848, been published in *The Athenaeum*' (*PDL*, p. 251). 'In The Hill Shadow' appeared in the *Athenaeum* on 23 Sept. 1848 (pp. 960–1).

**29.14.** Heraud's lecture: Heraud, a student of German, regarded himself as a disciple of Carlyle, imitating 'his master's Germanic style' (see Leslie Marchand, *The Athenaeum* [Chapel Hill, 1941], pp. 214–15). Carlyle's recorded remark that Heraud contrives 'to appropriate an Idea or two (even in Coleridge's sense), and re-echoes them in long continuance,—I fear as from *unfurnished* chambers' (S. J. Kunitz and H. Haycraft, *British Authors of the Nineteenth Century* [New York, 1936], p. 295) perhaps gives a clue as to the nature of his 'Transcendental lecture' which WMR mentions.

**29.16.** Patten: George Patten (1801–65), portrait painter in ordinary to the Prince Consort. WMR remarks that he was a 'painter of some elevation of aim, but not a successful executant' (*PDL*, p. 251).

**29.16.** Miss Glyn: Isabella Dallas Glyn (1823–89), Shakespearian actress of the 'Kemble School' (*DNB*).

**30.1.** Marston's party: WMR's visit to Westland Marston's house antedates by a decade the splendid regular gatherings of the London literati and cognoscenti at his home in Northumberland Terrace, Regent's Park in the Sixties. Obviously, however, he had begun by 1850 his traditional evenings—it was, WMR says, a 'regular evening-party'—which are dutifully and enthusiastically recorded in the memoirs of the period. See R. E. Francillon, 'The Marston Circle', in *Mid-Victorian Memories* (London, [1914]), Chap. 13.

**30.4.** *Sordello*: DGR's championing of *Sordello* among the Pre-Raphaelites is well known, but as M. B. Cramer has shown he was one of those responsible for inaugurating a 'coterie attitude' toward the poem, which makes it 'into a shibboleth for those with intellectual and literary pretensions' (*ELH*, viii [1941], 306). *Sordello* became among the group a source of banter—see the 3rd 'further resolution' in DGR's letter to TW, 27 Oct. 1850, 'That who will may hear Sordello's story told' (DW 60)—and a *cause célèbre*, as the frequent references to the poem in *PRBJ* (2 Nov., 8 Dec. 49; 26 Feb. 50) make clear. DGR wrote a sonnet on the poem (printed in fragmentary form in *Works*, p. 268, and recovered *in toto* by R. F. Metzdorf in *HLB*, 1953); as did JLT (included in WMR's edition, p. 77). Beginning ' "Sordello" I confess has puzzled me', the sonnet concludes in the sestet:

> If ever any man should cut my throat,
> I should be anxious, ere they hanged the knave,
> That the phrenologists should ascertain
> Whether his brain had ventricle or moat
> Wherein perchance Sordello might have lain;
> Demonstrate that, and I the man would save.

Nineteenth-century consternation over *Sordello* has only gradually given way to a calmer view of the poem; for the most recent and important evaluation of *Sordello* see Lionel Stevenson's 'The Key Poem of the Victorian Age', in *Essays in American and English Literature* (Athens, Ohio, 1967).

**30.12.** 70 copies: Cf. *PRBJ* 21 Jan. 50.

**31.1.** No. 2 contents: WMR's catalogue omits Woolner's 'O When and Where'.

**31.23.** sale of No. 2: *Germ* 2 sold even less well than the first number: 'Its debts exceeded its assets, and a sum of £33 odd, due on Nos. 1 and 2, had to be cleared off by the seven (or eight) proprietors, conscientious against the grain.' (*PFG*, p. 11.) See *PRBJ* 9 Feb.

<center>FEBRUARY 1850</center>

**1.1.** India-paper copies: WMR records (see also *PRBJ* 1 Jan. 50) that 50 copies of the first two numbers of *The Germ* contained etchings printed on India-paper, but there is no evidence that the practice was continued in later issues.

**1.3.** Cox: Edward William (later Serjeant) Cox (1809–79), barrister, poet, and editor, later M.P. As editor of the *Critic*, Cox reviewed *The Germ* in that journal (15 Feb. 1850, pp. 94–5; 1 June, p. 278); later employed WMR as unsalaried art critic.

**1.4.** Richardson: Richardson and Son, 172 Fleet Street, printer and publisher as well as bookseller.

**1.9.** Mrs. Patmore: Emily Augusta Andrews Patmore (1824–62), the original 'Angel in the House'.

**2.8.** Kingsley: Charles Kingsley (1819–75), novelist and poet.

**2.23.** FGS's Griseldis picture: Not identified, though it recurs frequently in subsequent entries. FGS did complete the picture and submitted it to the R.A. in 1851 under a fictitious name, but it was not accepted (see *PRBJ* 2 May 51). 'Stephens often used to declare "with satisfaction" that he had destroyed *all* his paintings' (Gere, p. 45). His known works—three in all—are in the Tate Gallery. The spelling 'Griselda' is also used. See Textual Notes Oct. 1850, line 63.

**2.26.** Smith's picture: Not identified.

**2.35.** *Germ* expenses: 'A tolerably clear indication of the fact that money was not plentiful among members of the P.R.B.' (*PDL*, p. 254). On this matter, FGS wrote to WMR after the evening's discussion:

Dear P.R.B.

Coming along home just now I have been thinking grievously of the failure of 'The Germ'. It has occurred to me that if you were to offer it in its present state to some decent publishers they might perhaps be induced to carry it on; as the loss to them could not in any event be very great, you of course retaining your

editorship, and using the same printers for it would be very unhandsome to the Tuppers to remove that from their office, after the great interest they have taken in the thing. Recollect that there will be good notices of the Work in *The Morning Chronicle*, *The Art-Journal*, *The Dispatch*, and *The John Bull*. I think I can pretty well answer for one in *The Morning Post*, but I shall know to-morrow. This ought to help on a bit as they will be unsolicited.

The letter breaks at this point and continues the following morning after his receipt of WMR's letter concerning Cox's offer:

I had written thus far before going to bed this morning intending to finish it during the day; but did not do so. I have just received your note containing the proposal from the Editor of the Critic. I am not surprised at this but confess that I had hoped you would receive one from some greater source, and really, *if you can do so decently*, I would wait a little till the other notices are made, before accepting this although it seem a very fair one. Mr. Cox decidedly knows what he is about but there would be no harm in having half-a-dozen P.R.B. organs if we could get them.

Your invitation to me is P.R.B. I will do anything that I can in such a cause. Your postscript specially delighted me about keeping this matter close. To me that is of more importance than any other perhaps for Madox Brown is a notorious character and can afford not to sell a picture, you are not an artist, and Tupper is at present out of the hunt, and I know that he enjoys a secret as much as myself; but above the fun of the thing, it is of great advantage to keep a thing to yourself. [Unpublished letter, dated 3 Feb. 1850, in AP. See July 21.7.]

**2.39.** *Critic*: WMR was art critic for this journal from Mar. to Aug. 1850 before transferring to the *Spectator*.

**3.3.** the 'Unmentionable': See above Jan. 16.11.

**3.6.** WMR's letter to FGS: Not in BSP. For FGS's reply see 2.35 above.

**3.9.** reviews: The second half of WMR's first notice in the *Critic* appeared, much to his chagrin, with his initials (see *PRBJ* 1 Mar. 50).

**4.5.** R.A. exhibitors: Charles Branwhite (1817–80); James Francis Danby (1816–75) and Thomas Danby (1817–86); Joseph Wolf (1820–99). For Anthony see Jan. 12.17.

**5.2.** F.S.: Frank Stone; DGR's notice of Stone's *Sympathy* is in *Works* (p. 572), where are also published several other of DGR's contributions to WMR's exhibition critiques.

**5.4.** separate impressions: See Jan. 21.11.

**7.7.** Allingham: William Allingham (1824–89), poet and associate of the P.R.B.s, especially DGR. Nothing by Allingham appeared in *The Germ*. Many years later (1863), Allingham recorded in his *Diary* (p. 91): 'I remember distinctly every breathing of the verses which were in the first number of *The Germ*, nearly fourteen years ago. Real love of nature and delicate truth of touch; with the quaint guild-mark, so to speak, of the P.R.B. (I can't bear to be verbally quaint myself, yet often like it in another.)'

**7.9.** Dr. Holland: George Calvert Holland (1801–65), homoeopathic practitioner and mesmerist; friend of CP.

**12.2.** Hannay: James Hannay (1827–73), Scottish writer and journalist, who began his career in the Royal Navy—the subject of his three-volume novel *Singleton Fontenoy* (1850). Hannay, who was introduced to the P.R.B. either by Munro or Calder Campbell, was the centre of a Bohemian set, which WMR characterized as 'greatly unlike that into which my associations as a P.R.B. had ushered me. The P.R.B.'s were all high-thinking young men, assuredly not exempt from several of the infirmities of human nature, but bent upon working up to a true ideal in art, and marked by habits generally abstemious . . . having next to no money to spend. . . . The Hannay set were equally impecunious, but not equally abstemious. They also may have laid out little money, having laid in still less; but they breathed the atmosphere of "devil-may-care", and were minded to jollify as best they could' (*SR*, i. 163–4). See George Worth, *James Hannay: His Life and Works* (Lawrence, Kansas, 1964).

**12.4.** *John Bull*: See Jan. 21.3.

**14.8.** *Morning Chronicle*: 4 Feb. 1850, p. 4. For other reviews see *Pre-Raphaelitism* 72.1.

**14.9.** Eastlake: Sir Charles Lock Eastlake (1793–1865), genre and portrait painter; elected President of Royal Academy in 1850.

**15.5.** Talfourd: Sir Thomas Noon Talfourd (1795–1854), judge and author; remembered mainly for his friendship with the Romantics.

**15.7.** Mr. Adams: Neither Mr. Adams nor the local paper is identified; WMR did, however, send *Germ* 1 and 2 for review (see *PRBJ* 21 Feb.).

**16.1.** WMR's review: Actually appeared on the 15th; the second half appeared on 1 Mar.

**16.2.** Notice of *Germ*: WMR ascribes both *Critic* notices to Cox in *PFG* (p. 12). See 1.3 above.

**16.4.** brother: Alexander Tupper, George's partner in the printing firm who renamed *The Germ*, *Art and Poetry* (see *PRBJ* 13 Mar.). Of their offer to continue *The Germ*, WMR wrote to FGS: 'Singularly generous, is it not? and this before they have received one farthing of our debt. I told him I should have great hesitation in accepting' (BSP, MS. don. e. 76, f. 15).

**16.8.** posters: In *PFG*, WMR says, 'Some small amount of advertising was done, more particularly by posters carried about in front of the Royal Academy (then in Trafalgar Square), which opened . . . [in] May' (p. 11). On this point, WMR wrote to FGS on 16 Jan. (BSP, MS. don. e. 76, f. 14): 'We think of having some posters—100 or so—printed, showing some of the principal points in No. 1. They would cost not more than 12/- or 13/- and could be stuck up in one day, Tupper thinks, at an expense of 1/-.' No posters are extant.

**16.13.** P.R.B. to DGR's: WMR wrote to all the proprietors; his letter to WHD is in HDP.

**16.17.** two poems: These were probably DGR's 'Bride-chamber Talk' and either JEM's 'Castle-moat' or WMR's 'Plain Story'.

**16.20.** DGR's 'Dante in Exile': 'Dante at Verona' (*Works*, pp. 6–16).

**16.25.** 'Jane's Portrait': '. . . (or *Mary's Portrait*, as it was sometimes called)' (*PDL*, p. 258). Revised as 'The Portrait' in *Poems* (1870).

**16.29.** TW's 'Hubert': 'I have no recollection of the poem *Hubert*' (*PDL*, p. 259). See next *PRBJ* entry.

**16.42.** Mitchell: Charles Mitchell (1807–59), bookseller and newspaper advertising agent; proprietor and publisher of *The Newspaper Press Directory*.

**18.2.** CGR's 'An Argument': Published in *Germ* 3 as 'Repining'.

**19.5.** Robert Dickinson: See May 49 27.2.

**19.6.** publication: *Art and Poetry* was jointly published by Aylott and Jones and Dickinson's; on the prospectus, however, Messrs. Dickinson's name only appears.

**20.1.** CP's 'Macbeth': In a strangely formal letter addressed to 'My Dear Sir', CP sent his essay to WMR requesting him to 'Be kind enough to let me see a proof, which I shall have back again immediately' (unpublished letter, dated by WMR 19 Feb., in AP). CP may have wished to forestall a repetition of the misprints that adorned his earlier *Germ* contribution (see Dec. 49 28.23).

**20.6.** etching: For 'Repining', but no such design is extant.

**21.5.** JEM's etching: JEM prepared for a fifth number of the magazine a design for DGR's 'St. Agnes of Intercession' (reproduced *Millais* 116; for the drawing see 249. See Plate 8). WBS, to whom JEM gave the impression of the etching, always believed that it was unique, but two further copies have recently come to light. In *LLJEM* there are also reproductions of two other designs (i. 51 and 65) which are identified as having been intended for *The Germ*.

**21.10.** April: *Germ* 3 appeared as *Art and Poetry* on 31 Mar. with the notice: 'The subscribers to this Work are respectfully informed that the future Numbers will appear on the last day of the month for which they are dated.'

**21.12.** Orchard's 'Dialogue': Published in *Germ* 4; Orchard died shortly before its appearance. For the continuation of the first 'Dialogue' see *PRBJ* 20 Mar.; no others in the series are known to have been written. Orchard must have written to both Rossetti brothers. His letter to DGR, dated 19 Feb. (in AP), is quoted at length in DGR's prefatory note to the 'Dialogue'.

**21.19.** WBS's book: *Memoir of David Scott, R.S.A. Containing his Journals in Italy; Notes on Art, and Other Papers* (Edinburgh, 1850). The volume was not reviewed in *The Germ*.

**21.21.** 'Meroth': Not identified.

**22.2.** double number: Nothing came of this proposal.

**22.5.** FMB's second paper: 'This second paper did not come out, and I know nothing further of it. Pity that the opportunity of printing it did not occur' (*PDL*, p. 261).

**22.10.** double . . . etchings: *Germ* 3 carried the notice to subscribers that '. . . a supplementary, or large-sized Etching will occasionally be given (as with the present Number)'. The *Lear* subject chosen was executed and published in *Germ* 3: 'The designs, a series, had been done some years before—very forcible compositions. They were purchased towards 1890 by Sir Henry Irving' (*PDL*, p. 261). DGR did not write the illustrative poem (see *PRBJ* 14 Mar.).

**22.18.** Marquis: In FGS's Griseldis picture.

**23.3.** Hastings paper: *The Germ* was reviewed in the *Hastings and St. Leonard's News*, 15 Feb. 1850, p. 4. After quoting from JLT's poem, 'A Sketch from Nature', the reviewer launches into his 'not altogether laudatory' examination of WHH's etching:

> The artist selects one of the most suggestive of his author's stanzas: he meditates —he muses—*his* thoughts are gone to dream-land also. The artist is a poet, but he is also an artist; he remembers this—he seizes his etching point, and fixes the creatures of his imagination in all the intensity of action, or passion, due to 'High Art'. He now remembers that he had a previous idea that art should copy the *simplicity* of nature; so, to balance his exalted conception of the principal figures, he jots in two or three daisies, prim as ancient martens; a circular grove of trees, trim as a box flower border; and lambs which suggest to the beholder the expressive monosyllable Bah!

This appraisal, which may be compared with that by Burne-Jones (see Jan. 1.1), is consistent with the reviewer's general assessment of Pre-Raphaelite principles:

> The projectors of the 'Germ' appear to have confounded Poetry and Art; and, in attempting to consider them as essentially one, have done violence to both. The poet jots down his impressions as the artist does his daisies, and the reviewer looks at the artificially-constructed hexameter, as a proper 'background' for simple ideas. The result of all this simplicity is a poetico-artistic Quakerism.

**23.6.** 'The Artist': Presumably WMR's objection to this title must have been as great as to the subtitle 'Conducted by Artists' (see *PRBJ* 25 Sept. 49).

**26.4.** Bedingfield: Richard B. Bedingfield.

**26.20.** the *Sunbeam*: Ian Fletcher, in his dissertation on the minority periodicals of the 19th century (University of Reading, p. 56), says that the *Sunbeam*, edited by Heraud, 'has some mild claims to be regarded as a pioneer of the magazine as total art form'.

**28.2.** DGR on copper: 'No trace of this is extant; I perhaps never saw it' (*PDL*, p. 263).

**28.4.** Bridgman: Not identified; WMR (who spells his name with an 'e' in *SR*) says only that he was 'a jocular writer in those days—a parody which he wrote of Patmore's poem *The River* tickled us not a little' (i. 169).

## MARCH 1850

**3.1.** White: An unidentified model.

**3.3.** red hair: In what must have been a fit of irony, WMR glossed this passage: 'Strange as it may seem to some readers, Dante Rossetti had a strong liking for hair of so vivid and positive a tint that most people would call it red' (*PDL*, p. 263).

**3.9.** Mr. Ellison: See Jan. 12.10.

**3.11.** *Art Journal*: xii (Mar. 1850), 96.

**3.16.** sonnet: The reference is not clear. If by WHH, the sonnet is not identified; for DGR's sonnet on Valentino's see Oct. 49 10.11.

**3.17.** Bassett: F. W. Bassett, not identified. There is a letter in BSP (dated 2 Dec. 1850) from Bassett to FGS containing a reference to WHH's hoax in which he passed off Elizabeth Siddal as his wife to JLT (see DW 55).

**6.5.** Wilkie style: Many of JC's productions are similar both in subject and treatment to the smooth-surface genre paintings of Sir David Wilkie, R.A. (1785–1841), as even a comparison of the two painters' titles suggests. One wonders how much JC's *The Pensioner* may have owed to Wilkie's *Chelsea Pensioner*. *The Novitiate* is unidentified, but it may be the same as 'The New Curate' (*PRBJ* 22 Mar.). See also *PRBJ* 30 May 49.

**6.8.** Cyclographic: See Appendix 3.

**6.24.** Collins: Charles Allston Collins (1828–73), historical genre painter. The brother of the novelist Wilkie Collins and friend of JEM, Collins, though influenced by the Pre-Raphaelites, was rejected for membership in the P.R.B. (see Nov. 5.7). Collins's most famous work is *Convent Thoughts* (Ashmolean), which Ruskin praised in his *Pre-Raphaelitism* pamphlet for its fidelity to natural detail. Collins abandoned painting for writing after 1858. See S. M. Ellis, 'Charles Allston Collins', in *Wilkie Collins, Le Fanu and Others* (London, 1931).

**6.24.** 'Sloshy': 'This was a painter named Rainford, whom Hunt and my brother had found in the house where they took a joint studio in 1848. He was then a slap-dash (or, as we called it, sloshy) painter, but got converted to the minute detail of the P.R.B. movement' (*PDL*, p. 264).

**6.31.** Herbert: John Rogers Herbert, R.A. (1810–90), historical genre and landscape painter. Though approached by DGR, Herbert was almost certainly not one of the proprietors of *The Germ* (see Sept. 49 23.2).

**6.35.** *Festus*: A spasmodic poem published in 1839, much praised by DGR. The *Angel World* was reviewed by WMR in *Critic* 1 Apr. 50, pp. 122–3 (Peattie).

**7.4.** TW's medallion heads: See *PRBJ* 19 and 23 May 49.

**7.6.** Horne: Richard Hengist Horne (1802–84), literary critic and poet, best known as the author of the 'Farthing Epic', *Orion*. After expressing his earnest wish for *The Germ's* success, Horne added:

By 'success', I do not mean its commercial circulation; for all questions of genuine art, whether in Poetry, Painting, or Sculpture, Architecture, etc. must look to no such reward in England in our present day. Acting, Singing, and Dancing—are too much for us. They not only carry off nearly all the bread and honey, but nearly all the *temporal* honours. But the success of the 'Germ' must be of another kind; and this I hope it will attain; as I am sure it will deserve to do, if the high promise *and* performance in these opening numbers be fully carried out. [Unpublished letter in AP, dated by WMR 6 Mar. 1850.]

**8.2.** WMR's poem: In *Germ* 4, WMR has two poems, 'To the Castle Ramparts' and 'Jesus Wept'.

**10.6.** Tucker: Raymond Tucker (fl. 1852–1903), minor genre and landscape painter.

**12.1.** *Standard of Freedom*: 2 Mar. 1850, p. 11.

**13.4.** Aleck Tupper: See Feb. 16.4.

**13.5.** title: Following the title on the wrappers appear the words, 'Conducted Principally by Artists'.

**13.7.** etchings: Neither TW nor Hancock undertook the work. FMB's was in fact ready for *Germ* 3; DGR's for 'Hand and Soul' was begun but scratched over (see *PRBJ* 28 Mar.). WHD did the etching for *Germ* 4.

**13.14.** JLT's poem: See Jan. 9.7.

**13.22.** WBS's poem: 'The Dance of Death', the first selection in *The Edinburgh University Souvenir* (Edinburgh, 1835). All the contributions in this anthology are anonymous; in my personal copy, which belonged to DGR, WBS has identified the pieces written by himself, his brother David, and his friend W. A. C. Shand. The illustration was not done (see *PRBJ* 19 Mar.).

**14.2.** WMR's poem: 'Cordelia' by WMR is the lead poem in *Germ* 3.

**16.2.** *Journal of Mystery*: Not in *ULS*, *BUCOP*, or *BMC*. WMR writes of North: 'He wrote a little in comic papers and other serials, and was constantly-trying and failing to start a magazine. One he did start, of a rapidly consumptive tendency, *North's Magazine* (SR, i. 166). According to Ian Fletcher (see Feb. 26.20, p. 52, n. 18), the unique copy of *North's Magazine*, which postdates *The Germ* by nearly two years, was destroyed when the British Museum was struck by bombs in the war. See Aug. 49 13.15.

**18.2.** *Christmas-Eve* and *Easter-Day*, published 1 Apr. 50 (reviewed *Germ* 4). In *Memoriam* appeared in late May.

**20.1.** Orchard: Internal evidence in the 'Dialogue'—the term 'Pre-Raffaelle' does not appear in the first eleven pages—suggests that this 'second portion' was also published in *Germ* 4 and does not refer to the continuation mentioned

earlier in *PRBJ* (see Feb. 21.12). Perhaps Orchard's death a week later led WMR to allow the term, to which he here objects, to go unrevised.

**20.6.** CGR's 'So it is': Published in *Germ* 3 as 'Sweet Death'. See also *PRBJ* 17 Jan. and 18 Feb.; also Feb. 18.2.

**20.7.** prospectus: For *Art and Poetry*; two versions are reproduced in *PFG*. See also Sept. 49 25.7.

**21.2.** Tennyson's elegies: CP wrote to Allingham on 17 Apr. 1850: 'His elegies are printed. I have one of the *only* half dozen copies at present in existence. He talks of publishing them next Christmas' (Champneys, ii. 173).

**21.11.** CP's poem on marriage: *The Angel in the House*, the first part of which, *The Betrothal*, was published in 1854.

**21.17.** CP on architecture: Probably CP's 'Character in Architecture', published in the *North British Review* (Aug. 1851).

**21.24.** DGR's 'An Autopsychology': The original title of DGR's fragment tale, 'St. Agnes of Intercession' (*Works*, pp. 557–70).

**22.4.** Miss Norton: An unidentified model. None of the titles in this entry can be equated with known works by JC.

**23.3.** DGR's poems: 'The Carillon' ('Antwerp and Bruges') and 'From the Cliffs: Noon' ('Sea Limits') appeared in *Germ* 3.

**23.6.** *Art Journal* advertisement: No such advertisement appears in the April number.

**23.7.** FMB's article: The *PRBJ* entry for 22 Feb. suggests that FMB had by then completed his second article.

**23.9.** Campbell's poem: See Jan. 24.4.

**23.20.** Harston's poems: 'I have not now any recollection of Mr. Harston's poems, have [any] at all survived the interval since 1850?' (*PDL*, p. 269); the Revd. Edward Harston's poems were not reviewed in *Art and Poetry*.

**26.2.** Orchard's death: 'No such notice was written. Some research was made for MSS. etc. left by Orchard, but nothing worth speaking of was found. Dr. W. C. Bennett (the Ballad-writer), who had been a neighbour of Orchard in the Greenwich district and an intimate of his, took part in this research' (*PDL*, p. 270). In 1859, Bennett published in an anthology called *Lays of the Sanctuary: and Other Poems* a poem entitled 'To the Memory of John Orchard, Artist', but it is little more than conventional elegiac doggerel, containing no personal reference whatever to the artist.

**27.8.** Shenton: Henry Chawner Shenton (1803–66), 'one of the last survivors of the able band of engravers in the pure line manner who flourished during the first half of the century' (*DNB*).

**28.3.** DGR's etching: Besides the design for 'Hand and Soul', DGR is also reported to have begun an etching for his tale 'St. Agnes', but because it proved

'quite disappointing and even exasperating to its artist who had no previous acquaintance with the aquafortis process, it was thrown aside, and then Millais undertook to produce an etching of the same subject' (*DGRDW*, p. 131). See Feb. 21.5.

**28.10.** *The Times* advertisement: This appears not to have been done.

**29.2.** Miss Love: Unidentified model, as is Lambert in 29.6.

### APRIL 1850

**2.1.** Posters: See Feb. 16.8.

**2.2.** 'Autopsychology': See Mar. 21.24.

**7.4.** Earles: An unidentified model.

**7.12.** frame: WHH's original frame is still with the picture (Ashmolean). See *Hunt* 15.

**7.19.** head: See corresponding textual note.

**8.1.** WMR's article: In the *Critic*, 15 Apr. 1850, pp. 199–200 (Peattie). See Feb. 50 3.9.

### JULY 1850

**21.7.** 'Gurm': 'As I have said elsewhere, we had a fancy for mispronounc[ing] "Germ" as "Gurm" ' (*PDL*, p. 272). The death of *The Germ*, with the 4th number, forced the P.R.B.s to face the financial realities of their venture, and in the correspondence and negotiations that followed WMR bore the main burden of responsibility. Unfortunately, the break in *PRBJ* between 8 April and 21 July leaves a serious hole in the recorded history of the magazine. That the success of the final number was insufficient to encourage the Tuppers to continue is bluntly documented in George Tupper's letter to WMR on 23 May (AP):

> I am sorry you did not come in today, having several things to say about the Gurm. The case stands thus—

| | | |
|---|---|---|
| Dickinsons have sold | 21 copies | — No. 4 |
| Aylott & Jones | 34 ,, | — ,, |
| You & your brother I suppose I may reckon at | 6 ,, | — ,, |
| Stephens has had | 9 ,, | — ,, |
| & his Subscribers | 13 ,, | — ,, |
| Dr. Hare (*Your's*) | 1 ,, | — ,, |
| Millais I sent (& *expect him to get rid of somehow*) | 6 ,, | — ,, |
| Sundry Subscribers. | 7 ,, | — ,, |
| Oh! I forgot Hunt. | 9 ,, | — ,, |
| Total | 106 | |

Now I have had this additional encouragement today—a letter from C. H. Collier Esq. Oriel College Oxford for 2 copies of each No. (Qy. Is this your friend?) also—a letter from Deverell undertaking to get rid of 10 of the next No. Still in spite of this (and to get it fairly into the University is a great thing) I must say I do not feel myself justified in bringing out another Number. The fact is it is a

very much more expensive Plaything than I am entitled to, and tho no child ever fretted so much after a rattle as I shall after my poor Gurm yet—yet—yet—

I shall be happy to appoint a time and place for all those concerned to assemble —or I will meet them where and when may seem most convenient to communicate the sad intelligence and consult as to the practicability of any measure for saving the poor wretch. My brother and self would not mind a loss (clear loss) of about £5 for the sake of Gabriel's stunning tale and Millais' Etching—but more than that we really dare not think of.

*The Germ* was also an 'expensive plaything' for the P.R.B.s, even though their obligation was only for the first two numbers. How expensive was first revealed when the charges for Nos. 1 and 2 were tendered at the end of January (see *PRBJ* 31 Jan.). By 10 May Tupper was urging a meeting to 'overhaul the accounts' (BSP, MS. don. e. 78, f. 5): 'I trust you will manage', he wrote FGS,

somehow or other to be present for without a staunch *backer* (mind this is not a pun) in business matters like yourself, it will be impossible for me to prevent the Meeting degenerating into a Poetico-spouting-railing-trolloping-mistifying-smoke-scandal-ergo-be-Imperative-Present-Present-I beseech you and you shall have my unmitigated prayers—now and evermore. Amen.

Whether this meeting (scheduled for the 15th) took place is not certain, but shortly afterwards, WMR undertook to write to the proprietors, giving each a breakdown of the account. His letter to FGS, dated 20 May, is extant in BSP (MS. don. e. 78, ff. 16–17):

The long expected (qy. desired?) moment arrived on Saturday, and Tupper presented me the bill for Nos. 1 and 2. It stands thus:

No. 1 — £19.  1.  6
No. 2 —   15. 15.  6

Total     34. 17.  0

He wishes—(tho' he spoke, as always, in the most friendly manner) to be paid before the end of the month.

Reckoning on £5. from the Publishers, the amount for each of us will be

8 ) 29. 17.
     3. 14.  6

as far as my arithmetic allows me to compute fractions.

Will you let me know the state of the case in your own regard, *soon*, for you know the month runs but a few days longer.

FGS's reply does not survive, but he must have taken exception to the amount he was to pay, for WMR writes again on 10 June (BSP, ff. 18–19) elaborating further on his calculations:

As far as the accounts to which I have access show, you have received 76 copies of No. 1 and 12 of No. 2. Of 3 and 4 I know nothing.

I am not quite certain whether I understand you correctly as meaning that you want to fork out the amount paid to you by your subscribers, if so, you could be entering into a labyrinth of arithmetic at which my calculating never arrived; inasmuch as, if you do so for your part, each of us 8 ought also to do so for his. What I have done is to take Tupper's bill £33. 17. –

Deduct therefrom what I        5.  8.  6
have recd. from the Publr.      28.  8.  6

This I have divided among the eight of us, which, making some allowance for Hunt's having paid the etcher's bill, gives about £3. 14. 6 each. Beyond this I have not elaborated our account so as to meet the case of each of us precisely.

Perhaps you may not be aware that I have paid Tupper—(this was on May 27) —£14. 17. 6—being for Gabriel and me, £2 of Deverell's, and the Publisher's money. Millais had his money ready: but, as he is out of town, I don't know whether I shall be able to get hold of it.

Two responses to WMR's letter are extant, from JC and WHD (both in AP). The second half of JC's letter of the 21 May (AP) tends to confirm WMR's remembrance that he failed to satisfy his share of the proprietors' indebtedness (see Sept. 49 23.2):

... My regular income now is £1 weekly, and since this commencement (about 5 weeks ago) I have regularly used it up although I live as economically (excuse the adverb) as possible.

I can manage to spare half-a-crown out of last week's, without inconvenience, and I will call with it this evening at Gabriel's;—next week I will pay you 7/6 and so on till the whole is paid. It was very kind of you to assist me and I assure you the loan was most acceptable. I owe Gabriel five shillings.

Now forget the 'Germ' for one moment, and rejoice with me. This morning I have sold my 'Italian Boys', and the payment is to be made in June. This will enable me to live comfortably (again I must beg your forbearance) for a whole year and if [I] am careful also to paint my next picture and pay Roberson's bill.

I shall pay God and the other man for my etching, but more than this towards the 'Germ' I really cannot do in justice to others, as you know I am a good deal in debt. Now do let us try next year and be more thoughtful as to our means, before undertaking anything (except the Germ which we had better bury at once—R.I.P.) rashly. . . .

P.S. *I cannot change* my decision as to the P.R.B.

WHD seems to have paid £2 on account, withholding for unspecified reasons a balance almost as great. Writing to WMR on the 23rd (MS. in AP), he says:

I have been studying your note very hard, and perceive plainly that there will be an awful struggle to raise up so much hard cash. The 'little account' has set my fertile mind to work, and I have contrived several schemes to defray it which I hope to have the honour of laying before the next party at Newman Street.

The first and best is—that we eight shall put ourselves *personally* up the spout.

With regard to my own (£1. 14. 6.), please inform Tupper that I will mount the scaffold like a man, and pay: but I cannot promise so early as the time you specify—not until the 2nd of next month.

Is it necessary for me to write to Tupper? Eight or ten is the largest number I can sell for certain.

Although WMR intended that the Tuppers' bill should be settled by the end of May, the matter dragged on for more than two years. On 1 Jan. 1851 (MS. in AP), George Tupper concluded his New Year's greeting with a further request about the 'poor Gurm':

I would not bother you but the fact is 'strong necessity supreme is' for our calls are excessively heavy this year. Will you be kind enough therefore to take an early opportunity of touching up those who were not so prompt as yourself and brother—Deverell, you remember, wrote to *me* stating some time when he should

be in tin—I suppose he forgot it—*I have never heard any more about that happy time.*

There is the large amount of 7/6 to be knocked off the a/c since the last credit I gave you—for the sum I received from the Life Office for the Advertisement. I don't remember anything else and I have no time just now to look.

In 1851, after learning that Tupper was a 'clear loser by some £30' (*PRBJ* 13 May 51), WMR tried, again unsuccessfully, to shake free from his recalcitrant brothers some of the money owing to the Tuppers. On 19 November, WHH wrote:

I hope sincerely that the Tuppers stand more chance of being paid by the other proprietors of the Germ before next year than they do by me. I have no money, and the little coming to me shortly is engaged more than doubly. I assure you they cannot blame me for the delay, because last year I sent to them a request for my bill and afterwards paid them their demand, supposing I thus silenced all claims (fond delusion).

When I last saw the Tuppers I represented to them the injustice of my having to pay a sum greater (I think, but certainly *much greater* in proportion) than that which some have to pay who have been put to no previous expense, as I was for the etching. They agreed with me in thinking it a mistake and suggested that I should speak with you on the subject, which has been forgotten by me when I have had an opportunity. So please 'take the pen' and remember in reconsidering our relative amounts that I paid for the printing of the etching alone £2.6. (I put down the lowest sum).

WMR must have reminded WHH that at least part of the expense to which he refers was for the separate pulls which he had requested (see Dec. 49 24.13) for on 26 November, WHH replied: 'At the receipt of your note representing your extensive Germ calamities I felt quite ashamed of having urged to your consideration my trifling subject for complaint. Assure the Tuppers that I am most anxious to make as speedy a settlement of my account as is possible as I will prove, if any more money ever comes into my hands' (Both WHH letters are in AP).

JEM too seems to have overlooked his indebtedness, but he reported to WMR on 28 Feb. 1852 that he would 'be very happy to pay my share of the unfortunate Germ. Can you manage to call? (at the same time see my pictures) when I will pay over to you the cash. I have often wondered at not seeing anything of you . . .' (MS. in AP).

By the autumn of 1852, the accounts had still not been settled, and two final extant letters from George Tupper to FGS and WHD (dated 9 Sept. and 27 Oct. 1852 respectively—the first in BSP, MS. don. e. 78, ff. 20-1; the second in HDP) provide almost the last word available on *The Germ* and also testify to Tupper's great patience with the dilatory proprietors. To FGS, Tupper is broad and direct:

Jack having told me that Gabriel and William Rossetti are to be at your Crib this evening, I have been endeavouring to contrive my presence, it being just the opportunity I wanted for arranging some scheme of settlement of the 'Gurm' account. As it seems, however, almost impossible for me to get round, I write to ask you to try if something cannot be done amongst the three who were always the principal movers in the affair—thus: let it be determined who *will* and who *will not pay* AT ONCE, and let the amounts of the fortunate '*will-nots*' be subscribed

for by the unfortunate '*wills*': then if, at any future time, Tin can be extracted from the defaulters, it may always be divided between those who shall have paid for them. This is, of course, the only fair way of proceeding, and ought, indeed, to have been come to long ago; yet I know, and greatly feel, that it will fall very heavy upon William Rossetti, who has paid so *much more* than any one else, and *so much more promptly*; for which reason I have hitherto abstained from mentioning the obviously proper course. The Governor, however, has now requested me to do *everything I possibly can* to get a settlement by the 18th (Saturday week) so I must put delicacy in my pocket. At the time I received the order, I did not (as you must remember) know even who the Subscribers were, much less their solvency or otherwise,—being quite content that you and the Rossettis would take care of me; and I stated as much to the Governor or he would not have considered himself justified in undertaking the thing—He (the Governor) therefore looks to me, and *I* think I have lost enough already—What think you?

Hunt will, no doubt, *now* pay his trifle immediately, if written to; and I should suppose Deverell would do the same. Hancock is the only doubtful one so the amount will not, at the worst, be very formidable. As to yourself, I have always told you I should speak plainly when necessary, being sure that you would then manage the affair; I therefore make no difficulty about now doing so, and trust to you, moreover, doing your best to get the whole business settled in the manner I have suggested by the 18th. . . .

What success Tupper encountered with WHD is not known, but the slightly ironic tone of his letter, belying the confidence expressed in his statement to FGS, is hardly surprising after so long a postponement:

Our friend Stephens having told me that you would have 'much pleasure— that is—a very moderate amount of pleasure' in settling your balance of the *Germ* account whenever I let you know where to send it, I have 'much pleasure' in intimating to you my readiness to receive the same here or at our residence at Milton Cottage South Lambeth. At which latter place we shall be very happy to see you any evening you may be up, or if you would drop me a note I would endeavour to get the domestic Stephens and perhaps a Rossetti or two. The amount of your old balance is (according to William Rossetti) £1.14.6, but I have a 'very moderate amount of pleasure' in informing you that Hancock has become a defaulter or in other words *repudiated*; hence there is his share of £3.14.6, to be divided between the remaining six proprietors which according to the most approved Cocker gives 12/5 each extra.

William Rossetti believing I had been kept out of it long enough, and knowing too that I wanted the Tin, has kindly advanced me the amount, therefore these twelve-and-five pences will go to him, but if you forward your amount of £2.5.11, altogether, I will settle with Rossetti, whose office is close here which will save you further trouble.

As Secretary of the P.R.B., it was WMR who assumed the responsibility for bailing out the group. And even forty years later, when he glossed this last letter while editing Deverell's memoir, he was characteristically generous about Hancock's defection:

The terms here applied to John Hancock, 'defaulter' and 'repudiated', were hardly deserved by that struggling young sculptor. The fact is that he had never taken any particular interest in the project of *The Germ*, which was out of his line; and he had published nothing in it at all. Dante Rossetti, on the prowl for possible contributors, or more especially 'proprietors', had, when he first conceived the project of *The Germ*, browbeaten Hancock into a sort of semi-assent:

but it was not greatly to be wondered at if, when the thing collapsed, Hancock reflected that he had never wanted it to exist, and objected to putting his hand into his pocket.

WHH was less charitable at the time, when WMR proposed that Hancock's share should be split among the other proprietors. Writing to FGS (undated letter in BSP, MS. don. e. 66, ff. 13–14), he fumed:

> William R's proposal is perfectly absurd, you or I never engaged ourselves to be responsible for Hancock, already I am cheated out of the amount payed for printing the etching and this is quite enough. Besides Hancock's position is by no means so deplorable as to render charity necessary. He seems to me to be the most flourishing of all the defaulters and the one who consequently should pay for us.

With this document, the formal history of *The Germ* closes. Some years later, George Tupper considered reviving the publication, but it was not until negotiations were opened between Elliott Stock and WMR about the facsimile, in 1883, that the magazine again figured prominently in WMR's correspondence. By that time, the original publication had become a collector's item commanding a high price. In AP there are three letters from George Tupper to WMR in which he discusses the 'rights' to the magazine and expresses apprehension lest a facsimile edition should affect the value of the original parts. In the end, Tupper deferred to WMR's wishes, though the facsimile was not finally published until eighteen years later. Tupper's patronage of *The Germ* is too little remembered in the history of Pre-Raphaelitism. Without him and the firm, the voice of the Brotherhood would have been silenced after two numbers. It is one of the more glaring failures of the P.R.B. that the Brothers did not reciprocate with equal enthusiasm Tupper's singular generosity.

**21.12.** WHD's etching: *Viola and Olivia* (from *Twelfth Night*) accompanied by a similarly entitled poem by JLT. Of this frontispiece, WMR says: 'The etching by Deverell, however defective in technique, claims more attention, as Viola was drawn from Miss Elizabeth Eleanor Siddal, whom Deverell had observed in a bonnet-shop some months before the etching was done . . .' (*PFG*, p. 25).

**21.22.** Free Exhibition: In the second edition of *PR&PRB*, WHH added the following note to his comments about DGR's advance showing outside the R.A.: 'William Rossetti tells me that Gabriel bought a wall-space at this gallery, feeling doubtful whether he would get his picture into the Academy, but he mentioned nothing about this to us nor did I know of the purchased exhibition until his brother had read the first edition of this book' (ii. 300).

**21.31.** Reach: Angus Bethune Reach (1821–56), journalist and novelist. Most commentators on the Pre-Raphaelites have followed WMR in attributing the first discussion in print of the letters 'P.R.B.' to Reach in his *ILN* column (4 May, p. 306). G. H. Fleming, however, in his *Rossetti and the Pre-Raphaelite Brotherhood* (London, 1967) argues on inference (from articles in the *Athenaeum* of 20 Apr. and in the *Spectator* and *Morning Chronicle* of 4 May) that 'by the beginning of May 1850, the existence of the Pre-Raphaelite Brotherhood had become common knowledge in the London art world' (p. 136) and dismisses WMR's supposition that the news had been leaked by Munro. He may be

correct; nevertheless, Reach's notice was the first in which the meaning of the letters was specifically exposed.

**21.33.** *Athenaeum*: 7 and 20 Apr. 1850—'An assault, but hardly a savage one' (*PDL*, p. 274). DGR's letter is not extant.

**21.43.** papers: For notices of JEM's and WHH's pictures, see *Pre-Raphaelitism* 71.2.

**21.44.** *Household Words*: Dickens's well-known attack, 'Old Lamps for New Ones', appeared on 15 June (pp. 265–7).

**21.48.** German source: 'It was written, I think, by Dr. Waagen' (*PDL*, p. 274). Lamenting the 'mediocrity of attainment', which he describes as the most 'preponderating influence' of the exhibition (p. 36), the author of this pamphlet —and from internal evidence he would seem to be English rather than German (he is not identified in Halkett and Laing)—found the whole show depressing. As for WHH and JEM, as exemplars of a new school, he acknowledges that they possess 'talent, in the lower sense of the word', but concludes that 'pitiable is copyism ever', and he accuses the two artists of abandoning the 'genuine English manner wrought out after earnest toil and endeavour' that characterizes the work of Hogarth and Turner (p. 19). Their pictures he finds 'merely disgusting', and he charges them with 'prepense choice of the worst instead of the best models, of pure ugliness for its own sake'. 'In the puerile contorted monstrosity of some of his idiosyncrasies bearing the guise of humanity', JEM particularly excels. WHH's *Missionary* is superior to the *Carpenter's Shop* in that it employs 'less free recourse to ugliness and distortion', but 'in spirit as in manner, [it is] equally, though less saliently with its companion, elaborately trifling, and emphatically silly and unreal'. As for their use of natural models, the author observes: 'It is noticeable . . . how little in the way of real nature, even in the isolated parts, mere literalness of finish can realize; the very reverse of the notion,—a central one in their system, entertained by these profound thinkers, the "Pre-Raphaelites" ' (p. 18).

**21.57.** JC's letter: This undated letter is not extant in AP; it must, however, antedate his letter dated 21 May quoted in 21.7 above.

**21.73.** brackets: 'The words in brackets indicate some flaw in the letter' (*PDL*, p. 275). See corresponding Textual Note.

### OCTOBER 1850

line **5.** Deverell: 'I think it was my brother who fixed upon Deverell as a P.R.B. But the nomination was not fully ratified by others, and it cannot be said that Deverell, who died at an early age, was ever absolutely a P.R.B.' (*PDL*, p. 276). The question of a replacement for JC occupied the P.R.B.s until the famous meeting of 13 Jan. 1851 when the Rules were drawn up and it was decided to postpone the election of new members. See *PRBJ* Jan. 51 line 5 ff.

line **6.** WHD's work: *Twelfth Night* was WHD's picture exhibited at the National Institution in 1850; WMR reviewed the exhibition in a three-part article in the *Critic*.

line **8.** two pictures: *The Marriage of Orlando and Rosalind* (now at Birmingham) was not exhibited at the R.A. until 1853, when WHD sent five works and had two accepted; but this seems not to be the work described in *PRBJ*. *The Banishment of Hamlet* was shown at the National Institution in 1851 and noticed in the *Spectator* on 19 April (pp. 377–8). Although Peattie assigns this article to WMR, he himself, in 1899, was 'rather strongly of the opinion that the critique is [my] brother's throughout' (HDP, p. 79). WMR did not, however, include it in DGR's *Works*. The *Hamlet* picture, with some others by WHD that were owned by the family, was destroyed in a gas explosion some years later.

line **12.** Other recent designs: None of these designs seems ever to have been executed in oils. The last two, in pen and ink, are now in the City Museum and Art Gallery, Birmingham. Both are reproduced in H. Reitlinger's *From Hogarth to Keene* (London, 1938). There is no information available on the specific *Hamlet* subject described; however, also at Birmingham is a pen and ink drawing from the Ghost scene. WHD must have planned a series of illustrations for the play. The Egyptian Ibis picture is not identified.

line **18.** Millais: JEM spent the summer in Oxford with C. A. Collins.

line **22.** JEM's CP picture: *The Woodman's Daughter*. The lines are accurately quoted, but there are three departures from CP's punctuation.

line **36.** Mr. Combe: Thomas Combe (1797–1872), Superintendent of the Clarendon Press and early patron of the Pre-Raphaelites. See *The Combe Bequest* (*Pre-Raphaelitism* 16.6). For the details of the sale, for which JEM was responsible, see Mary Lutyens, 'Selling the Missionary', *Apollo*, lxxxvi (Nov. 1967), 380–7.

line **41.** Rigaud: John Francis Rigaud, R.A. (1742–1810), historical and portrait painter who did decorative subjects for ceilings and staircases. For WHH's and FGS's work on the Trinity House restorations see *PR&PRB*, i. 159–60.

line **49.** WHH's '2 Gentlemen': *Valentine Rescuing Sylvia from Proteus*, exhibited R.A. 1851 (No. 594); *Isabella* almost certainly refers to an early study from Keats's poem, perhaps Hunt 112. See May 49 23.2.

line **54.** WHH's 'Lady of Shalott': For a detailed study of this picture, see Samuel J. Wagstaff, Jr., 'Some Notes on Holman Hunt and *The Lady of Shalott*', *Wadsworth Athenaeum Bulletin*, 5th ser. No. 11 (Summer 1962), 1–21. The study here described may be *Hunt* 119.

line **55.** WHH's Ruth and Boaz: Never executed as a painting (see *Hunt* 120). For 'Isabella' design see May 49 23.5.

**24.11.** Dickens: WMR's hostility may have been in response to the *Household Words* article attacking the Pre-Raphaelites (see July 21.44).

**25.1.** DGR's letter: Not in DW, but DGR wrote a similar letter to his mother (DW 58).

**25.4.** WBS's letter: Dated 13 Oct. 1850 (in Durham University Library). On the *Bothie* WBS continues: 'But this after all is a matter of doubtless importance

—indeed I sometimes think there are no rules whatever absolutely binding on the poet or as we call him in relation to the executive—the artist. Even the most catholic of laws—that of unity of sentiment, and subordination of parts to a whole, seems not invariably just. There are unintentional irregularities, however, in the *Bothie*.'

**25.9.** Hannay's novel: *Singleton Fontenoy*, 3 vols. (London, 1850); there are several references to the book in *PRBJ*. WMR reviewed it in the *Critic* 15 Nov. 1850, pp. 554–5 (Peattie).

**25.11.** FMB's Chaucer: Exhibited R.A. 1851 (No. 380); see *Brown* 11.

**26.2.** three volumes: The Beddoes was reviewed in the *Critic* 1 Jan. 1851, *Eidolon* on 1 Dec.; the third work is not identified (Peattie).

**26.5.** Fairless: Thomas Kerr Fairless (1825–53), landscape painter, specializing in country scenes and sea-scapes.

**26.17.** WCT's picture: Neither this picture nor the 'fairy subject' by Bernhard Smith is identified.

**27.4.** TW's cast: This plaster medallion of Mrs. CP is reproduced in Champneys (i, facing p. 118).

**27.5.** TW's 'Amala': An inclusive title for poems later incorporated in *My Beautiful Lady* (1863). Early MS. drafts of 'Dawn', 'Wild Rose', and 'My Lady's Glory' are in the Colbeck Collection at U.B.C.; they were formerly owned by WBS and contain his suggestions for revision. In the Beinecke (see Aug. 49 19.9) there is an 8-page manuscript of 'Amala' consisting of twelve six-line stanzas, the first of which reads:

> Strong in her parent's strength of love,
>  Enthroned by native worth
>  She holds her sway on earth:
> Her soul looks downward from above
>  Exalted stars: its power
>  Sweetens the sweetest flower.

**27.5.** Masson: David Masson (1822–1907), biographer and editor, best known for his *Life of Milton*. Masson married Emily Rosaline Orme, whose mother was the eldest sister of Emily Patmore.

**27.8.** Cayley: Charles Bagot Cayley (1823–83), translator and poet, and one-time suitor of CGR. 'Mr. Cayley had lately been a pupil of my father for Italian' (*PDL*, p. 280).

**27.19.** Mrs. Browning's poem: 'Maud's Spinning' appeared in *Blackwood's* in Oct. 1846; reprinted in 1850 as 'A Year's Spinning'.

**27.20.** Jerrold: Douglas Jerrold (1803–57), essayist, novelist, playwright, and humourist.

**27.22.** Cook: Eliza Cook (1818–89), minor domestic poetess.

**27.23.** Mackay: Charles Mackay (1814–89), song-writer and journalist, editor of *Illustrated London News.*

**27.24.** Vom Bach: See May 49 23.11. Mr. Sartoris may be Edward John Sartoris (1817–88), husband of Fanny Kemble's sister, Adelaide.

**27.27.** TW's design: Not in 'List of Works' in *TWLL*, but probably the same work described in *PRBJ* 10 Oct. 49.

**28.1.** books: See 26.2 above.

**28.4.** DGR's letter: DW 59.

**28.7.** Mrs. Browning's poems: *Poems: New Edition*, 2 vols. (London, 1850) containing the first printing of 'Sonnets from the Portuguese'.

**29.4.** Hannay to India: He did not go.

**29.9.** *The Fourth Estate*: Subtitled, *Contributions towards a History of Newspapers and of the Liberty of the Press* by F. K. Hunt (London, 1850). Hunt assumed the editorship of the *Daily News* in 1851.

**29.11.** Bon Gaultier: Pseudonym of Sir Theodore Martin (1816–1909), co-author with William Aytoun of *The Bon Gaultier Ballads* (1845).

**29.12.** DGR's sonnet: DGR wrote two sonnets on this picture (*Works*, p. 173) which were printed on gold paper and fixed to the frame of the painting when it was exhibited. Only the first, 'This is that blessed Mary, pre-elect', was printed in the catalogue. Of the second, 'These are the symbols. On that cloth of red', WMR says, it 'was inscribed by my brother on the frame of his first picture: he never published it otherwise' (*Works*, pp. 663–4). The two sonnets appear to have been printed separately at the time, however (see Aug. 49 25.2).

**31.4.** Burrington: Edwin Henry Burrington, minor poet, author of a single volume, *Revelations of the Beautiful and Other Poems* (London, 1848).

**31.6.** WMR's poetry-reviewing: WMR severed his connection with the *Critic* in Nov. 1851, though he contributed occasionally to that journal afterwards; his art notices were transferred to the *Spectator* commencing in early Nov. 1850 (see Peattie).

### NOVEMBER 1850

**1.13.** FMB's picture: *Chaucer at the Court of Edward III*, sold to Robert Dickinson and by him to the dealer D. T. White in 1855 for £50 (*Brown* 11). FMB in his Diary describes the transaction: 'I sold this picture to Dickinson for 85 per cent. of whatever he might afterwards sell it for, to be paid after he should have received the money. I have since urged him to put it up to auction, which he has done, but no one would buy it; so he still has it. This year 1854 he paid me £20 on account of it, which was all I ever had for it' (*PDL*, p. 108). FMB subsequently repurchased the picture from White and in 1876 sold it to the Sydney Art Gallery.

**3.4.** WMR's notice of Allingham: Published in the *Critic* 15 Oct. 1850, pp. 496–8 (Peattie); CP's review appeared in Nov. in the *Palladium*.

**3.7.** Keats's Cleopatra: The description is of Jane Cox. In a letter written to George and Georgina Keats on 29 Oct. 1818, Keats said: 'She is not a Cleopatra, but is at least a Charmian; she has a rich Eastern look; she has fine eyes and fine manners. When she comes into the room she makes the same impression as the beauty of a leopardess' (WMR, *Keats* [London, 1887], p. 31). CP was wrong in equating her with Fanny Brawne.

**3.14.** DGR's stanzas on republics: Almost certainly the three parenthetical stanzas in 'Dante at Verona' beginning 'Respublica—a public thing'.

**5.8.** Collins . . . P.R.B.: In *PR&PRB*, WHH quotes JEM as saying that the P.R.B.'s rejection of his proposed election 'had cut Collins to the quick' (i. 189). It may have been in retaliation that JEM refused to support WHD in Jan. 1851. See also *PRBJ* 2 May 51.

**5.17.** TW's allegorical design: No work fitting this description appears in the 'List of Works' in *TWLL*. See also *PRBJ* 27 Oct.

**5.43.** Mr. Rintoul: Robert Stephen Rintoul (1787–1858), founder and editor of the *Spectator*. WMR was for a time engaged to Rintoul's daughter, Henrietta.

**5.56.** Williams on Wells: 'Wells is an interesting literary figure, and one of whom personally next to nothing seems to be known. I preserve this passage with the strong expressions used by his Brother-in-law; but of course I in no way commit myself as to the statements made, which may have been erroneous for anything I am aware of. The allegation regarding Thomas Keats is not wholly new' (*PDL*, p. 284). The fraud against Thomas Keats (1799–1818) consisted of at least two forged letters signed 'Amena Bellefila'. The episode is discussed at some length in Keats's own letters.

**5.75.** *Seven Lamps*: Published in 1849; WMR's first review of Ruskin was of *The Stones of Venice* in the *Spectator* in Dec. 1851.

**6.2.** Hook: James Clarke Hook, R.A. (1819–1907), sea and landscape artist.

**6.7.** specimen: WMR's first contribution to the *Spectator* (9 Nov. 1850, pp. 1075–6) was on 'The Elections at the Royal Academy' (Peattie).

**7.5.** Miss Faucit: Helena Saville Faucit (1817–98), actress, wife of Sir Theodore Martin. She opened in Westland Marston's *Philip of France* at the Olympic on 4 Nov. 1850.

**7.8.** Cayley: Published his translation of Dante in 1851.

**10.1.** FMB's *Chaucer*: Mary Bennett identifies three Pre-Raphaelite models in the picture: WMR for the troubadour, WHD for the page, and DGR for Chaucer (*Brown* 11).

**10.3.** WMR's notice: No such article seems to have been written.

**10.8.** Harding: James Duffield Harding (1798–1863), landscape painter, technical innovator in lithography.

**10.10.** *Critic* notice: 15 Nov. 1850, pp. 547–8; the two named works are by James Spilling and W. S. V. Sankey; *Hymns* was translated by Mrs. P. Llewellyn (Peattie). Moile's history was not reviewed (see next *PRBJ* entry).

**12.1.** paragraph: 16 Nov. 1850, p. 1099 (Peattie); on George Jones, R.A. (1786–1869), military and genre painter, Keeper of the Antique School of the R.A. (1840–50). See May 51 2.40.

**13.7.** DGR's stanzas: 'The Burden of Nineveh', first published in the *Oxford and Cambridge Magazine* (1856).

**13.15.** Mr. Paxton: Sir Joseph Paxton (1801–65), horticulturist and architect, chief planner of the Great Exhibition and designer of the Crystal Palace. WMR's notice of 'The Great Exhibition Building' appeared in the *Spectator* 16 Nov. 1850, pp. 1099–1100 (Peattie).

**13.20.** Exhibition: WMR's notice appeared in the *Spectator* 23 Nov. 1850, pp. 1122–3; 7 Dec., p. 1171 (Peattie).

**14.11.** poem by Allingham: Entitled 'Wayconnell Tower', the poem appeared in *Household Words* on 16 Nov. 1850 (p. 181); revised and shortened, it is No. xxviii of Allingham's *Day and Night Songs* (1854).

**30.6.** caricature: See Jan. 51 line 29.

**30.12.** *Guardian*: 1 June 1850, p. 396; the review was not by Ruskin.

**30.27.** DGR's parody: 'Now lost, I am sorry to say. I forget what may have been the subject of this parody of Poe's strangely haunting poem' (*PDL*, p. 289).

### DECEMBER 1850

**2.4.** FGS's song: From *Measure for Measure*, III. i. 1.

**2.5.** P.R.B. meetings: Although WHH later complained that for too many of the P.R.B.s and associates 'the pleasantness of our Bohemian meetings was what they most enjoyed' (*PR&PRB*, ii. 339), the record of activities in *PRBJ* belies his strictures. How vital to the idea of the Brotherhood was the camaraderie of the group is poignantly revealed in a letter from TW to WMR (AP, dated 20 Mar. 1854), written while he was in Australia:

> You, my dear William, who have not been far from your friends for any length of time cannot imagine the impatience I feel to get among you all again; sometimes I look over the criticisms on Art in the Spectator and feel the great want of some one to talk art with; for since I left home I have scarcely met one who talks rationally on that subject: the people, I mean the aristocratic part, of Sydney are remarkably kind to me, but what amount of kindness from strangers—glory of climate—richness of produce can compensate the loss of one's old friends' society? Those coffee-drinking PRB meetings seem to be delights gone dim and spectral in the past. Sometimes when I think of the delight of meeting you all again, and hearing the news of two years, I fancy it in some way fabulous, and that it will elude me as the statues do that I seem sure of. The only drawback I feel in contemplating my prospective pleasure is that some of the friends I love may

have changed in character and grown hard and icy, losing the fresh impulsive energy which has ever been my peculiar joy. I know no one I could justly apprehend this of—but it is the common complaint of those who return to friends after a long absence. If my PRBs are the same I shall be quite content and can conform easily to any other changes.

**2.6.** FGS's tale: Neither the tale nor the Edinburgh journal is identified.

**2.18.** P.R.B. household: See Nov. 49 6.3.

**3.1.** DGR's design: *Borgia*, dated 1851 (Surtees 48).

**3.2.** DGR's ballad: 'Dennis Shand' was first published by WMR in 1904 (*Works*, pp. 193–4). DGR included the poem in his first trial book of 1869, but withdrew it from the published volume. See WMR's note in *Works* (p. 666).

**3.5.** Mrs. Browning's poem: See Oct. 50 28.7.

**3.11.** Grundy's: WMR's notice appeared in the *Spectator* 7 and 21 Dec. 1850, pp. 1170–1, 1218 (Peattie).

**4.1.** Kennedys: William Denholm Kennedy (1813–65), Scottish landscape and figure painter who, after 1840, specialized in Italian subjects.

**4.2.** Poole: Paul Falconer Poole, R.A. (1807–79), historical painter. For DGR's notice see *Works* (p. 585). Joseph Mallord William Turner (1775–1851) Ruskin compared to the Pre-Raphaelites.

**7.2.** Red Lion Square: DGR for some months in 1851 shared a studio with WHD at No. 17 Red Lion Square, the same rooms that Burne-Jones and Morris occupied in Nov. 1856.

**7.3.** North Senior: 'He (as it happened) was the father of . . . William North . . .' (*PDL*, p. 291).

**7.18.** *Athenaeum*: 7 Dec. 1850, p. 1286, in 'Fine Art Gossip'. The attack is on a photograph of a religious subject by Mr. Mayall 'who bids fair to outstrip the Pre-Raphaelites even in that limited race in which they are both confined':

The soi-disant Pre-Raphaelite ignores the principles of art, and affects to despise all the approaches hitherto made towards the establishment of fixed ideas on the subject of beauty and taste. Ignoring, also, the advantages which these studies may be supposed to have wrought out in giving a true direction to the imagination, he sits down before some model in the selection of which he has taken no further account than as it may answer his desire to imitate the ugliness of some early master, and searching out its—perhaps disgusting—details with microscopic eye, thinks that he has achieved all by a successful imitation, and hopes by this process to work out a patent way to the true and the beautiful. The photographist, with no such overweening pretention, and without loss of so much ill-applied labour, does the same thing much better, and has, already—with something yet remaining that is disagreeable in exaggerated hardness of effect and 'tinniness' of execution—produced more than these worshippers of the merely old.

**8.5.** Mrs. Patmore: For the plaster medallion see Oct. 27.4. For Mrs. Orme see Oct. 27.5.

**10.1.** JEM's design: 'The design was, I think, *A Marriage Before the Flood*, representing the nuptial feast, and one of the guests, on looking out of the window, startled to see the portentous first beginning of the storm—a very fine thing indeed. The "picture" must be the one from *The Woodman's Daughter*, by Patmore' (*PDL*, p. 292). This must be JEM's design 'The Eve of the Deluge' (see *Millais* 257) which he abandoned in favour of *The Return of the Dove to the Ark*, though he took up the subject again in 1851.

### JANUARY 1851

line **3.** moving: 'The Rossetti family had moved from No. 50 Charlotte Street to No. 38 Arlington Street, Mornington Crescent' (*PDL*, p. 292).

line **7.** new members: With the resignation of JC from the P.R.B. in May 1850, the question arose of electing a new member to round out the original number (see *PRBJ* 18 Jan. 50). Of the two serious candidates, WHD had the greater claim; C. A. Collins, who was nominated by JEM, was rejected earlier (see Nov. 50 5.8). While WMR does not specifically mention WHD in connection with the November meeting, all the evidence points to a kind of consensual assumption that he would be elected at the anniversary meeting of the Brotherhood which was to meet at FGS's on 2 Jan. WMR says that 'Deverell . . . was regarded, at the close of 1850, as practically a P.R.B.' (HDP), and there is ample documentation to suggest that WHD himself had good reason to anticipate his election as almost a certainty. On 23 Dec. 1850, FGS wrote to WHD: 'I am writing to the P.R.B. to come here to hold the anniversary meeting on the 2nd January. You must come and we will elect you into your proper chair in force' (HDP, p. 37). Certainly, FGS was not acting solely on his own initiative, for on the eve of the meeting (undated letter in BSP, MS. don. e. 66, ff. 4–5), WHH wrote to FGS:

> Since receiving your note of last week I have wanted to see you about the meeting which is to take place at your house tonight, as however I have not been able to get over things must occur as they can be provided for in the meantime. My principal object was to convene a meeting before of the original P.R.B.s so that everything might be settled ready for receiving Deverell officially at your meeting, as, altho in itself the form is of little consequence in this case, whatever system is followed now will be looked upon in future as a precedent, and thus becomes of course important.
>
> Tomorrow I will call on Gabriel, and Johnny, to make more sure of having a full meeting; be prepared with some rules to propose, and expect some stringent ones from me, have paper ready for the Secretary and do not allow anything to occur calculated to interrupt the business character of the night until every thing necessary is settled.

And on the day of the scheduled meeting, JLT added as a postscript to his letter to FGS (BSP, MS. don. e. 78, f. 19v): 'Happy New Year to you! and P.R.B. to Deverell. I suppose tonight eh? You may interpret P.R.B. "Penis rather better"—which to him is important.'

Assuming that the anniversary meeting was held—and there is no confirming evidence that it was since the meeting to which WMR refers in *PRBJ* was at WHH's on the 13th—either WHD was rejected, perhaps on JEM's vote, or his

election was held over until the meeting at which the rules were formulated, one of which was that the election of new members should be deferred until after the opening of the year's exhibitions, by which time, as WMR says 'the Præraphaelite Brotherhood, tho' never expressly dissolved or discontinued, had ceased to have any corporate solidarity, and so the question of Deverell's election was no further raised' (HDP, p. 38).

line **8**. rules: See Appendix 1.

line **24**. manifesto: 'This "declaration" appears to have been lost this long while past. I fancy that none of the other P.R.B.'s wrote any declaration. Had they done so, the papers would now be very interesting documents' (*PDL*, p. 293). WHH's 'note for a P.R.B. meeting' must have been written close on this date: 'It having become necessary, from the misunderstanding which exists relative to the extension of meaning professed in the initials P.R.B., to expound concisely how this is consistent with our principle of painting all things from Nature without attempting to follow the manner of the early painters, I write this to perform my promise to bring my ideas to this meeting, and to compare them with those of others, that in so doing we may discover whether we are all actuated by the same motives in painting, and that we may determine whether it is advisable or not to continue the use of the initials with their present meaning' (*PR&PRB*, ii. 339–40).

line **29**. Earl: Thomas Earl(*fl*. 1836–85), animal painter who specialized in dogs and rabbits. This caricature, on which no information is available, was seen as the opening volley in what the P.R.B.s feared might be a renewed attack on them at exhibition time (see also *PRBJ* 30 Nov. 50). In an unpublished letter in AP (dated 21 Apr. 1851), FGS wrote an anxious postscript to WMR:

P.S. Have you seen the Athenaeum on Collinson and Deverell (?) ???? as P.R.B.s. 2nd P.S. I got a note from the country this morning pointing out a notice in the Morning Chronicle on C and D, perfectly abusive.

Mein Gott! while I wrote the above they brought me two other letters, one mentioning the same thing, another in addition points out the Athenaeum, and refers [to] the publication of that print of T. Earl's, by Fores, as being answered with some reviling of the Holy Bd. in an advertisement or notice in half a dozen papers, The Dispatch, Etc. . . . and don't you think this will do for a beginning gemeine Bruder?

Make the Spec- speak out, but temporarily could not Hannay do something for us? You observe these notices are against the P.R.B. as much as the Painters. Try if Hannay cannot do something with the Daily News. . . . The worst of it is that revilement is not (I fear) without some show of truth and reason, in the instances cited. I really think something ought to be done; if this abuse is of no consequence against us then it follows that the S and C are of no service to the cause. The rancour, of course, is most evident but everyone will not think about that but adopt the opinions.

If anything is or can be done, now is the time before the R.A. opens, on the 5th May—only three weeks. There is a meeting (at your place?) on the 3rd but could not one take place before.

Could not somebody, yourself or Gabriel, write an exposé of the principles of the Holy Bd. and we get it inserted, such as never been done except in Orchard's article in 'The Germ' which of course nobody read. I don't mean anything

transcendental but a statement of facts and of our real intentions. There is a notion abroad, I fancy, that the Bd. is connected with 'The Foreigners' and that we desire to alter the Established Church, which Johnny Millais is to propose to the Queen while painting her portrait. The first idea, which seems to have firm hold, may be much weakened by getting Gabriel to cut off his moustaches and sacrificing himself to good pleb whiskers, such as our own (by the way I am beating you all to nothing in that respect) now rub your hand up your cheek in protest of denial.

Call a meeting at Gabriel's and let us have Deverell and Collinson and Collins present to talk over the approaching storm. It will be of little use waiting until the opening as then all the journals will have spoken and will not alter their own words. Collins's brother might be of use, going much into literary society, if he could be fairly interested in the matter. What a bitter pill this row will be for Collinson. Buckle on your armour.

**19.1.** *Sir Reginald Mohun*: WMR reviewed the new canto in the *Critic* 15 Feb. 1851, pp. 87–8 (Peattie). See Sept. 49 20.2.

**26.9.** Bennett: William Cox Bennett (1820–95), poet and song-writer; published his collected *Poems* (London, 1850).

**26.14.** WMR's notices: Peattie records one notice only by WMR for Jan. 1851 —'North London School of Drawing and Modelling' (4 Jan., pp. 19–20)—plus a review of Beddoes (1 Jan.) in the *Critic*.

### FEBRUARY 1851

**2.4.** Wordsworth monument: TW executed in 1851 a memorial tablet with a medallion portrait; he did not win the competition for the monument, but his design (1852) is reproduced in *TWLL* (facing p. 28); for a description see *PRBJ* 9 Mar. 51. Mr. Fletcher of Ambleside is not identified, but a letter from Mrs. Fletcher to TW is printed in *TWLL* (p. 11).

**2.13.** JEM's third picture: JEM exhibited three pictures at the R.A. in 1851: *The Woodman's Daughter* (No. 799), *Mariana* (No. 561), and *The Return of the Dove to the Ark* (No. 651)—see *Millais* 29, 30, 32.

**2.16.** WMR's notice: None is listed in Peattie before 15 Feb.

**9.1.** new system: That is, under the dispensation of the new rules, enacted at the last meeting on 13 Jan. (see Appendix 1).

**9.15.** Miss McDowall: This professional model is not identified, but the picture must be a study for the small oil panel, *The Bridesmaid*, also known as *All Hallows' E'en*. In a letter to Mrs. Combe, dated 15 Jan. 1851, JEM described the picture as then completed (*Millais* 33).

**9.19.** David Scott's designs: Engraved by WBS. WMR reviewed the work in the *Spectator* 1 Mar. 1851, pp. 210–11 (Peattie).

**23.2.** DGR's portrait: No such work is identified in Surtees.

**23.5.** WMR's notice: *Spectator* 8 Mar. 1851, pp. 235–6 (Peattie).

MARCH 1851

**2.3.** Hannay's cousin: James Lennox Hannay, a barrister and later magistrate (see *Hunt* 19 and 117).

**2.5.** TW's Carlyle: Plaster medallion. TW did a bronze medallion in 1855 (see 'List of Works' in *TWLL*).

**9.1.** FGS's Griselda picture: See Feb. 50 2.23 and May 51 2.18. For FGS's sketch see *PRBJ* 2 Dec. 50.

**9.8.** TW's Wordsworth: See Feb. 2.4.

**9.27.** WMR's notice: WMR's review of Hannay and four volumes of verse appeared in the *Critic* 15 Mar. 1851, p. 136 (Peattie). *The Vision of the Vatican* is not attributed to Hannay in either the *New CBEL* or in the bibliography of his writings in George Worth's critical study.

MAY 1851

**2.16.** best pictures: William Dyce, R.A. (1806–64); Charles Robert Leslie, R.A. (1794–1859); William Mulready, R.A. (1786–1863). Dyce was greatly influenced by the Nazarenes, later by the Pre-Raphaelites.

**2.18.** FGS's *Griselda*: No details are available on the deception involving the picture's submission. The reference is almost certainly not to FMB. See Feb. 50 2.23.

**2.25.** monkey: 'This was Mr. Chorley, the musical critic of *The Athenaeum*' (*PDL*, p. 298). Henry Fothergill Chorley (1808–72).

**2.33.** WMR's notice: *Spectator* 12 Apr. 1851, p. 355; seven further notices were published between 26 Apr. and 28 June (Peattie).

**2.38.** Mrs. Collins: 'Widow of William Collins, R.A., and mother of Charles Allston Collins' (*PDL*, p. 298).

**2.40.** Jones: 'George Jones, R.A., was an old-fashioned painter of military and scriptural subjects. He was Keeper of the Academy and as such was at the head of the Antique School, and may have been instructor to Millais in the days of his boyish prowess. "Mrs. Jones" (it will be understood) was the spouse of Jones, R.A.' (*PDL*, p. 298).

**6.1.** *Daily News*: Two notices of the exhibition appeared in this paper, the first on 3 May, the second on the 5th. WMR's summary of the critique seems to be a truncation of the two notices, in the first of which the Pre-Raphaelites are referred to as having 'come out in strength, adhering to their tenets with the faith of martyrs, yet commanding respect by their fervid and devotional artistic principles' (p. 6).

**6.6.** Editor of *Spectator*: R. S. Rintoul (see Nov. 50 5.43) tended to feel that WMR was somewhat too partisan in noticing pictures by the P.R.B. After

three (out of seven) of his notices of the R.A. exhibition of 1852 had appeared, WMR received the following gentle chastisement from Rintoul (AP, dated by WMR 13 May 1852):

Just cast your eye upon the last paragraph of an article on Photography, which accompanies your own proof. From that you will see what some, by no means illiberal connoisseurs, continue to think of the Pre-Raphaelites. Of course I will not allow such disparaging terms to appear in the same paper with your *aesthetic raptures*! But I would suggest that some of your language is too warm-coloured for the tone of calm criticism. It defeats its very object, and brings down abuse on the meritorious objects of your admiration. There is *some* just foundation for the very general dispraise of the Pre-Raphaelites even in this exhibition. For instance, though 'The Pretty Baa-Lambs' may have all the artistical merits you ascribe to it, the first-sight, the general effect, is displeasing: most people call it *ugly*. They cannot overcome this impression even after listening to 'reason'.

I would have preferred talking over these points; but you will not misunderstand that I am only cautioning you on the use of terms which may tend in some measure to defeat your intention.

**7.3.** Eclectic: Hannay did not after all speak (see DW 64); WMR obviously misdated the letter.

**7.8.** Cox: FGS experienced some difficulty with Cox, who was not altogether satisfied with his reviews and notices for the *Critic*. Writing to WMR on 14 Mar. 1851, Cox asked: 'Don't you think friend Stephens is a *little too severe*—he should be somewhat more descriptive of pictures—not such mere *dogmatic judgments*. Could you not give him a hint and shew him how *you* did it which was a model of such notices' (unpublished letter in AP). Both FGS and WMR seem to have regarded their connection with the critical press as an opportunity primarily to advance P.R.B. aims, and perhaps fortunes—even WHH acknowledges that between 1850 and 1858, WMR 'manfully used his pen in support of . . . P.R.B. principles' (*PR&PRB*, ii. 340)—but FGS tended to be more callow about the issue (see his letter of 3 Feb. 1850, quoted in Feb. 50 2.35). In the correspondence that followed Cox's letter to WMR, FGS wrote him on 24 Apr. 1851 (AP):

I fear my hasty writing must have caused you to imagine me in a funky state about the press-notices. I had no idea of a pamphleteering campaign against Slosh the Giant, but thought a distinct assertion of *certain* principles would be (by *certain*, I mean *settled*) of service as affording the Englishmen a means of judging for themselves according to the appearance of Nature itself not thro' the mysterious jargon of Studios and Reviews. The wretches would catch at this, so flattering to their vanity, and really it might lead them to look for themselves.

Think! 'Every Man his own Critic.' Ah! the complacent self-huggings. Really tho' it would be too Low-Church. Let us then keep the Lapstone out of the Temple. *Mort à Slosh*!

I am glad Gabriel has the Leader to do. A great crony of the Critic's by the way. *Could not this be made permanent?* Gabriel might do it, or if too lazy, we might take it on our shoulders by working alternately. The trouble would be very slightly increased.—Hunt, with proper management so as not to frighten the Noble Steed with the idea that he was bearing his destiny, would even undertake it, I think. Fancy, every P.R.B. with his own newspaper.

**11.7.** WHH's picture: 'The subject was not painted' (*PDL*, p. 299).

**12.5.** Behnes: William Behnes (d. 1864), sculptor. 'Behnes had at one time had Woolner in his studio, and had given him some sculptural training' (*PDL*, p. 300).

**12.11.** DGR's notice of Poole: See DW 65; printed in *Works* (p. 585).

**13.1.** Ruskin's letter: 'The Pre-Raphaelites' (13 May 1851, pp. 8–9) written in response to an especially vitriolic notice in *The Times* on 7 May. 'Imitation of false perspective' (line 16) is a conflated quotation from this letter.

**13.23.** Thorburn: Robert Thorburn (1818–85), miniaturist; Sir William Charles Ross (1794–1860) was also a miniaturist.

**13.43.** tendencies . . . repudiate: WMR made his first extended attempt to clarify Pre-Raphaelite principles in his *Spectator* article on 4 Oct. 1851 (pp. 955–7) after the appearance of Ruskin's pamphlet, *Pre-Raphaelitism* (London, 1851); however, he did not in that article address himself to Ruskin's charge of 'Romanist and Tractarian tendencies'.

**13.49.** notice of WHH: 'A notice, written by my brother, of Hunt's picture; it was offered for insertion, and actually inserted, in my notice of the Academy Exhibition in *The Spectator*' (*PDL*, p. 302). Printed in *Works* (p. 585).

**13.55.** thanks to Ruskin: WHH writes in *PR&PRB* (i. 183): 'After leaving a sufficient interval to follow Ruskin's last letter in the *Times* to make sure that we should not be influencing in any degree or manner the judgment of the writer, Millais and I posted a joint letter to thank him for his championship. The address at Gower Street was given in the letter, and the next day John Ruskin and his wife drove to the house, they saw my friend, and after a mutually appreciated interview carried him off to their home at Camberwell and induced him to stay with them for a week.'

**13.59.** Mr. Boddington: Not identified; JEM's picture was purchased by Thomas Combe, as was C. A. Collins's *Convent Thoughts*. All these pictures are now in the Ashmolean Museum, Oxford.

**13.64.** *Guardian* and *Bell's Weekly*: Notices of the exhibition appeared in the *Guardian* on 7 May (p. 331) and in *Bell's Weekly Messenger* on 10 May (p. 5). In the *Guardian*, by far the most space is allocated to JEM, whose pictures, the reviewer noted, 'cannot be looked at and passed by with . . . indifference. They demand our sympathy, and waken our feelings by their strong individuality, and we find ourselves returning again and again to contemplate and to become familiar with every part. . . .' Despite the reference in *Bell's Weekly* to 'the rising talent which the walls display', which WMR took to apply to the P.R.B., the sequel was anything but laudatory. In subsequent notices, JEM and WHH are totally ignored, and on 31 May FMB's *Chaucer* was summarily abused. Collins's *Convent Thoughts* elicited the following tribute: 'This is a beggarly attempt to resuscitate the execrable manner of the mediaeval age. . . . If Mr. Collins is intending always to paint in this manner, he may probably find customers— for there are always a sufficient number of idiots in existence to esteem such trash as specimens of high art—but the hanging committee ought not to allow

the space at their command to be occupied with such hard and discreditable daubs' (p. 2).

**13.77.** *Germ*: For details of the financial settlement of *The Germ* see *PRBJ* July 50 21.7.

**16.2.** *Punch*: 'Punch Among the Pictures', 21 May 1851 (p. 219): 'The pictures of the P.R.B. *are* true and that's the worst of them.'

**16.9.** minor Wordsworth monument: Presumably the medallion portrait; see Feb. 2.4.

**16.11.** Ruskin's second letter: 'The Pre-Raphaelite Artists', *The Times* 30 May 1851, pp. 8–9.

**16.28.** JLT's bas-relief: Not identified.

**16.41.** Knight: John Prescott Knight, R.A. (1803–81), portrait and historical painter; secretary of the R.A. (1848–73).

**16.45.** JLT's poem: There is no poem of this date in WMR's edition of JLT's poetry which fits this description.

**24.1.** engraving: *Illustrated London News* 24 May 1851, p. 463. C. A. Collins's *Convent Thoughts* is referred to in the exhibition notice as a 'Pre-Raphaelite Folly'.

**24.4.** notice of FMB: *Illustrated London News* 17 May 1851, pp. 415–16.

**24.7.** *Athenaeum*: 24 May 1851, p. 560.

**24.7.** WMR's notice: The Bridgewater notice appeared in the *Spectator* 24 May, pp. 499–500; his P.R.B. notice on 31 May, pp. 523–4 (Peattie). Several of WMR's reviews of JEM, WHH, FMB, and the Pre-Raphaelites in general are reprinted in *Fine Art, Chiefly Contemporary* (London, 1867).

**24.11.** FMB's studio: 17 Newman Street (see Jan. 50 12.2).

**24.13.** DGR's painting: DGR exhibited at the Old Water-Colour Society in 1852, *Beatrice Meeting Dante at the Marriage Feast Denies Him Her Salutation* (see Surtees 50).

## JANUARY 1853

line **9.** R.A. exhibits: For the works mentioned see *Hunt* 22 and *Millais* 34 and 35; of TW's sculptures mentioned, only his design for the Wordsworth monument is reproduced in *TWLL*; FGS's portrait of his mother, if an oil, is not known, but there is a pencil sketch of her in the Tate Gallery, together with his oil, *Mother and Child*.

line **16.** DGR's lady: 'Christened (at my suggestion) *Rosso-vestita*' (*PDL*, p. 306). For this and the other pictures exhibited at the Old Water-Colour Society see Surtees 45, 50, 54.

line **18.** WHH's pictures: *Claudio and Isabella* was exhibited at the R.A. 1853;
*The Light of the World* was completed in 1853, sold to Thomas Combe, and
shown at the R.A. in 1854 (see Hunt 18 and 24). *Strayed Sheep* was commissioned
by Charles Maude. Of this work, WHH wrote to FGS from Clive Vale Farm,
near Hastings (undated letter in BSP, MS. don. e. 66, ff. 9–10): '. . . it is certain
that there has not been one decent day excepting last Sunday since we have
been here. . . . As Mr. Maude requires sunlight in the picture, and moreover
seems to have a prestige for sheep, *it is often extremely difficult* to work on *PRB
principles* with the hope that he will be satisfied with the result.'

line **23.** WHH to Syria: WHH left England for the Holy Land on 16 Jan. 1854.

line **23.** JEM's pictures: The Stuart period picture is *The Proscribed Royalist*,
exhibited at R.A. 1853; *The Ransom* was not executed as an oil painting until
1862 (see *Millais* 61).

line **26.** DGR's picture: 'This was not painted' (*PDL*, p. 307).

line **27.** TW to Australia: TW sailed from Plymouth on the ship *Windsor* on
24 July 1852 and arrived at Port Philip, Victoria, on 27 Oct. He kept a log of
his journey, but according to his daughter it was destroyed (*TWLL*, p. 15).

line **31.** FGS's portrait: Not identified.

line **31.** *Spectator*: WMR was art critic on the *Spectator* from Nov. 1850 until
1858. Many of his notices there and in other journals are reprinted in *Fine Art,
Chiefly Contemporary*.

**17.5.** Howitts: Dr. Godfrey at whose home in Melbourne TW visited often
during his sojourn in Australia. Howitt was a botanist and physician and the
younger brother of William Howitt who, with his two sons and R. H. Horne,
went to Australia to prospect for gold in June 1852, just a month before TW.
TW's letters to his father contain frequent references to the hospitality and
friendliness of the Howitts. For William and Mary Howitt's relationship with
the Pre-Raphaelites see C. R. Woodring's *Victorian Samplers* (Lawrence, Kansas,
1952).

**17.10.** JC: JC did not remain long as a 'working brother' at the Jesuit College
of Stonyhurst. He later married a sister-in-law of J. R. Herbert by whom he had
one son. His later artistic career was undistinguished. WMR says that 'Collinson
was not the sort of man to excite ardent emotions of friendship; but a P.R.B.
was a P.R.B. . . .' (*SR*, i. 65).

**17.17.** McCracken: Francis MacCracken, Belfast merchant and shipping agent,
one of the early collectors of Pre-Raphaelite art, who bought pictures from
DGR, WHH, FMB, JEM, Arthur Hughes, and others. He purchased *Ecce
Ancilla Domini* in 1853, and WMR says that he was DGR's 'mainstay in his
most struggling years' (*FLM*, ii. 119). There are frequent references to
MacCracken in DGR's letters (see DW 95, 116–17, 169, 204). His pictures were
disposed of in two sales at Christie's (the first anonymously) in June 1854 and
31 Mar. 1855. MacCracken seems to have been a tough bargainer, and though
WMR insisted that DGR's 15-line sonnet on him, parodying Tennyson's

'Kraken' (*Works*, p. 272), was 'a mere piece of rollicking fun, without the least real sting in it' (*FLM*, ii. 119), the poem probably reflects accurately enough the P.R.B.'s attitude toward their ungenerous patron:

<div align="center">

MacCracken

Getting his pictures, like his supper, cheap,
  Far, far away in Belfast by the sea,
His watchful one-eyed uninvaded sleep
  MacCracken sleepeth. While the P.R.B.
Must keep the shady side, he walks a swell
  Through spungings of perennial growth and height:
  And far away in Belfast out of sight,
By many an open do and secret sell,
Fresh daubers he makes shift to scarify,
  And fleece with pliant shears the slumbering 'green'.
There he has lied, though aged, and will lie,
Fattening on ill-got pictures in his sleep,
Till some Præraphael prove for him too deep.
  Then, once by Hunt and Ruskin to be seen,
Insolvent he will turn, and in the Queen's bench die.

</div>

**17.30.** Blackfriars: DGR occupied the Chatham Place house from 17 Nov. 1852 until Mar. 1862.

**17.39.** Carlyle: WMR's allusion is probably a free paraphrase of a general theme in 'The Stump-Orator', No. 5 (May 1850) of *The Latter-Day Pamphlets*.

**23.2.** *Ancilla*: The original title is maintained in Surtees 44.

**23.5.** DGR's translation: Unpublished until *The Early Italian Poets* (1861). The volume appeared without illustrations, though DGR did prepare an engraved title-page which was not used. For details of the design, called *The Rose Garden*, and the plate see Surtees 125.

# BIBLIOGRAPHY

This list of manuscript and printed sources is limited to works cited in the Introduction or Explanatory Notes.

## MANUSCRIPTS

The Angeli Papers, Special Collections, University of British Columbia Library. Autograph material relating to the Rossetti family, including the original manuscript of the *P.R.B. Journal*.

The Deverell Papers, Henry E. Huntington Library: 'The P.R.B. and Walter Howell Deverell. Letters from D. G. Rossetti and Others with a Narrative and Illustrations.' By Frances Deverell, with a Preface by William Michael Rossetti (HM 12981–2).

The Stephens Papers, Bodleian Library, Oxford. Letters to Frederic George Stephens (MS. don. e. 57–87, e. 78, d. 116–19).

## PRINTED MATERIAL

ALLINGHAM, HELEN, and D. RADFORD, eds. *William Allingham: A Diary*. London: Macmillan, 1907.

ANGELI, HELEN ROSSETTI. *Dante Gabriel Rossetti: His Friends and Enemies*. London: Hamish Hamilton, 1949.

BAUM, PAULL F., ed. *Dante Gabriel Rossetti: The Blessed Damozel. The Unpublished Manuscript, Texts and Collation*. Chapel Hill, N.C.: University of North Carolina Press, 1937.

BENNETT, MARY. 'The Pre-Raphaelites and the Liverpool Prize', *Apollo*, lxxvi (Dec. 1962), 748–53.

—— 'A check List of Pre-Raphaelite Pictures Exhibited at Liverpool, 1846–67, and Some of Their Northern Collectors', *Burlington Magazine*, cv (Nov. 1963), 486–95.

—— *Ford Madox Brown, 1821–1893*. Exhibition organized by the Walker Art Gallery, Liverpool, 1964.

—— *PRB MILLAIS PRA*. Exhibition organized by the Walker Art Gallery and the Royal Academy of Arts, London, 1967.

—— *William Holman Hunt*. Exhibition organized by the Walker Art Gallery, Liverpool, 1969. All three exhibitions were arranged by Mary Bennett, who prepared the catalogues and wrote an introduction for each. 'Footnotes' to the Millais and Hunt Exhibitions appeared in the *Liverpool Bulletin*, xii (1967), 33–59; xiii (1968–70), 26–64.

BENNETT, W. C. 'To the Memory of John Orchard, Artist' (a poem) in *Lays of the Sanctuary: And Other Poems*. London: Elizabeth Good, 1859.

BODKIN, THOMAS. 'James Collinson', *Apollo*, xxx (May 1940), 128–33.

[BURNE-JONES, EDWARD]. 'Essay on the Newcomes', *Oxford and Cambridge Magazine* i (Jan. 1856), 50–61.

CHAMPNEYS, BASIL. *Memoirs and Correspondence of Coventry Patmore*. 2 vols. London: Bell, 1900.

COOK, E. T., and ALEXANDER WEDDERBURN, eds. *The Works of John Ruskin*. 39 vols. London: Allen, 1904–12.

CRAMER, M. B. 'What Browning's Reputation Owed to the Pre-Raphaelites, 1847–1856', *ELH*, viii (Dec. 1941), 305–21.

DOUGHTY, OSWALD, and J. R. WAHL, eds. *Letters of Dante Gabriel Rossetti*. 4 vols. Oxford: Clarendon Press, 1965–7.

ELLIS, S. M. 'Charles Allston Collins', *Wilkie Collins, Le Fanu and Others*. London: Constable, 1931.

FLEMING, G. H. *Dante Gabriel Rossetti and the Pre-Raphaelite Brotherhood*. London: Rupert Hart-Davis, 1967.

FLETCHER, IAN. 'Union and Beauty: An examination of Some Nineteenth Century Minority Periodicals.' Unpublished Ph.D. dissertation, University of Reading, 1965. The chapter on *The Germ* is of particular interest.

FORD, G. H. *Keats and the Victorians: A Study of His Influence and Rise to Fame*. New Haven, Conn.: Yale University Press, 1944.

FRANCILLON, R. E. *Mid-Victorian Memories*. London: Hodder and Stoughton, [1914].

FREDEMAN, WILLIAM E. *Pre-Raphaelitism: A Bibliocritical Study*. Cambridge, Mass.: Harvard University Press, 1965.

—— *Prelude to the Last Decade: Dante Gabriel Rossetti in the Summer of 1872*. Manchester: John Rylands Library, 1971. Reprinted from the *Bulletin of the John Rylands Library*, liii, nos. 1 and 2, 1970–1.

—— 'A Key Poem of the Pre-Raphaelite Movement' [on 'Mrs. Holmes Grey'], in *Nineteenth-Century Literary Perspectives: Essays in Honor of Lionel Stevenson*, ed. Clyde de L. Ryals. Durham, N.C.: Duke University Press, 1974.

—— 'Rossetti's "The Blessed Damozel": A Problem in Literary History and Textual Criticism', in *English Studies Today*. 5th Series. Istanbul: I.A.U.P.E., 1973.

GERE, JOHN. 'Alexander Munro's "Paolo and Francesca" ', *Burlington Magazine*, cv (Nov. 1963), 509–10.

*The Germ: Thoughts towards Nature in Poetry, Literature, and Art*. Numbers 1 and 2, January and February 1850. Continued as *Art and Poetry, Being Thoughts towards Nature, Conducted by Artists*. Numbers 3 and 4, March and April [dated May] 1850.

HILL, G. B., ed. *Letters of Dante Gabriel Rossetti to William Allingham, 1854–1870*. London: Unwin, 1897.

HOUGHTON, WALTER. *The Wellesley Index to Victorian Periodicals, 1824-1900*. Vol. i. Toronto: University of Toronto Press, 1966.

HUNT, WILLIAM HOLMAN. *Pre-Raphaelitism and the Pre-Raphaelite Brotherhood.* 2 vols. London: Macmillan, 1905–6; 2nd ed. rev. 1913.

IRONSIDE, ROBIN. *Pre-Raphaelite Painters.* With a Descriptive Catalogue by John Gere. London: Phaidon, 1948.

KUNITZ, STANLEY J., and HOWARD HAYCRAFT, *British Authors of the Nineteenth Century.* New York: Wilson, 1936.

LIFE, ALLAN R. 'Leigh of Newman Street', *Journal of the London House and William Goodenough House Fellowship*, iii, no. 7 (1972), 36–40.

LUTYENS, MARY. 'Selling the Missionary', *Apollo*, lxxxvi (Nov. 1967), 380–7.

MARCHAND, LESLIE A. *The Athenaeum: A Mirror of Victorian Culture.* Chapel Hill, N.C.: University of North Carolina Press, 1941.

METZDORF, ROBERT F. 'The Full Text of Rossetti's Sonnet on *Sordello*', *Harvard Library Bulletin* vii (1953), 239–43.

MILLAIS, J. G. *The Life and Letters of Sir John Everett Millais.* 2 vols. London: Methuen, 1899.

MULHAUSER, FREDERICK L., ed. *The Correspondence of Arthur Hugh Clough.* 2 vols. Oxford: Clarendon Press, 1957.

ORMOND, RICHARD L. 'Portraits to Australia: A Group of Pre-Raphaelite Drawings', *Apollo*, lxxxv (Jan. 1967), 25–7.

PACKER, LONA MOSK. *Christina Rossetti.* Berkeley: University of California Press, 1963.

PARKER, KINETON, ed. *The Painter-Poets* (The Canterbury Poets, ed. William Sharp). London: Walter Scott, n.d.

PEATTIE, ROGER W. 'William Michael Rossetti', *TLS*, no. 3257 (30 July 1964), p. 665. Includes Clough's letter to Dr. Heimann concerning W. M. Rossetti's review of the *Bothie* in *The Germ.*

—— 'William Michael Rossetti as Critic and Editor, Together with a Consideration of his Life and Character.' Unpublished Ph.D. dissertation, University of London, 1966. Contains a thorough bibliography of W. M. Rossetti's writings.

REID, J. C. *The Mind and Art of Coventry Patmore.* London: Routledge, 1957. Excellent bibliography of Patmore's periodical writings.

REITLINGER, HENRY. 'The Pre-Raphaelites', *From Hogarth to Keene.* London: Methuen, 1938.

RICKS, CHRISTOPHER. *The Poems of Tennyson.* London: Longmans, 1969.

ROSSETTI, WILLIAM MICHAEL. *Fine Art, Chiefly Contemporary: Notices Reprinted, with Revisions.* London: Macmillan, 1867. Containing many of Rossetti's notices of P.R.B. artists and his earliest essay on Pre-Raphaelitism, from the *Spectator* (4 Oct. 1850).

—— 'Who were the Pre-Raphaelite Brothers?' *Pall Mall Gazette*, xliv (10 Sept. 1886), p. 6. A letter in response to one in the previous week's issue on Bernhard Smith's connection with the P.R.B.

—— *Life of John Keats.* London: Walter Scott, 1887.

—— *Dante Gabriel Rossetti as Designer and Writer.* London: Cassell, 1889.

ROSSETTI, WILLIAM MICHAEL. ed. *Dante Gabriel Rossetti: His Family-Letters with a Memoir.* 2 vols. London: Ellis, 1895.

—— ed. *Poems by the Late John Lucas Tupper.* London: Longmans, Green, 1897.

—— *Præraphaelite Diaries and Letters.* London: Hurst and Blackett, 1900. Containing letters, extracts from Ford Madox Brown's Diary, and the *P.R.B. Journal.*

—— ed. *The Germ . . . Being A Facsimile Reprint of the Literary Organ of the Pre-Raphaelite Brotherhood, Published in 1850.* London: Stock, 1901. The four numbers printed separately, with a pamphlet containing Rossetti's Introduction (entitled Preface on the cover).

—— *Some Reminiscences.* 2 vols. London: Brown Langham, 1906.

—— ed. *The Family Letters of Christina Georgina Rossetti, with Some Supplementary Letters and Appendices.* London: Macmillan, 1908.

—— ed. *The Works of Dante Gabriel Rossetti.* London: Ellis, 1911. The standard edition.

RUSKIN, JOHN. 'The Pre-Raphaelites', *The Times,* 13 May 1851, pp. 8–9; 'The Pre-Raphaelite Artists', *The Times,* 30 May 1851, pp. 8–9.

—— *Pre-Raphaelitism.* London: Smith, Elder, 1851. Not until the 2nd ed. (1862) did Ruskin's name appear on the title page.

SCOTT, WILLIAM BELL. 'Alexander Munro', *The British School of Sculpture, Illustrated by Twenty Engravings from the Finest Works of Deceased Masters of the Art, and Fifty Woodcuts. With a Preliminary Essay and Notices of the Artists.* London: Routledge, 1872.

—— *Autobiographical Notes of the Life of William Bell Scott and Notices of His Artistic and Poetic Circle of Friends, 1830–1882,* ed. W. Minto. 2 vols. London: Osgood, 1892.

SMITH, MINNIE BERNHARD. 'Bernhard Smith and His Connection with Art; or "The Founders of the P.R.B."'. Unpublished typescript ('Proof one of seven') in the British Museum, 1917.

STEPHENS, FREDERIC GEORGE. *Dante Gabriel Rossetti* (Portfolio Artistic Monographs, no. 5). London: Seeley, 1894.

STEVENSON, LIONEL. 'The Key Poem of the Victorian Age', in *Essays in American and English Literature.* Athens, Ohio: Ohio University Press, 1967.

TENNYSON, HALLAM. *Alfred Lord Tennyson: A Memoir.* 2 vols. London: Macmillan, 1899.

THALE, JEROME. 'The Third Rossetti', *Western Humanities Review,* x (Summer 1956), 277–84.

THOMAS, WILLIAM CAVE. *Pre-Raphaelitism Tested by the Principles of Christianity: An Introduction to Christian Idealism.* London: Wertheim, MacIntosh, and Hunt, 1860.

TUPPER, JOHN L. 'English Artists of the Present Day. No. XIX. Thomas Wool-
ner', *Portfolio*, ii (July 1871), 97–101.

WAGSTAFF, SAMUEL J., JR. 'Some Notes on Holman Hunt and *The Lady o,
Shalott*', *Wadsworth Athenaeum Bulletin*, 5th ser., no. 11 (Summer 1962),
pp. 1–21.

WATTS-DUNTON, THEODORE. 'Rossetti and Charles Wells', in *Joseph and his
Brethren*, with an Introduction by A. C. Swinburne. The World's Classics.
London: Oxford University Press, 1908.

WOOD, CHRISTOPHER. *A Dictionary of Victorian Painters*. London: Antique
Collectors' Club, 1971.

WOODRING, CARL RAY. *Victorian Samplers: William and Mary Howitt*. Lawrence,
Kansas: University of Kansas Press, 1952.

WOOLNER, AMY. *Thomas Woolner, R.A., Sculptor and Poet: His Life in Letters*.
London: Chapman and Hall, 1917.

WORTH, GEORGE J. *James Hannay: His Life and Works*. Lawrence, Kansas:
University of Kansas Press, 1964.

# INDEX

## FOREWORD

Indexing the *P.R.B. Journal* poses unusual problems, and readers should familiarize themselves with the organization and structure of the edition and apparatus before consulting the two separate indexes—the General Index and the P.R.B. Entry Index. In the General Index will be found all names mentioned in the *PRBJ* and in the apparatus (with certain exceptions) together with titles or descriptions of all artistic and literary works, grouped under the name of the artist or writer. A few subject headings are also provided, but these are limited principally to proper names other than persons, to the Pre-Raphaelite Brotherhood as an entity, to *The Germ*, and to periodicals. Since the *PRBJ* treats so exclusively the seven members of the Brotherhood, it has not seemed useful to analyse in the General Index every casual context in which they occur in the *Journal*, and only references to specific works and important activities are noted. However, since some readers may wish access to a day-by-day record of one or more of the Pre-Raphaelites, the P.R.B. Entry Index provides by day, month, and year those entries in which each P.R.B. is mentioned. Owing to the fullness of the Appendices and Explanatory Notes, three exclusions have been necessary: (1) secondary materials used for documentation, unless such material is quoted or in some way commented upon; (2) all references to the sources of published or unpublished material, though the information contained therein is, of course, indexed; and (3) the lists contained in Appendices 2, 4, and 5, the first two because they are simply lists, the last because it is virtually an index to the most important information in the *PRBJ* concerning *The Germ*.

Index references for the preliminaries, appendices, and introductions are by page number or general section (Appendix 2). Most references, however, are to the *PRBJ* entry (by date) or to the Explanatory Notes (by date and line number, normally a figure following a point [23.17], but sometimes specified [line 7]). An Explanatory Note number in bold-face (May 49 **23.17** or line **9**) refers also to the corresponding *PRBJ* entry; a number in roman refers either to the entry alone (May 49 23) or to the note independent of the entry (May 49 23.17). Thus, under WHH in the index, the entry—

Continental tour and studio sharing with DGR, Aug. 49 13.1, **14.5**,
    Sept. 25, 26, 28, Oct. 10 . . .

means that information on this subject will be found in *PRBJ* entries

for 14 Aug., 25, 26, 28 Sept., and 10 Oct., and in the Explanatory Notes for 13 and 14 Aug. 1849. Index entries are arranged chronologically within sub-headings; when the year and month do not change, they are not repeated.

Eighteen sets of date and line key numbers are duplicated in the Explanatory Notes; however, because of their propinquity—all but one appear on the same page—these are not distinguished in the index. Page references to the *PRBJ* are not given, even for the longer entries; they are provided for the six-page note entry for 21 July 1850 (21.7). Finally, periodicals are grouped together alphabetically under a single heading.

# PART I: GENERAL INDEX

attacked in press, 13.64; caricature in *Punch*, 16/23; noticed in *ILN*, 24.1

Collins, Wilkie, Mar. 50 6.24, Jan. 51 line 29

Collins, William and Mrs., May 51 **2.38**

Collinson, James
  *General*: p. xxiii
  mentioned in P.R.B. poems, pp. 121–2
  Cyclographic criticism of DGR, p. 109
  vacations on Isle of Wight with WMR, Sept. 49 11–17, 25.8
  replacement for in P.R.B., Sept. 49 20.11, Oct. 50 line 5, Jan. 51 line 7
  proprietor of *Germ*, Sept. 49 23.2
  refuses to contribute to *Art and Poetry*, Mar. 50 22
  letter to WMR on *Germ* settlement, July 50 21.7 (p. 230)
  resigns P.R.B., p. 103, n. 2; letter to DGR on quoted, July 50 **21.57**
  *Athenaeum* review of cited by FGS, Jan. 51 line 29
  enters Jesuit college and later history, Jan. 53 **17.10**
  *Artistic works*:
    *Answering the Emigrant's Letter*, Oct. 49 **8.2**, Nov. **12.18**, 15, Dec. 10, 23, 28, Feb. 50 16, Mar. 2, 6, 22, 25, Apr. 7, July 21
    *The Charity Boy's Debut*, May 49 18.4
    'The Child Jesus' (*Germ* 2 etching), Dec. 49 10, **28.11**, Jan. 50 12, 13, 16, 18, 22, 28
    *Italian Image Makers at a Roadside Alehouse*, May 49 18.4, July 50 21.7 (p. 230)
    *The Novitiate* ('The New Curate', 'The Controversy'), Mar. 50 **6.5**, 22
    *The Pensioner*, Oct. 49 8.7, Nov. 12.18, Dec. 10, 23, 28, Mar. 50 **6.5**, 22
    *The Renunciation of Queen Elizabeth of Hungary*, Dec. 49 **10.12**, Apr. 50 7
    *The Rivals*, May 49 **18.4**
    Zachariah picture, July 49 **24.4**, Sept. **11.5**

Dora in the reaping (proposed Tennyson subject), Mar. 50 22
*Literary works*:
  'The Child Jesus' (*Germ* 2 poem), Dec. 49 **28.11**, Jan. 50 **9.16**, 10, 11, 17, 19, 31, Feb. 11
  Sonnets, Jan. 50 23, **25.12**

Combe, Thomas and Mrs., Oct. 49 15.3, Oct. 50 line **36**, JEM's letter to, Feb. 51 9.15; purchases Collins's *Convent Thoughts* and JEM's *Return of the Dove*, May **13.59**; WHH's *The Light of the World*, Jan. 53 line 18

Compton, ?, DGR on, May 49 **15.16**

Cook, Eliza, Oct. 50 **27.22**, 31

Cottingham, Nockalls J.
  *General*: May 49 **16.2**, 17.7, Sept. 23, Feb. 50 17, 24
  and WHH, May 49 16.2, July **26.12**, Aug. 13.1; letters to, **.5**, 19
  and DGR, May 49 16.2, 27, Feb. 50 26
  and TW, May 49 19, **23.17**, July **22.34**, Aug. 13.21, Sept. 20, 28, Oct. 6, Mar. 50 7

Cox, Edward William, editor of *Critic*, Feb. 50 **1.3**, invites WMR as art critic, **2.35**, 3, 11; reviews *Germ*, Feb. **16.2**; Oct. 26, 31, Nov. 3, 11; letter to WMR on FGS's reviewing quoted, May 51 **7.8**

Cox, Jane, Nov. 50 3.7

Cramer, M. B., Jan. 50 30.4

Cross, John, Nov. 49 **22.1**, Mar. 50 9, 10

Cundall, Henry, publisher, July 50 21

Cyclographic Society, criticism sheets of, Appendix 3; JEM's attempts to revive, p. 108; May 49 16.2, Sept. 20.11

Dalziels, the, Dec. 49 20.4

Danby, J. F. and Thomas, Feb. 50 **4.5**

Dante, Tennyson learns Italian to read, Mar. 50 21; C. B. Cayley's translations of, Oct. 50 27, Nov. 5, 7.8; *see under* DGR for his translations and paintings from

Davy, Dr. John, manager of Wordsworth memorial competition, Feb. 51 2

Dennis, Imogen, p. viii

Mary Virgin picture in catalogue of, Oct. 29

Freeman, Ronald E., p. ix

Frost, H. Harvey, his copy of *Germ* in Beinecke, Aug. 49 19.9, Sept. 25.14

Gavarni, S. P. C., Oct. 49 **10.11**

Gere, John, May 49 22.3, Feb. 50 2.23

*Germ, The*, pp. xxiii, xxvii

title: proposed titles for, Appendix 4; WMR's reaction to *PRBJ* as title, Sept. 49 25.7, **27.7**; retitled *Art and Poetry*, Jan. 50 7.15, by Alexander Tupper, Feb. 16.4; announcement of title change, 21.10; 'The Artist' suggested by DGR, **23.6**

planning: chronology of, Appendix 5; North on planning, Aug. 49 **13.15**; first reference in *PRBJ* to 'Monthly Thoughts', **13.16**, 14; format, **15.3**; DGR on date of first number, Sept. 25.8; for publication *see* Aylott and Jones

proprietors: Sept. 49 **23.2**, Mar. 50 6.31, July 21.7

prospectuses and advertising: issued with 'P.R.B.' letters on, Sept. 49 **25.7**, DGR's letter to WMR on, **26.1**; Haynes prints, Nov. **25.20**; in *Athenaeum*, Jan. 50 7.15; by posters, 15, Feb. **16.8**, July 21; new prospectus for *Art and Poetry*, Jan. 21.3; FGS's plan for publicizing, Feb. 2.35; new prospectus, Mar. **20.7**

contributors: WMR's cover sonnet, Aug. 49 **19.13**; WHD, Sept. 20.11; WBS, 25.9; JLT, Oct. 13.8, Dec. 15.7; CP, Nov. **2.11**; Calder Campbell, 15.7; George Tupper, 25.16; WMR's 'Fancies at Leisure', Dec. 49 21.16, Jan. 50 **19.6**, 23.6

contents: No. 1, Dec. 49 28.1, printed in No. 2, Jan. 50 **28.6**; No. 2, Jan. **31.1**; No. 3, Mar. 30; No. 4 summarized, July 21

illustrations: No. 1, WHH, Jan. 50 **1.1**; No. 2, JC, Dec. 49 **28.11**; No. 3, FMB, Feb. 50 **22.10**, India paper etchings, Feb. **1.1**

finances: Jan. 50 **31.23**, Feb. **2.35**, **16.4**, July **21.7**, May 51 13/15

reviews: *Oxford and Cambridge Magazine*, Jan. 50 1.1; *John Bull* and *Bell's Weekly Messenger*, **21.3,** Feb. 12, 15; *Weekly Dispatch*, Jan. **21.9**; *Art Journal*, **25.14,** Mar. **3.11**; *Critic*, Feb. 1.3, 16; *Morning Chronicle*, **14.8**; *Hastings and St. Leonard's News*, **23.3**; *Standard of Freedom*, Mar. **12.1**. *See also* Feb. 2.35

unused material: JEM's Castle-moat poem, for No. 5, May 49, 15.8; WCT's address and essay on nature, for No. 1, May 27.2, Dec. **22.8**; 'For The Things of These Days', series of political poems, Aug. 26.1, Nov. **6.17**; DGR's 'St. Agnes' and JEM's illustration, for No. 5, Feb. 50 21.5, Mar. **21.24**; FMB's second article on painting, for No. 3, Feb. **22.5**

miscellaneous: H. Harvey Frost's copy in Beinecke Library, Aug. 49 19.9, Sept. 25.14; WMR's fac-simile reprint edition, July 50 21.7 (p. 233)

Gibbon, Edward, excluded from 'List of Immortals', p. 106

Gibbons, Mr., purchaser of WHH's *Rienzi*, Aug. 49 **13.9**, 14, 25; commissions WHH's *Claudio and Isabella*, Oct. 50 intro.

Glyn, Isabella Dallas, Jan. 50 **29.16**

Gobelins tapestries, Oct. 49 **10.13**

Goethe, Wilhelm, DGR's design for *Faust*, pp. 110–12

Great Exhibition, May 49 16.2, 21.2, Mar. 50 19, Nov. 11, **13.15**

Green, N. E., founder of Cyclographic Society, p. 108; Cyclographic criticisms of DGR's paintings, pp. 109, 111–12

Grisi, Giulia, Aug. 49 **16.4**

Hall, S. C., reviews *Germ*, Jan. 50 **25.14**; Feb. 4

Hallam, Arthur Henry, Nov. 49 **2.24,** Mar. 50 18

Hancock, John

*General*: Cyclographic criticisms of DGR, pp. 109–11

mentioned in P.R.B. poems, p. 123

JEM's portrait of, May 49 24

# PART II: P.R.B. ENTRY INDEX

Indicated in this part of the Index are the *PRBJ* entries in which each of the seven
P.R.B.s is mentioned, however casually. When the reference is inferential rather
than direct—as when WMR says that all members attended a P.R.B. meeting—
the date is placed in square brackets; if there is further uncertainty, a question mark
is employed within the bracket. William Michael Rossetti presents the major
problem since it might be argued that as the author of the *PRBJ* he appears in
every entry; however, unless an entry contains a specific reference to his work or
activities—often accompanied by a personal pronoun—his presence has not been
assumed. The total number of entries (out of 255) in which each P.R.B. appears is
shown in parenthesis following his name.

*Collinson* (64): *May 49*: 15, 18, [19], 27, 28, 30; *July 49*: 24, 26; *Aug. 49*: 16, 24,
28; *Sept. 49*: 11–15, 17, 18, 20; *Oct. 49*: 8, 9, 16; *Nov. 49*: 1, 6, 12, 14, 15, [19];
*Dec. 49*: 10, [13?], 14, [19], 23, 28, 31; *Jan. 50*: [1], 9–13, 16–19, 22, 23, 25, 28,
31; *Feb. 50*: 2, 7, 11, 16; *Mar. 50*: 1, 2, 6, 22, 25; *Apr. 50*: 7; *July 50*: 21; *Oct.
50*: intro.; *May 51*: 7, *Jan. 53*: 17/22

*Hunt* (89): *May 49*: 15, 19, 23–5, 27, 29; *July 49*: 22, 26; *Aug. 49*: 13, 14, 16, 19, 24,
25, 29; *Sept. 49*: 25–8; *Oct. 49*: 10, 12, 13, 18; *Nov. 49*: 1, 6, 9, 10, 12–14, 19, 21,
22, 25; *Dec. 49*: 10, 13, 15, 17, 19, 24, 27, 28; *Jan. 50*: [1], 5, 7, [10?], [12?], 16,
18, 22; *Feb. 50*: 2, 4, 11, 14, [16], 23; *Mar. 50*: 1, 3, 4, 6, 13, 25, 29; *Apr. 50*:
7; *July 50*: 21; *Oct. 50*: intro., 25, 26, 28; *Nov. 50*: 5, 13, 14, 30; *Dec. 50*: 2, 7, 8,
[9], 10; *Jan. 51*: intro.; *Feb. 51*: 9; *Mar. 51*: 2; *May 51*: 2, 7, 8/10, 11, 13/15; *Jan.
53*: intro., 17/22

*Millais* (71): *May 49*: 15, 17, 19, 21, 23, 24, 27, 29; *July 49*: 22, 25; *Sept. 49*: 20;
*Oct. 49*: 10, 15, 18; *Nov. 49*: 1, 6–9, 11, 12, 19–22; *Dec. 49*: 7, [13?], 15, 16, [19],
23, 24, 28–30; *Jan. 50*: 1, [10?], 12; *Feb. 50*: 2, 4, 11, 13, 16, 21, 24; *Mar. 50*: 3, 21;
*Apr. 50*: 8; *July 50*: 21; *Oct. 50*: intro; *Nov. 50*: 5, 13, 30; *Dec. 50*: 2, 7, 9, 10, 12;
*Jan. 51*: intro.; *Feb. 51*: 2, 9; *May 51*: 2, 6, 7, 8/10, 12, 13/15, 16/23, 24; *Jan. 53*:
intro., 17/22

*D. G. Rossetti* (200): *May 49*: 15–25, 27–30; *July 49*: 22, 24–6; *Aug. 49*: 13, 14,
[15?], 16–20, [24?], 25, 26, 28, 29; *Sept. 49*: 19, 20, 23, 25–8; *Oct. 49*: 8, 10–13,
18; *Nov. 49*: 1, 6–15, 18–22, 24, 25; *Dec. 49*: 7, 8, [10], 13–31; *Jan. 50*: [1], 5–11,
[12?], 13–16, 19, 20, 22–9, 31; *Feb. 50*: 1–5, 7–10, [11], 12, 13, 15–17, 19–28;
*Mar. 50*: 1–5, [7?], 9–11, 13–17, 19–21, 23, 24, 26–9, 30; *Apr. 50*: 1–3, 7, 8;
*July 50*: 21; *Oct. 50*: intro., 24–9; *Nov. 50*: 3, 5, 9, 11, 13, 14, 30; *Dec. 50*: 1, 3,
5–7, 9, 10; *Jan. 51*: intro., 26; *Feb. 51*: 2, [9], 23; *Mar. 51*: 2; *May 51*: 7, 8/10, 11,
12, 13/15, 16/23, 24; *Jan. 53*: intro., 17/22, 23/29

*W. M. Rossetti* (234): *May 49*: 15–24, [25], 27–30; *July 49*: 22, 24–6; *Aug. 49*:
13–17, 19, [24], 25, 28; *Sept. 49*: 11–15, 17–28; *Oct. 49*: 6–16, 18, 19; *Nov. 49*: 1,
2, 6–13, 15, [18], 19, [20], 21, 22, 24, 25; *Dec. 49*: 7, 8, [10], 13–19, 21–31; *Jan.
50*: 1, 6–31; *Feb. 50*: 1–23, 25–8; *Mar. 50*: 1–3, 6–8, 10, [12?], 13, 14, 17–23, 25–
31; *Apr. 50*: 1–4, 7, 8; *July 50*: 21; *Oct. 50*: intro., 24–31; *Nov. 50*: 1–14, 30;
*Dec. 50*: 2–4, 7–12; *Jan. 51*: intro., 19, 26; *Feb. 51*: 2, 9, 23; *Mar. 51*: 2, 9; *May
51*: 2, 6, 7, 8/10, 11, 12, 13/15, 16/23, 24; *Jan. 53*: intro., 17/22